Network
Aesthetics

Network
Aesthetics

Patrick Jagoda

The University of Chicago Press
Chicago and London

Patrick Jagoda is assistant professor of English at the University of Chicago and a coeditor of *Critical Inquiry*.

The University of Chicago Press, Chicago 60637
The University of Chicago Press, Ltd., London
© 2016 by The University of Chicago
All rights reserved. Published 2016.
Printed in the United States of America

25 24 23 22 21 20 19 18 17 16 1 2 3 4 5

ISBN-13: 978-0-226-34648-9 (cloth)
ISBN-13: 978-0-226-34651-9 (paper)
ISBN-13: 978-0-226-34665-6 (e-book)
DOI: 10.7208/chicago/9780226346656.001.0001

The University of Chicago Press gratefully acknowledges the generous support of the Division of the Humanities at the University of Chicago toward the publication of this book.

Library of Congress Cataloging-in-Publication Data

Jagoda, Patrick, author.
Network aesthetics / Patrick Jagoda.
pages cm
Includes bibliographical references and index.
ISBN 978-0-226-34648-9 (cloth : alkaline paper)
ISBN 978-0-226-34651-9 (paperback : alkaline paper)
ISBN 978-0-226-34665-6 (e-book)
1. Arts—Philosophy. 2. Aesthetics. 3. Cognitive science. I. Title.
BH39.J34 2016
302.23'1—dc23
2015035274

♾ This paper meets the requirements of ANSI/NISO Z39.48-1992
(Permanence of Paper).

This book is dedicated to an assemblage of friends—including the late-night conversational, the lifelong, and the social media varieties— to whom I am grateful for inspiration and discussion, collaboration and argument, shared meals and intellectual support. Whenever I undertake the difficult task of thinking through and beyond network form, I constellate you in my imagination.

Contents

Figures

Acknowledgments

In *Times Square Red, Times Square Blue*, Samuel (Chip) Delany suggests two distinct but overlapping terms to describe social ways of being in the world—"contact" and "networking." Contact may take place in line at the grocery store, in intense conversation at home, or at the copy machine at work. Networking, on the other hand, may happen at conferences, cocktail parties, or workshops. During the time I have worked on *Network Aesthetics*, I have been fortunate enough to learn a great deal from friends, family, and colleagues through both contact and networking, from intimate conversation and casual exchange to face-to-face debates and indirect inspirations, that I can capture only provisionally through my citations and these acknowledgments.

Any project—even a single-authored monograph—is a large-scale collaboration. A number of people volunteered significant time and attention to help me move through countless drafts of this book. This project would have been absolutely impossible without the sustained and meticulous close reading of manuscript drafts by Scott Bukatman, Jim Hodge, Keith Jones, Patrick LeMieux, Tara McPherson, Daniel Morgan, and Priscilla Wald. I'm grateful for advice and ongoing conversations, in the years leading up to publication, with Lauren Berlant, Bill Brown, Jim Chandler, Hillary Chute, Cathy Davidson, Frances Ferguson, Abe Geil, Tom Gunning, Timothy Harrison, Katherine Hayles, Tim Lenoir, Tom Mitchell, Larry Rothfield, and Avery Slater. I also owe much to a quarter of intense discussions with my co-instructor Eivind Røssaak and the graduate students who participated in the Center for Disciplinary Innovation "Network Aesthetics | Network Cultures" seminar at the University of Chicago.

People who have been equally crucial to my thinking, without neces-

sarily needing to read a single draft, are my family, especially Irus, Ziggy, David, and Mark. Also, thanks to Kristen Schilt, who has taught me some indispensable things about shared projects, queer families, and thick partnerships.

I'm thankful for more local (but no less important) contributions from several colleagues along the way. For help with the introduction: Adrienne Brown, Andrew Leong, Nasser Mufti, John Muse, Debbie Nelson, Zachary Samalin, and the University of Chicago English Department. For shaping my thought about chapter 1, I'm grateful to the participants of the "Networks in American Culture/America as Network" symposium at Mannheim University, at which I presented an earlier version, especially Wendy Chun and Regina Schober. For help with key conceptual points in chapter 2, thanks to Ian Baucom and Fred Moten. For chapter 3, I appreciate a close reading by Phil Kaffen. For chapter 4, thanks to the attendees of the "Debating Visual Knowledge" symposium at the University of Pittsburgh, the Post45 workshop at the University of Chicago, and the "Every Wednesday Lecture" at the Franke Institute for the Humanities, at which I presented this work. Also, I appreciate feedback on earlier versions from Stephanie Boluk, Doron Galili, Mollie McFee, Lisa Nakamura, Scott Richmond, and Richard Jean So.

Of all of the parts of *Network Aesthetics*, chapter 5 required the greatest number of risks and revisions. I consider myself lucky for exchanges with David Levin and Leslie Danzig, as well as Sha Xin Wei, the students of my "Transmedia Games: Theory and Design" course, and members of the Topological Media Lab with whom I created the alternate reality game (ARG) *The Project*. Also, special thanks to participants in my "Network Art: Distance, Intimacy, and Correspondence" independent study, with whom I began to really think through the complicated form of ARGs: Peter McDonald, Phil Ehrenberg, Ellen Kladky, Bea Malsky, Kalil Smith-Nuevelle, and Ashlyn Sparrow. From my collaborators at the Game Changer Chicago Design Lab, especially Melissa Gilliam, I have learned so much about creating alternate reality games. This chapter would also not have been possible without the generous fellowship from the Richard and Mary L. Gray Center for Arts and Inquiry that allowed me to experiment, fail in interesting ways, and, as a result, find my way to more nuanced thoughts.

For his careful attention, throughout the review and editorial process, many thanks to Alan Thomas at the University of Chicago Press. Also, I appreciate the patience and crystal-clear responses to my queries from Randy Petilos, Joel Score, and my careful copy editor, India Cooper. I'm grateful

to my RA Eran Flicker for help with chapter 3. Also, many thanks to my fantastic RA Joshua Kopin and to Stephanie Kaufman for their careful assistance in preparing the final manuscript. Additional proofreading assistance came from Bill Hutchison, Haitham Ibrahim, and Jean Thomas Tremblay.

Finally, I'm also grateful for the structural elements that have allowed me to write this book. The Mellon Postdoctoral Fellowship in New Media at the University of Chicago enabled me, in both my teaching and research, to delve into fields such as television studies and game studies and to experiment with practice-based research and game design. The eventual revision process was also made possible by the Donald D. Harrington Faculty Fellowship, and the faculty and graduate students of the American Studies Department at the University of Texas at Austin.

<center>* * *</center>

An earlier, shorter version of chapter 2 was published as "Terror Networks and the Aesthetics of Interconnection" in *Social Text* 105 (2010): 65–90, © Duke University Press, and is republished here with permission; and an earlier, shorter version of the coda appeared as "Network Ambivalence" in *Contemporaneity: Historical Presence in Visual Culture* 4, no. 1 (2015): 108–18.

Introduction
Network Aesthetics

Only connect!
E. M. Forster (*Howards End*)

Something huge and impersonal runs through things, but
it's also mysteriously intimate and close at hand. At once
abstract and concrete, it's both a distant, untouchable order
of things and a claustrophobically close presence, like the
experience of getting stuck in a customer service information
loop every time you try to get to the bottom of things.
Kathleen Stewart (*Ordinary Affects*)

Encounters with Network Form

In E. M. Forster's 1910 novel *Howards End*, the protagonist Margaret Schlegel urges the individualistic Henry Wilcox, "Only connect!" Margaret's "sermon" to Henry counsels intersubjective sympathy and implores him to "live in fragments no longer."[1] In this early twentieth-century moment, prior to the outbreak of World War I and the full-blown onset of modernity, Margaret's idea of connection seems a perfectly innocent moral imperative for Henry's salvation. A century later, it no longer makes sense, as it may have within modernism, to formulate connection as an aspiration.

In an early twenty-first century world saturated increasingly by always-on computing, pervasive social media, and persistent virtual worlds, connection is less an imperative than it is the infrastructural basis of everyday life.[2] In place of the choice implicit in the insistence that we only

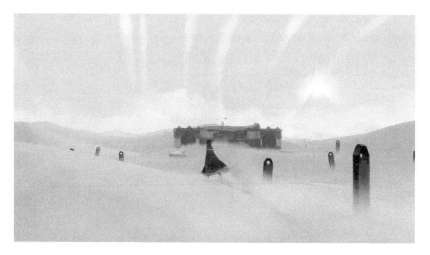

0.1. *Journey* (thatgamecompany, 2012).

connect, we are now reminded constantly of the alleged fait accompli of interconnection. This feeling of linkage, often from a distance, becomes sensible in thatgamecompany's *Journey*, a popular and critically acclaimed videogame released in 2012. In this game, the player guides a robed avatar through a lonely desert world. A few minutes into the game, the player discovers that *Journey* is in fact a networked experience in which she can encounter other players but cannot communicate or coordinate goal-oriented actions with them using language, via either the instant messaging or voice chat options common to most online games (fig. 0.1). The game evokes an atmosphere of intense alone-togetherness—a feeling of being with another person across an unknown distance. As one anonymous player observes in *Journey Stories*, a Tumblr blog that receives contributions from the game's fans, "When our journey ended after about 90 minutes it was in an immensely cathartic moment, in a way that no game has ever made me feel before. It is hard to explain how the game evokes emotions. How masterfully it plays with the feeling of *connectedness*."[3] Unlike Forster's "Only connect!" this response treats "the feeling of connectedness" as a common affective state, a default condition with which an artful game "plays." At the same time, this player's response also gestures toward linkage as a problem and an unfolding temporal experience that is fleeting, constrained, rare, and "hard to explain." This opening juxtaposition of a modernist novel with what we might call a post-postmodernist videogame suggests the varied ways that divergent cultural forms attempt to make sense of human relations at different historical moments.

The argument of *Network Aesthetics* is that the problem of global con-nectedness cannot be understood, in our historical present, independently of the formal features of a network imaginary. By network imaginary I mean the complex of material infrastructures and metaphorical figures that inform our experience with and our thinking about the contemporary social world. This book explores aesthetic and affective encounters with network form through a comparative media approach that spans the novel, film, television serial, digital game, and transmedia alternate reality game. This method is closely tied to the growing interrelationship among cul-tural forms that digital and networked technologies make possible in our time—as well as the increased embeddedness of these forms in everyday life.

Networks, a limit concept of the historical present, are accessible only at the edge of our sensibilities. Networks exceed rational description or mapping, and it is at this point that we might turn to aesthetics and cultural production for a more robust account. Though this introduction offers a broader transnational and historical context for thinking about networks, the chapters that follow focus on US literature, visual media, and digital productions of the late twentieth and early twenty-first centuries. In se-lecting these coordinates in space and time, I address the rise of network science that converged with widespread cultural, economic, political, and technological interest in networks that flourished in the United States. At the same time, close attention to this group of cultural works generates a more coherent narrative and constellation of concepts that informs a larger transdisciplinary body of scholarship about networks.

In its most common present-day iteration, a "network" is a structure composed of links and nodes. It is a figure for a proliferating multiplicity that at once enables and challenges our very capacity to think. The word "network" is certainly not new and has been in use for hundreds of years. It was not until the mid-twentieth century, however, that scientists, human-istic scholars, and artists alike began to use a more generalized network vocabulary to describe new visions of a post–World War II world. Since the 1970s, the interdisciplinary study of complexity has come to encom-pass a wider range of research on social networks, systemic resilience, emergence, and connectivity. A resurgence and expansion in the study of networks that began even later—in the 1990s—has taken disciplinary shape through the field of network science. This development was enabled by new techniques of mapping and visualization but perhaps just as centrally by the proliferation of the network as the principal architecture and most resonant metaphor of the globalizing world. Since the late twentieth cen-

tury, scientists, politicians, journalists, poets, and artists have increasingly framed the world in terms of the interconnection of people and nations, objects and economies, transportation hubs and computers. Networks, across these contexts, have become practically ubiquitous as both literal infrastructures and figurative tropes. The most conspicuous example of the conflation between these aspects of the network imaginary is arguably the Internet, which is not simply a system of linked computer networks but also a figure through which we experience a concatenated world. Alongside computer networks, the language of networks began to frame a confusingly diverse range of forms: terrorist networks, economic systems, social media, disease ecologies, neural structures, and traffic patterns. The science of networks has come to influence disciplines that include biology, economics, epidemiology, informatics, neurology, and sociology.[4]

This proliferation of network discourse has led Bruno Latour to observe, "The word network is so ambiguous that we should have abandoned it long ago."[5] Indeed, maybe we *should* have abandoned the word. But we have not done so. The language of networks shows no sign of abating anytime soon. In the transdisciplinary enthusiasm that orbits the concept, "network" is far too easily taken up as a term that we should already know. However, as Nietzsche observes, "What is familiar is what we are used to; and what we are used to is most difficult to 'know'—that is, to see as a problem; that is, to see as strange, as distant, as 'outside us.'"[6] In approaching our network imaginary as a problem, it would be an impossible undertaking to write a history of *the* network, as if "network" were a discrete, containable thing with both a singular origin and a clear referent.[7] First of all, there are many things that we call networks in the early twenty-first century. Second, to further complicate matters, networks are ontologically slippery, approached simultaneously as objective things in the world—natural structures or infrastructural technologies—and as metaphors or concepts to capture emergent qualities of interconnection in our time. Third, the language of networks, though currently dominant, may be only one way to conceptualize contemporary connectedness. In order to make other figures thinkable or imaginable, however, I propose that we must first come to terms with a diverse network imaginary. The language and representational strategies associated with these structures have surely grown normative and familiar. To call something a network often serves as a cliché rather than, as it once did, an evocative metaphor of relationality or a nonhierarchical model of interconnection. The word "network" is thus a keyword of the historical present, but at the same time, given its relentless usage, it increasingly lacks descriptive edge.

While the language of networks might be omnipresent, these forms are most distinctly felt, materialized, and conceived through the experience of everyday media and ordinary social practices. Such experiences may occur in the ambient togetherness afforded by social media platforms like Facebook or Snapchat, the stranger sociality enabled by smartphone apps like Grindr or Tinder, or the overwhelming sense of obligation triggered by something as common as an overloaded email in-box. Social scientists have already explored many such platforms and apps.[8] Along with the cultural anthropologist Kathleen Stewart, I believe that the process of studying ordinary situations, as they unfold, can help to "record the state of emergence that animates things cultural" and "to track some of the effects of this state of things."[9] This book also attends to ordinary experiences of connection, but it does so through literary and art works that heighten sensitivities to and encourage layered reflection on everyday embeddedness in networks.

All of the works that I examine in this book seek to defamiliarize and make networks sensible through what I call *network aesthetics*. As I elaborate below, the category of "aesthetics," for me, serves as an expansive rubric for sensing and thinking through culture. A number of narrative and visual works that preceded the rise of computing and networking in the latter half of the twentieth century, including novels and films, already deployed various techniques—from multiprotagonist narratives to cinematic crosscutting—to instantiate networks. These older forms have further mutated in response to the cultural zeitgeist of the network. At the same time, since the late twentieth century, new media forms such as online videogames and transmedia narratives have opened up new vistas for apprehending networks by inviting people to play with, alter, and experience them from the inside. My core interest lies in the way that different cultural forms access networks through a range of both medium-specific and transmedia features that include narrative, text, images, audio, and procedural or participatory interactions. These elements prime us to undertake cognitive but also somatic and affective encounters with networks. While feelings of interconnection are the starting point of my analysis, the works I study also deploy network forms to foreground experiences that I examine across five chapters: senses of historical situatedness in the present, emergences of complexity over time, modes of realism that become available with the greater centrality of networks, perceptions of technologically enabled sociality from a distance, and propositional relations made possible by networked media.

To briefly illustrate the way a cultural work might offer aesthetic insight into a network imaginary, consider *We the Giants* (2009), a browser-

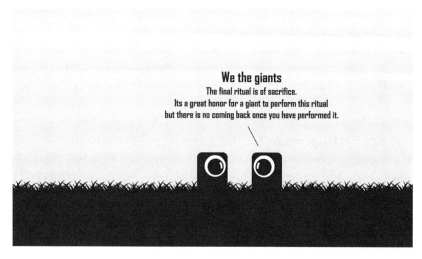

We the giants
The final ritual is of sacrifice.
Its a great honor for a giant to perform this ritual
but there is no coming back once you have performed it.

0.2. *We the Giants* (Peter Groeneweg, 2009).

based, 2D side-scrolling platform game created in Flash that depends on networked gameplay yet never allows real-time interaction with another person (fig. 0.2). In this short, linear digital game, a single player controls a square-bodied cyclopic creature. The player communicates with other nonplayer characters that offer basic instructions about how this race of giants participates in a ritual of sacrifice. On the final screen of the game, the player zooms out to discover the game's key objective—the acquisition of a star that is located in the upper reaches of the night sky. However, in most cases, the player can come nowhere near the star. In the only truly agential act in the game, the player has the option of sacrificing her body as a stepping-stone that might allow the next player to come closer to the shared goal of touching the star. Thus the player collaborates asynchronously and serially with a network of hundreds of other players whom she cannot direct or control, except indirectly through the residue of previous play-throughs and the tactical placement of her body, which is surrendered through suicide. Through its specific mechanic of sacrifice, the game foregrounds the importance of a collectivity—anonymous yet united in its purpose—to achieving what remains impossible for an individual. Even though it does not allow the player to interact with another player in real time, as she might in a standard networked multiplayer game with a chat option, *We the Giants* serves as an aesthetic microcosm that makes a network of relations sensible through the constraints that it imposes on copresence. By removing the possibility of instant communication, the game emphasizes our

daily reliance on computer networks for communication and coordination. Though this feeling of alone-togetherness is a common quality of life online, the artful design of *We the Giants* encourages deliberate reflection on the pleasures, uncertainties, frustrations, and dependencies of networked technologies.

In its attentiveness to a wide range of cultural works, including the aesthetics of videogames such as *We the Giants*, this book attempts to revise the common treatment of networks as control structures that originated in the computing and cybernetics research of the early Cold War. Many analyses of networks in the humanities focus largely on their structural dimensions, but I hope to attend to those microlevel affects and effects that are a key domain of literary and art works. Beyond the sublime of interconnection, which is a dominant mode of encountering systemic totalities, network aesthetics concern the ordinary affects of networked life-worlds—their promises and failures, their freedoms and constraints. What senses of networks, I ask, become available when we begin an analysis of the Internet, for instance, not with technical protocols but with everyday affects (such as expectation or frustration) that they generate? How do we understand networks when we treat them as forms through which people daily encounter, manage, and construct quasi-anonymous forms of being—whether the ambient reciprocities afforded by social media such as Facebook or uncertain feelings about the vicissitudes of the global economy? And how, then, might attention to ordinary connections and network aesthetics influence how we experience and engage an extraordinarily interconnected culture characterized by social media, networked games, virtual worlds, new media artworks, mobile devices, and rapid transnational flows of people and ideas?

As I hope to show, connection, in our time, has become an assemblage of ordinary problems that animate the spectrum between linkage and disconnection—problems that nonetheless retain some traces of an earlier yearning for contact and generate a sense of networks that do not quite work. Since the late twentieth century, the phrase "everything is connected" has become indecipherable. It simultaneously connotes a felt fact of contemporary life, a metaphysical discovery, and a scientific paradigm; a banal catchphrase of globalization, an ideology of digital media, and a fantasy of social sublimity; a provocation that surges forth from experiences of alienation, a reaction formation developed through encounters with irreducible complexity, and a corollary of a control society; a corporate slogan, a paranoid pronouncement, and a realization of apophenia; an idea that

burgeons from deep human bonds, a sense that rises out of ephemeral affinities, and an impossible desire for ambient intimacy; an epistemological foundation, an experience of diaspora, and a utopian impulse; and perhaps still, as in *Howards End*, a spiritual conviction. Whether exceptional fact or ordinary affect, belief or desire, interconnection in the twenty-first century seems ubiquitous and unavoidable. Network aesthetics contribute to a fuller experience and account of our network imaginary.

The Emergence of a Network Imaginary

This book does not set out to define "network" or to translate this concept into a static form (both all-too-common analytical operations that offer a false sense of mastery). Nevertheless, it is useful to delimit the concept of the network, if only in a provisional or heuristic manner, before turning to the specific transmedia interventions that are my ultimate concern. In its most generalized form—the one promulgated, for instance, by network science—a network is a complex and interconnected structure made up of groups of "nodes" that are interconnected by "links." The best-connected of these central nodes are called "hubs." The form of the network, as it is most commonly taken up, departs from the organizational schemes of classical centralized systems and traditional hierarchies, adopting instead decentralized or distributed modes of operation. Although there are several types of networks, the primary characteristics shared by these structures are openness, flexibility, extensibility, complexity, internal asymmetry, and an interdependence of individual parts.[10]

Regardless of its nodal composition, a network is never a static structure, even as network graphs, maps, or visualizations might sometimes suggest a fixed form. Networks depend on an active flow among interlinked vertices. As the sociologist Manuel Castells puts it, a network is "susceptible to innovating without threatening its balance."[11] Alexander Galloway and Eugene Thacker go a step further to suggest that perhaps the fundamental feature of a network is its capacity for "radically heterogeneous transformation and reconfiguration." In this sense, interconnected operability, online access, and a live status are not merely possible states but the necessary and defining conditions of any network.[12] Indeed, one of the difficulties of even naming, let alone thinking through, networks is that they are inherently emergent—capable of spatiotemporal transformations and scalar shifts. The very notion of *a specific and nameable network* becomes problematic, thereby signaling the term's instability.[13]

Within the sciences, social sciences, and humanities alike, the term "network" comes most consistently to take on two different referents that include technological or communication systems, on the one hand, and social organization, on the other. In the first instance, a network is a tool or an interconnected system (e.g., a telegraph network, the World Wide Web, or a social media platform). In the second, a network is a configuration of human or nonhuman actors (e.g., the Underground Railroad, a guild in a massively multiplayer online game, or the US economy). As Latour notes, Castells blurs these meanings in his characterization of the network as "a privileged mode of organization thanks to the very extension of information technology."[14] Since Castells's formulation of the "network society" in 1996, we have seen an accelerated economic, political, and cultural dependence on communications technologies (especially those numerous systems and processes commonly bundled into the signifier "Internet") for production, transmission, storage, and organization.

While networks, in Castells's dual sense, take on a new significance beginning in the mid-twentieth century, these structures have a long history. The word "network" (an amalgamation of the Old English words "net" and "weorc") emerged in the sixteenth century, at which time it referred to a piece of work, such as manufactured fabric, in which threads or wires were interlaced into an intersecting arrangement. In the seventeenth century, the word was extended from nonliving objects to living ecologies and biological structures such as cells. As Armand Mattelart explains, even preceding the widespread usage of the word, the image of the network appeared in the late seventeenth century through "metaphors of the living organism, and especially those taken from the circulation of the blood," such as references to "the reticular body." The concept, especially in France, also came to inform both "science and military cartography," including "fortifications" that were imagined as a "complex system of 'arteries.'"[15]

It was not until the nineteenth century that the connotations of "network" edged closer to the word's common contemporary usage to describe communication systems. For the first time, in these years, the word "network" was recorded in reference to a variety of complex, netlike systems, including interconnected business organizations, transportation routes, telecommunication lines, and electrical structures—all part of an emerging imperial world system.[16] The first modern communication technology to aspire to rapid nationwide connectivity (albeit not yet "transnational" or "global" linkage) was the French semaphore telegraph network, invented by the Chappe brothers in the 1790s. This optical and signal system of tow-

ers enabled communication across approximately three thousand miles of French territory. Even so, this early form of the telegraph was scarcely used for commercial or civil purposes—applications that would only become viable well after the innovations of William Cooke, Charles Wheatstone, and Samuel Morse on the electric telegraph in the 1830s. Along with telegraph lines, railways contributed to the proliferation of the language and metaphor of networks in the nineteenth century throughout Britain, continental Europe, and the United States. As Mattelart demonstrates, technical inventions, especially as they became more accessible and popular, connected the abstract concept of a network with "new types of exchanges between people" and even suggested possibilities of "a new democracy." Transportation and communication systems in the nineteenth century already carried an aspirational dimension, which aligns with the Enlightenment ideal of rationality that "links, unites and guarantees the free flow of people and goods."[17] With the transition into the twentieth century, a network imaginary began to unfold in the realm of communications, and also in media (a central concern of this book), in the shift from technical media—Friedrich Kittler's triumvirate of gramophone, film, and typewriter—to networked media such as radio, television, and the Internet.[18]

As forms that become visible across a transdisciplinary and transnational scope, networks have a history that might be best restricted (again, heuristically) to the period following World War II. It was not until the late twentieth century, as Luc Boltanski and Eve Chiapello observe, that "the network" emerged as a normative concept that could be applied to everything from the human brain to the global economy to geopolitics to even the Earth itself as an interconnected totality. These years saw the emergence of a new "mode of judgment which, taking it for granted that the world is a network (and not, for example, a structure, a system, a market or a community), offers fulcra for appraising and ordering the relative value of beings in such a world."[19] Pronouncements of global interconnectivity by Marshall McLuhan and Buckminster Fuller in the 1960s were still prescriptive; by the 1990s similar observations were already (at least understood broadly to be) descriptive—and no longer radical.

I contend that three major, and roughly parallel, developments that began in the middle of the twentieth century and took a programmatic form by the 1990s imbued a generalized network concept with the explanatory power and reach that it has achieved in the early twenty-first century. These three developments, none of which should be read as deterministic, are rarely discussed together. Juxtaposing these narratives, however, suggests the historical complexity of our current network imaginary. First,

a series of mathematical and scientific innovations produced a theoretical framework within which to think about networks. This work made possible, ultimately, network science — arguably the most coherent and influential articulation of a generalized network structure in the late twentieth century. Second, though communications networks in the nineteenth century already included extensive material substrata such as railway and power lines, American-led development of the Internet and its decentralized informational architecture instantiated the network model, both materially and metaphorically, at a global scale. Third, neoliberalism and the postindustrial economy, as well as forms of resistance to these systems, began to embrace networks as key organizational and conceptual models. Each of these three transformations, which are interrelated, requires a brief overview because, together, these scientific, media, and geopolitical coordinates serve as a foundation for the imaginary that the various cultural works I explore in this book defamiliarize, intensify, and challenge.

First, network science has been crucial to the theoretical foundation and intellectual legitimation that has allowed networks to flourish as a dominant present-day epistemological model in the sciences and the humanities. This history informs many of the works I analyze in the following chapters. Even as graph theory constitutes the mathematical foundation of network science, a systematic study of interconnected structures can be traced back most directly to 1940s general systems theory.[20] Serving as a response to scientific reductionism, systems theory came eventually to influence the renewed mathematical interest in cryptography and computation during World War II and the field of cybernetics that developed after the war. The language of networks began increasingly to inflect scientific research during these years.[21] That scientific discourse was far from neutral, already serving the imagination of a fledgling military-industrial complex. Along with fields such as mathematics and the biological sciences (which had a longer history of deploying network metaphors), the social sciences first began a serious study of networks in the 1950s and 1960s, which saw the proliferation of quantitative methods within fields such as sociology and psychology. These approaches made possible a new research agenda concerned with networks, which included Stanley Milgram's well-known 1967 "small world" experiment that examined the "six degrees of separation" between any two people in the United States.[22] Graph theory, systems theory, and social network analysis all contributed to the present-day scientific interest in networks. Even so, the interdisciplinary field of network science did not form a coherent research program until the 1990s.[23]

Second, the gradual development of the Internet after World War II has

been crucial in realizing a network imaginary at an infrastructural level and making it, in the early twenty-first century, a material reality for billions of people around the world. According to Castells, communication and information networks since the 1980s represent a significant change in *type* rather than mere *degree*. These systems provide "the material basis for [the network's] pervasive expansion throughout the entire social structure."[24] Today, everything from daily communications to traffic lights to weapons systems depends on interlinked material infrastructures. As early as 1997, Bill Clinton's administration realized the unprecedented significance of computer networks and databases to US interests, establishing the President's Commission on Critical Infrastructure Protection to defend the digital frameworks that support every facet of life.[25] While there are already many histories of the Internet, my focus on the relationship between material technologies and imaginaries in the following chapters makes it useful to foreground the coemergence of this system alongside network form at the outset.[26]

Cryptography efforts in the 1940s as well as postwar cybernetics, informatics, and computing research all contributed to an interest in interconnected technologies among scientists and engineers. In the early 1960s, Marshall McLuhan already imagines the "electronic interdependence" of the "global village." Even so, in texts such as *The Gutenberg Galaxy*, he draws not from technology or engineering but, primarily, from a romantic imaginary made possible by thinkers such as Pierre Teilhard de Chardin. In *Understanding Media*, he deploys numerous metaphors to capture an increasingly linked world, arguing that the mechanical "explosion" of industrialism has ceded to an electronic "implosion." He imagines new media extending the human "central nervous system itself in a global embrace, abolishing both space and time as far as our planet is concerned."[27] Although McLuhan's celebration of a globalized network was premature, especially at a technical level, by the late 1960s computer scientists and engineers were already beginning to envision the possibility of computers that operated not merely as calculating devices but as expressive media and distributed communication technologies. In 1969, the Defense Advanced Research Projects Agency (DARPA) established a limited military packet switching network called ARPANET. By 1973, computer scientists had developed a new technical protocol (TCP/IP) that replaced a closed network model with a flexible and open architecture.[28]

The popularization of the Internet within consumer culture and growing public consciousness of networks, even in the United States, came fairly

late in the twentieth century. The emergence of nonnetworked personal computers in the 1970s gave many American users, outside of military and university settings, an initial experience of interactive computing. In the 1980s, personal computers grew in popularity and, despite limited practical applications, found a place in many American households. Even as vibrant research into the production of a commercially viable Internet continued alongside the rise of personal computers, computer networks did not enter mainstream experience during these years. As the sociologist Thomas Streeter argues, "Networking was ignored in part because the dominant culture was seeing things through free-market lenses and thus imagined that microcomputers were about isolated individuals buying and selling objects." In fact, "information" (a concept that enabled the conversion of complex processes into concrete things, products, or pieces of property) was a more prominent computing metaphor in these years than "network."[29] Even in its earliest popular version, in the late 1980s and early 1990s, the Internet was more often imagined as an "information superhighway" than as a "network of networks" (as Tiziana Terranova described it a decade and a half later).[30] Even as late as 1993, as Streeter demonstrates, computers were already a norm in the United States, but going online was still a rare experience. The Internet did not enter widespread public consciousness until the introduction of two "user-friendly" technologies—the World Wide Web (introduced by Tim Berners-Lee in the early 1990s) and graphical web browsers (including Mosaic in 1993 and Netscape Navigator in 1994).[31] It was thus not until the mid-1990s that the generalized network concept attached to a dominant communication technology and came to impact everyday experiences of most first-world subjects, initially in the United States and subsequently around the world.

Third, the proliferation of the network concept is connected closely to the expansion of US neoliberalism and finance capitalism, as well as resistances to it. In the 1960s, the network imaginary was central to countercultural movements such as New Communalism as well as to the New Left's broader adoption of news media, especially televisual networks, as a key aspect of its strategic planning in anti-Vietnam protests.[32] By the 1970s, networks had already lost some of their oppositional charge with the rapid expansion of free market ideology that was strengthened by the deterioration of the Bretton Woods System of international monetary management, the rise of financial privatization, and the shift toward deregulation as a dominant American policy. The sense of decentralization inherent in network form aligned with these developments and served as a model for the

fundamental techniques of post-Fordism, including flexible production, affective labor, and the centrality of information technology. Indeed, this movement from industrial to postindustrial society is at the core of what Castells means in his sociological formulation of the "network society." A sense of increased global interconnection in this transitional era can be traced, in part, through a parallel movement from "machine" metaphors to "network" metaphors.[33] This change in figurative language also sees parallels in the shift from the language of self-consistent and structurally complex "systems" to socially infused and live "networks." Such rhetorical transformations marked considerable changes in corporate practices. Alan Liu, for instance, identifies "networking" in the 1980s and 1990s as the dominant information technology paradigm in business, which brought about a transition from an earlier mainframe-enabled "total" or "synoptic" experience to more horizontal forms of connectivity enabled by Internet communication and new opportunities for transnational transportation.[34]

Networks, then, are not only theoretical figures or technological infrastructures. They also serve as organizational blueprints for different forms of economic, political, and social life. As theorists such as Manuel Castells, Wendy Chun, and Alexander Galloway have demonstrated, networks often suggest a new diagram of power and a decentralized management style that undergirds the transition from Foucault's disciplinary societies to Deleuze's societies of control.[35] Networks are, moreover, not always liberating alternatives to the concentrated nucleus of power that accompanies centralized organization, even if the deployment of the term has often suggested a utopian freedom. Networks represent more complex forms of ideology that inform contemporary labor, organize dominant thought styles, and reformulate the parameters of human identity and interrelation. Despite the claims of early techno-libertarians, network structures and technologies do not usher in an age of wholly decentralized power, unproblematic democracy, or, in Bill Gates's infamous formulation, "friction-free capitalism."[36] These structures build upon previous systems of power and give rise to emergent systems of control. They also bring forth new forms of resistance, including technologically oriented opposition in the form of "hacktivism" and "exploits," as well as social movements or concepts of anticapitalist struggle such as Michael Hardt and Antonio Negri's "multitude," which have been inspired by a subversive understanding of network organization.[37]

Thus far, my examination of the rise of a generalized network concept in the late twentieth century may suggest that it is more proper to fields such

as mathematics, computer science, and economics than to the disciplines of the humanities. However, this concept appears in some of the most influential humanities scholarship produced during this same period, in a variety of ways, as metaphor, model, method, and material infrastructure. Additionally, the sciences in this period came to influence the humanities in key ways, including through fields such as cybernetics, statistics, and network science. For these reasons, a brief review of some of these usages is necessary before turning to my own focus on network aesthetics as they play out across media that draw on and transform both scientific and humanistic sources.

The term "network," and the interdisciplinary vocabulary that accompanies it, come into play throughout late twentieth century humanities research. Indeed, some of the most familiar and influential humanities scholars can already be treated as network thinkers. In comparative literature and area studies, we find networks in metaphors of transnational "circulation" of languages, "linkage" among cultures, and "relations" to the Other, as in the seminal postcolonial thinking of Édouard Glissant.[38] The term also travels through continental philosophy, especially through Gilles Deleuze and Félix Guattari's articulation of the "rhizomatic" network in their magisterial 1980 work *A Thousand Plateaus*.[39] In the discipline of history, Michel Foucault also relies heavily on the language of networks in his practices of "archaeology" and "genealogy."[40]

The critical theory of the mid-to-late twentieth century tended to treat networks in fairly abstract terms; early twenty-first century work in the humanities has, by distinction, taken up networks as concrete entities. Emergent humanistic fields, such as the digital humanities and new media studies, have demonstrated new ways of studying networks as powerful methods and material infrastructures for organizing and analyzing knowledge. In both of these capacities, networks have also influenced new forms of collaborative and multimodal scholarship. In the digital humanities, network methods have played an important role in experiments with social network analysis and relational sociology. Scholars across the humanities have sought to use visualization tools to understand and analyze heterogeneous and complex data sets related, for instance, to the exchange of historical documents and the production of literary texts across periods.[41] Others, in media studies, have explored the historical and cultural dimensions of networks. The field of media archaeology offers rigorous studies of both old and new communication networks as diverse as the postal system, the telegraph, undersea networks, and the Internet.[42] In new media

studies, networks have been central objects of study through research in areas such as virtual worlds and social media.[43] In a more generalized sense, theorists such as Alexander Galloway, Eugene Thacker, and Steven Shaviro have focused on networks as key figures for media theory.[44] Much of the existing scholarship in the humanities has deployed network metaphors or approached networks from an ontological, epistemological, and archaeological standpoint.

Certainly scholarship in art history and media studies has considered the aesthetic dimensions of networks going back to the pre-Internet experiments within avant-garde movements such as Fluxus, postformalism, performance art, and mail art. But we have not yet seen a sustained comparative media analysis of the relationship of networks to various cultural forms that accompany and mediate our ordinary and habituated experiences of these structures.[45] This book, then, turns to narrative, visual, and procedural art forms that encourage an active, critical, and even transformative engagement with the network as the new dominant configuration and category of life. Networks leave traces throughout everyday life in the contemporary period. Literary and artistic works pick up these traces and register key tensions and contradictions of network form in a heightened and concentrated way. The pedagogy of such works, in turn, promotes a sharpened analytical perspective on the everyday aesthetics of everything from social media to banking interfaces. In this way, the network imaginary also entails and requires a more capacious understanding of aesthetics, as well as culture, than the one that comes to us from both classical and modern aesthetic theory.

Aesthetics in the Era of Networks

Before elaborating network aesthetics as such, the concept of aesthetics itself requires careful consideration. The term "aesthetics" has widespread usage and includes a diverse set of phenomena such as formal appreciation, taste, pleasure, embodiment, play, and affect.[46] Though I offer a more precise frame for approaching aesthetics, I do not depend on a restrictive definition throughout the book but rather treat it as a heuristic that embraces the varied usage of the term in literary studies, art theory, philosophy, and related fields. For me, the term opens up an inquiry into a variety of concepts connected to networks and enables a theoretical engagement with media. Consequently this study takes seriously the resurgence of critical attention to aesthetics that has gained traction during the early years of the

twenty-first century, including movements such as the "New Formalism." Along with critics such as Ellen Rooney, I believe that a focus on aesthetics and form can maintain the political, social, and cultural dimensions introduced to literary criticism in the late twentieth century.[47] Certainly the category of aesthetics has often led to analytical foreclosure, historical sloppiness, and sociopolitical exclusion—especially when treated as a universal measure of taste, an invocation of textual transcendence, or a principle of canon formation. At the same time, the aesthetic qualities of a work actively inform and form a world (to which they nonetheless never wholly correspond). Thus, rather than regressing back to a decontextualized version of the aesthetic, formal, sensual, or affective, I follow scholars who have explored and historicized the political dimensions of aesthetics.[48]

One of the most important reconceptualizations of contemporary aesthetic theory and its political dimensions, one that is especially useful in framing my own formulation of network aesthetics, comes from Jacques Rancière. Rancière contends that the turn against aesthetics is not unique to the cultural and historicist developments of the late twentieth century but is "as old as aesthetics itself." "Aesthetics," for him, is a polyvalent term but also one that names a generative "confusion" that enables critics to analyze the "objects, modes of experience and forms of thought" that pertain to art. Thus "aesthetics" designates two related things: "a general regime of the visibility and the intelligibility of art and a mode of interpretative discourse that itself belongs to the forms of this regime." Even as some critics have attempted to eliminate the term, Rancière insists that the existence of art depends fundamentally on aesthetics insofar as this discourse demarcates "a specific form of visibility and discursivity . . . a specific distribution of the sensible tying it to a certain form of politics."[49] "Aesthetic acts," as he calls them, are "configurations of experience that create new modes of sense perception and induce novel forms of political subjectivity." Aesthetics are thus political because they not only constitute a discourse on art but also organize our very sense of "an idea of thought" itself.[50]

Rancière's precise articulation of aesthetics offers an illuminating way to think about network aesthetics. Drawing from Immanuel Kant (via Foucault), Rancière describes aesthetics as "the system of a priori forms determining what presents itself to sense experience."[51] Networks, as I have been discussing them in this introduction, are one of these historically significant "a priori forms." What I am calling a network imaginary draws upon this insight. In other words, a network marks a form mediated by myriad works of art—a category in which I include novels such as Don DeLillo's *Under-*

world, videogames such as thatgamecompany's *Journey*, and new media installations such as Paul Sermon's *Telematic Dreaming*. That a literary novel, a popular videogame, and a museum-based piece can at all be discussed in a series suggests a blurring between categories of high and low, and between avant-garde and popular forms, which began during earlier eras of modernism and postmodernism but has reached a new apex with digital media that make most cultural forms accessible via a single technological device. Mediation through all of these forms brings with it a particular configuration of the sensible that organizes space and time, visibility and invisibility, intimacy and distance, connection and disconnection, unified totality and provisional relation.

How, then, does such an account of aesthetics relate to the political? This characterization of network form may seem too broad to allow us, for instance, to imagine forms of art that would suggest a novel political program. And that is surely the case. As Rancière again observes, "The arts only ever lend to projects of domination or emancipation what they are able to lend to them . . . what they have in common with them: bodily positions and movements, functions of speech, the parceling out of the visible and the invisible."[52] Network aesthetics, as they play out in narrative art forms like the novel and procedural art forms like the videogame, mark both the dominating and emancipatory dimensions of networks. On the one hand, dystopian rhetoric has accompanied network politics primarily through discussions of technological surveillance, terrorist networks, and critiques of the distributed nature of US power by antiglobalization movements. On the other hand, communication networks from the telegraph to the Internet have also inspired utopian imaginaries and democratic dreams. This sense of utopian possibility with which networks have been repeatedly infused has also served, for instance, as a core affective and discursive undercurrent of US advocacy for globalization. Like material networks themselves, a network imaginary remains adaptable to myriad ends. Regardless, a network is no longer a wholly oppositional form, as it may once have been. Since the beginning of the twenty-first century, it has been as likely to be institutionalized by national militaries and transnational corporations as to be celebrated or employed by guerrilla fighters and hackers.[53]

It is important to insist, then, that artworks that experiment with network aesthetics are political, fundamentally, not because of their specific representational tactics or strategic values. "Politics" is not a term reserved for negotiations, elections, campaigns, or ideologies.[54] It can serve, more capaciously, to describe a field of sensibility in which certain ways of being or particular lives—for instance, women, unarmed black men, or precar-

ious populations living outside of first-world digital networks—might be only distantly detectable or wholly unrecognizable. Like all art, the assemblage of work that I will be discussing is political, first and foremost, "because of the very distance it takes with respect to [society's structures and groups], because of the type of space and time that it institutes, and the manner in which it frames this time and peoples this space." Politics, in other words, has to do with the experience and configuration of *space, time, and social relations*. Literature and art are crucial domains of study, in the project of understanding networks, insofar as they disrupt the distribution of these elements within the cultural imaginary, "suspending the normal coordinates of sensory experience."[55] To show how aesthetics takes on specificity in the context of network form, and how it might open up varied experiences of contemplating relationality and being in relation, I turn now to my core concept of network aesthetics. Here, Rancière's notion of the "distribution of the sensible" yields to a more specific constellation of aesthetic encounters—what we might call *sensibilities of distribution*.

Network Aesthetics: From Control to Nonsovereignty

Networks raise many problems for aesthetic encounter. How, we might ask, can one see, sense, or perceive anything when everything is interconnected? One common approach to this problem in our time involves information visualization. The goal of such visualizations, as Lev Manovich describes them, is "to discover the structure of a (typically large) data set" whose form cannot be known in advance through key visual techniques (which also serve as epistemological principles) such as reduction and spatial properties. Since the 1990s, network visualizations have risen to prominence in the realm of information studies, offering advantages for making visible connections among data elements that bar charts, line graphs, and scatter plots do not.[56] Network visualizations use the familiar node-and-link structure to map practically any phenomenon from Internet traffic to brain activity to social entanglements (fig. 0.3). These visualizations are taken up primarily in the sciences, and are thus sometimes assumed to be representationally neutral; nevertheless, they invariably adopt an aesthetic charge. As Galloway observes, "Any visualization of data must invent an artificial set of translation rules that convert abstract number to semiotic sign."[57] Such conversion principles are at play between not only data and visualizations but also network form and its myriad translations into textual, visual, narrative, ludic, and participatory contexts.

While network visualizations exist purportedly to aid understanding

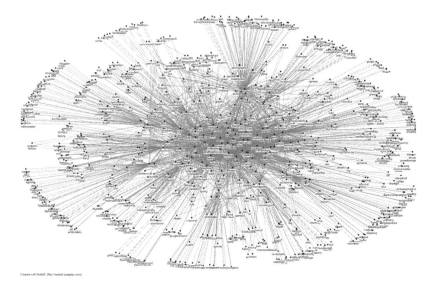

0.3. Network visualization of a Flickr tag search (Chris Moore, 2013). Creative Commons license (Attribution 2.0 Generic): https://www.flickr.com/photos/crypticon/8413214206.

in the sciences, representations of networks that serve primarily aesthetic purposes—for instance, in cyberpunk novels such as William Gibson's *Neuromancer* (1984)—more often emphasize the sublime boundlessness of networks that are open, extensible, and complex. This illimitable feeling points to both the synchronic (e.g., the massive scale of the Internet) as well as the diachronic (e.g., the transformation of the global economy at micro-temporal speeds) complexities of network phenomena. Galloway goes so far as to claim that the sublime has, both in the sciences and arts, become an all-consuming information aesthetic: "Every map of the Internet looks the same. . . . A word cloud equals a flow chart equals a map of the Internet. All operate within a single uniform set of aesthetic codes. The size of this aesthetic space is one." Lamenting the loss of an avant-garde in our time, and the blow this delivers to analytical thought, he concludes, "One can not talk about genre distinctions in this space, one can not talk about high culture versus low culture in this space, one can not talk about folk vernac-ular, nor about modernist spurs and other such tendencies."[58] For Galloway, this aesthetic uniformity suggests that networks remain, at least at present, unrepresented and perhaps, given their complexity, unrepresentable.

 Though Galloway's observation about the aesthetic consistency of network images is persuasive, his claim about the unrepresentability

of networks resembles the common critique (really, the truism) that real-
ist representation fails to totally capture its object. However, even if some
things or totalities are "unrepresentable," they can still be encountered and
experienced. The category of network aesthetics that I develop in this book
seeks to complicate the claim that all engagements with networks repro-
duce the same aesthetic form, thereby leaving networks unrepresented.
Instead, I argue that networks are made sensible and accessible through a
wide variety of forms, genres, styles, and media that do not all point back to
a single model of network sublimity. Undoubtedly, the sublime does remain
important as an aesthetic strategy in our time, but it is vital to emphasize
that even that aesthetic takes a multitude of forms.[59]

As opposed to the hierarchies implicit in the version of the sublime that
appears in various discourses of romantic naturalism, theological meta-
physics, and humanistic transcendence, the network sublime suggests a
distributed sovereignty that undergirds an era of finance capital and neo-
liberalism. Networks, as they are mediated through cultural works, give
this sociopolitical phenomenon a palpable form. Even as a network sub-
lime resonates with romantic and modernist imaginaries, its representa-
tional logics are profoundly shaped by the politics of a long twentieth cen-
tury of increased US global reach, which has included military, economic,
and cultural aspirations that reached greatest visibility during the Cold
War. As Alan Liu observes, "If the network is our contemporary intu-
ition of infinity, then its boundlessness is matched by an equally infinite,
equally unreal hunger for security."[60] On the one hand, networks—whether
militarily inflected terrorist networks or commercial communications
networks—carry with them a sense of limitless connection. On the other,
these networks suggest a seemingly contradictory need for control that is
ensured through everything from passwords to restrictions set on social
media circles. Such security betrays a paranoid fear that dates back at least
to Cold War Communist spy networks. This earlier anxiety about an exter-
nal enemy mutated, by the late twentieth century, into a structural fear that
ungoverned overreach may yield systemic collapse.

While my argument does not exclusively concern computer networks,
the history of computing is nonetheless exemplary of the primacy of con-
trol in discourse about networks. The development that began during
World War II and took off during the Cold War is overrun with the language
of control. Cybernetics in the 1940s (linked in a variety of ways to com-
puter science via figures such as John von Neumann) already marked its
objective as the study of "control" and "communication" systems.[61] How-

ever, the height of linkage between computing and control arguably came in the 1980s. It was not merely scientific innovations or imaginative fictions that solidified this confluence of terms but also the period's emphasis on autonomous individuals. If the "personal computer" reified information and digital technology, then this process continued with *the transformation of networks into controllable things*. As Streeter explains, there are two commonly told (and seemingly competing) scholarly narratives about the rise of the Internet. The first story, exemplified by Paul Edwards's book *The Closed World*, is one of "visions of nuclear war and efforts to erase individuality through centralized command and control." This narrative focuses, for instance, on military development and posits the apocryphal core motivation of the ARPANET project as a national attempt to prepare for surviving a nuclear attack. The second story follows "the gradual triumph of decentralized personal computing over centralized, impersonal computing" that emphasizes "the triumph of personal freedom, individual *control*, and uniqueness."[62] What strikes me about these two accounts is that even though they emphasize seemingly opposite affordances of networked technologies (i.e., centralized command versus decentralized computing), they both rely on a core desire for control. Today, many of these underlying assumptions persist in narratives that imagine networks as reified objects that can be managed, bringing to mind technologies (e.g., a computer network that is "user-friendly") or unified threats (e.g., a terrorist network that can be defeated through military engagement).

Many of the most insightful scholarly analyses of networks still take the frame of control and sovereignty as their starting points. Networks are often addressed, in the humanities, through theories of decentralized and distributed sovereignty, such as the political theory of "Empire" and the "multitude" elaborated by Hardt and Negri. Similarly, Galloway and Thacker frame their manifesto on network ontology by declaring "network" a keyword for "the nature of control today, as well as resistance to it," and a "problem of sovereignty." The early twenty-first century, they explain, depends on a new "networked sovereign."[63]

Sovereignty has been a fruitful point of departure for political thought and a popular term since the early twentieth century, but it also limits what is seeable, sayable, and thinkable about networks. I take seriously Lauren Berlant's contention that sovereignty is a generally problematic starting place for thought. As she notes, "Sovereignty, after all, is a fantasy misrecognized as an objective state: an aspirational position of personal and institutional self-legitimating performativity and an affective sense of control

in relation to the fantasy of that position's offer of security and efficacy."[64] Berlant's broader understanding of sovereignty as a fantasy structure proves crucially important for an analysis of a network imaginary. If sovereignty, whether personal or institutional, is predicated on misrecognition of perceived mastery, how can it offer anything but a limited account of networks? If we assume that the normative or desired state of networks is one of stable control, how can we attend to the ways that networks reconstellate our ways of communicating, imagining, relating, and becoming—the forms of perpetual and everyday change that Stewart describes as "the *poesis*, or creativity, of ordinary things"?[65] Finally, if networks suggest a departure from an individualistic paradigm and an embrace of a worldview organized around distributed agency, and perhaps interdependence, what do we miss, analytically and affectively, if we begin network analyses with a primary concern about sovereignty?

My provocation, then, is to ask what a study of a network imaginary might look like if we instead take *nonsovereignty* as our analytical scattering point.[66] The concept of sovereignty helps Galloway and Thacker trace a coherent and flexible theory of networks as such, but it does not always enable them to attend closely to those heterogeneous elements of networks that they name in passing as "antagonistic clusterings, divergent subtopologies, [and] rogue nodes."[67] Technological infrastructures and protocols are surely important to any discussion of networks. These elements, however, make human experience secondary. They foreground control, management, and strategy over modes that are at least as common in network society—experiences of being ungoverned, disconnected, lost, laggy, intimately entangled, abandoned, frustrated, or broken down. Such experiences are not grand but profoundly ordinary. Still, this ordinariness matters to understanding social life in a historical moment when everything, in ways that can be both resonant and baffling, is construed as connected.[68]

The cultural works I analyze focus on ordinary experiences with networked technologies, communication, transportation, and social groups. To be clear, the aesthetic qualities of such works are not mere supplements to knowledge but rather unique ways of thinking through ordinary network relations. Two brief cultural examples from the 2010s—a text-based novel and a multimedia networked videogame—might offer a more concrete sense of the importance of the ordinary that is crucial to my concept of network aesthetics. The first work, Jennifer Egan's National Book Critics Circle Award–winning *A Visit from the Goon Squad* (2010), is a novel that tracks an ensemble of intersecting characters across numerous locations

(from New York City to Kenya) and times (from the late 1960s to the near future). Thematically, the novel takes up myriad topics associated with networks, including family structures, changes in social media, quantum entanglement, and intimate relations in contemporary America. The novel's form, however, is even more striking, as the text pursues a network perspective through frequent transitions among characters and narrative points of view (first, second, and third person, as well as a chapter that is structured as a PowerPoint slideshow). Rather than mapping a static structure, the novel gives the reader an experience of social and technological networks that change across time. *A Visit from the Goon Squad* avoids extraordinary events—the journalist Jules Jones, for instance, channels the novel's ars poetica through his worry that he has "no 'event'" to structure his celebrity profile of Kitty Jackson." Instead of tracking a single protagonist's interiority, this novel reflects upon ordinary affects and relations in the aggregate. The chapter that takes the form of Alison Blake's PowerPoint presentation documents her mother's annoying habits, an everyday conversation in the car, and her brother Lincoln's obsession with "rock songs that have pauses in them."[69] At the same time, however, Alison represents her family experience through mock graphs, diagrams, and visualizations that mediate the personal through big-data techniques that forge connections among characters but never yield a satisfying sense of comprehension of the novel's overall social network.

A second example, taken from videogame culture, is "Twitch Plays *Pokémon*," an online social experiment that began in February 2014 (fig 0.4). During this event as many as 121,000 participants played an emulated version of Nintendo's videogame *Pokémon Red* at the same time. Rather than merely participating in parallel, users joined this single-player game, online and simultaneously, inputting commands into a shared chat window. In the so-called Democracy mode, the game engine identified the most frequently selected command entered within a designated window of time and implemented that command in the game. Essentially, "Twitch Plays *Pokémon*" became an experiment in large-scale, real-time collaboration and collective intelligence. Remarkably, despite myriad errors, the network of thousands of simultaneous players completed the game in 16 days, 10 hours, 4 minutes, and 4 seconds. The experience of this event involved a dimension of network sublimity and awe about the fact of so many participants contributing to a single, coordinated event. But it also brought an important sense of the ordinary—and one that is considerably different from that evoked in Egan's novel. Here, the shared challenge of thousands

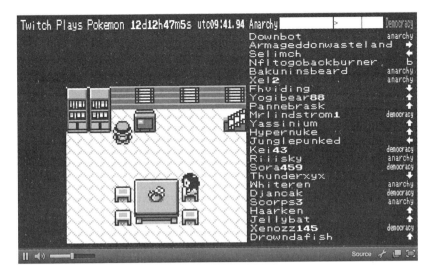

0.4. Twitch Plays *Pokémon* (2014).

of people improbably completing a single game together unfolded along-
side frenzied button mashing, inadvertent comedy, aesthetic appreciation,
off-topic chat, misalignment of goals, and moments of utter organizational
chaos. The ordinary player interactions were organized around the form of
an online game that not only represented a network but allowed players to
participate in a live networking process whose parameters were constantly
shifting, as people signed in and out, and others sought to convert chaos
into order.

Through the influence of movements such as the digital humanities and
the uptake of methods such as media archaeology, aesthetics have taken
a peripheral position in media studies scholarship. I want to argue, how-
ever, that aesthetically oriented works (including both *A Visit from the
Goon Squad* and "Twitch Plays *Pokémon*") use varied medium-specific
affordances to open up sensitivities to ordinary networked experiences
that scientific studies or sociological theories cannot accomplish alone.
With network aesthetics, I ask: What might we learn about networks if we
encounter them, often uncertainly, not as totalizing models but rather as
immanent opportunities for thinking through human and nonhuman re-
lations in the historical present? The objective of this book is not to solve
the problems suggested by this question but to offer a robust account of the
problematic that is network form.

In their attentiveness to ordinary situations and relations of a networked

society, cultural objects open up a key dimension of nonsovereignty by animating the irresolvable problematics of our time in a thick fashion. Art, Rancière contends, is "a practice of dissensus." This dissensus, which is an irreconcilable tension that defines aesthetics, emerges from "the rupture of a certain agreement between thought and the sensible" that we experience through a work of art that keeps readers or viewers at a distance while simultaneously drawing them in. Dissensus, moreover, captures the fundamental way in which the aesthetic is political—that is, dissensus generates "the suspension of power, the *neither . . . nor . . .* specific to the aesthetic state" that enables "a revolution that is no mere displacement of powers, but a neutralization of the very forms by which power is exercised."[70] This state of suspension is closely related to the nonsovereignty that I am proposing as the starting point for an analysis of networks. It is this inherent contradiction of art and literature that makes it so well suited for grappling with the internal complexities, unforeseeable emergences, and relational intensities that make up a network imaginary. Networks need not merely be control structures, management systems, or scientific graphs but can also serve as figures for encountering contemporary forms of what Adorno calls "contradiction." Networks, after all, suggest a culture that grows shallower even as it becomes increasingly interconnected.[71] They instantiate new forms of centralization but also introduce decentralization or distribution. They simplify the world and yet, as Michel Serres observes of systems, seem simultaneously to imbue it with new dimensions of complexity.[72] It is such tensions that constitute the analytical field of network aesthetics.

One crucial starting point for this project, which surely echoes throughout this introduction, is Fredric Jameson's "cognitive mapping." For Jameson, cognitive mapping is the "mental map of the social and global totality." Cognitive mapping is neither cartographic nor mimetic in nature. Instead, it is an "aesthetic" that can "enable a situational representation on the part of the individual subject to that vaster and properly unrepresentable totality which is the ensemble of society's structures as a whole."[73] Drawing from a Marxist sense of abstraction, Jameson posits cognitive mapping as a theoretical way of *knowing* the world without accurately *representing* it. Any knowledge of a historical period enframed by multinational capitalism, he contends, is an open-ended process—not a static itinerary or model meant to stand in for its object. It is, as the term deliberately suggests, a *mapping* rather than a *map*.

Cognitive mapping is a transhistorical concept that has unfolded across three major stages that Jameson sketches out, heuristically, as market, monopoly, and multinational capitalism. In each era, cognitive mapping

informs neither individual subjects nor the structure of the larger capital-
ist system but traces the relations between these terms. The first stage of
classical market capitalism follows "a logic of the grid." In this era, Jameson
argues, the map serves as a viable aesthetic form of mediation between
individuals and larger systems of capitalism, which still retain a degree of
correspondence. In contrast, the second stage of monopoly capitalism (or
imperialism) creates an unbridgeable gap between individual experience
and large-scale colonial systems. The key aesthetic technique that me-
diates the world of imperialism and gives its inconceivable global reality
a form is allegory or figuration. Finally, the third stage of late capitalism,
which encompasses the historical span that concerns me in this book, is
"the moment of the multinational network." In this era, the earlier distance
between domestic life in the West and the unknown foreign operations of
empire cedes to a kind of global immediacy that inserts individuals into "a
multidimensional set of radically discontinuous realities."[74] For Jameson,
cognitive mapping remains a more uncertain or speculative aesthetic in this
third stage of capitalism. As early as 1984 (the date of *New Left Review*'s
original publication of "Postmodernism, or, The Cultural Logic of Late
Capitalism"), he hypothesizes that an "aesthetic of cognitive mapping—a
pedagogical political culture which seeks to endow the individual subject
with some new heightened sense of its place in the global system—will
necessarily have to respect this now enormously complex representational
dialectic and to invent radically new forms in order to do it justice."[75]

Jameson does not offer an account of the "radically new forms" that
might enable access to multinational capitalism in the future. Nearly three
decades later, Galloway (who adopts Jameson's concept of "cognitive map-
ping" as well as Deleuze's "control society") insists that, still, "we do not yet
have a critical or poetic language in which to represent the control society."
This present-day, unrepresentable social model entails a movement from
factories to multinational corporations, from the discrete material labor of
industrialism to the flexible information labor of post-Fordism, from sin-
gular signatures to passwords, from uniform consumption to the moneti-
zation of diverse affects, from centralization to network form.[76] The core
project of my book, and the close analyses that follow, is to demonstrate
that we *do* in fact have the language for grappling with crucial experiences
of (if not the totality of) finance capital, control societies, and network
form. That language may be provisional and in process, but it already ex-
tends across media from novels and poetry to film and television to video-
games and transmedia storytelling—and beyond.

If it is now commonplace to organize the world of the late twentieth and

early twenty-first century, from its microscopic to its macroscopic scales, in network terms, then it is important to emphasize that US cultural production during this period has played a major part in this paradigmatic shift. Network aesthetics, in my usage, operate across media. In literary fiction, novels such as Marge Piercy's *He, She and It* have used narrative form to grapple with a world transformed by transnational corporations. In poetry, texts such as Jena Osman's *The Network* follow etymological and historical networks through their processes of emergence. In cinema, especially since the early 1990s, films from Robert Altman's *Short Cuts* to Steven Soderbergh's *Contagion* have depicted interlinked systems through crosscutting, audio bridges, and parallel narratives. On television, series such as *The Wire* approach social networks through experiments with seriality. In comics such as Warren Ellis's *Global Frequency*, we see medium-specific elements such as panels and gutters, as well as ekphrastic techniques that gesture toward video and computational media, that invoke the use of networked organization to address networked threats. Museum-based artworks such as Sharon Molloy's painting *Transient Structures and Unstable Networks* and installations such as Chiharu Shiota's *In Silence* make networks visible and tangible, inscrutable and haunting, without instrumentalizing them in the service of information visualization. Alongside such sequential narrative and static artistic forms, diverse digital media have approached networks through a variety of nonlinear procedures, processes, and protocols. These works, for instance, have included real-time software art (Jason Salavon's *Rainbow Aggregator*), networked mobile art (Julian Oliver's *No Network*), interactive narratives (Christine Love's *Digital: A Love Story*), videogames (From Software's *Dark Souls*), virtual worlds (Tale of Tales' *The Endless Forest*), and alternate reality games (Microsoft's *The Beast*).

To clarify, my concept of network aesthetics does not aim to identify a new genre that informs a wide range of fiction, poetry, film, television, comics, videogames, and digital media. More substantively, the diverse cultural works that I analyze use aesthetic strategies to render, intensify, and influence the way we understand and interface with a network imaginary. They enable readers, viewers, and players to think about networks not merely by knowing or representing them but by *feeling and inhabiting* them, often through ordinary scenes, interruptions, and contradictions. Cultural works, then, open up concentrated access to forms of participation, interaction, absorption, and apophenia as well as less controlled experiences of overload, confusion, distance, and paranoia that defamiliarize a networked historical moment.

Networks appear most like sovereign forms when they are treated as static totalities, for instance in information visualizations that foreground spatial structures rather than assemblages that change over time. All of the cultural works that I explore in this book, however, posit a sense of time, duration, change, and emergence (a concept I take up in chapter 2). Across sites and situations, network aesthetics emphasize not merely that everything is connected but that people and things connect, intersect, disconnect, become, atrophy, transform, or emerge over time. Therefore, while I deploy the term "form" frequently in this book, I do so not to signify something merely synchronic. The art critic Nicolas Bourriaud proposes a useful shift from a language of "forms" to one of "formations." This latter term makes thinkable dynamic relations, developed across time, between artworks and other artistic, social, or political situations. The term "formation" captures the emergent and process-oriented properties of "form." Even so, I often use these words interchangeably, in order to stress that this dynamic sense of formation is already active in earlier cultural theory, as it is in Raymond Williams's analysis of televisual "form" in terms of "flow."[77] Network form is, thus, a process-based concept. As Anna Munster observes in her analysis of avant-garde net art, "Even if a network image is static, imagining it durationally means acknowledging its constitutive dynamism." Thus, instead of the network, Munster proposes a shift to the language of "networking."[78] I carry forward this insight, while also maintaining that such processes are never implicitly utopian or oppositional—even the word "networking" thrives in corporate business practices and cyberlibertarian manifestos alike.

A Transmedia Method for New Media Culture

This book borrows methods from numerous disciplines, including literary criticism, media theory, cultural analysis, art history, critical theory, online archival work, self-observation, and practice-based research. My primary means of elucidating a network imaginary is to explore how numerous media grapple with the limits and possibilities of network form. For example, a short story collection such as Walter Mosley's speculative *Futureland* (2001) makes sensible sociopolitical networks through linear narrative accounts of multiprotagonist experiences of race and class in an era of digitally mediated capitalism. In a different medium, Rob Wittig's "email fiction" or "chatmail" *Blue Company* (2001–2) uses serial email delivery and narration of ordinary events to communicate the intimacies

and gaps inherent in both online romances and affective labor. In yet another way, the videogame *Killer Flu* (2009) invites a player to role-play an avian flu pandemic to demonstrate that panic is an inappropriate response to global infectious disease networks. Networks, across these works, are surely not identical concepts. Nonetheless, each work makes sensible certain problems of network form.

The term "media," which is central to this study, refers most often either to channels of communication or to material elements or platforms that enable expression. The former sense is most common to communication and media studies; the latter is more often used in fields such as English and cultural studies.[79] My concept of network aesthetics speaks to both senses of media, insofar as it examines the interplay between networked communication systems and artistic forms. My method, throughout this book, draws heavily from media studies. I attend to *medium specificity* (that is, each chapter focuses on the way a different artistic medium takes up networks) but also insist on the fundamental *transmedia ecology* within which all of my selected late twentieth- and early twenty-first-century works emerge. This comparative media approach responds to the specificity of the problem of network form in two key ways.[80]

First of all, if the mantra of the present is that everything is interconnected, comparison itself becomes difficult. As the cultural anthropologist Arjun Appadurai has asked, "How can we compare social objects in a world where most such objects, whether nations, ideas, technologies, and economies, seem deeply interconnected"?[81] Despite the way that network form complicates the drawing of distinctions, comparison remains the basis not only of fields like comparative literature but also of conceptual thought throughout the humanities. It would be premature to conclude that networks threaten the humanities (though, of course, such rhetoric has been a common part of discussions about a humanities crisis in an era dominated by digital technologies and STEM education). Instead, network form challenges us to develop new methods that enable even more nuanced ways of analyzing our historical present.

The second way in which a media comparison emerges out of the problem of the network has to do with developments in networked media. As Henry Jenkins has argued, the digital revolution of the late twentieth century has dramatically altered our media ecology. In particular, we have seen the rise of what he calls a "convergence culture" in which users are expected to move across various media and platforms to make their own connections.[82] Sometimes, this culture manifests in fictional worlds that

stretch across multiple media—as with the constellation of the *Matrix* films, comics, videogames, and virtual worlds that Jenkins discusses. More broadly, the term "transmedia" also captures the frequent and rapid oscillation among artistic media—often on a single screen—that has become a regular part of life in the early twenty-first century.

The current transmedia ecology encourages a scholarly approach of the sort that I am suggesting here—one that maintains clarity about distinct media properties while simultaneously oscillating among media to gain a better sense of their interactions. Such comparative work takes place in media studies but also exceeds it. As Appadurai again observes, "We need to probe the cohabitation of forms, such as the novel and the nation, because they actually produce new contexts through their peculiar inflection of each other."[83] The primary objective of this study is, along the lines that Appadurai suggests, to probe the cohabitation of forms. Network form, in this case, only becomes thinkable relationally, for instance through the seriality that is common to television or through the ludic play that characterizes videogames. Such juxtapositions and interplays defamiliarize network forms by demonstrating that what may appear both ubiquitous and total in our time is, in fact, heterogeneous, fractal, but also mutable.

Human and Nonhuman: Affects and Networks

Along with scholars such as Marshall McLuhan, Friedrich Kittler, Katherine Hayles, Andy Clark, Brian Rotman, Bernard Stiegler, Bernhard Siegert, and Mark Hansen, I believe that we think through, alongside, against, and in concert with media.[84] Moreover, if we take "think" to signify only rational comprehension, it is crucial to add that we also feel and change and give ourselves over to—that is, *affect*—our world through media. Before laying out my precise itinerary for the following chapters, and the works that serve as my core examples, I would like to raise one final theoretical point about the importance of the human and nonhuman dimensions of networks.

My focus on the aesthetic and formal aspects of artistic and literary works created for human audiences may seem conservative at a moment in which scholarship in the humanities has turned increasingly to the nonhuman. We see this interest in a broad range of analyses concerned with areas such as posthumanism, animal studies, speculative realism, and object-oriented philosophy.[85] The same is true in media studies. Media theorists such as Kittler have emphasized the radically nonhuman dimensions

of media as they "determine our situation," while Galloway and Thacker have, in a more specific way, focused on the nonhuman aspects of networks.[86] Bernhard Siegert declares that with the rise of communications networks, "human beings have ceased to be the relays of history."[87] At the same time, other critics have insisted upon the bodily and affective dimensions of media. Mark Hansen, drawing on the work of Henri Bergson, contends that digital media operate "squarely in the domain of experience" and that matter and images do not exist without being perceived and processed by a human being. For him, "media art," in particular, is "rooted in embodied affectivity" that entails "the capacity of the body to experience itself as 'more than itself' and thus to deploy its sensorimotor power to create the unpredictable, the experimental, the new." In his later work, Hansen has further argued that networked technologies facilitate especially crucial mediations between human beings and nonconscious affect. Social media networks, in particular, foreground the role of technics as a way of generating affect among users.[88] For example, people's ambient relationships to Facebook (which remains, like personal computers themselves, perpetually in the background of work and life tasks) make clear the place of digital media in enabling sustained human encounters.

This book focuses on cultural works created for human users, but it also remains attentive to the nonhuman dimensions of the media that ground them. Following critics such as Hayles, I pursue a middle ground between the more extreme positions in media studies that we see in the work of scholars such as Kittler and Hansen. In other words, I am interested in "the dynamics entwining body and machine together."[89] Research on social media networks suggests the importance of reading contemporary sociality through the interplay between human interactions and nonhuman, automated networks.[90] Aesthetics serve as one critical interface between the nonhuman and human aspects of networks. Even as nonhuman entities and processes play an increasingly important role in our world—through network protocols, algorithmic stock trading programs, and web systems that change with real-time big-data processing—aesthetic encounters offer human beings a way of speculating about and intervening in such systems.[91] A great deal of contemporary art might even be said to emerge from the very inaccessibility and incomprehensibility of network technologies. In turn, the nonhuman elements of networks that operate at spatial and temporal scales beyond human conception become approachable through art. Network aesthetics track processes that exceed human cognition because they either fall under the threshold of perception (e.g., subconscious effects

of social media) or overload an individual's real-time processing capacity (e.g., complexities of a global political system).

In order to capture the interplay between the human and the nonhuman, and between individuals and networks, this book often draws on affect theory or nonrepresentational theory.[92] I elaborate "affect" locally in the chapters where it most centrally appears (chapters 2 and 4). At the outset, however, it is worth noting that the language of affect has much in common with the discourse surrounding networks. Affect can be understood as a "non-conscious experience of intensity" that differs from either emotion or feeling. It captures "unformed and unstructured potential."[93] Affect, however, also concerns interpersonal relations and networks. As Brian Massumi observes, "The body doesn't just absorb pulses or discrete stimulations; it infolds *contexts*, it infolds volitions and cognitions that are nothing if not situated." In the early twenty-first century, contexts come to be framed in network terms. Moreover, communication systems represent a key infrastructure for the experience, management, and production of affects: "The network distributes. Interlinks. Relates. The network is the relationality of that which it distributes. It is the being of collective becoming. Communicational technologies *give body to relationality as such*."[94] My concept of network aesthetics accentuates already-existing intersections between network theory and affect theory.[95] Through the analyses that follow, I consider affects as they unfold not only in social media but also across a broader range of media that seek to channel, make sensible, resonate with, problematize, or simply intensify our experience of and with networks—which is to say, the thick contemporaneity of our technologically driven culture.

A Mapping: Nodes and Links

Network Aesthetics explores what Appadurai calls a "cohabitation of forms." Each chapter examines how a different literary or artistic form attempts to make sense of network form and to configure the contradictions that it presents. Therefore, every chapter offers a brief overview of the form in question (e.g., maximalist novels or complex serial television shows) and offers a sustained analysis of one or more examples. These examples are meant to be "singular" in Massumi's sense of being "neither general (as is a system of concepts) nor particular (as is the material to which a system is applied)."[96] In this relational sense, an example can be thought of as a network *node* that cannot be entirely systematized but nonetheless connects to

a variety of other examples. Thus, in each chapter I situate my selected cultural works in relationship to other works to which they connect formally and thematically.

At the same time, I attend to the unique aesthetic insights that each work offers about network form. Though the distinction between "high" and "low" art is less and less relevant in our twenty-first-century transmedia ecology, it is worth noting that many of my examples are populist artworks that belong to a late moment of what Benjamin called "technological reproducibility."[97] These selections surely have something to do with my own tastes. At the same time, with this particular constellation of nodes, I seek deliberately to expand the discussion of network art that has been regularly restricted to avant-garde productions. Too often, obscure experiments or museum-bound new media art pieces, intellectually illuminating and philosophically generative though they may be, restrict our sense of how key concepts travel through and influence cultures. Nonetheless, I have selected examples that are formally instructive about the features of a network imaginary and that clearly foreground a particular quality of network aesthetics that appears in many other cultural works.

If the examples in this book are *nodes*, the concepts that these examples illuminate and share among them can be thought of as *links*. As I have noted, "network aesthetics" is not an easily definable category like a genre or artistic movement. Each chapter, therefore, foregrounds *a specific guiding aspect* of network aesthetics: what I call their "maximal," "emergent," "realist," "participatory," and finally "improvisational" dimensions. These categories are not mutually exclusive but are indeed copresent in many of the works I analyze. Moreover, each chapter locally takes up a number of philosophical keywords that are essential to the humanities but have been complicated and forever altered by the network form. These concepts include "event," "accident," "emergence," "realism," "play," "process," and "failure," among others. These concepts serve both to clarify and, through their specificity, to disrupt the more monolithic concepts of the network, imagined as a definite and uniform structure.

The first part of *Network Aesthetics* turns to linear narrative forms. I focus here on media that emerged prior to World War II but have continued to develop in the late twentieth and early twenty-first centuries. Chapter 1 examines maximalist American novels from the late 1990s, especially Don DeLillo's *Underworld* (1997) and Neal Stephenson's *Cryptonomicon* (1999). These texts grapple with a language of networks that signals both the ongoing effects and the decline of US hegemony in the late twentieth century.

Figurative language and formal experimentation in these novels frame networks as historical structures that can be experienced, even as they ultimately surpass human comprehension, as well as novelistic form. The second chapter approaches films that explore the emergent qualities of networks and takes up Stephen Gaghan's *Syriana* (2005). This film's cinematic montage and multiprotagonist narrative structure mark parallels and divergences between privileged US subjects and precarious migrant workers in the Middle East. These techniques also foreground networks as systemic processes that unfold in highly politicized terrorist collectives across time. This chapter explores network films in order to demonstrate how cinema generates a different understanding of the concept of the "accident" in our era of interconnection—including the narrative of terrorist "blowback" that still remains a key frame for understanding the war on terror. The third chapter focuses on David Simon's *The Wire* (2002–8) in order to analyze the relationship between seriality and network form in the broader context of American television. Here, I attend to the ways that *The Wire* and other serial dramas complicate "realism" and aestheticize social and economic networks through medium-specific televisual techniques. My analysis also interrogates the ways that televisual form gives us access to Latour's actor-network theory and an understanding of social networks.

All of the artistic media discussed in these opening chapters—novels, films, and television series—stage the interplay between linear story-telling techniques and nonlinear systemic structures. How, I ask in these contexts, do network aesthetics enable readers and spectators to negotiate the antinomies—of linearity and nonlinearity, connection and disconnection, chronology and distribution—that mediate experiences of networks? Moreover, how does the clash of formal logics in each of these works take up the US situation of the late twentieth and early twenty-first centuries in ways that privilege ordinary interactions among webs of actors, rather than individual protagonists?

The works in the first part of the book interrupt conventions of older media while also adapting them to a context of a postindustrial, networked society. In the second part, I consider media that rely on the World Wide Web itself to understand and reshape networks. These digital artworks are process-driven, interactive, nonlinear, cocreated, and explicitly dependent on networked audiences. These chapters focus on different types of digital games (including computer, video, and transmedia games). I contend that this popular form serves as an instructive microcosm, if not quite the paradigmatic case, for the larger digital media situation that has become a key

object of study for new media studies and the digital humanities. Through their mechanics, procedural capacities, navigable worlds, and multimedia interactions, digital games demand ways of perceiving and working that open up new experiences of network form. They also reconfigure our relations to media that arose within earlier historical moments. Therefore, the second part of the book involves a deliberate shift in voice and method that corresponds with the unique affordances of digital media and participatory cultures. Specifically, while the first three chapters tend toward formal, cultural, historical, and theoretical analysis, these final chapters also incorporate archives and techniques that are suggested explicitly by the computer networks and the maker ethics that accompany gaming culture.

The fourth chapter, then, delves into the ways that videogames have engaged in substantive and meaningful experiments with networks that privilege participatory aesthetics. In particular, I examine Introversion's popular single-player simulation game *Uplink* (2001) and two "artgames" that depend on online play—Jason Rohrer's *Between* (2008) and thatgamecompany's *Journey* (2012). Alongside close formal readings of these games, I employ self-reflection on my own gameplay and an analysis of online documents that include creator commentaries, game reviews, and player-created blogs. The networked nature of these games gives us a different access to the concepts of "control," "action," "extimacy," and "play." The fifth and final chapter looks at the emerging and avant-garde new media form of alternate reality games (ARGs) that creates transmedia storytelling platforms composed of text, video, audio, phone calls, websites, email, social networks, locative technologies, and other media. More than any other artistic form explored in this project, ARGs from *The Beast* (2001) to *Superstruct* (2008) rely on and complicate participatory social networks by means of their improvisational elements. Because designers do not announce ARGs explicitly as fictional or ludic experiences, their game aesthetics blur with the ordinary dimensions of everyday networked life. In this final chapter, I explore the digital humanities method of practice-based research as a mode of inquiry into networks. The key node in this chapter is *The Project* (2013), an ARG that I codesigned. The experience of designing this game enables me to analyze networks from an insider perspective, taking up such concepts as "process," "collaboration," and "failure."

Though the nonsovereignty of networks is a concern throughout this book, this concept appears most centrally in these final two chapters. A short coda then turns from the book's core task of making sense of network form and reflects instead on the question of whether it is possible to

envision an outside to our contemporary network imaginary. Instead of a strategy of avant-garde newness or negational opting out, this final section sketches out a pedagogy of ambivalence that is intensely present to the potentials and mutations of our network imaginary.

Conclusion: Network Experience

In his sociological study of computer-based communication, Streeter shows that the Internet did not become a mainstay of US culture until a host of technological, political, and economic elements were in place. Most important to the popularization of the Internet were the experience and feel of networks. Computer networks became the essential technology of our time largely because of experiences that had less to do with technical innovations than with design and social interactions. More than the rational benefits of packet switching, for instance, potential users were drawn to the email communication, experiences of multitasking, pleasures of graphical user interfaces, and satisfaction of interactivity that network computers promised.[98] As Streeter shows, we can track such feelings through a variety of documents and events, including political debates and legal proceedings. We can also access them through a uniquely aesthetic mode of thought.

In the chapters that follow, I explore what network aesthetics might teach us about the unfolding culture of the twenty-first century. At moments throughout the book, however, I also gesture toward realms that exceed, at least at present, not only the knowable but also the sayable, seeable, audible, and playable. Similarly, I explore what might be lost or feel lost in an all-consuming and, at times, a seemingly compulsory participation in networks. Such promises and risks, I contend, are perhaps the best reasons to take network aesthetics seriously.

Part 1
Linear Forms

———

It is nothing less than the onset, the leading edge, of
the discovery that *everything is connected*, everything
in the Creation, a secondary illumination — not
yet blindingly One, but at least connected.

Thomas Pynchon (*Gravity's Rainbow*)

In the far future of Fredric Brown's 1954 science fiction short story "Answer," two operators turn a "switch that would connect, all at once, all of the monster computing machines of all the populated planets in the universe — ninety-six billion planets — into the supercircuit that would connect them all into the one supercalculator, one cybernetics machine that would combine all the knowledge of all the galaxies." Upon activating this unprecedentedly powerful network, one of the operators asks the supercalculator "a question that no single cybernetics machine has been able to answer": "Is there a God?" Ominously, at the climax of the tale, the networked machine replies, "Yes, *now* there is a God," kills the interrogator, and severs itself forever from human control.[1] Fifty years later, the television series *Battlestar Galactica* (2003–9) told a story motivated by similar cultural anxieties. In the miniseries that launched the show, artificially constructed Cylons achieve sentience and escape from their human creators. After developing their own military force, the Cylons initiate a massive attack against human civilization. The only human-operated military "battlestar" to survive this near-total nuclear genocide does so precisely by *not* being linked into the computerized defense network that is incapacitated by a powerful virus.[2] Networks, in both of these scenarios, are major

technological achievements that enable control and communication, but they are also infrastructures that make their human creators susceptible to perpetual vulnerabilities.

During the period extending from the birth of cybernetics in the 1940s to the construction of the US military's ARPANET in the 1960s to the commercialization of the Internet in the 1980s to the rapid proliferation of the World Wide Web and social media networks in the 1990s and early twenty-first century, the transformation of transnational communication gave rise to dystopian fears—as well as utopian investments—that were most prevalent in science fiction narratives across media. In his 1993 book *Terminal Identity*, Scott Bukatman argues that "it has fallen to science fiction to repeatedly narrate a new subject that can somehow directly interface with—and master—the cybernetic technologies of the Information Age, an era in which, as Jean Baudrillard observed, the subject has become a 'terminal of multiple networks.'"[3] As the science fiction editor Gardner Dozois observes, extending Bukatman's point about technological networks to a more generalized network paradigm, we live in "an interlocking and interdependent gestalt made up of thousands of factors and combinations thereof: cultural, technological, biological, psychological, historical, environmental." Science fiction, he continues, is a literary genre uniquely able to explore this very "*interdependence* of things."[4]

Though cultural fears about the loss of individual control date back to Cold War–era science fiction about "hive minds," a concern with networks as such proliferates in later twentieth-century works.[5] Cyberpunk novels such as William Gibson's *Neuromancer* (1984) and Neal Stephenson's *Snow Crash* (1992), as well as films such as *The Matrix* (1999), all represent threateningly ubiquitous computer networks. Beyond the Internet and other communications systems, science fiction has also explored networks in the more capacious sense taken up by network science. For example, speculative novels such as David Brin's *Earth* (1990) and films such as M. Night Shyamalan's *The Happening* (2008) dramatize anxieties about ecological networks. Other science fiction works, including Pat Cadigan's novel *Synners* (1991), Walter Mosley's story collection *Futureland* (2002), and Warren Ellis's comic book series *Global Frequency* (2002–4), move beyond thematic representation and use formal experiments to intensify the anxieties and hopes inherent in social networks.

Despite the undeniable importance of science fiction as a genre that makes networks accessible, the linear narrative works that I explore in the first part of this book draw largely from other sources—including his-

torical novels, techno-thrillers, conspiracy films, urban fiction, and pro-
cedural crime drama—in order to aestheticize networks. My departure
from science fiction has largely to do with an interest in ordinary network
experiences. It is not that science fiction is incapable of attending to and
speculating about everyday life. However, the space operas and global
narratives that remain common within science fiction tend to privilege the
systemic nature of networks, as well as interactions between various nodes
and links. Admittedly, the cultural works on which I focus—novels such
as Don DeLillo's *Underworld* (1997) and Neal Stephenson's *Cryptonomicon*
(1999), films such as Stephen Gaghan's *Syriana* (2005), and television seri-
als such as *The Wire* (2002–8)—make visible similar structures. At the same
time, these works privilege affective experiences of networks. Moreover,
unlike science fiction works, these pieces are not predominantly specula-
tive.

The cultural works I analyze all appeared in the 1990s and 2000s. Un-
doubtedly, there are prescient works such as Thomas Pynchon's novel
Gravity's Rainbow (1973), a passage of which serves as the epigraph for this
overview, which already grapple with an emergent network imaginary.
Even so, my historical selection of texts allows me to focus on a moment
when US culture was more densely saturated by networks and within a new
paradigm. Personal computers and the web, for instance, lost some of their
novelty during this period and became increasingly commonplace technol-
ogies, especially in the United States. While questions of control are still
significant in these works, networks are not imagined exclusively in polar-
izing dystopian or utopian terms, as is often the case in science fiction.

The first three chapters of this book take up works that examine net-
works through linear narratives, even as they borrow from and enter into
conversation with digital and networked media.[6] These novels, films, and
television series are, in one sense, inherently inadequate to the task of
comprehensively representing networks as totalities or large-scale struc-
tures. Specifically, the sequences of text or images that constitute these
works make any unified understanding of nonsequential networks impos-
sible. Walter Benjamin, in his 1936 essay "The Storyteller," already laments
the disappearance of stories—especially a mode of oral storytelling that
is supplanted by the novel and news media—amidst an increased prolif-
eration of information. "The value of information," he writes, "does not
survive the moment in which it was new. It lives only at that moment; it
has to surrender to it completely and explain itself to it without losing any
time."[7] Communications networks have even further complicated the role

of narrative in the late twentieth and early twenty-first centuries. In their decentralization and nonlinearity, they defy and exceed narrative form.

At the same time, the rise of networks by no means entails an obsolescence of storytelling. On the contrary, in the early twenty-first century, there is a greater availability of narrative across media than ever before. Even so, long-form narratives of the type that the following chapters analyze stand in contrast (temporally) to the velocity of many networks and (spatially) to their scale. As Bernard Stiegler notes, "Networks of current events necessarily function at the speed of light" because "the value of information as commodity drops precipitously with time." By contrast, "the time of relation, of 'narrative,' is always belated with respect to what is narrated, is always cited in being recited."[8] The limitations of linear narrative artworks are arguably also assets in grasping networks. In Stiegler's sense, these cultural works can channel networks by slowing down time and, through their tactical belatedness, make these structures sensible via temporal constrictions and dilations. In terms of scale, narrative can zoom in and out of networks to offer both glimpses of macrolevel social networks and experiences of microlevel affective relations. Stories also dramatize, even induce, both the pleasures and anxieties that accompany enormous economic, geopolitical, and technological networks.

Linear narratives can plot series of linkages across time and evoke varied experiences of networked wholes, while still keeping alive the tensions, contradictions, and elisions introduced by networked processes. The works that I analyze do not promise easy resolutions. They insert readers and viewers into the midst of various uncertainties and ambivalences. By attending to both the medium-specific qualities of these works and to their comparative media dimensions, the first three chapters examine the maximal, emergent, and realist qualities of network aesthetics.

Maximal Aesthetics:
Network Novels

> Acts of mapping are creative, sometimes anxious,
> moments in coming to knowledge of the world, and
> the map is both the spatial embodiment of knowledge
> and a stimulus to further cognitive engagements.
>
> **Denis Cosgrove,** *Mappings*

> And how can you tell the difference between orange
> juice and agent orange if the same massive system
> connects them at levels outside your comprehension?
>
> **Don DeLillo,** *Underworld*

The Network Novel

In this chapter, I explore the network novel—a late twentieth-century genre that reworks and intensifies the cultural concerns regarding a world interconnected by communication and transportation networks, and made unprecedentedly dependent upon an informational economy. I date the apex of this genre to the 1990s. Certainly there are earlier examples, such as Thomas Pynchon's *Gravity's Rainbow* (1973), which was published in the early years of complexity science and during the rise of globally oriented American neoliberalism. It was not until the early 1990s, however, that the popularization of the Internet altered the public perception of information technology and transformed networks into an even more prominent metaphor of contemporary life. Numerous novels published during the period registered this major shift and explored the interdisciplinary significance

of networks. Several formally innovative novels from the 1990s, including
Pat Cadigan's *Synners* (1991), Marge Piercy's *He, She and It* (1991), Amitav
Ghosh's *The Calcutta Chromosome* (1995), and David Mitchell's *Ghostwritten* (1999), examine the danger and promise of the seemingly ubiquitous
network form. Similarly, early twenty-first-century novels and interconnected short story collections, such as Richard Powers's *Plowing the Dark*
(2000), Walter Mosley's *Futureland* (2001), David Mitchell's *Cloud Atlas*
(2004), and Jennifer Egan's *A Visit from the Goon Squad* (2010), oscillate
among multiple perspectives and transnational sites in order to interrogate
the significance of networks in an unfolding present.

In what follows, I neither categorize all of the recurring attributes of
the network novel nor offer a comprehensive list of texts that make up
this canon. Instead of such encyclopedic labor, I use this genre to explore
the relationship between network structures and novelistic form in late
twentieth-century American literature. While network visualizations offer
a stable representation or *a map* of elements configured as nodes and links,
the novel makes possible *processes of mapping* networks across space and
time.[1] As we will see, network novels do not take networks for granted as
stable objects. They seek to intervene, linguistically and aesthetically, in the
cultural field of the network imaginary. My selected textual nodes for this
analysis—Don DeLillo's *Underworld* (1997) and Neal Stephenson's *Cryptonomicon* (1999)—foreground the maximal capacities of network aesthetics.
Maximalism marks a quality of all of the cultural works in this book insofar
as they animate complexity in order to both enable and limit knowledge.
The novels in this chapter also activate a series of other concepts that network form encourages us to think about in new ways. These intersecting
concepts include "knowledge," "history," "event," and "materiality," as well
as Fredric Jameson's aesthetic of "cognitive mapping."

With *Underworld* and *Cryptonomicon*, DeLillo and Stephenson veer
from previous creative orientations—postmodern literature and science
fiction, respectively—to write maximalist texts that aspire to be histories of
the present.[2] Both novels historicize a world that increasingly follows network logics through formal and stylistic techniques. DeLillo's and Stephenson's texts also envision networks in varied pasts and possible futures that
give shape to their contemporary moments in the late 1990s. It is important
to emphasize that these novels do not merely represent or thematize networks. Instead, they find their fundamental aesthetic raison d'être in the
paradigm shift of the network society that they interrogate and intensify
through metaphor and technological imaginaries.

Even as I am not proposing a set definition of the network novel, it is worth thinking heuristically about this genre category at the outset. What, fundamentally, does it mean for *Underworld* and *Cryptonomicon* to be network novels? One way to answer this question is to differentiate the network novel from two important genres that are related but register different historical imperatives: the encyclopedic narrative and the postmodern novel. The "encyclopedic narrative," first of all, is a category proposed by Edward Mendelson as a central genre of Western literature, a transhistorical collection of texts that include Dante's *Commedia*, Melville's *Moby-Dick*, and Joyce's *Ulysses*. Encyclopedic narratives are maximalist works that originate within national cultures. Unlike epics, which take place in "a legendary past," encyclopedic narratives attempt to make sense of their present moment's historical emergence. Through techniques such as synecdoche and metaphor, these texts seek "to render the full range of knowledge and beliefs of a national culture, while identifying the ideological perspectives from which that culture shapes and interprets its knowledge." The encyclopedic narrative assembles numerous literary styles and genres, "incorporating, but never limited to, the conventions of heroic epic, quest romance, symbolist poem, Bildungsroman, psychomachia, bourgeois novel, lyric interlude, drama, eclogue and catalogue."[3]

Underworld and *Cryptonomicon*—especially given their maximalism—could easily be mistaken for encyclopedic narratives, but notable differences set them apart from this genre. The Enlightenment-era genre of the modern encyclopedia is aligned with nationalist aspirations.[4] Alphabetically ordered and intent on totalizing classification, an encyclopedic compendium of human knowledge develops a general system to assimilate all the globe's diversity. The encyclopedia represents a prime archival structure of imperial organizing ambitions that finds its present-day extension, for instance, in big data. However, network novels dating back to *Gravity's Rainbow* reveal an ambivalent relationship to such informatic organization. On the one hand, these texts achieve historical scope, geographical coverage, and multidisciplinary referentiality that are in fact encyclopedic. On the other, these novels privilege decidedly nonencyclopedic fragmentation, apophenic linkage of elements, difficulty of access for their contemporary audiences, and lack of neat segmentation. Moreover, these texts shift *explicitly* from a national to a transnational frame. Finally, for Mendelson, an encyclopedic author seeks an external vantage point—a "position at the edge of a culture"—from which to redefine that culture and its boundaries. A network novel, however, produces a different kind of lead-

ing "edge" that aestheticizes immanent interconnectedness without any hope of transcendence.[5]

Second, it is worth marking a difference between the post-1945 postmodern novel and the network novel. Certainly one might track continuities between these genres, which become evident in the movement between DeLillo's later postmodern novels such as *Libra* (1988) and *Mao II* (1991) and the network novel *Underworld*. Nevertheless, as I hope to demonstrate, a novel such as *Underworld* performs and encodes its sense of connectivity, at a formal level, in ways that are specific to an era saturated by networks.[6] The shift from postmodern literature to the network novel parallels the broader technological transition that the media critic Tiziana Terranova marks in her analysis of the novelty of open Internet infrastructure. "Within open architecture, in fact," Terranova explains, "electronic space is not conceived as composed of different fragments, juxtaposed together in a pastiche mode, as in postmodern architecture. The different components accommodated by open architecture are no inert fragments of living or dead styles, but autonomous networks in continuous expansion and modification."[7] In place of the fragmentation, pastiche, and metafictional impulses of the postmodern (though these persist to some degree), the network introduces the extensibility and reconfigurability of "open architecture."[8] This change is mirrored in the novels that I analyze in this chapter at the levels of both genre and medium. *Underworld*, for instance, manifests an inclusive awareness of genres reaching from sentimental melodrama to cultural satire to historical metafiction.[9] Similarly, DeLillo's "multimedia mimicry," as Timothy Parrish calls it, involves aesthetics that channel media such as the novel, photography, comics, radio, home video, film, and television. Without striving for a realistic description or ekphrastic rendition, both *Underworld* and *Cryptonomicon* invoke the metamedium of the Internet.[10]

The form of the novel flourished in the eighteenth century and achieved maturity in the nineteenth century; network novels demonstrate that this literary form continues to affect the present, both informing and being informed by networks. It is worth emphasizing that the ceaseless announcements of the novel's obsolescence (which did not originate but nonetheless proliferated through the discourse of *post*modernism) have been overstated, inattentive to the form's historical changes, and symptomatic of broader ideological fears about new technologies and the cultural authority of literature.[11] The novel remains an important narrative technology of interiority that figures into and changes within a transmedia ecology. Novels

remain popular and culturally significant (as was confirmed, for instance, by the success of *Underworld*, a best seller that earned DeLillo $1.3 million for English-language rights to the novel and another million for rights to its cinematic adaptation).[12]

The two novels that I discuss in this chapter do not approach networks as a concept that we should already know. Both texts juxtapose various historical moments, from the mid- to late twentieth century, to defamiliarize and trouble our sense of what a network has been, is, and might be. These novels—one literary and the other purportedly popular—go about this task in different ways. When juxtaposed, they suggest a spectrum of linguistic mapping techniques undertaken by the broader genre of network novels. DeLillo, on the one hand, foregrounds language and novelistic form as a means for making sense of networks and exploring their disorienting effects. Stephenson, on the other hand, emphasizes the limits of natural language and the novel in a transnational era that relies on the very different logic of computer code and network protocols. Both texts treat networks as dynamic historical structures that can be experienced, even as they invariably exceed human comprehension.

When read together, then, *Underworld* and *Cryptonomicon* disclose both the novel form's epistemological capacity to know networks and its capacity to record the structural impossibility of knowing networks through language alone.[13] As I also argue, the various clashes of formal logics in these texts run parallel to paradoxical sociopolitical logics inherent in the discourse and material practices associated with transnational networks of late capitalism. In the mid-to-late twentieth century, the language of networks frequently marked the rise of US power, and by the end of the century, it served just as often to signal America's domestic crisis and imperial excesses. For all of their instructive differences, *Underworld* and *Cryptonomicon* both use network aesthetics to animate these tensions.

Network Unknowns: Events and Atmospheres in *Underworld*

The network imaginary invites us to think anew about concepts that are at the very core of the humanities, including knowledge and history. Though network science uses networks to make sense of the world, especially through the mapping of connections among nodes, the defining complexity of networks also invokes the realm of the unknown. In aesthetics, the quality that most commonly evokes the way that networks exceed individual human comprehension is the sublime.[14] The sublime emerges

1.1. Visualization of Instagram network, user "speedoflife" (Andy Lamb, 2012). Creative Commons license (Attribution 2.0 Generic): https://www.flickr.com/photos/speedoflife /6924482682.

from eighteenth-century romanticist writing about awe-inspiring natural objects, from majestic mountains to turbulent oceans, that can be analyzed but remain formless, indistinct, and incomprehensible in their entirety.[15] As Jean-François Lyotard observes, however, the sublime may also have been the dominant sensibility of modern art, which has sought to "present the fact that the unpresentable exists."[16] This modernist fascination with the unrepresentable continued through the postmodern period. As Joseph Tabbi explains, following World War II, the sublime no longer summoned either a theological or an artistic order, but rather one dominated by the increasingly unknowable technological and corporate networks that appear, for instance, throughout the work of American novelists such as Norman Mailer, Thomas Pynchon, Joseph McElroy, and Don DeLillo.[17]

A network sublime emerges directly from postmodern antecedents and is most evident in those ubiquitous network visualizations that represent big-data outputs (fig. 1.1). It also appears in literary texts such as the 1984 cyberpunk novel *Neuromancer,* in which William Gibson famously

conjures his "cyberspace" network by describing it as "a consensual hallucination experienced daily by billions of legitimate operators, in every nation. . . . A graphic representation of data abstracted from the banks of every computer in the human system. Unthinkable complexity. Lines of light ranged in the nonspace of the mind, clusters and constellations of data. Like city lights, receding." Gibson's series of sentence fragments, spatial figures, and similes evokes the sublime by, at once, declaring the network's totality ("a graphic representation of data abstracted from the banks of every computer in the human system") and gesturing toward an apprehension that is at most partial, tangential, or asymptotic ("unthinkable complexity").[18]

Though the extraordinary sublime remains arguably the most common aesthetic concept for representing interlinked systems, network novels instead approach the unknowns of interconnection through ordinary encounters. *Underworld*—a print text about an increasingly electronic era that does not focus predominantly on computer networks—registers many of the epistemological problems that accompany the rise of networks as a dominant form. Unlike more explicit novelistic appropriations of digital media, whether print novels that thematize networks (e.g., William Gibson's *Pattern Recognition*) or electronic literature that relies on the web (e.g., Michael Joyce's *Twelve Blue*), *Underworld* conveys a sense and experience of networks. Across its 800-plus pages, DeLillo's novel moves among several connective styles—associative stream of consciousness, paranoid terror, dialectical synthesis, historical juxtaposition, and hypertextual suggestion—and through each of these modes invites active participation. By challenging and disorienting the reader, the novel privileges everyday processes of networking in the historical present over networks as comprehensible structures of control and organization.

Underworld underscores the ways in which a novel both can and cannot know networks. One character, the waste theorist Jesse Detwiler, articulates a recurring proposition of the novel: "Everything's connected."[19] This novel's larger project involves historicizing both the epistemological and aesthetic dimensions of this claim about interconnection. Instead of beginning its narrative at the end of World War II—the "post-1945" that serves as a common marker of the beginning of American "global" power in texts such as *Gravity's Rainbow*—DeLillo starts in the early 1950s. The opening chapter features the event of the pennant game between the New York Giants and the Brooklyn Dodgers that took place on October 3, 1951—a day characterized not merely by the home run dubbed the "Shot

Heard 'Round the World" but also by the Soviet Union's second atomic bomb test. In this noisy historical scene, the abundant linkages begin. DeLillo's text generates a history of American life in the latter half of the twentieth century, estranging readers from this chronology by narrating it largely in reverse order. It is nevertheless a history that emphasizes myriad internal connections that crisscross among ordinary atmospheres and world-historical events. Dense linkages among characters, plotlines, and themes are, of course, nothing new. This oft-mentioned feature of *Underworld* is already an aspect of many modernist texts and encyclopedic narratives, and is arguably a feature of the majority of texts that scholars identify as "literary." Nevertheless, this novel frames interconnection through a contemporary language of networks.

Underworld foregrounds its sense of dense connection across time most concretely in the form of a recurring object: the baseball with which Bobby Thomson homered to win the 1951 National League pennant game. While the baseball acquires considerable monetary value, the object itself is secondary to the meanings that it makes sensible.[20] Nick Shay, the eventual owner of the ball in the 1990s, reflects on the ball's connectivity as he holds it during a spell of insomnia: "You have to know the feel of a baseball in your hand, going back a while, connecting many things, before you can understand why a man would sit in a chair at four in the morning holding such an object, clutching it." For Nick, as for the reader, the significance of the ball derives from its historical linkages. Marvin Lundy, an obsessive collector of baseball memorabilia and longtime owner of the ball, savors this sense of association. For many years, Lundy tracks the ball's complicated lineage and assembles that experience into a comprehensive worldview—a network epistemology that he calls "the dot theory of reality." His rigorous research leads him to treat the network generated by the ball's movements as weltanschauung, technique, and method. "I looked at a million photographs," he explains, "because this is the dot theory of reality, that all knowledge is available if you analyze the dots."[21]

In *Underworld*, connectedness does not take the predominantly spatial form of the network graph or information visualization; instead it serves as a temporal technique for sensing and producing history. The novel does not merely represent a chronological period that we might call the network era but foregrounds the diachronic quality of the network imaginary as it reformulates what is often considered a historical "event."[22] Admittedly, monumental events, in their most conventional sense, are not lacking in *Underworld*. The text represents the Giants-Dodgers pennant game of

1951, the launch of the *Sputnik 1* satellite of 1957, the Cuban Missile Crisis of 1962, the Jackson (Mississippi) civil rights rally of 1964, Truman Capote's Black and White Ball of 1966, and other well-known historical markers. The nature of an event is not assumed, however, in any of these cases. Take, for instance, the novel's recurring event of the Northeast blackout of 1965—a power failure that affected thirty million people in the United States and Canada. *Underworld* gives the reader access to the blackout in two primary passages. In one, Nick Shay walks through the Bronx in 1965 as the neighborhood loses power. In the second, Big Sims and Nick Shay hop among clubs in the Los Angeles area in 1978 as they recall and discuss the now-famous blackout. In the former scene, the electrical disruption has not yet been codified as an event, whereas in the late 1970s passage Nick introduces the day precisely as a monumental historical event: the "great Northeast blackout."[23]

The repetition of the Northeast blackout in these two scenes offers a way of understanding the novel's own concept of network epistemology as well as its concept of history. In the 1965 passage, which appears second in the text, Nick's awareness of the blackout's scope gradually expands through a constellation of observations and encounters. Far from the loftiness of a historical event, the blackout begins as a local development that Nick meets with relative indifference. The reader becomes grounded only through a series of overheard utterances and conjectures that are as disconnected from one another as the nodes of the Northeast's disrupted electrical infrastructure:

> Someone said, "Is that the lights?"
> We sipped our stingers, Jerry and I.
> The bartender said, "You know what?"
> Someone started talking in the men's room, loud enough for us to hear.[24]

Through dispersed conversation and speculation, the electrical loss in the bar is eventually extended to the entire street ("I think the whole block's out") and then the neighborhood ("Is Brooklyn out? I think Brooklyn's out"). Throughout the evening, knowledge of the blackout arrives only in scattered pieces of hearsay and conjecture, and amidst unrelated thoughts and affects. As he drifts through Manhattan, Nick feels like a "stranger" in the city. He feels somehow lost, realizing that he only knows it "at street level, fitfully." With the edges of an event still indistinct, Nick experiences a complex atmosphere around him. He senses, at once, the extent of a larger totality that both includes and isolates him, the scope of a connection that

he did not previously realize, and the mounting threat of disconnection: "The power grid gone. What did it mean? The whole linked system down. Or not linked sufficiently perhaps." The news of the blackout's transnational scale arrives only hours later, in fragments, coming from an anonymous man who gives Nick a ride home.[25]

In the 1978 passage, which appears in the novel prior to the representation of Nick's 1965 experience, the Northeast blackout takes the status of a famous event and a shared memory in the conversation between Nick Shay and Big Sims. Even so, in the novel, the blackout does not serve the same function that it takes in so many popular renderings of network science—namely, as a historical origin of the rise of the network era and the widespread American realization of dependence on interlinked technological systems.[26] The topic of the blackout enters the late 1970s bar conversation as an uncertain and nonmonumental, though no less historical, term. It comes to Nick in the form of a mere association ("This place reminds me") and lingers as a faded memory with an unknown cause ("Nobody remembers"). Nick mentions the blackout in the midst of a conversation about rumors and conspiracy theories. Instead of sharing in the reminiscence, Sims drifts associatively outward. He tells Nick that he finds it difficult to imagine that thirty million people were affected by the blackout but that the census suggests there are only twenty-five million African Americans in the United States. He suggests that the census has underreported the number of African Americans—itself a kind of blackout. History in this passage is organized around an event—the "great Northeast blackout"—but instead of operating as an origin or teleological narrative, history becomes expressed in a web of associations, beliefs, rumors, embellishments, small talk, sentiments, and conspiracy theories.[27]

The perceptions that make up the exchange between Nick Shay and Big Sims are not distractions from some ultimate truth. They are instead features of *Underworld*'s historical sense of a reality that can best be apprehended through the metaphor and language of networks. Regardless of the accuracy of Sims's theory about census underreporting, his sentiments and beliefs are real elements of the atmosphere of his present. His observations resonate with a systemic racial inequality that he senses but cannot quite reduce to the nominal category of an isolated event.[28] While Sims's theory may seem far-fetched, it registers an environment of disconnection that the isolated linguistic unit of "Northeast blackout of 1965" cannot convey. In this way, *Underworld* substitutes the homogeneity of event-as-origin with the heterogeneities and inconsistencies of event-as-atmosphere. We are

left with a loosely mapped network—not a sublime totality—spurred by a memory of the blackout and irreducible to any cause.

Cognitive Mapping and Aesthetics of Disorientation

Underworld seeks a knowledge of networks that eschews transcendent interconnectivity in favor of immanent processes of disconnection, disorientation, and drift. Networking in this novel, we might say, also has a fundamental dimension of not-working (to repurpose Geert Lovink's term) that is registered at the level of DeLillo's prose style. In one revealing passage, the waste management executive Brian Glassic, on an ordinary drive through Manhattan in the early 1990s, suddenly perceives an interconnectedness that feels both total and totalizing:

> He drove into the spewing smoke of acres of burning truck tires and the planes descended and the transit cranes stood in rows at the marine terminal and he saw billboards for Hertz and Avis and Chevy Blazer, for Marlboro, Continental and Goodyear, and he realized that all the things around him, the planes taking off and landing, the streaking cars, the tires on the cars, the cigarettes that the drivers of the cars were dousing in their ashtrays—all these were on the billboard around him, systematically linked in some self-referring relationship that had a kind of neurotic tightness, an inescapability, as if the billboards were generating reality, and of course he thought of Marvin.[29]

Glassic's trajectory takes him through a barrage of images and objects that belong not merely to the bounded space of the modern city but to a world figured by many as global. DeLillo's single, overloaded sentence reproduces the experience of speeding along an artery of a highway system that interlinks nodes across the United States and leads to the airplanes that make possible a movement beyond national borders.[30] The syntax intensifies this feeling of mobility and abundance as nouns, material things, become converted into corporate logos that generate an authoritative logic, a Logos, and a world. The passage begins with alliterative flourishes ("spewing smoke of acres" and "truck tires") that seem to encourage a spoken delivery, which, if undertaken, leaves a reader breathless and exhausted. If this drawn-out sentence begins with a concrete relationship to language, the list ultimately yields a virtual relation between advertisements and the "reality" of the objects they are "generating." Capitalist iconography and the world it produces become "systematically linked" in a "self-referring

relationship." Glassic looks around and recognizes a late twentieth-century environment operating not according to causal logic but rather according to laws of interconnection. The "neurotic tightness" and "inescapability" that he experiences are not the result of a plenum packed tight with consumer objects, like the supermarket in DeLillo's earlier *White Noise* (1985). As opposed to that closed system, this open world takes the form of a perpetually transforming network.

Perhaps the only external vantage that Glassic can manage during his drive comes through language. Through the subjunctive, the sentence suggests that it is "as if the billboards were generating reality." Without any breath remaining for the articulation of an alternative, this turn of phrase nevertheless casts doubt and unreality upon the networked world order that Glassic intuits. It gestures toward some disconnected space outside of the network, which can only be compared to a virtual situation ("as if") but never delimited. Appropriately, Glassic's vision leaves him preoccupied, disoriented, and, in a short time, utterly lost. In a world plastered with billboards, he can no longer get his bearings from the sky: "When he went past Newark Airport he realized he'd overshot all the turnoffs and their related options." After searching for a "friendly exit," Glassic finds himself in the midst of the "Fresh Kills landfill on Staten Island," a site that he realizes, in a moment of surreal recognition, he is scheduled to visit the very next morning. This location is not merely of professional interest. It is also the corollary of the advertisements that besieged him during his drive through New York: "The landfill showed him smack-on how the waste stream ended, where all the appetites and hankerings, the sodden second thoughts came runneling out, the things you wanted ardently and then did not." The place is filled with "every kind of used and lost and eroded object of desire." And yet the landfill is not simply the direct consequence of material accumulation but also a site linked to so many others that Glassic visits or imagines: the highway, the hotel, the Condomology prophylactic store, the legendary toxic cargo ship, the Kazakh nuclear test site, and so on. In *Underworld*, becoming-lost in the movement among locations—an experience that Glassic's flow allegorizes for a reader who may find herself drifting through DeLillo's hefty tome—is not merely a precondition for finding oneself once again. It is an endemic circumstance of the late twentieth-century historical moment: a complement to a realization of total linkage, a response to ubiquitous connectivity, and a manifestation of maximal network aesthetics. To put this differently, becoming-lost serves as a foundation for the possibility of perceiving the world anew by defamiliarizing (without wholly rejecting) network form.[31]

Through Glassic's disorientation, DeLillo stages a core problem of *Underworld*—that of mapping a network. Here, I would like to suggest that Fredric Jameson's concept of "cognitive mapping," though not an exact critical counterpart to DeLillo's aesthetic technique, offers a useful analytic correlate.[32] Cognitive mapping, as it operates in an era of multinational capitalism insistent on global totality, is not mimetic in nature. *Underworld* offers a model of such an aesthetic and sensory mapping practice that arguably exceeds the artistic possibilities that Jameson describes in his initial articulation of cognitive mapping in the mid-1980s. While DeLillo's text shares with a classical map a stability of structure, its overwhelming quantity of interconnections simultaneously resists cognitive comprehension or the experiential capacity to maintain all of its segments cohesively in consciousness. Nevertheless, the novel both thematizes and invites a participatory process of mapping that is predicated on the problematic of linkage.

Underworld explicitly marks its investment in mapping just prior to Glassic's drive through Manhattan, when he grasps for a comprehensible map. In this moment, he asks Marvin Lundy verbally for directions that he fails to retain, forgetting the described route as soon as he reaches his car. Shortly thereafter, he is lost within the "inescapability" of interconnection. Glassic eventually regains his bearings in a spatial sense, and a careful reader of *Underworld* might achieve similar clarity regarding the narrative, but there is no equivalent topological stability to be found in the novel's excess of links. DeLillo's novelistic mediation of networks engenders an intensification of the experience of late twentieth-century America. As only a novel can do, *Underworld* conveys a linguistic sense of networks that never yields schematic knowledge of its contemporary moment.

Through his concept of cognitive mapping, Jameson favors a Marxist language of dialectics and utopia, as he seeks a "complex representational dialectic" of the "global system." In contrast, DeLillo adopts the discourse of complexity and networks, compromised as it may be by finance capital, to imagine linkages among seemingly discrete things. Even as networks may elicit what Glassic experiences as a "neurotic tightness," DeLillo remains ambivalent toward, and not entirely dismissive of, these structures. Indeed, a dialectical process with a telos appears as only one possibility among many—most notably, in the chapter in which Klara Sax attends the screening of the "lost" Sergei Eisenstein film *Unterwelt*. As the novel's layered perspectives demonstrate, in an era dominated by infrastructures of interconnection, it is largely meaningless to be wholly either for or against networks. Both the extreme utopian and dystopian senses of networks—

celebration of a structure that "generates reality" and paralysis in the face of information overload—apprehend network form as a fait accompli, a formal inevitability. As such, they are incapable of grasping networks as a historically constructed paradigm, a perpetually changing concept, and a metaphorical figure through which subjects mediate everyday life.[33]

Underworld does not simply substitute an indefinable network complexity for an encyclopedic mapping that seeks (for Mendelson) to depict a national culture or a cognitive mapping that animates (for Jameson) the "collective struggle" that drives Marxism.[34] The novel both uses and problematizes the network frame that grounds it in a particular historical period, refusing any underlying truth or consequence of interconnection. *Underworld* thus foregrounds its own inevitable blind spots as a history of the short American century stretching from the beginning of the Cold War through its immediate aftermath. It does so primarily, as I argue in the next section, through a thick engagement with language.

Network Edges and Edgy Intensities

Underworld, as I have already suggested, does not produce a unified theory of networks. The text explores the relationship between novelistic language and network form in order to elucidate how a late twentieth-century American historical consciousness is shaped through the perception of and embeddedness within networks. One extended episode that takes place at the novel's midpoint serves as a particularly instructive microcosm of the text's linguistic problematization of networks. Here, readers encounter networks, in parallel with the scene's placement in the novel, in the midst of things. The sequence, set in 1974, focuses on Nick Shay's younger brother Matt. During this period, Matt works for "the Pocket," a US government weapons operation in southern New Mexico that is involved in a web of undertakings that no single employee comprehends. The staff at the Pocket has access to classified information, but the venture is also founded on an atmosphere of structural secrecy that is achieved through division of labor and decentralization of information.

In the 1970s of *Underworld*, the figure of the network departs from the crowd desire for a concrete connection of people and bodies that we see coalescing in the earlier scene of the 1951 pennant game. The distribution of "points" and "levels" that characterizes the "systems business" of the Pocket introduces unprecedented abstraction and a sense of interconnected totality that inspires both wonder and paralysis:

There were people here who didn't know where their work ended up, how it might be applied. They didn't know how their arrays of numbers and symbols might enter nature. It could conceivably happen in a flash. Everything connected at some undisclosed point down the systems line. This caused a certain select disquiet. But it was a splendid mystery in a way, a source of wonder, how a brief equation that you tentatively enter on your screen might alter the course of many lives, might cause the blood to rush through the body of a woman on a tram many thousands of miles away, and how do you define this kind of relationship?[35]

At the Pocket, the disruption of causal logic accompanies a loss of transparency in the movement of information from one workstation to the next, and eventually out into the world. Sequential chains cede to branching webs that suggest a "kind of relationship" that Matt feels but cannot know or define—as he senses, "everything connected," but only "at some undisclosed point down the systems line."

Even though it marks the very object of his discomfort, Matt adopts the language of networks to describe the indefinable relationship between his everyday actions and a world that seems only tangentially related. At first, he understands the ubiquity of connectedness only through the early Cold War idiom of paranoia. At a party thrown by the "bomb-heads," he is overtaken by this feeling: "Paranoid. Now he knew what it meant, this word that was bandied and bruited so easily, and he sensed the connections being made around him, all the objects and shaped silhouettes and levels of knowledge—not knowledge exactly but insidious intent." Paranoia, however, proves an inadequate response to the emergent historical situation that Matt experiences. Paranoia may suggest a kind of network, albeit a centralized system organized around the paranoid subject at its center who is the victim of "insidious intent." By distinction, Matt slowly discovers a system that is even more terrifying for its radical decentralization. He grasps desperately for metaphors to describe a historical transition that he only intuits: "He was surrounded by enemies. Not enemies but connections, a network of things and people. Not people exactly but figures—things and figures and levels of knowledge that he was completely helpless to enter." In this passage, the reader witnesses Matt's self-interrupting thought sequence as he revises his terms, grappling to find words that resonate with his transitional situation in the 1970s. In the process, a broader paradigm shift becomes apparent through Matt's transition between two different "figures," as the dominant Cold

War figure of "enemies" cedes to an emerging figure of "a network" of "connections."[36]

Matt's crisis escalates through this midpoint section of *Underworld*. He feels increasingly besieged by an incomprehensible system of endless interconnections. The horror he feels stems from a growing inability to differentiate among discrete things, a sense of totalizing fusion that yields an irresolvable confusion. "And how," he wonders, "can you tell the difference between orange juice and agent orange if the same massive system connects them at levels outside your comprehension?" Matt's abstract anxiety about this "massive system," he gradually realizes, derives from a more concrete ethical discomfort about taking part in an incalculably vast weapons project. He *knows* and simultaneously, through compartmentalization and disavowal, *keeps himself from knowing* the ways in which his work feeds into a global system of American war making. Through Matt, *Underworld* traces how a network disperses thought through a switchboard language that displaces real consequences—mass death perpetuated in places such as Vietnam—onto a simulation of eithers and ors. In place of certain knowledge, the network imaginary that Matt encounters yields something closer to the historian Robert N. Proctor's concept of "agnotology": the study of ignorance and forms of nonknowledge. As Proctor notes, "Ignorance has many interesting surrogates and overlaps in myriad ways with—as it is generated by—*secrecy, stupidity, apathy, censorship, disinformation, faith*, and *forgetfulness*."[37] In this sense, for Matt, the network is less a void of knowledge than it is a form for structuring a layered ignorance that enables him to bear an impossible present.[38]

Even as *Underworld* problematizes the obfuscation enabled by network ideology, the novel is not categorically dismissive of networks as generative figures. Much as empirical networks are characterized by flexibility, they also function as pliable metaphors with numerous connotations and affordances. Admittedly, *Underworld* does not suggest networks as alternatives to closed systems such as the Pocket. Matt, like the reader, is left not with a way out of his ethical crisis but only with a clearer articulation of an unresolved and perhaps irresolvable problem. As his girlfriend Janet sleeps on a rare shared camping trip, Matt, suffering from insomnia, comes to the following formulation: "Because everything connects in the end, or seems to, or seems to only because it does." Matt frames this point as a conjunctive series that insists on a single choice, but the novel itself offers no decisiveness. This chain of parallel options is instead figured as the very field of possibility or the horizon that structures historical consciousness in

the late twentieth century. All that we can access of our present is the varied experiences—alternately individual, collective, contradictory, connective, cognitive, affective, aesthetic, and so on—of networks in both their orienting and disorienting dimensions.[39]

Underworld's most notable accomplishment is arguably its capacity to apprehend a historical atmosphere of networks and to demonstrate how this form insinuates itself into the bedrock of language and material consciousness. A late twentieth-century environment pervaded by networks is marked, for instance, through the recurrence of the word "edge" and its numerous correlates, which show up over a hundred times in the course of the text.[40] The word "edge," here, carries many meanings. Edges are, first of all, margins. Albert Bronzini sits in his kitchen, for example, at "the edge of the room," listening to music that reaches him "edgewise." Characters such as the graffiti artist and community organizer Ismael Muñoz are forced to inhabit slightly more metaphorical edges, dwelling "on the fringes" of a society that does not recognize their value. "The true edge," as the character of Lenny Bruce reminds his audience, "is not where you choose to live but where they situate you against your will." In a related sense, edges are barriers, boundaries, and epistemological horizons.[41]

Alongside these senses of margin and border, edges also suggest a connotation that, at first, appears completely opposed: a sense of connectivity.[42] In early graph theory as well as later network science, an "edge" is a link that connects two nodes. In *Underworld*, omnipresent edges come to serve as textual seams and stitches among actors that may at first appear unrelated. Edges, in their varied meanings, become figures of the network society's antinomy of connection and disconnection. An edge captures an irresolvable tension between inside and outside, limit and porous membrane, which is perfectly expressed through Klara Sax's childhood dream of "a child located at the edge of a room, or a child dreaming the room but not in it herself—a room surreally open at one end." Though it is often represented as a spatial marker, the ubiquity of the very word "edge" in the novel transforms it into an intensity—an "edgy" state, a sense of "living on the edge," a perpetual readiness to make connections.[43]

The broader point suggested by the role of "edges" in conjuring networks is that language itself is for DeLillo a fundamental technique of mediation between individual readers and collective networks that have become increasingly ungraspable through cliché and overuse as metaphors. DeLillo offers a number of ars poetica moments in which he foregrounds this aspect of his aesthetic. One of the most compelling comes through the character of

Albert Bronzini, a teacher. Bronzini tells his friend the Jesuit priest Andrew Paulus, "This is the only art I've mastered, Father—walking these streets and letting the senses collect what is routinely here." Shortly thereafter, lying in a bathtub, Bronzini delves deeper into the techniques of his sensory apparatus. "How language is webbed in the senses," he reflects. "Out of sand-blaze brilliance into quirky minds such as his, into touch, taste and fragrance." Here, language is figured as a perceptual capacity that absorbs certain network properties.[44]

DeLillo remarks even more explicitly on the role of language to *Underworld* in "The Power of History," a *New York Times Sunday Magazine* piece that appeared a month before the novel's publication. In several passages, he conceptualizes a relation between language and the apprehension of history, describing the pleasure that attends "the prospect of recovering a nearly lost language, the idiom and scrappy slang of the postwar period." His goal in the novel, he explains, is to capture a "language to reinvigorate the senses" and suggest a "sense of history." DeLillo conceives of literary language as something powerful, as "a form of counterhistory," a "life-giving force" and "an agent of redemption" that can "shape the world."[45]

Without denying the importance of language to *Underworld*'s particular aesthetic encounter with the network imaginary, I would like to suggest that DeLillo's overdetermination of language keeps him from exploring a materiality of networks that certainly includes but also exceeds a linguistic register. This problem of (and sometimes for) the novel—a problem that one can track across the network novel genre—becomes most apparent in the epilogue. Prior to this closing section, the text builds to a climax that features the historical accident of Nick Shay's murder of a waiter named George Manza in 1952, an event that ripples through the entire novel. Forty years later, in the 1990s, Nick yearns for his earlier days when he was "dumb-muscled and angry and real." The epilogue, entitled *Das Kapital*, however, reflects on a new world founded on multinational capital and its virtual networks. This new world, Nick observes, produces dedifferentiation. "Capital burns off the nuance in a culture," he notes, later adding, "not that people want the same things, necessarily, but that they want the same range of choices." Recognizing the importance of customization to the 1990s and the way this ideology differs from the Cold War's uniformity, Nick nonetheless insists on this new system's "furtive" sameness.[46]

In its analysis of the transition from the Cold War to a network society, the epilogue recognizes computer networks as the primary technological infrastructure of the present. Nick realizes the importance of the Inter-

net by observing his son Jeff: "The real miracle is the web, the net, where everybody is everywhere at once, and he is there among them, unseen." Even so, *Underworld* ends on a decidedly anxious and uncertain note regarding networks. In the final scene, Sister Edgar, an edgy nun who has appeared in each major era of the novel, dies and, in that moment, experiences a vision of transcendent linkage: "There is no space or time out here, or in here, or wherever she is. There are only connections. Everything is connected. All human knowledge gathered and linked, hyperlinked, this site leading to that, this fact referenced to that, a keystroke, a mouse-click, a password—world without end, amen." She feels wonder in response to the "lustrous rushing force" of the "net," but there is also "the paranoia of the web" that is the consequence of the "grip of systems." Sister Edgar observes that "the intersecting systems help pull us apart, leaving us vague, drained, docile, soft in our inner discourse, willing to be shaped, to be overwhelmed—easy retreats, half beliefs." The "fantasy of cyberspace," we are told, is predicated on the idea of "difference itself, all argument, all conflict programmed out." Following this commentary, the novel ends with a single terrifying word on a computer screen: "Peace."[47]

For DeLillo, real difference cannot be found in computer networks, which reduce everything, including history itself, to an interconnected sameness, a "peace" predicated on the elimination of diversity. DeLillo's implied position in the epilogue closely resembles one commonly held by critics of globalization in the 1990s and 2000s who sought to problematize the homogenizing fantasy of American empire and resist the normalizing effects of mass culture that were foregrounded in common "end of history" narratives. The word "peace," for DeLillo, carries a resonance that is simultaneously literal and ironic, suggesting a homogenization that serves as the utopian promise of globalization for neoliberals and as its feared dystopian consequence for antiglobalization activists. The association of the Internet with the word "peace," in the epilogue's final moment, places computer networks in a long line of communications technologies from the optical telegraph to broadcast media that have, in their nascent stages, inspired promises of democracy and universal peace that they could not deliver.[48]

Even this final passage is not categorically opposed to network form, which remains *Underworld*'s primary metaphor, formal principle, approach to language, and historical paradigm. For all of the novel's conceptual appreciation of networks, however, it is curious that this epilogue criticizes the Internet as a material network infrastructure. In place of network protocols and computer code through which "all conflict" is

"programmed out," language remains the optimal agent of redemption in (and of) the novel. However, even as *Underworld* frequently marks its own formal limits of knowledge, as a novel, it does not yet address the role of networks in the late twentieth and early twenty-first centuries as infrastructures that exceed language. To analyze this internal edge of the network novel, I now turn to Stephenson's *Cryptonomicon*, published just two years after *Underworld*, which grapples precisely with the limits of knowing the materiality of computer networks through language alone.

Material and Transnational Networks in *Cryptonomicon*

The relationship between network and novel is allegorized on the very first pages of Neal Stephenson's *Cryptonomicon*. In the prologue, Corporal Bobby Shaftoe sits on a US Marine Corps truck that is moving through Shanghai on November 28, 1941. To pass the time, he composes a haiku. Approximately one week prior to the Japanese attack on Pearl Harbor and the parallel occupation of the International Settlement in Shanghai, Bobby struggles to represent the truck and its contents in a mere seventeen syllables, realizing the limits of haiku form. "The modern world's hell on haiku writers," he laments. "'Electrical generator' is, what, eight syllables? You couldn't even fit that onto the second line!" This opening passage highlights *Cryptonomicon*'s own novelistic scope and maximalist ambitions by juxtaposing them with a more compressed and antiquated literary form. The sense of anachronism evident in the appearance of haiku in the 1940s of the novel extends to the entire scene. As Shaftoe drifts from his failed composition and "takes stock of the situation," he hears coolies "sing to each other, and plant their feet on the pavement in time to the music," and witnesses them transport boxes filled with legal tender, on long bamboo poles, from one bank to another. This strange display is explained as a network of mutual enforcement practiced by "the Hong Kong and Shanghai Bank of course, City Bank, Chase Manhattan, the Bank of America, and BBME and the Agricultural Bank of China and any number of crappy little provincial banks." These banks keep each other honest by presenting bills printed by those institutions and, in exchange, demanding the equivalent quantity of silver or gold that backs the currency. These opening pages feature a number of cultural asymmetries and historical nonsynchronicities. Chinese coolies with bamboo poles run alongside rapidly moving American trucks; a centralized international banking system coexists with informal wartime enforcement protocols adopted by local banks; the urban space of Shang-

hai appears as a node within transnational circuits that have somehow put US Marines on Chinese soil; and, of course, the haiku appears (in its formal incapacity to fit modern technology) nested within the more capacious novelistic form of *Cryptonomicon* itself.[49]

Cryptonomicon bears little stylistic resemblance to *Underworld*, but it is a network novel that grapples with a compatible configuration of formal and historical problems. In the prologue, *Cryptonomicon* does not merely introduce a rival literary form in order to demonstrate the novel's comparative advantage in representing post–World War II technologies. In my reading, the relationship between haiku and novel sets up an analogous relationship between novel and network. For Stephenson, as for DeLillo, novel form can apprehend but never wholly comprehend networks. A novel, in other words, perceives or channels a particular historical consciousness shaped by networks, but it cannot use language to achieve the epistemic fantasy of an exterior position from which to grasp networks in some total sense. As I argue in the remainder of this section, *Cryptonomicon* foregrounds its own formal limitations and ultimately proposes that both communications and sociopolitical networks can only be approached through a materiality that exceeds language. While DeLillo, as I observed in the last section, believes in the power of language to order the world and sense the present historically, Stephenson insists that computation, code, and cultural convergences must be at the heart of such an encounter.[50]

To understand *Cryptonomicon*'s network aesthetics, something must first be said of its historical parameters and its maximal novelistic form. The novel oscillates between the edges of the American century—two historical contexts that it interweaves through a variety of themes and narrative techniques.[51] First, the novel explores the Allied cryptographic efforts to decrypt Axis codes during World War II and the ways in which this work laid the foundation of digital computing and networking in the coming decades. Second, the text follows a late 1990s project by the Epiphyte Corporation to install fiber-optic cables in the Philippines and construct a data haven in the fictional Sultanate of Kinakuta. *Cryptonomicon*'s three primary American characters (Lawrence Waterhouse and Bobby Shaftoe in the 1940s and Randy Waterhouse in the 1990s) animate the techno-scientific, military, and financial dimensions of the narrative.[52] Two other characters (the Japanese engineer Goto Dengo and the nationally indistinct and potentially ageless priest Enoch Root) participate in both historical contexts. The action of the novel takes place across five continents (jumping among cities that include San Francisco, London, Tokyo, Manila, Algiers, and

Brisbane) and includes characters from six. Thus it also belongs to what Rita Barnard has called "emergent fictions of the global."[53] However, instead of a "global" landscape made homogenous by American power, the novel emphasizes the ambivalences of a world that is influenced but never wholly dominated by a network of US interests.[54]

In an incisive reading of *Cryptonomicon*, Katherine Hayles observes that "code is at the center of its thematic concerns, both as cryptological system and computer algorithm."[55] Stephenson approaches materiality, for example, through the recurring metaphor of "burying and disinterring" information that is key to both the history of computation (e.g., the engineering problem of developing computer memory) and the process of reading through a maximalist novel (e.g., in which a reader must store and retrieve information in order to manage an overwhelming data field). Without denying the centrality of code to the novel, I contend that networks (especially communications networks) serve as a closely related and critical metaphor for the text's materiality and a reader's aesthetic experience of it. Like computer code, networks are *Cryptonomicon*'s condition of possibility, which mark it as a product of the late twentieth century and serve as the underlying infrastructure through which the novel can never fully think.

Stephenson's imagination of the network's limit differs in a noteworthy way from Sister Edgar's vision of transcendent linkage in *Underworld*'s epilogue, as well as from the fantasies of a great deal of early cyberpunk fiction. Indeed, even though *Underworld* and *Cryptonomicon* were published within nineteen months of each other (October 3, 1997, and May 1, 1999, respectively), the difference between their renderings of the Internet is emblematic of a broader paradigmatic shift in the cultural imaginary of networks in the 1990s. The earlier vision of sublime cyberspace as a virtual or disembodied reality yields, in *Cryptonomicon*, to an imagination of a spatially grounded and transnationally oriented commons that both facilitates and constrains cross-cultural communications. Stephenson's novel avoids the high-tech Orientalism of earlier fictions, which, as Wendy Chun argues, commonly use an exotic aesthetic to orient readers toward emergent computer technologies.[56] Moreover, in place of network mysticism, *Cryptonomicon* explores the concrete infrastructural spread of computer networks.

Cryptonomicon's departure from earlier technological fiction is evident in the narrative of the 1990s Epiphyte Corporation start-up, created by Avi Halaby and Randy Waterhouse, which taps into the telecommunications growth in "Rapidly Developing Asian Economies." Avi explains in an encrypted email to Randy that the technology "where no one can compete"

with the United States is "networking."[57] Epiphyte's first business venture
targets Filipino "Overseas Contract Workers." The corporation lays down
deep-sea fiber-optic cables to enable inexpensive communication between
workers and their families. Alongside this investment in network infra-
structure, the company promotes the sale of small, book-sized devices that
encase "a thimble-sized video camera, a tiny screen, and a lot of memory
chips." The innovation has to do not with the videophone hardware but
with the software that capitalizes on low-traffic lulls to facilitate smoother
communication. These "Pinoy-gram" messages, as Epiphyte calls them,
are sent to stores in Manila, where they can be picked up by the families of
migrants.[58]

In its second venture, funded in part by profits from the first, Epiphyte
invests in undersea cables in a "north-south direction, connecting Austra-
lia and Asia." The corporation runs these lines through the Philippines, a
country that is ideally located to support such cables but has not yet made a
substantive transition to the information era. Instead of deep-sea wires, Avi
imagines "a network of inter-island cables" that move, for instance, across
the "shallow and flat" land between Luzon and Taiwan. Since "national
boundaries are artificial and silly," according to Avi, "shallow, short-hop
cables" can cover the entire region, easily connecting the Philippines to
nearby islands such as Borneo. The ultimate goal of these cables, the reader
gradually learns, is to create a data haven in the independent country of
Kinakuta, which is located at the center of a triangle formed by Singapore,
the southern tip of Taiwan, and the northern tip of Australia.[59] The overtly
libertarian goal of this venture is to achieve "secure, anonymous, unregu-
lated data storage" through a network of data havens and consequently to
establish a dependable form of electronic currency.[60]

Even as both of Epiphyte's network ventures unfold amidst financial and
legal abstractions, the novel concretizes these deals through detail-oriented
maximalism.[61] In a number of passages, the text emphasizes the physical
levels of communications networks. For example, Randy observes the
hired divers who are laying undersea cable in Manila Bay:

> Some of them are working out in the surf zone, bolting sections of cast-
> iron pipe around the cable. Some are working a couple of miles offshore,
> coordinating with a barge that is injecting the cable directly into the
> muddy seafloor with a giant, cleaver-like appendage. The shore end of the
> cable runs into a new reinforced-concrete building set back about a hun-
> dred meters from the high-tide level. It is basically just a big room filled

with batteries, generators, air-conditioning units, and racks of electronic equipment. The software running on that equipment is Randy's responsibility, and so he spends most of his time in that building, staring into a computer screen and typing. From there, transmission lines run up the hill to the microwave tower. The other end is being extended out towards a buoy that is bobbing in the South China Sea a few kilometers away. Attached to that buoy is the end of the North Luzon Coastal Festoon, a cable, owned by FiliTel, that runs up the coast of the island. If you follow it far enough you reach a building at the northern tip of the island, where a big cable from Taiwan comes in. Taiwan, in turn, is heavily webbed into the world submarine cable network; it is easy and cheap to get data into or out of Taiwan.[62]

This description, however technically oriented, tedious, and unliterary it may seem, adopts a distinct aesthetic that stands in sharp contrast to the transcendental cyberspace of Gibson and DeLillo. In place of a sublime invocation of seamless global networks, this passage employs a logical, procedural prose. The text traces the communications network from an installed cable (the "shore end" room and the "microwave tower") and its supporting software (itself created not through immaterial labor but through the hand-eye coordination of "staring into a computer screen and typing") to the South China Sea, then to the North Luzon Coastal Festoon and Taiwan, and finally to the existing "world submarine cable network."

The impulse of this passage parallels descriptions in other network novels, including Pat Cadigan's *Synners* (1991), Neal Stephenson's earlier *Snow Crash* (1992), and Daniel Suarez's *Daemon* (2009), that describe the technical subroutines, protocols, and cables that make up networked computers and their infrastructures. It is important to stress that *Cryptonomicon*'s descriptions of the physical basis of communications networks, their transnational geographies, and their subjection to different governmental and corporate protocols (as with the North Luzon Coastal Festoon that, we are told, is owned by FiliTel) do not somehow de-aestheticize them but introduce a particular material aesthetic. The concreteness of these networks—their basis in fiber-optic cables, transnational legal norms, and cultural practices—becomes a necessary material precondition of rendering (if never comprehending) the complex history that underlies contemporary senses of interconnection.[63]

As an extension of its technical investments, *Cryptonomicon* explores the concrete spatial and temporal dimensions of networks. Spatially, the novel

shifts from the earlier language of a continuous and global cyberspace to one of a transnational topology. The text's concern with specific national and corporate influences on a supposedly borderless Internet arguably reaches a crescendo during a meeting that Epiphyte and several Asian contractors have with the sultan of Kinakuta. The sovereign begins by using the very language of the earlier network imaginary, announcing to the gathered entrepreneurs that "physical location no longer matters in a digitized, networked world" and that cyberspace "knows no boundaries." Shortly thereafter, however, he surprises everyone in the room by traversing the fantasy of a seamless Internet: "But hey, the sultan continues, that's just dizzy-headed cyber-cheerleading! What bullshit! Of course locations and boundaries matter!" In place of the "conventional understanding of the Internet: a decentralized web connecting each place with all the other places, with no bottlenecks," the sultan displays a map with thick national networks but limited transnational information traffic. This pattern, he observes, is "not weblike at all." In place of an Internet that resolves difference and conflict, this map reveals new pathways and protocols of control that become overlaid on older boundaries and divisions in a palimpsestic fashion.[64]

The differences between *Cryptonomicon* and *Underworld*'s treatment of geopolitical space highlight the novels' distinct approaches to networks. While both works are, in a number of senses, US novels, the worlds that they depict privilege disparate geographies and senses of America. With the exception of Nick Shay and Brian Glassic's brief trip to Kazakhstan in *Underworld*'s epilogue, DeLillo's novel unfolds within the borders of the continental United States. It is during the flight to Kazakhstan that the novel comments most explicitly on the changing role of space within late twentieth-century capitalism. In a conversation with the Russian entrepreneur Viktor Maltsev and Glassic, Nick admits, "I thought leaders of nations used to dream of vast land empires—expansion, annexation, troop movements, armored units driving in dusty juggernauts over the plains, the forced march of language and appetite, the digging of mass graves. They wanted to extend their shadows across the territories." In response, Glassic explains that, in the late twentieth century, those in power are less interested in space and have moved "inward and smallward" with computing.[65]

Underworld certainly reflects upon the transformation of space and problematizes the centrality of globalization discourse in the formation of American power in the latter half of the twentieth century.[66] Nevertheless, DeLillo's consciousness of what Nick Shay calls "a planetary context" remains largely abstract.[67] While the world that exists outside of US borders

remains at the fringes of *Underworld*'s America, it is concretely present on every page of *Cryptonomicon*, not just in its movement among locations, but also its complication of geographical and cultural categories. For instance, Randy's love interest—unambiguously named America (Amy) Shaftoe—has an accent that is described as "largely Midwestern, with a trace of Southern twang, and a little bit of Filipino, too." Physically, "if you saw her on the streets of some Midwestern town you might not notice the traces of Asian ancestry around her eyes." Amy does not simply allegorize a pleasant global multiculturalism but rather signifies more complex historical processes and networks of communication, war, and media.[68]

It is significant, then, that *Cryptonomicon* explores networks not only as spatial or topological structures but also as historical and temporal ones. Notably, the novel's vision of communications networks and their transnational asymmetries transcends its contemporary 1990s. Instead of settling for a fetishistic fidelity to technical details (a common feature in "hard" science fiction), the novel initiates an ambitious process of mapping the dominant contemporary network paradigm back onto the changing world of the 1940s. This operation does not merely establish a definite origin to computing and networking in this wartime period. Through its World War II narrative, *Cryptonomicon* uses the older form of the novel to historicize newer networks. It registers the radical specificity of the past while simultaneously demonstrating, through narrative, that history's solidarity with the present.[69] The novelistic historicism complicates the narrative of novelty that animates "new media" and demonstrates the conceptual variation of network form—its textures, connotations, versions, and affordances—across different periods.

As in *Underworld* and other network novels, one of the most compelling features of *Cryptonomicon* is not its overt theorization of the network imaginary but its aesthetic intensification of its historical emergence. This sense of history comes across, for instance, in a passage from the early 1940s in which Lawrence Waterhouse (who has been recruited by the military) travels via train from London to Bletchley Park to aid in Allied cryptographic efforts. In an underground portion of the journey, the darkened tunnel becomes visible for an instant:

> Something catches his eye out in the darkness beyond the window. The train has reached one of those parts of the Underground where dim gun-barrel-colored light sifts down, betraying the stygian secrets of the Tube. Everyone in the car blinks, glances, and draws breath. The World has

rematerialized around them for a moment. Fragments of wall, encrusted trusses, bundles of cable hang in space out there, revolving slowly, like astronomical bodies, as the train works its way past. The cables catch Waterhouse's eye: neatly bracketed to the stone walls in parallel courses. They are like the creepers of some plutonic ivy that spreads through the darkness of the Tube when the maintenance men aren't paying attention, seeking a place to break out and up into the light.[70]

As the train moves underground, Lawrence glimpses the communications cables that are, along with the rest of the visible world, "rematerialized" for a moment. Despite the raw physicality of these "encrusted trusses" and cables "bracketed to the stone walls," Lawrence, who is logical and literal-minded to the point of absurdity, cannot make sense of what he sees without recourse to figurative language. The cables are, via simile, "like astronomical bodies" and "like the creepers of some plutonic ivy." In this quick flash of light, a temporary respite from total darkness, the cable system outside the train window becomes coterminous with "The World."

Though divided from it by half a century of narrative time, this description of the railway's "Underground" appears a mere four pages after the description of the undersea cables that Epiphyte (led by Lawrence's grandson Randy) lays out in the Philippines of the 1990s. This juxtaposition marks a parallel between these midcentury communications systems and the late twentieth-century Internet while maintaining a defamiliarized strangeness that refuses to collapse the two periods. The historical subjects who inhabit each moment have a radically different sense of these networks. Nevertheless, in the midst of the Second World War, Stephenson shows invisible information networks as already wiring and constituting the greater "World." For all of their chaotic unknowns, these communications systems already suggest a mutation in transnational power. Even as Lawrence looks forward to an unknown future, he also registers a past that exceeds his knowledge, as well as the historical scope of the novel. The "stygian secrets of the Tube" include not only the winding cables but also a history of the British railway system, built with the aid of foreign investment and generative of the global financial markets that develop through the twentieth century. Later, he also explicitly remarks on the historical coemergence of European colonization and communications networks. This repeated invocation of earlier networks gestures toward the emergence of the network imaginary.[71]

Stephenson's novel maintains an uncertain relation to networks that is built into its very title: *Cryptonomicon*. In the fictional world, the "Cryp-

tonomicon" is a collaboratively produced cryptographic encyclopedia that collects numerous strata of knowledge gathered and amended by generations of cryptanalysts. The compound word "Cryptonomicon," however, is equally suggestive of the novel itself and its reflection on historical transformation. "Crypt" comes from the classical Latin *crypta*, which refers to a "vault," but also from the Greek *kryptós* for "hidden, concealed." "Nomicon" is closely related to the Greek *nómos* for "usage, custom, law."[72] *Cryptonomicon* thus becomes a kind of compendium of hidden law. The encrypted law of the novel itself is organized through a seemingly paradoxical dual process of rapid proliferation and paranoid concealment of information across transnational networks. The text overflows with complex encryption that is unbreakable by human beings. These instances suggest a computational order that is cognitively inaccessible because it surpasses the scope of unmediated human knowledge and the temporal span of a human life.

The orders of incomprehensibility signaled by *Cryptonomicon*'s title are central to the novel's sense of the epistemological limits that ground a network imaginary. In the World War II portion of the narrative, the Allies already find themselves saturated with information. Only a handful of officials, including Roosevelt and Churchill, have access to all of the enemy information that is decrypted at Bletchley Park, but even "they have other cares and distractions." In the 1940s, communications and information processing technology become so complex that even top-level decision makers "cannot trace individual threads of the global narrative at their whim, running from hut to hut patching connections together . . . fashioning a web to catch Hitler's messages as they speed through the ether." Individual characters compose local narratives to make sense of world events, as the novel demonstrates through Lawrence Waterhouse's attempt to process the world situation in this same chapter ("Here are some of the things Waterhouse knows"). The "global narrative," however, figured here as an intersecting network of "threads," is inaccessible to any single person. The language through which the text renders supraindividual networks does not appear in the interest of encyclopedic encapsulation or metaphysical sublimity. Even with its gargantuan length, *Cryptonomicon* cannot be "a web" fashioned tightly enough "to catch" even a small fraction of a world a novelist might nonetheless seek to form and bring to consciousness."[73]

If *Underworld* reaches too dystopian a vision of network homogenization, *Cryptonomicon* is arguably too utopian in its treatment of networks and digital technologies.[74] Nevertheless, both novels suggest that networks, in their formal ubiquity and metaphorical flexibility, invite various types of

often-contradictory cathexis. The work of the network novel, then, is to stage, interrogate, and intensify such investments. While the "global narrative" of our era concerns and is increasingly processed through computational networks—with their technical subroutines, cultural protocols, and historical strata—a novel, regardless of its scale, invariably relies on natural language in its literal and figurative varieties. Compared to computer networks, *Cryptonomicon* suggests, a novel promises only an impressionistic sense that finds a rough analog in a haiku that tries, impossibly, to account for an "electrical generator" while facing formal restrictions that were conceived by and for a very different world.

Conclusion: Novel Histories

To emphasize the novel's limits, as I have done through my analysis of *Underworld* and *Cryptonomicon*, is not to dismiss this form in its capacity to grapple with the network imaginary. Limits are, after all, not merely markers of inadequacy but parameters that enable innovation and experimentation. A creative form's constraints also mark the social limits and historical horizons of the human world from which it issues. Georg Lukács points out, in his 1962 preface to *The Theory of the Novel*, that "the problems of the novel form" can be analyzed as "the mirror-image of a world gone out of joint." As he contends later, "Every form is the resolution of a fundamental dissonance of existence."[75] Every form, in other words, attempts to reconcile contradictions that accompany experiences of the world at a particular historical moment. Following Lukács, David Cunningham reads the novel form as "a formal equivalent" of capitalist modernity or "a mediation of social form."[76] This mediation takes place, in part, between abstraction and concretion—two aspects of both capital and networks with which *Underworld* and *Cryptonomicon* grapple. As Cunningham astutely observes, Lukács (like Marx before him) does not simply condemn a modernity constituted by capitalism for its abstraction nor does he celebrate concreteness as a redemptive alternative. He strives, instead, to elaborate real abstraction. In other words, the movement of capital, in all its systemic intangibility as transnational finance, represents one of the most concrete experiences of modernity. The novel, as a "formal equivalent" of this experience of finance, is of course by no means shrouded in abstraction. In various concrete ways, novels such as *Underworld* and *Cryptonomicon* follow individual protagonists, stage ordinary encounters, and mediate evocative materialities.

In this chapter, I have explored the network novel of the 1990s as a linguistic mediation between the abstraction and concretion of network form. Unlike some earlier postmodern conspiracy texts that Jameson analyzes — texts that employ a complexity that pardons readers or viewers from narrative or historical responsibility — the novels I discuss understand themselves to be manifestly historical.[77] These texts emphasize that the network is not an ahistorical form or reified object, as it is often imagined. In both *Underworld* and *Cryptonomicon*, history is itself treated as an ongoing process of networking. History, in both novels, is not a chronology to be narrated or captured. The aesthetics of these novels, though they convey different senses of materiality through varied associations with language and communications infrastructures, highlight historical processes. They use language and maximal narrative form to process a world understood simultaneously as an epiphenomenon of material networks and as a reality that can only be analyzed through network metaphors.

Novelistic mediation invariably changes the network imaginary by informing and thereby, however ambiguously, forming it. As Terranova observes, "A piece of information spreading throughout the open space of the network is not only a vector in search of a target, it is also a potential transformation of the space crossed that always leaves something behind — a new idea, a new affect (even an annoyance), a modification of the overall topology."[78] A novel, like information, is an active form. It does not merely record a vision of the social world but enacts transformations on the consciousness of individual readers and the desires of larger-scale social networks through which it circulates. In a variety of ways, networks imply and generate a messy aesthetics of perpetual transformation. It is this concept of systemic change to which I turn in the next chapter through an analysis of network films.

– 2 –
Emergent Aesthetics: Network Films

Everything is connected.

Syriana **tagline**

At the same time, media technologies gave renewed
importance to catastrophic accidents. Repetitions
expanded the scale of dangerous events, while photographs
could capture the sensory impact of ephemeral sights
and sounds and films could replicate their shocking
suddenness. By bringing train wrecks, airplane crashes,
and collapsing bridges or buildings vividly before the
mind, the new media altered the function of reflection.

Ross Hamilton (*Accident*)

Beginning in the early 1990s, networks started to constitute a new cine-
matic genre—one that has arguably received greater critical attention than
other narrative forms that inform the network imaginary, including novels
and television shows. David Bordwell has identified around 150 films from
this period that foreground social networks through assemblages of charac-
ters who are linked and whose paths intersect, only occasionally and often
accidentally, through the unfolding of complex narratives. The networks
in which these characters take part exceed any single participant's under-
standing of the whole. In most of these films, the connections that join the
narrative parts are made manifest to viewers only in a gradual and partial
fashion.[1]

Several directors, including Robert Altman (*Nashville, Short Cuts*),

Alejandro González Iñárritu (*Amores perros, 21 Grams, Babel*), and Steven Soderbergh (*Traffic, Contagion*), have experimented repeatedly with narratives organized around the parallelism and simultaneity suggested by networks—structures that complicate without fully negating the chronological sequencing that has been more common in mainstream Hollywood films. Critics only began to recognize these films as belonging to a coherent cinematic genre around 2005, coining related category names that have included "hyperlink cinema," "criss-crossers," "multiprotagonist films," "fractal films," "database cinema," and "network narratives," all of which emphasize different qualities that are shared among a largely consistent canon.[2] Itself a now-recognizable genre, the network film has borrowed from and influenced many others, including comedy (*Love Actually*), melodrama (*Things You Can Tell Just by Looking at Her*), crime drama (*Gomorra*), and science fiction (*Southland Tales*).

Multiplot techniques and ensemble compositions in film are, of course, far from an unprecedented innovation of the 1990s. They can be traced to earlier cinematic experiments—most notably D. W. Griffith's *Intolerance* (1916), Edmund Goulding's *Grand Hotel* (1932), and Eddie Sutherland's *International House* (1933)—as well as later revisions of this form such as Altman's *Nashville* (1975). Even so, it is significant that it was not until the 1990s that these scattered experiments cohered into an identifiable and nameable genre reinforced through a large quantity of releases with shared formal properties. Bordwell traces the explosion of these films to around 1993 and 1994, which saw the release of Altman's *Short Cuts* (1993), Michael Haneke's *71 Fragments of a Chronology of Chance* (1994), and Quentin Tarantino's *Pulp Fiction* (1994). His explanation for the form's spike in popularity involves a variety of economic and film-industry developments during this period. The proliferation of narrative experimentation in the mid-1990s had much to do, for instance, with a surge in independent filmmaking, which needed to stand out in a crammed marketplace. Consequently, both independent and popular films began to reach back to earlier innovations of directors such as Welles, Hitchcock, and Altman.[3] The transmedia influence on Hollywood in the 1990s and 2000s also encouraged a cross-pollination of films with comic books, television shows, videogames, and online phenomena, introducing other narrative structures and formal experiments to popular cinema.[4] Network films, in particular, became possible, in terms of production, through the growing trend of star actors committing to ensemble films for fewer days of shooting and lower salaries and, at the consumption end, through the spread of a DVD format well suited for traversing and reviewing multiplot narratives.[5]

Bordwell, who has offered perhaps the most detailed taxonomy of the major tropes and traits of network films, claims that transformations of Hollywood and viewing technologies in the 1990s were central to the genre's rise. While these elements certainly had a great deal to do with the sustained popularity of network films, Bordwell underplays the importance of the paradigm shift taking place during these years in the areas of complexity and network science, as well as the mass cultural interest in these new scientific fields. If indeed the development of the network film genre primarily represented "the dominant principle of offbeat storytelling" in the 1990s — the equivalent of "what flashback tales were for the 1960s" — it would not necessarily have turned to this *specific* formal fascination with interlinked nodes in a transnational context.[6] If we can postulate that genre enables a viewer to decode a film in a mode similar, if never identical, to the one in which it was encoded, then an understanding of the network imaginary requires a sense of the specific ways the network films of the late twentieth and early twenty-first centuries encode their historical present.[7]

Network films, I argue in this chapter, flourish in a cultural milieu characterized by an interest not only in network structure but also in dynamic processes of emergence: the creation of complex higher-level phenomena from interactions among lower-level components of a system. Emergence is a key concept for all of the cultural works in this book insofar as it demonstrates the complex ways that networks change over time. Moving pictures, in particular, use audiovisual aesthetics and formal techniques such as crosscutting to explore this paradigm. While cinema, similarly to the novels I discuss in chapter 1, relies on linear (if not always chronological) narrative, it also complicates temporality through techniques such as montage, as well as variations in frame speed via techniques such as slow motion and time-lapse photography. Here, I consider the way that the network films of the 1990s encourage reflection on and critical engagement with several concepts that help us think more precisely about networks — especially "conspiracy," "accident," "blowback," and "emergence."

The primary node of this chapter is Stephen Gaghan's *Syriana* (2005). This film is exemplary in the sense that it engages with a transnational historical present marked by the majority of network films, albeit more directly than most other examples of this genre. In a more irreducibly singular way, however, the film uses its formal innovations to grapple with the specificity of discussions in sociology, economics, and politics about so-called terrorist networks. In narrowing my analysis to the treatment of terrorist networks in a single film, I hope to counteract the dominant tendencies in discussions of network films to classify and categorize the genre. Instead of

dealing with networks in general or even network films as a type (methodologies that often encourage broad generalizations about network form), I engage with *Syriana*'s emergent network aesthetics as they unfold in a sociopolitical context of terrorist networks and contemporary geopolitical affects.

Conspiracy and Accident

Syriana, which was conceived shortly after the al-Qaeda attacks of September 11, 2001, and based loosely on the CIA operative Robert Baer's memoir *See No Evil*, explores the situation of early twenty-first-century networked warfare.[8] Set in locations that include Houston and Washington, DC, Marbella and Geneva, and Beirut and Tehran, the film's tight interconnectivity oscillates between ordered paranoia and the chaos of unpredictable events—modulations that dramatize the film's promotional tagline: "Everything is connected." The narrative details prove too complex to summarize, but the major event that ties the numerous plotlines together, and causes them to converge, is the merger between Connex (a large oil conglomerate) and Killen (a smaller oil company that has won rights to promising oilfields in Kazakhstan). This global event comes to affect thirty-seven thousand workers in 160 countries. The film's focus on various institutions, including the vast reach of Connex-Killen itself, conveys a sense of interconnectivity that the film's tagline foregrounds. Tracing the illegal rise of Connex-Killen to financial power, *Syriana* follows an ensemble cast highlighted by four men: Bob Barnes (George Clooney), a CIA field officer; Bryan Woodman (Matt Damon), an energy analyst in a derivatives trading company; Bennett Holiday (Jeffrey Wright), an attorney with Sloan-Whiting; and Wasim Ahmed Khan (Mazhar Munir), a Pakistani immigrant worker.[9]

To achieve greater precision about the ways in which *Syriana* is a network film and what it has to convey about the network imaginary, it is useful, first of all, to consider how it both borrows and departs from earlier film genres. Though a number of genres, such as the thriller, are relevant, *Syriana* has the most in common with the politically oriented conspiracy films that were most prevalent from the 1960s through the early 1980s. Films from *The Manchurian Candidate* (1962) to *The Parallax View* (1974) to *Blow Out* (1981)—all of which prefigure some key thematic concerns of the network films of the 1990s and 2000s—already use the concept of conspiracy to conceptualize and aestheticize social totality. As Fredric Jameson has

observed, conspiracy serves in such films "to think a system so vast it cannot be encompassed by the natural and historically developed categories of perception with which human beings normally orient themselves."[10] The crucial aspect of Jameson's analysis of conspiracy is his treatment of it not as an empirical category (the existence of *actual* conspiracies is beside the point) but as an aesthetic, narrative, and epistemological concept. Conspiracy, he notes, is "a narrative structure" that portrays "a potentially infinite network, along with a plausible explanation of its invisibility."[11] In this way, a conspiracy displays a dual desire to make known the outline of an often-global plot while simultaneously reinforcing the unknowable nature of a world system that always exceeds anything we could discover or perceive.

If the conspiracy film is a postmodern modification of the earlier detective story in which an individual investigator approaches, and in most cases solves, a crime that affects a social collective, then *Syriana* continues this tradition by grappling with collective mysteries that are now figured as networks. One of the important ways that many network films stand in formal contrast to earlier conspiracy films is in their move from a single protagonist to a multitude of perspectives.[12] In Gaghan's film, a huge cast of characters refuses primacy to any single participant—including Bob Barnes, who, in some senses, echoes the conspiracy film's earlier misanthropic male heroes, such as *The Conversation*'s Harry Caul (Gene Hackman), *The Parallax View*'s Joe Frady (Warren Beatty), and *Three Days of the Condor*'s Joe Turner (Robert Redford). At the same time, multiple protagonists do not resolve the fundamental lack of collective processes that Jameson identifies as a key feature of earlier American conspiracy films, which belong to a decidedly individualistic paradigm. As he points out, "The conspiracy wins, if it does (as in *The Parallax View*), not because it has some special form of 'power' that the victims lack, but simply because it is collective and the victims, taken one by one in their isolation, are not."[13] *Syriana*, even with its multiple perspectives, depicts human interactions that are distributed and fragmentary, rather than collective. Indeed, the network of American global capital "wins," if we can even make this judgment from the structural tragedy that frames the film's narrative (if not, as we will see, its affective atmospheres), only because it achieves a collective coordination that its victims cannot muster.

As Bordwell, María del Mar Azcona, and other critics have observed, a major point of departure of the network film from earlier genres is "its emphasis on random chance and chaos" and on "accidental events."[14] Admittedly, accidents are not lacking in earlier conspiracy films and are argu-

ably even central to their narrative constructions.[15] Take, for instance, Brian De Palma's *Blow Out* (1981), in which the word "accident" is used more than twenty times. In this film, the sound technician Jack Terry (John Travolta) witnesses what appears to be a car accident while recording sound effects for a low-budget horror movie. The accident, it turns out from the film's omniscient narrative perspective, is not a chance event at all, but rather the intended assassination of a popular presidential candidate. The remainder of the film follows Terry's attempt to correct the mass media's and the public's mistaken categorization of the candidate's death as an "accident" by proving that it is the result of a plan constructed by an organized cabal. Even as the assassination is not random, Terry is drawn into a conspiracy through the initial contingency, indeed the accident, of having recorded audio at the location at which the crash took place. The film begins with a Terry who is detached and carefree, but the accident of his situation quickly introduces him to a corrupt political conspiracy and its corresponding disillusion. *Blow Out* is exemplary of conspiracy films that introduce their protagonists—frequently information agents such as journalists and criminal investigators—to sinister collusions through unanticipated witnessing.[16]

Seeming accidents, conspiracy films tend to suggest, are rarely in fact *accidental* and are suggestive of an underlying order if we subject them to a thorough investigation. Network films, though their narratives are similarly dependent on contingent events, seem at first to offer the opposite view. This latter approach to accident is especially evident in the subset of network films that Wendy Everett calls "fractal films," such as *Sliding Doors* (1998), *Run Lola Run* (1998), *Free Radicals* (2003), and *The Butterfly Effect* (2004). By drawing explicitly on chaos theory and complexity science, these films emphasize the "random, unstable, and unpredictable ways" in which human stories interact with each other.[17] Accidents here, whether chance encounters or unforeseeable consequences, are irreducible to any human-derived plan or conspiratorial configuration. The traffic accident in particular, as Bordwell has astutely observed, has become a recurring trope that "snugly suits degrees-of-separation storytelling."[18]

Accidents, in network films, are both a cultural response to complexity science and a convenient mechanism for representing small worlds on the big screen, but *Syriana* also emphasizes the importance of the accident as a core feature of network processes. When first introduced, the veteran CIA field agent Bob Barnes engages in a covert deal that is intended to curb illegal arms trafficking in the Middle East. In Tehran, Barnes sells a pair of

Stinger antiaircraft missiles to an Iranian arms dealer.[19] These weapons are intended to explode shortly after the transaction, assassinating the target. One of the missiles does, in fact, detonate according to plan, eliminating the dealer and his associates. However, before the successful assassination, the Iranian man completes a secondary exchange that puts the other weapon in the hands of an Egyptian who, we later learn, is a rogue Islamic cleric responsible for the coordination of anti-American attacks. Barnes's covert operation, in sum, does not go as anticipated, and a US agent accidentally supplies a terrorist network with a deadly weapon.

Without merely rehearsing the existence of a hidden order, as is characteristic of the conspiracy film, this scene complicates a conventional concept of the accident. Accident, here, is not the opposite of a well-organized conspiracy; nor is it evidence of chaos theory or complexity science. To say that the outcome of Barnes's operation is "accidental" is not to suggest either that it is wholly a matter of chance or that there is no structured relation between the CIA agent and the anti-American cleric. In a sharp analysis of modern technology, Paul Virilio offers a reformulation of the accident that helps to elucidate its role in *Syriana* and disentangles it from its conceptual ties to contingency:

> In classic Aristotelian philosophy, substance is necessary and the accident is relative and contingent. At the moment, there's an inversion: the accident is becoming necessary and substance relative and contingent. Every technology produces, provokes, programs a specific accident. For example: when they invented the railroad, what did they invent? An object that allowed you to go fast, which allowed you to progress—a vision *a la* Jules Verne, positivism, evolutionism. But at the same time they invented the railway catastrophe. The invention of the boat was the invention of shipwrecks. The invention of the steam engine and the locomotive was the invention of derailments. The invention of the highway was the invention of three hundred cars colliding in five minutes. The invention of the airplane was the invention of the plane crash.[20]

Aristotle uses the term "accident" (*sumbebekos*) to separate that which is mutable from that which is essential, namely "substance" (*ousia*).[21] For Virilio, however, modern warfare, with its defining quality of speed, demonstrates the necessity of the accident—the originating or implicit catastrophe that founds every technological system.

Syriana stages the significance of accident as an inherent quality of modern technology, political organization, and network form. The early scene

from the film shows that weapons theft and proliferation can be understood as inherent consequences of the production of anti-aircraft missiles. At the level of plotting, we might say that a missile introduced in the first act must explode by the finale. However, the film more profoundly underscores the accident as a fundamental method of network epistemology. Accident, in *Syriana*, is not a chaotic force that exists in opposition to orderly storytelling. Narrative does not necessarily reduce the multilinear complexity of accident to a linear sequence. Instead, narrative, with both its order and its aporias, becomes *necessary* to conceptualize an unexpected event and imbue it with significance. Accidents that erupt in the midst of a story represent interruptions that spur questions and compel an audience toward proliferating interpretations and potentials. Though the codependence of narrative and emergent accident may be more easily perceptible in what Marsha Kinder calls the reconfigurable new media form of "database cinema" (such as Chris Marker's 1999 CD-ROM *Immemory*), it is also present in network films.[22] To make sense of *Syriana*'s appropriately complex approach to accident—as both an epistemological rupture and a catalyst of change—I now turn to the film's specific examination of terrorism and build on Virilio's provocation. *Syriana*, I ultimately contend, reveals the necessity of accident through its historical exploration of how American capitalism enabled the "accident" of the so-called terrorist network.

Blowback

It is no accident that threat and terror are at the heart of *Syriana*'s approach to accident. The post-9/11 political landscape that the film sketches for the viewer is one characterized by uncertainty, fear, and looming catastrophe. This is a world enframed by a war on terror and a corresponding development of anti-American organizations in the Middle East. The film's affective intervention into this transnational struggle—a contemporary condition of perpetual and preemptive warfare—depends on multifaceted relationships between networks, terrorism, and accidents that serve as *Syriana*'s sociopolitical context. In this section, before returning to a close reading of the film, I hope to offer routes into thinking through a military-industrial-media-entertainment complex that situates network forms in the present, especially in a period of waning American hegemony.[23]

The network has been a crucial form not only to complexity science and cinematic form but also to the US military. Since the early twenty-first century, the military has sought to adapt to an era of interconnection by combining tactical theory, legal control, and the development of projects that

support the doctrine of "network-centric warfare." As outlined in numer-
ous US military documents, a network-oriented strategy depends on easier
intelligence sharing, greater command speed, self-synchronization of low-
level units, noncontiguous organization, increased integration of informa-
tion technologies, and the "demassification" of forces.[24] The critic Mike Hill
points out that, along with combat upgrades, the overarching campaign
for the "Revolution in Military Affairs" (RMA) promoted a "culturally em-
bedded soft war" that assimilated religion, biology, economics, language,
technology, and other nodes of a "total" grid of conflict.[25] A large part of the
perceived need for network warfare (or at least its retroactive justification)
has to do with the increasingly networked organization of enemies follow-
ing the Cold War. In one of their best-known aphorisms, the RAND Cor-
poration analysts John Arquilla and David F. Ronfeldt observe, "It takes a
network to defeat a network."[26] This maxim—a punchy tagline that merges
the "humanitarian" and "warfighting" aspects of the RMA—reframes en-
mity as network antagonism. As Galloway and Thacker contend, networks
have in fact been widely characterized as inimical weapons systems: "The
U.S. military classifies networks as weapons systems, mobilizing them as
they would a tank or a missile. Today, connectivity is a weapon."[27] Network
warfare, then, seeks to respond to enemies that are multinodal, distributed,
and unpredictable.[28]

Since the 1970s, the US military-industrial-media-entertainment com-
plex has gradually brought about a paradigm shift in warfare by reorienting
attention to one type of anti-American enemy in particular: the terrorist
network. As familiar as this label has become, especially following the at-
tacks of 9/11, it is worth observing that the terrorist network remains a
strange figure: fundamentally oxymoronic in its connotation of both a de-
structive force and a creative matrix of connectivity. Terrorist networks,
like all networks, are both material social assemblages and metaphorical
figures. Discursively and conceptually, the terrorist network extends the
early twentieth-century innovation of "total warfare" to the early twenty-
first century.[29] Given their distributed nature, terrorist networks make
winning or ending any defined struggle impossible. This way of thinking
enables a perpetual war against an enemy construct too formless and fluid
to defeat. As Siva Vaidhyanathan has noted, "The rhetorical value of al-
leging a 'network' at the heart of a threat to security or identity is clear:
It's impossible to tell when a war against a network is over because it can't
be seen. A network can be dispersed, distributed, encrypted, and ubiqui-
tous."[30]

The assemblage of the terrorist network suggests not merely a spatial

dimension—that is, an organization that is distributed geographically—but also a temporal one. While the "terrorist" is an identifiable and criminalized figure, the "terrorist network" names something that is ever in flux and at different temporal states of emergence. Indeed, affects of threat and terror, as Brian Massumi has observed, always arrive from the future. Terror is, for this reason, inherently "undefined" and "open-ended."[31] Even so, a network, with its sundry possible referents and changing associations, makes threat, even in its nonexistent and unobserved future state, intensely real. In other words, even as the terrorist network resists total knowledge or disassembly, it achieves an empirical status, in the present, through the affective distribution of threat. The term's affective charge fosters a variety of serious political outcomes, reinforcing a state of emergency and validating a policy of preemptive warfare.

The affectively resonant dimension of the terrorist network (the point at which, I will later suggest, *Syriana* makes its most compelling aesthetic and political intervention) is evident in the language of accident that curiously characterizes discussions of terrorist networks. Especially in the aftermath of the 9/11 terrorist attacks, pundits have frequently framed the convergence of American military interests and the rise of global terrorism as irresolvable historical accidents. Much earlier, in the midst of 1950s Cold War espionage operations, the CIA even coined a term that sought to capture the process by which American-supported guerrillas turned against the United States: "blowback." This neologism also refers more broadly to the unintended consequence of secret governmental operations. After 9/11, analyses of the global movement known as the Salafi jihad began to characterize the rise of anti-American terrorism as a quintessential example of blowback.[32]

The political scientist Mahmood Mamdani treats processes of blowback as the organizing principle of his post-9/11 history of the Cold War and the terrorism that emerged from it. Far from a sudden chance emergence that replaced the erstwhile Soviet threat, Mamdani argues, terrorism was engineered to win the Cold War. Instead of calling the phenomenon "terrorism" or even "counterinsurgency," the Pentagon originally dubbed guerrilla opposition to Soviet-supported regimes "low-intensity conflict." By translating terrorism into the realm of limited war making, the CIA signaled a strategic connection between third-world "hot" insurgencies in Southeast Asia, Africa, Central America, and the Middle East and the allegedly "cold" standoff between the United States and the Soviet Union. The CIA's strategic support of anti-Communist combatants—a process that included

arms dealing, funding, privatizing information about concrete terror tactics, forming private militias, and even supporting the publication of terror textbooks aimed at children in places such as Afghanistan and Pakistan—steadily achieved a global scope. This structural indictment, which is not a morally reductive condemnation of American foreign policy, does not insist that the CIA maliciously trained terrorists. Instead, in an effort to win the Cold War "by all means necessary," the United States privileged short-term objectives over long-term politics.[33]

Certainly the concept of blowback, however crude, already complicates the stability of the classical realist distinction between friend and enemy in the modern era by acknowledging links between American military operations and anti-American activities. At the same time, blowback tends to be organized around the unintentional or unforeseeable nature of actions taken within the military-industrial complex. On the rare occasions when American politicians or military personnel acknowledge the historical association between state and antistate terror, such a nexus hinges on a contingent language of accidents. We find this rhetoric, for example, in the work of an exemplary apologist for the historical forces that contributed to the rise of contemporary terrorist networks, the forensic psychiatrist and counterterrorism consultant Marc Sageman. In his 2004 book *Understanding Terror Networks*, Sageman vehemently objects to the notion that the United States was causally complicit with the rise of contemporary terrorism. For Sageman, it is precisely the figure of the terrorist network—what he understands as "a new type of terrorism"—that marks a separation between the CIA's earlier funding and training of guerrillas and the subsequent rise of the anti-American Salafi jihad. The local set of prototerrorist movements during the Afghanistan war in 1988, he maintains, was completely distinct from the global network that developed by 1998 with the formation of the World Islamic Front and the bombings of US embassies in Nairobi and Dar es Salaam. Given the different paradigms operating at either end of this brief period (1988–98), Sageman contends that we cannot take any direct blowback thesis seriously. In the earlier years, he maintains, the United States trained insurgents in lesser "guerrilla" tactics ("the use of assault rifles, land mines, and antiaircraft weapons") rather than in explicit "terror" tactics ("explosives, casing a target, and analysis of its vulnerability"). In conclusion, Sageman states that the CIA-trained jihadists in the 1980s "were not the same people [as] or had a different mentality" from that of the contemporary jihadists who emerged just a decade later.[34]

Rather than dismissing Sageman's argument outright, it is important to

acknowledge a certain seductiveness in its deployment of sharp historical and categorical distinctions. Nevertheless, his position does not account adequately for the precise process of change that enabled the shift from guerrilla to terror tactics, thereby neglecting the dynamic properties of networks that are supposedly characteristic of the "new" paradigm of terrorism. The rationale of Sageman's argument mirrors the broader underlying strategic logic that gave rise to terrorism and has allowed different forms of it to flourish in the early twenty-first century. In its limited ability to link only direct or short-term consequences back to preceding causes, his claim is symptomatic of the same ahistoricity that led the CIA to employ techniques of terror for instrumental gains while deliberately ignoring long-term effects. Here, the language of absolute "newness" that characterizes terrorist networks—and indeed many network forms—comes both to contain the past and to intensify the still-unrealized developments of the near future.

The language of blowback associates the rise of "a new type of terrorism" with unplanned or unanticipated consequences. However, the very fact that the advent of anti-American assemblages was so unexpected to military strategists reveals a deep-seated imperial fantasy of control that accompanied the construction of pro-American militias during the Cold War. In their goal of winning the Cold War "by all means necessary," US military strategists and policymakers failed to perceive the uncontrollable volatility of networks that enabled the gradual transformation of enemy forces. As Sageman himself declares later in his book, without acknowledging how this observation affects his prior dismissal of the relation between the terrorism of the 1980s and that of the 1990s, "Terrorist networks are not static; they evolve over time."[35] To foreground the nature of this evolution, which is central to *Syriana*'s formal specificity as a network film and critical to its affective engagement with the time-based quality of accident, I turn to one final related concept that complicates the spatial bias of network thought: emergence.

Emergence

Emergence, which became prominent in complexity science and network analysis in the 1990s, concerns the appearance of unexpectedly complex phenomena that are difficult, if not impossible, to derive from the individual components that make up a system. Complexity science has shown that emergent sums consistently exceed the constituent parts, and network

interactions, that brought them into existence. In various scientific disciplines, researchers have tracked the emergence of complex phenomena from simple parts. We see such work in biology (e.g., behaviors within ant colonies), neuroscience (e.g., decision making in neural networks), economics (e.g., large-scale changes in financial systems), and the social sciences (e.g., the dynamic properties of cities).[36] While the concept of emergence only achieved the status of an interdisciplinary paradigm in the 1990s, its usage and application have a longer history that dates back to the late nineteenth and early twentieth centuries. Before its centrality in the sciences, a version of the concept animated discussions among American pragmatists in the 1890s, British emergentist philosophers in the 1920s, Gestalt psychologists in the 1920s and 1930s, and systems theorists in the 1940s and 1950s that approached complexity in holistic terms.[37]

The turn to emergence theory in the sciences and social sciences in the late twentieth century was a powerful response to prior forms of reductionism, but it also represented a critical shift from a concern with structure and stability (prominent in the homeostatic concerns of early postwar cybernetics) to an interest in dynamics, process, and change.[38] While the study of emergence has become a central part of scientific disciplines such as biology and physics, the social sciences have been slower to take up this research trajectory. Even as Auguste Comte and Émile Durkheim both posited fledgling versions of emergentism in the nineteenth century, fields such as sociology faced long-standing difficulties in developing empirical methods and models for studying social processes. Indeed, it was not until the 1990s that computing capacities began to support complex bottom-up simulations. For the first time, in the late twentieth century, researchers could program "multiagent systems" in which thousands of units would communicate with one another and produce artificial societies to simulate emergent outcomes.[39]

The network films that grew in popularity during the 1990s, I would like to suggest, raise questions about social networks that are parallel to, if not quite interchangeable with, those confronted by the social science research that explored complexity and emergence during this same period. These films, however, take an aesthetic and affective rather than an empirical approach to social processes and network change. For instance, the audiovisual particulars of film form in *Syriana*, which I analyze in the next section, track the evolution of terrorist networks over time. The film's aesthetics are not some degraded engagement with emergence but a parallel path of exploration that, particularly in the 1990s, did not depart drastically

from scientific research in the field. As John H. Holland, the creator of genetic algorithms and a key figure in the field of complexity science, noted during this period, "Despite its ubiquity and importance, emergence is an enigmatic, recondite topic, more wondered at than analyzed."[40] Emergence in natural systems (e.g., changes in bird flocking patterns and weather systems) and human systems (e.g., shifts in language and communication) remains, even with new computing and big-data analysis capabilities, largely "enigmatic."[41] As such, it is often more accessible through speculative and aesthetic, rather than empirical, means.

Many network films give viewers access to affective experiences of network change and human consequences that scientific models can only suggest abstractly. In thinking about the precise contribution that films make to the study of network emergence, we might consider their relationship to the concept of "complexity." Complexity, in the context of film aesthetics, might be understood in two very different ways. In a passage about the structure and processes of the modern city (in this case, Manchester), Steven Johnson captures these two senses of complexity:

> There is, first, the most conventional sense of complexity as sensory overload, the city stretching the human nervous system to its very extremes, and in the process teaching it a new series of reflexes—and leading the way for a complementary series of aesthetic values which develop out like a scab around the original wound. . . . There is also the sense of complexity as a self-organizing system—more Santa Fe Institute than Frankfurt School. This sort of complexity lives up one level: it describes the system of the city itself, and not its experiential reception by the city dweller.[42]

Complexity is thus both "sensory overload" and, in a somewhat opposed sense, "a self-organizing system." Johnson marks both of these meanings but privileges the latter as the proper object of scientific study. It remains crucial, however, that sensory confusion and systemic fusion, disorientation and pattern, are in equal measure descriptive of the complexity that makes up human experience and understanding of any system. The emergent processes by which a human network changes and reconfigures depends on a similar coexistence of oppositions—the appearance of new relations that could not be predicted from constitutive parts, alongside a controlled transformation enabled by the self-organizing properties of systems. While a complex network depends on a variety of patterns, an individual's experience of such a system is often chaotic or grounded in sensory experience that cannot easily be processed on a conscious level.

As Johnson acknowledges, however, any experience of complexity, whether it be a walk through a bustling industrial urban space or an engagement with the stock market, rarely ends in mere sensory overload. Such an experience yields "a new series of reflexes" and produces "aesthetic values which develop out like a scab around the original wound." A scab, to extend Johnson's metaphor even further, is a sign of healing. At the same time, in the process of healing, a scab often produces a lasting mark, a scar. In the case of complex systems, disorientation does not merely, after a time, abate and enable a sense of certainty. If systems were static structures, regaining one's orientation might, however gradually, be possible. However, as complexity science has demonstrated, systems (including social networks) are characterized by perpetual change.

Returning to the historical development of terrorism, by means of the concept of emergence that I have been discussing, it becomes impossible to think of Cold War operations as unrelated to the formation of present-day enemies. Moreover, emergence complicates the causal chronology implied by "blowback" in favor of multidimensional change, which is neither perfectly linear nor wholly discontinuous but something else altogether—distributed. Analyses such as Sageman's, which describe terrorist networks in topological terms, are insightful insofar as they render the synchronic structures of these organizations. They suggest very little, however, about the precise way in which sanctioned forms of violence (e.g., state terror or capitalist-enabled war making) might, over time, be related to criminalized forms of violence (e.g., "terrorist" attacks). The cycles of death and the traumatic entanglement that have fueled the war on terror and its extensions have neither a single origin nor a set teleology. Rather than being unrelated to US foreign policy or, inversely, a direct consequence of it, terrorist networks are symptoms of the transnational violence supported by American-style capitalism. Even though Sageman is right that US support of al-Qaeda and other similar groups may have been indirect, his point represents an insufficient defense of American Cold War policies. After all, historical effects are *always* indirect, circuitous, and to a large degree unpredictable. Global linkages are never controllable assets of a sovereign system. The concept of a network may imply relations rationalized, but not all of its potential interconnections can be accounted for. In fact, the study of networks reveals that it is precisely the unforeseeable consequences, built-in accidents, and nonsovereign possibilities of any action for which individual actors must take responsibility.

Network films attempt to make sense of this kind of unanticipated his-

torical change. In a sense, they operate as dynamic models, but that does not mean that they seek to reproduce networks through cinematic techniques or to make them cognitively explicable in the way that computer-based models might. Even so, like all models, network films generate new connections and form bridges among different ontological and epistemological scales. One advantage of such films as models is the way they use moving images to enable audiences to think of complex networks as emergent and temporally bound phenomena. This formal property stands in distinction to the spatial bias of network science. The graph theory on which this field is based demonstrates, as Galloway and Thacker note, a "diachronic blindness" that "works against an understanding of networks as sets of relations existing in time."[43] Networks in their flexibility, extensibility, and expansion cannot be understood without a language of emergence—a form of change that departs from cause and effect and seeks to capture complex interactions among interlinked actors in dynamic systems. To show how cinema enables an encounter with network emergence, the remainder of this chapter turns to *Syriana* and argues that it foregrounds specific affective engagements with terrorist networks.

Syriana's Emergent Network Aesthetics

In *Syriana*, speed becomes palpable through frequent camera movements, quickly paced dialogue, and rapid montage.[44] Brief shot lengths push the viewer through an impressively economical plot that nonetheless resists the narrative redundancy characteristic of classical Hollywood cinema. Early on, the film challenges the viewer's processing capacity with fast cuts across its sizable cast and diversity of geographical locations. On the one hand, this spatial scope and forward velocity conform to conventions of the political thriller with its figuration of a global world.[45] On the other hand, *Syriana* challenges the characteristics of this genre by denying viewers the anticipated knowledge of imminent disaster that, as Alfred Hitchcock famously noted, differentiates accumulated suspense from outright surprise.[46] The stolen Stinger missile, it is true, produces narrative suspense. But through its weaving together of several other plotlines, *Syriana* also forces a more strained and active mode of meaning making. In other words, it suggests a planetary network but cuts away before a first-time viewer can properly assimilate the available information, let alone compose something like a stable map.

Confusion is a key aspect of *Syriana*'s aesthetic and has much to do with

the experience of "complexity" that so many critics have mentioned in their reviews of the film. Notably, though, the effect of this confusion departs from a particularly postmodern mode of disorientation. As Jameson observes in his reading of David Cronenberg's conspiracy-laden film *Videodrome* (1983), known for its confusing developments, "The Philip K. Dick–like reality-loops and hallucinatory after-effects are so complex as to relieve the viewer of any further narrative responsibility."[47] Incomprehension in *Syriana* offers no comparable relief. Like older conspiracy films, it marks a world system that can no longer be apprehended by the individual or even a constellation of individuals. The viewer experiences a perpetual lag. Instead of signaling a retreat from historical thinking or responsibility, however, the film uses the spread of characters, events, and connections to stage the conditions of potential emergence and to prompt an engagement with its historical present. The film's numerous confusions — the technological capacity to move quickly between cities around the globe, the elliptical language of Washington lawyers and politicians, the multimillion-dollar corporate mergers with details and consequences that remain obscure even to the major players — not only make up the fabric of the early twenty-first century world but also make accidents probable, likely, even necessary.

Accidents throughout the film are at once essential preconditions for its velocity and interruptions of that speed. Unexpected events both set into motion additional accelerations and slow things down by producing cathexis points that invite numerous potential affective and political investments. There is, of course, the original rupture of the misplaced Stinger missile, which bookends the film's narrative. But there are many others. Some accidents are sudden, like the tragic drowning death of Bryan Woodman's son in the emir's Marbella swimming pool during a private party (paired with the more auspicious accident of Woodman's survival when he jumps in to save his son just a second after the power is cut, narrowly avoiding electrocution). This unexpected event yields a complex of affects and effects: shock at the young boy's death, guilt about parental insistence on the value of the boy's autonomy that left him unsupervised, mourning that puts distance between Bryan and his wife Julie, sympathy that leads Prince Nasir Al-Subaai (Alexander Siddig) to offer Bryan a $75 million oil-interest contract and then to appoint him his economic adviser, and so on.[48] Other accidents unfold over a string of contingencies and choices that yield consequences that exceed the sum of their parts. This is certainly the case with the Pakistani immigrant Wasim Khan's path to terrorism — from unemploy-

ment to violent mistreatment by immigration officials to enrollment in an Islamic school to training for a role as a suicide bomber. Challenging the straightforward causality of this sequence, the film offers only fragmented scenes from Wasim's life without externalizing most of the boy's motivations.

The breaks that are marked and afforded by *Syriana*'s accidents are critical to the film's aesthetic. The role of breaks in a network film may seem counterintuitive insofar as networks, in general, are characterized primarily through their connections. In her reading of the film, Azcona emphasizes precisely these kinds of continuous links by describing *Syriana*'s cinematic style via Bordwell's concept of "intensified continuity": a term that describes a major shift in filmic practices after about 1960 that most noticeably includes a significant reduction of average shot length.[49] As Azcona notes, "The information-packed narrative flow of *Syriana* never gives spectators a break." Through *Syriana*'s continuous and relentless delivery—its accelerated stream of images—plots merge and thematic clusters emerge to suggest that "everything is interconnected." Alongside such continuity, however, the film's quick cuts highlight a fragmentation that underlies linkage, especially in the fractured processes that make up American capitalism—the holes that are no longer visible in the gestalt whole of globalization. The film stresses, again and again, that a break can be both an interruption and a pause, a cut and a scattering point.[50] The film's accidents demonstrate both of these qualities. The drowning of Bryan Woodman's son is, on the one hand, a sudden rupture that nonetheless fits Hollywood conventions of continuity editing. On the other hand, the event suggests a necessary pause on the viewer's part, a recalibration of the narrative that preceded it. The film's flow of images rarely slows down enough to enable sustained reflection, especially during an initial viewing. Even so, such moments suggest multiple trails of affective intensities.

Intensity, in Bordwell's usage, involves a sense of heightened anticipation that characterizes suspense in a great deal of contemporary cinema. In *Syriana*, however, intensity more closely resembles Brian Massumi's characterization of it as "the incipience of mutually exclusive pathways of action and expression, all but one of which will be inhibited, prevented from actualizing themselves completely."[51] A relatively minor scene early in *Syriana* illustrates this other form of intensity. In an ordinary moment, Bob Barnes has lunch with his son at a Mexican restaurant in Princeton, New Jersey. The intimate conversation between the two characters begins as a shaky moving camera tracks a seemingly unrelated scene: food prepara-

tion and the transportation of what turns out to be their recently prepared meal from a restaurant's frenzied kitchen to their table.[52] In this moment of audiovisual disjunction, the shot of two Mexican cooks and a waitress is juxtaposed with the audio of a private conversation. Before the image and audio tracks eventually synchronize when the food reaches the table, the initial dialogue between Barnes and his son grabs the attention of an audience that is still seeking to follow the narrative. Regardless of the audience's focus, a great deal is easily missed. The scene's intensity comes not from suspense but from an "incipience" of "mutually exclusive pathways," only one of which is ultimately actualized within the film's linear format. This scene is arguably marginal to the primary narrative. Nevertheless, it is thematically indispensable in its demonstration of the interdependence between world-historical and quotidian events, and between global production and ordinary American consumption. In this scene, it is as if a viewer must choose among dimensions of the event and yet, given their constitutional entanglement, cannot possibly unravel them, especially in real time. There is no manifest narrative connection between the Mexican waitress and the American father and son. Instead, the scene animates a connective desire that is frustrated by the temporality of the global in its relentless simultaneity and speed. The film does not frame this ordinary first-world experience through explicit critique, but rather invites viewers to encounter and observe it.

Syriana's network aesthetics are evident in its minor scenes but also, as I have already suggested, in its sustained exploration of the emergent qualities of perpetual warfare enabled by terrorist networks. The film's treatment of war is curiously unlike the many post-9/11 productions that elaborate upon or intensify the war on terror. *Syriana* is, we might say, a war film without a war.[53] Though the film focuses on CIA operations in the Middle East and attends to the military-industrial-media-entertainment complex, it depicts neither minor skirmishes nor epic battles. For the most part, warfare in *Syriana* operates as a permanent condition of transnational capitalism, figured specifically through American oil interests. Unlike films about conventional wars (*Patton*; *Saving Private Ryan*), asymmetrical guerrilla struggles (*Platoon*; *Apocalypse Now*), or urban warfare (*The Battle of Algiers*; *The Hurt Locker*), *Syriana* explores perpetual violence: an emergent atmosphere of terror that follows from early twentieth-century "total war" and the mid-to-late-century "cold war."[54] Michael Hardt and Antonio Negri refer precisely to this historical mode of warfare when they describe the "seemingly permanent state of conflict across the world." This contem-

porary "civil war" takes place "not within the national space, since that is no longer the effective unit of sovereignty, but across the global terrain."[55] This permanent conflict serves the goals of preserving existing geopolitical hierarchies, prolonging a system of US dominance in the midst of what Giovanni Arrighi has called its "terminal crisis," and regulating social life through interventions into areas such as economics, religion, and culture.[56] Thus the figure of the terrorist network adds a temporal aspect to the earlier "spatial dimension of Total War."[57]

While *Syriana* explores different facets of transnational networks, its most resonant thread concerns the emergence of political terror. Through a series of formal and narrative concatenations, the film distinguishes between terrorist networks, as externalized enemies, and the broader yet no less terrifying networks of late capitalism. This distinction becomes evident in the juxtaposition of two crucial scenes at the film's climax, during which several of the stories, characters, and themes converge. Both scenes feature explosions that serve as counterparts of the detonation that takes place during the CIA operation in the film's opening sequence. These explosions imbue the film with a structural synthesis and linkage among narratives; they also, in a more literal but no less important sense, mark violent geopolitical and affective ruptures within the present.

In the first sequence, the CIA assassinates Prince Nasir, whose defiance of US economic interests has transformed him officially into a "terrorist." As the scene begins, Barnes, who has grown increasingly disillusioned with CIA activities, stalls Nasir's caravan and rushes to warn him of the attempt on his life.[58] Despite his tenacity, he cannot prevent the coming destruction. Using a precision-guided missile fired from a distant drone vehicle, the CIA succeeds in eliminating Nasir. Yet before Barnes and Nasir are both obliterated in the explosion, they share an instant of fleeting, partial awareness. They have crossed paths once before, meeting accidentally in an elevator when Barnes was operating as an undercover agent involved in orchestrating Nasir's downfall, but in this final encounter, Barnes has had a change of heart (fig. 2.1). Postponing the moment of death, shot-reverse-shot editing depicts the men looking uncertainly at each other. Before the missile hits, Nasir does not have time to convey anything but the memory of meeting Barnes under the agent's false identity: "You're the Canadian."

This scene could be read as a moment of reflective alliance, but it more properly conveys the profound dimness with which all global actors, regardless of their access to privileged political information, encounter the vast network of relations through which their lives unfold. With only this

2.1. Accidental meeting between Bob Barnes (George Clooney) and Prince Nasir Al-Subaai (Alexander Siddig) in an elevator in *Syriana* (Participant Media, 2005).

single line of dialogue—in the midst of an action-oriented sequence conveyed through rapid montage and considerable camera movement—a wide range of potential affects is suggested but never actualized. The series of shots opens up intensities that exceed any meaning inherent in their sequencing. The facing encounter between Nasir and Barnes, in other words, represents a break from the economic narrativization and continuity that remain the film's dominant mode. The viewer dwells, though only for a moment, in a complex atmosphere in which Nasir and Barnes affect each other. It is unclear what impressions or memories, aside from distant recognition, are exchanged in this instant. The viewer cannot be sure what combinations of embarrassment, regret, guilt, surprise, curiosity, understanding, association, hostility, desperation, and uncertainty pass between these men in a relational and emergent process that exceeds their respective positions as narrative figures. Instead of the tactics and strategy featured elsewhere in the film, which are often explained belatedly, here we inhabit a virtual space that can never be actualized into liberal consensus—or anything else. This brief pause makes the economic, political, and military networks suggested by the film feel simultaneously too vast (in their geopolitical and historical span) and too small (in their imperceptible affective reconfigurations) to be adequately perceived, let alone communicated, through language.[59]

If Barnes's interruption of Nasir's caravan leads to a reopened space of potentials, the missile hit that follows represents a very different type of "break." This subsequent disruption is initiated from a remote location at which a CIA director commands a group of agents, who sit at screens with joysticks in hand, as if playing a videogame, to "take the target out."[60]

2.2. CIA agent about to "take the target out" during the assassination of Prince Nasir in *Syriana* (Participant Media, 2005).

2.3. The CIA's God's-eye-view during the assassination of Prince Nasir in *Syriana* (Participant Media, 2005).

Through crosscutting, the scene juxtaposes the more intimate, uncertain ground view with the CIA's satellite-enabled God's-eye view, which instrumentalizes the picturesque desert terrain below and achieves distance through technology (figs. 2.2, 2.3).[61] The difference between air and ground perspectives is most powerfully registered through the film's audio. Even as the first half of the booming blast is heard on the ground, the instant cut to the tightly controlled and darkly lit CIA control room (never framed in a long shot) reveals an absolute silence in which the kill is confirmed only via abstract satellite visualization. Through a single integrated view — a militarized "global picture" — all of the world's space becomes subject to destruction. An event that is deafening and horrific on the ground is experienced as a silent series of remote calculations. With its weaponized network and its optical interface, the military apparatus reveals its status as both "big

brother" and, in Thomas Barnett's early twenty-first-century realpolitik term, "system administrator."[62] In converting the entire Earth into an observable terrain, the military combines aerial reconnaissance with a representational fantasy of network totality. The CIA merges a pretension to scopophilic omniscience with military omnipotence, treating the entire planet as a comprehensible and thus conquerable site in which nothing is too vast or too small to fall outside of its operational parameters.

In an incisive reading of this scene from *Syriana*, Caren Kaplan criticizes the film for supporting the military fantasy that an American missile is capable of absolute lethal precision: that is, of hitting anyone, anywhere in the world.[63] As Kaplan explains, one problem with the representation of the perfectly accurate tactical missile strike that hits Nasir is that it is "too easy to pose the orbital view as more lethal and less humane than the grounded or located scale of the naked gaze."[64] As many Hollywood films demonstrate, marine snipers and hand-to-hand combat can be as deadly as precision-guided munitions. High-tech arms are reserved primarily for covert operations and occasional international wars. But not all contemporary conflicts involve official combatants.

Despite the reproduction of the orbital view that Kaplan persuasively analyzes, *Syriana* does complicate the idea of global military vision. When read in conjunction with the scene that immediately follows the CIA-orchestrated assassination, the film's climax calls into question American hegemonic pretensions of global presence and invincibility. The hubristic technophilia of the first scene cedes here to the less sovereign, but no less determined, precarity of the second. The film transitions from the bombing sequence to a small fishing boat occupied by Wasim, the young Pakistani migrant worker turned terrorist, and his close friend. Steering the boat toward a Connex-Killen oil tanker, the two boys execute a suicide attack using a shaped-charge explosive that was stolen from CIA agent Barnes's Stinger missile in Tehran earlier in the film. As soon as the boat reaches the oil tanker, the screen fades to white, offering neither image nor audio to capture what promises to be a powerful impact. The final words of the film come, in Arabic, from an ideological video of Wasim that was shot before his death. His funeral instructions begin with the following request: "During the funeral I want everyone to be quiet and I should be lying on my side." This posthumous call for silence, which the film itself respects at a formal level through a soundless representation of the boy's act of suicide bombing, serves as a haunting counterpart to the hush in the CIA control room following Nasir's assassination. While these forms of silence are radi-

cally different, spanning distinct distances and modes of violence, they are connected through the film's form, which emphasizes not causation but linkage that preserves, rather than resolves, the paradoxes of a transnational political system.

Instead of serving merely as another depiction of perfect precision bombing—an extension of the technological fantasy of bloodless conflicts modeled after the 1991 Gulf War—*Syriana*'s juxtaposition of absolute military accuracy with an equally successful guerrilla attack produces a moment of critical tension. Despite its presumed dominance of global space and the electromagnetic spectrum, the American military machine, we are reminded, remains vulnerable to disruptions by suicide bomber attacks such as the 2000 attack on the USS *Cole* in Yemen that closely resembles Wasim's attack in the film. Subject to the unjust laws of transnational capitalism, forced into poverty, and unaccounted for by US power spread thin by its interest in broader world-historical stakes, Wasim slips under the radar. Like the concentration camp prisoner, the refugee, and the Somali pirate, the suicide bomber becomes a figure abandoned and then hunted by the state.[65] The very state-induced hopelessness of his existence commits Wasim to a suicidal act against the global conglomerate of Connex-Killen. The climax demonstrates that while military optics may presume to convert everything into a target, the system that supports American power produces its own blind spots. This myopia is the result not simply of accumulated intelligence failures but of network relations and a structural incapacity for total knowledge. Barnes and Nasir may share an affective atmosphere for just a moment, before the CIA interruption, but Wasim is affected by the world around him for a much longer duration. He suffers persistent nonbelonging through job loss, the failure to support his family financially, and a loss of dignity when he and his father are beaten by guards in an immigration queue, before he finally seizes his desperate need to affect the world, violently, in turn.[66]

If the plotline that follows Wasim throughout *Syriana* concerns the formation of terrorist networks, then the film as a whole offers a glimpse of a system of internecine violence that operates through interplay among economic, legal, military, and political actors. For Sageman and some military analysts, it is notable that terrorists organize in networks; it is also important to highlight the constantly changing networks of capital, armaments, and strategic interests that produce the conditions that support networked antagonisms. As *Syriana* brilliantly demonstrates, sovereign force and terrorist counterforce are not Manichean opposites. They are codependent

terms that participate in the same vicious cycle, the same inertial trajectory, and the same networks of terror. As the name of the oil conglomerate Connex-Killen suggests—linking together such signifiers as "Conoco," "Exxon," and "clean," and metaphorically merging "connection" with "killing"—networks and terror become entangled.

The activities masked by a vocabulary of generative "interconnection" and corporate "synergy" in the film depend on various forms of disconnection. The linkage between military and corporate operations is not simply parallel but historically and materially entwined. As David Graeber has observed, it could be argued that the fact that the US military "can, at will, drop bombs, with only a few hours' notice, at absolutely any point on the surface of the planet" is a power that "holds the entire world monetary system, organized around the dollar, together."[67] The widespread terror enabled by this unmatched bombing capacity, then, does not somehow misfire, through blowback, in a way that inadvertently fuels anti-American terrorism. The "accident" of terrorism is instead, from the start, built into the very relations reinforced through those contagious and uncontrollable affects of terror that constitute its web.

Syriana shifts the viewer's attention from terrorist networks to the asymmetrical networks of poverty from which these enemies of the state emerge. In an analysis of the American RMA, Ashley Dawson offers a critique along these same lines: "Once again, then, the military is turning to a series of technological fixes for the intractable social problems generated by the spiraling inequalities of the neoliberal world order."[68] While network warfare privileges tactics and strategy, it is in fact logistics—the uneven distribution of global resources—that produce despair and incite "terrorism." Exploring these logistics, *Syriana* focuses on the oil economy as a major source of job loss, underdevelopment, and violence. Despite the incredible importance of oil as a global resource, the film does not settle for the neat causal logic that underlies the popular "Blood for Oil" argument. *Syriana* admittedly begins and ends by demonstrating that the basis of capitalism's creative destruction can be found in an oscillation between oil interests and the armaments industry. However, the film treats oil as only one significant hub in a worldwide US-dominated matrix of terror that is sustained by numerous individual nodes, including the energy analyst Bryan Woodman and the derivatives trading company for which he works, the attorney Bennett Holiday and his corrupt law firm, and Barnes and the bureaucracy-ridden CIA.[69]

Syriana dwells in the complexity of a network of place, race, politics,

economics, and ethics, but the ending of the film registers some ambiva-
lence by flirting with a conservative return to the family. After an estrange-
ment from his wife and son as well as the death of his client Prince Nasir,
Woodman reunites with his family. Similarly, Holiday returns from work,
discovers his estranged father slumped over on the front stoop, and leads
him into his home. Even the recently deceased Barnes is shown, one last
time, in two pleasant photographs: one with a friend and one with a group
of coworkers. Instead of the deadly network tracked throughout the film,
the viewer is left with a call to return to a simpler mode of organization
based on kinship. At the same time, the formal copresence inherent in
this final sequence complicates these images. In this concluding montage,
scenes of functioning families are juxtaposed with the audio from Wasim's
final video in which he announces, "The next world is the true life." This
otherworldly voice suggests that instead of serving as a safe alternative to
networks of terror, Western kinship and community structures remain
bound, in an ironic relation, to the Pakistani boy's appeal to a different logic
of martyrdom. The illusory comfort of momentary disengagement from
geopolitical affairs allotted to Woodman and Holiday (though not Barnes,
who is himself sacrificed by the CIA, a victim of the "accident" of collateral
damage) coexists in an irresolvable tension with the poverty and death of
which Wasim's disembodied voice serves as a reminder. Since Wasim's sac-
rifice is spurred by a deep concern for his own family's financial survival
and a disciple's fidelity to the Muslim cleric who trains him for the attack,
this final montage can be read as a reminder that, in an unjust world, not all
families are allotted equally happy endings. Even so, the film juxtaposes the
family and the network as parallel but not entirely compatible structures.

Syriana demonstrates how aesthetic techniques serve as an indispens-
able tool for reflecting upon, dwelling in, and perhaps moving beyond the
numerous paradoxes that characterize the contemporary network imag-
inary, especially as it manifests in the figure of the terrorist network. As
the network scientist Albert-László Barabási suggests, "If we ever want to
win the war [on terror], our only hope is to tackle the underlying social,
economic, and political roots that fuel the network's growth."[70] Instead of
hanging on to the residual Cold War view of terrorist organizations as hos-
tile structures that must be defeated or eradicated, we are perhaps better
served by working through the processes of historical emergence of which
networks make us aware. *Syriana* approaches this difficult task in a variety
of ways, through narrative and formal attributes, but perhaps most of all,
as I contend in the conclusion, through the affective breaks that it affords.

2.4. Migrant workers waiting for a bus in *Syriana* (Participant Media, 2005).

Conclusion: "The next world is the true life"

The prologue to *Syriana* begins with a shot of a desert in the early moments of the sunrise. This desolate landscape, tinted blue in the early morning light, looks like another world. The camera cuts to a crowd of ordinary workers, visible only through a haze, waiting for a bus. When the transport arrives, these migrant workers shove each other to get on board and compete for the possibility of a day's work. We see their dirty shoes and worn tools. A few of the men stop to look directly at the camera as it pans across their faces (fig. 2.4). For all of its narrative focus on oil interests and global capital, *Syriana* maintains a tension and a possibility that it is about these workers, these peripheral by-products of a global system. "Capitalism cannot exist without waste," observes a smirking Reza Barhani, the middleman who brokers a meeting between the Washington lawyer Dean Whiting and Prince Meshal. The human waste of capitalism includes Wasim, a migrant worker who, in Judith Butler's terms, might count neither as "a livable life" nor, after his self-sacrifice, as "a grievable death."[71] Wasim's undead perspective—one that develops through the dehumanizing indignities he suffers—raises numerous questions about the possibilities of change, of emergence, of another world.

Neither the global sublime of late capitalism represented by Connex-Killen nor Wasim's transcendent belief in "the next world" as "the true life" offers a way out of the differently valenced kinds of terror that *Syriana* depicts. The double loss that concludes the film, however, is not a nihilistic statement about the inevitability of systems or the inescapability of violence. These final moments deploy something like what Dominic Fox has termed an "aesthetic of dejection" and a politics of "dysphoria." Fox

suggests that dejection has the capacity to make other orders visible. When the world is "disenchanted," he writes, it "is revealed as 'a' world, a world among possible worlds." From the perspective of despair, "not only is another world possible, but the present world is *impossible*."[72] The desolation of *Syriana* shows that the neoimperial wasteland—the particular world of neoliberalism and globalization—is unsustainable in the long term.

While the CIA missile blocks the capacity of either Barnes or Nasir to continue the process that their mutual facing might have initiated, those pathways remain open to the film's viewers. In response to the terror network of transnational capitalism that undermines belonging, potential, relation, and processes of mutual becoming, *Syriana* reintroduces these terms through its sense of emergence. If capitalism has become, as Graeber observes, "a vast bureaucratic apparatus for the creation and maintenance of hopelessness, a giant machine designed, first and foremost, to destroy any sense of possible alternative futures," then network cinema occasionally offers other worlds through its aesthetics.[73] *Syriana* poses a direct challenge to the wholly quantifiable reality implied by the precision-guided missile. The American military and intelligence community's compulsion for sovereign control breaks down under the weight of the film's accumulation of links through countless moments of affective uncertainty and unanticipated accident.

Conspiracy films suggest that apparent accidents are rarely accidental, but they still employ so-called accidents as surface-level signs of centrally planned cabals that must be discovered by tenacious investigators. Network films, on the contrary, treat accidents only as signs of themselves. Commenting on the role of accidents and coincidences in network films, Bordwell contends, "Unlike coincidences in real life, movie coincidences create 'small worlds' in which characters will intersect again and again, especially if the duration and locale of the action are well circumscribed."[74] Contrary to Bordwell, I would argue that for all of their apparent artifice and conventions, network films do in fact strive to capture a mode of "real life," a kind of network realism on which I focus in the next chapter. Though accidents and emergences may produce unanticipated ripples and compel responses, they are, in a world primed to networks, in no way extraordinary or anomalous. They are neither contingencies nor signs of conspiracy but ordinary features of everyday life. The assumption that accidents are unlikely to happen depends on a privileged worldview in which an experience (or, more accurately, a fantasy) of control is the norm—something that is unavailable, for instance, to the migrant workers in *Syriana*'s pro-

logue and indeed to the vast majority of the world. The intensity of network films has much to do with making viewers affectively aware of the ubiquity and everydayness of nonsovereign experience in an interconnected world. Accident in this world, we might say, is both imminent and immanent. In its aesthetic form, accident also serves as an opening: a realization of other potentials and unexplored forms of refusal.

Syriana leaves no room for a form of hope predicated on optimism. The film's paramount accomplishment, one that is profoundly epistemological and pedagogic, is the way that it uses its cinematic techniques to foster an ambivalent presence and patience in the audience. The bodily engagement that it elicits (through images, audio, movement, and editing) encourages an affirmation of the present. Another world emerges from the film's systemic tragedy, but it is not a "next" world that arrives from some distant horizon. It is instead an immanent world present in the relations, the sensations, the maneuvers animated in *Syriana* itself and the range of potential reactions to the film—conflicting affects of empathy and rage, guilt and disavowal, agency and powerlessness, connection and disconnection. The hope generated by these experiences is not located in the projection of future success. Instead, the film promotes, to use Massumi's term, an "aesthetic politics" that seeks to "expand the range of affective potential" in our own time.[75] Expanding that potential involves rethinking the network of relations that seem to comprise the contemporary world—a process that necessarily involves taking a step back and posing the fundamental question of what constitutes a "world."

In criticizing American neoliberalism and militarism, it is too easy, in turn, to defend or romanticize violent acts perpetrated by anti-American actors—as if this form of opposition were the only alternative to the present system. While acts of terrorism are a form of violence different from state terror, the two are related, belonging to a shared political, economic, and social network. In *Syriana*, Wasim's attack, for all of the complex desire that it suggests, is not triumphant or hopeful. It does not, even through the film's parallelism and implied simultaneity, avenge or redeem the CIA's murder of Prince Nasir. Rather than bringing the clash full circle, this act only accelerates the spin of a vicious death cycle. The film, then, does not simply imply that the present situation needs to change. As the feedback loops of emergence teach us, even the very process of "changing changes."[76] Even the conditions and terms of relation—their rhythms and patterns—mutate. Attending to affect increases sensitivity to such constitutive change.

The networks that make up the worlds of transnational capitalism can-

not be understood without the tragedies of the impoverished worker and the suicide bomber. More than the modern romance or imperial adventure tale, the tragic mode (to which I return in my reading of *The Wire* in the next chapter) has the capacity to explore the underlying structures of early twenty-first-century systems and institutions. The tragic highlights systemic disconnections, but it also suggests that new links can be established on the grounds of loss. As Fred Moten observes, a tragic-elegiac mode can introduce "a generative break, one wherein action becomes possible, one in which it is our duty to linger." Such a discontinuity invites improvisation and novelty. Breakdown yields not hopeless expiration but "a lyrical surplus."[77] In other words, violent loss may incite mourning, which replaces a sense of sovereignty with shared affects, vulnerabilities, and interdependencies.[78]

Network films, even those with comparatively conservative orientations, reveal that an individual has access to only a very limited perspective on the broader world that she inhabits, especially at the most macroscopic and microscopic scales. Nevertheless, lower and higher-level aspects of complex systems have mutually animating effects. Component parts affect their emergent sums just as mutating wholes alter the elements that compose them. Any transformation of the present, then, depends on a realization (both in the sense of an *understanding*, however limited, and of a corresponding *fulfillment*) of our inherent connectedness to others, including the difficulties and complications that come with such bonds. As any engagement with affect reminds us, thought alone cannot generate a deep sense of interdependence that might transform the way we live. Then again, nothing alone determines a life or a world. Everything connects, at least for a time, to something else. Webs of linkage, fields of affective possibility, enable precisely such emergences, which sometimes surpass the expectations of the historical present and its inevitably limited horizons of thought. The network aesthetics of films such as *Syriana* contribute to the generation of another world—not a transcendent "next world" but a world that is messy, uncertain, heavily linked, and perhaps even realizable now, in this life.

– 3 –

Realist Aesthetics:
Televisual Networks

Networks usurp reality.

Lars Bang Larsen (*Networks*)

Read between the lines.

The Wire **season 5 tagline**

Televisual narratives have experimented for several decades with the mul-
tiprotagonist structures and complex plotting that were broadly adopted in
cinema only in the network films of the 1990s and 2000s.[1] In the 1950s, soap
operas with large ensemble casts, such as *Search for Tomorrow* (1951–86)
and *As the World Turns* (1956–2010), began to complicate a more common
televisual episodic form with a serial structure that had already proven suc-
cessful in earlier contexts, including nineteenth-century novels and early
twentieth-century comics and radio dramas. Even with the popularity of
daytime soaps, and evening outliers such as *Peyton Place* (1964–69), long-
arc narrative form did not break through into primetime American televi-
sion until the 1980s with shows such as *Dallas* (1978–91), *Knots Landing*
(1979–93), and *Dynasty* (1981–89). As Jane Feuer points out, the category
of "art television," including narratively innovative series, emerged con-
currently, with programs such as *Hill Street Blues* (1981–87), *Moonlighting*
(1985–89), and *thirtysomething* (1987–91).[2] Even so, formal experiments
with seriality were not commonplace until the 1990s, when they shaped a
number of shows, across genres, which included *Seinfeld* (1989–98), *Twin
Peaks* (1990–91), *The X-Files* (1993–2002), and *The Sopranos* (1999–2007).

As the television scholar Jason Mittell explains, there was no single

causal agent or event that explains a spike in televisual narrative complexity in the 1990s. Instead, this shift was enabled by a host of factors that included the migration of successful filmmakers to television; the need for television writers to respond creatively to the competition represented by more cost-effective reality TV formats; the continued transformation of the three-network system into a panoply of specialized channels that could sustain complicated serials with smaller cult followings; the recognition of the value of high-prestige narrative programs, especially for sustaining the brands of premium cable channels; the rise of VCRs in the 1980s, DVDs in the 1990s, and video streaming in the 2000s; and the expansion of convergence culture and online fan participation in multifaceted narrative worlds.[3]

The development of narrative complexity in television serials, especially since the 1990s, has enabled the medium to engage in unique ways with what I have been calling the network imaginary. Admittedly, television shows share numerous formal properties with feature films, most evidently the fact that they are composed of edited moving images and audio. Nevertheless, differences in institutions, transmission, reception, industry practices, and available genres require a separate consideration of the ways that television has experimented with network aesthetics. Writing in the late 1960s, Marshall McLuhan and Quentin Fiore already treat television as the preeminent medium (rivaled only by computers) that puts people in touch with a collective and global life based on interconnection. "Television transformed the nature of mass media," they write, "but it also introduced a new tactility—a sense of media networks and collective relations that exceeded individual consciousness."[4] Though the broader relationship between television and a sense of networks may require additional investigation, this chapter undertakes the more modest task of exploring how early twenty-first-century serial drama grapples with key concepts and problems raised by the network imaginary. In what follows, I am especially interested in the ways that the prominence of television dramas, centrality of entertainment and communication media to everyday life, and ubiquity of network form necessitate a rethinking of the classical category of realism.

In order to elaborate television's network aesthetics and the particular realism it sets forth, it is important to consider the major formal reason that complex televisual narratives often depart from contemporary filmic narratives. Television shows such as *Lost* (2004–10), *Heroes* (2006–10), *Skins* (2007–13), and *Breaking Bad* (2008–13) have all approached social networks, and done so differently from those films (such as *Syriana*) that I discussed in the previous chapter. Despite the range of distribution mech-

anisms and viewing formats available for audiovisual media in this period, a persistent variation in the reception of film versus television has much to do with duration. While films tend to last no more than two or three hours and produce a limited number of sequels, complex television shows may run for several seasons with ten to fifteen episodes per season on premium channels and approximately twenty-four episodes per season on major network channels in the United States.[5] While multiseason television series emerged as early as the 1950s, it has only been since the late twentieth century that shows have more regularly moved from a self-contained episodic to a long-arc serial format that conveys narratives across multiple seasons. As Jeffrey Sconce notes, such extended arcs have enabled an increasingly detail-oriented form of storytelling: "What television lacks in spectacle and narrative constraints, it makes up for in depth and duration of character relations, diegetic expansion, and audience investment."[6] By oscillating between episodic and serial form, post-1990s programs not only are able more regularly to convey linearly delivered narratives but also can suggest complex communities, cities, and universes that ground social networks.

Though varied television formats (from live broadcast to DVD to on-demand Internet streaming) lead to different viewing experiences, all of the available formats have encouraged a sustained world-building that bears greater resemblance, in some respects, to contemporary interactive digital environments than to cinema.[7] As Raymond Williams already observed in the 1970s, television quickly transformed the scope of narrative reception more than any earlier medium by giving rise to a "dramatized society" that built drama "into the rhythms of everyday life." As he explains, television enables the viewing of several different types of drama a day—"And not just one day; almost every day. . . . What we now have is drama as habitual experience: more in a week, in many cases, than most human beings would previously have seen in a lifetime."[8] The ubiquity of television programming and the considerable quantity of material that makes up most serials enable a fuller examination of intricate social networks that viewers can live with and process over extended periods of time. Even more profoundly, televisual forms transform the way we experience and think about everyday reality.

The core of my analysis in this chapter focuses on a single series, *The Wire*. This show is by no means exemplary of American television. Indeed, given the incredible diversity of programming in the early twenty-first century—including news, educational programs, game shows, sitcoms, sporting events, cartoons, talk shows, and reality TV—no single series or cluster of shows could stand in for the whole. Nevertheless, *The Wire* op-

erates, in the pages that follow, as an orienting point that raises questions about both televisual and network form. My focus on a single series seeks deliberately to complicate a tendency in media studies, and sometimes television studies, to assume the explanatory value of Williams's generalized concept of television's "flow," and similar theories, while largely ignoring the medium's specific programming.⁹ Though both institutional and social analyses are crucial to television studies, we can also learn a great deal about network form, in particular, through careful engagement with televisual aesthetics and formal innovations.

The key node of *The Wire* offers insight into how dramatic television series aestheticize social networks and put forward a realism proper to them. For all of the writing about this series, ranging from sociological commentary to genre-specific analysis, very little scholarship has attended to the show's fascination with network form, including its treatment of the social networks that make up the city of Baltimore.¹⁰ *The Wire*, which ran for five seasons between 2002 and 2008 and yielded sixty approximately hour-long episodes, follows a wide-ranging assemblage of social actors who relate in a variety of both extraordinary and ordinary ways to early twenty-first-century American institutions and systems. These systems include law enforcement, the drug trade, the legal apparatus, the prison complex, the school system, segregated city zones, political parties, media outlets, and the growing mass of the homeless. My analysis concerns the ways that *The Wire*'s aesthetic makes sensible associations among its featured social actors and the networks they form. In order to highlight the many tensions of the series—between artifice and reality, experimentation and experience—I put forward and elaborate the term "network realism." This concept foregrounds the centrality of networks to a realism that resonates with the early twenty-first century. It also helps to account, in part, for the importance of network aesthetics in our time. Moreover, this concept enables a comparative media analysis that situates *The Wire*, and contemporary television drama, in a dense media ecology. "Network realism" will thus help us address the relationship between two critical terms—mediation and realism. Before exploring this concept, however, it is crucial to frame how the series fundamentally approaches social networks.

Social Networks and "Soft Eyes"

In the fourth season of *The Wire*, a major mayoral debate unfolds shortly before the Baltimore city election. The debate comes through in a series

of fragments, audio sound bites addressing Baltimore's crime epidemic and images of the three candidates—incumbent Clarence Royce, challenger Tony Gray, and the eventual underdog winner, Tommy Carcetti—campaigning on different television screens. The visual focus of this linear sequence, however, is not on the debate itself but on the massive ensemble of characters either watching or not watching this episode of political theater. To a few of Baltimore's citizens it is a central event, but to most this contest is entirely peripheral. During a series of short scenes that takes the debate as its nexus, members of the Royce and Carcetti camps scrutinize the television coverage. Meanwhile, detectives in the homicide unit watch with distant interest, listening selectively for issues that pertain to their daily criminal investigations. The ex-con Dennis "Cutty" Wise, in another vignette, notices the debate on his screen before immediately switching the channel to a football game. Even further at the edges, Namond Brice, a young aspiring drug dealer, turns off the debate as if it were televisual static and begins to play *Halo 2*, a first-person shooter videogame.[11] In this series, plotting is subordinated to the detailed mapping of Baltimore's intersecting social worlds. Rather than compressing time—a common function of cinematic montage—this sequence enlarges connections that bind together the story lines and life-worlds of vastly different, though overlapping, Baltimores.

As this complicated scene suggests, *The Wire* explores social networks by forging audiovisual and narrative links among a web of major and minor characters. This human web is arguably one of the reasons that this series has been so often celebrated and debated by social scientists. The human geographer Nigel Thrift, for instance, describes *The Wire* as "social science fiction."[12] In an extended essay on the topic, the sociologists Anmol Chaddha and William Julius Wilson observe, "*The Wire* captures the attention of social scientists concerned with a comprehensive understanding of urban inequality, poverty, and race in American cities."[13] Another sociologist, Roger Burrows, in a commentary on a ten-week curriculum that his department at the University of York organized around the show, describes *The Wire* with even greater enthusiasm as "a form of entertainment that does the job some of the social sciences have been failing to do" and that stands in "contrast to dry, dull, hugely expensive studies that people carry out on the same issues."[14] While *The Wire*'s aesthetic can be understood as participating in a type of empirical work, the series diverges, in my view, from traditional social science, as well as specific sociological applications of the series that seek to demonstrate existing concepts that organize the field.

Through its televisual form, *The Wire* consistently represents, parallels, and complicates what is called social network analysis, a method used to map assemblages of actors represented as nodes connected by links. The vocabulary of "social networks" entered the social sciences in a prevalent way in the 1960s and 1970s, a period that also saw a parallel development of complex systems theory and the emergence of world-system analysis.[15] As David Knoke and Song Yang explain, prior to the serious study of networks most social science scholarship assumed that "actors make decisions and act without regard to the behavior of other actors." Social network analysis, which achieved a considerable presence in psychology, anthropology, and sociology through the latter half of the twentieth century, demonstrated that "actors participate in social systems connecting them to other actors, whose relations comprise important influences on one another's behaviors."[16] *The Wire* mirrors this core insight of social network analysis, albeit through aesthetic means, by representing distributed associations among social actors instead of focusing on a single protagonist.[17]

The claim of social network analysis to examine how "actors participate in social systems" arguably raises more questions than it answers, especially regarding so-called social systems. Even as this method incorporates new quantitative techniques, including the modeling and visualization of networks, it is important to emphasize that it shares some conceptual assumptions with earlier theoretical paradigms, particularly structuralism. At the foundation of structuralism (importantly, a self-proclaimed scientific approach) is a distinction between the "individual" and the "social" as opposed scales that represent separate starting points for analysis. Individuals, in structuralist thought, are either microcosmic instances of broader and preexisting structures or else actors that are influenced by larger systems.[18]

Not all forms of what might broadly be called social network analysis, however, posit hidden social forces that individual actors inhabit or negotiate. The approach that perhaps deviates most significantly from a structural form of social network analysis, while still maintaining an emphasis on associations among actors, is actor-network theory (ANT). ANT, a method developed by Bruno Latour, Michel Callon, and John Law in the 1980s, regards the "social" not as "a stabilized set of affairs" but instead as a "tracing of associations" or "a type of connection."[19] Latour calls the former approach a "sociology of the social" (a category that includes forms of social network analysis) and the latter one, adopted by ANT, a "sociology of associations." As Latour explains, ANT does not seek systemic explanation through actors that "realize potentialities" of a set social structure. Instead,

3.1. David Parenti lectures on "learning adverse" youth in *The Wire* (HBO, "Final Grades," 2006).

ANT follows actors serially across time and shows them "rendering virtualities actual" through dynamic associations. "Society," as he put it succinctly, "is the consequence of associations and not their cause."[20]

ANT resonates with the project of *The Wire*, which contains an implicit critique of what Latour calls a "sociology of the social." For example, in the fourth season of the series, the show introduces David Parenti, a professor of sociology at the University of Maryland who studies urban youth who have been identified by the legal system as repeat violent offenders. With the aid of retired police major Howard Colvin, Parenti observes the complex interactions of the eighth-grade students at Edward Tilghman Middle School and, at the end of the study, compiles an academic presentation (complete with a network graph) about "learning adverse" students (fig. 3.1). Although Parenti presumably incorporates social network analysis into his research, he fits the rich specificity of interactions among both human and nonhuman social actors that the season of *The Wire* itself observes into preestablished theoretical categories. Suggesting a parallel with Latour's critique, Parenti reduces the heterogeneity depicted through the fourth season's meticulous examination of Baltimore public schools into an

already-available "vocabulary of social forces" and an "all-purpose meta-language."[21]

In what follows, I do not simply apply ANT to *The Wire*—a method that could, at best, yield limited success, especially given Latour's insistence on thick description and a procedural maneuverability that mutates with any particular social atmosphere a researcher encounters. I am nonetheless interested in the ways that ANT, a sociological method, operates in relationship to an aesthetic work that uses televisual form to make sense of social networks in a US city.[22] *The Wire*, contrary to many of the academic appropriations of it, is not a mere representation of well-established social scientific tenets. The series can instead itself be read as a social scientific endeavor that complicates commonly assumed distinctions between science and aesthetics, experimentation and experience. If scientific empiricism relies fundamentally on sense experience and observation, then it is insufficient to treat *The Wire* as a literary epiphenomenon of social reality that reports, secondhand, on the findings of the empirical social sciences. More robustly than this diagnosis would suggest, the series mediates and alters experience. Indeed, as Latour reminds us, ethnographic participant observation and quantitative social network analysis both rely on relational changes between researchers and the actors they study. As a key ANT slogan has it, "There is no in-formation, only trans-formation."[23]

The blurring between science and aesthetics in *The Wire* becomes most evident in its careful tracking of associations among social actors. The sequence of the Baltimore political debate with which I began this section already points to the show's aesthetic attentiveness. The scene offers neither immersive spectacle nor episodic disjointedness. It does not unfold for the piercing cinematic gaze of the Hollywood spectator; nor does it prove comprehensible to the domestic glance of a certain distracted television viewer.[24] In *The Wire*'s own idiom, absorbing and tracing the sprawling field of associations within the contemporary American city requires "soft eyes." This critical capacity is what a veteran public school teacher suggests to Roland "Prez" Pryzbylewski when he begins working at Baltimore's chaotic Tilghman Middle School and feels incapable of reaching the students. "You need soft eyes," his more seasoned colleague tells him.[25] It is the same advice that the homicide detective Bunk Moreland later offers to Detective Kima Greggs when she arrives on her first murder scene: "You got soft eyes, you can see the whole thing. You got hard eyes, you staring at the same tree, missing the forest."[26]

Across sixty episodes, *The Wire* suggests—through both its represen-

tations and the demands it makes on viewers—that mapping something as complex as an urban network requires an attentive, painstaking way of looking, listening, and experiencing.[27] Such a task calls for flexible thought that negotiates the scales of reality articulated by its actors—the individual, the family, the neighborhood, the city, the nation, and even a transnational imaginary—without assuming any of them as a privileged vantage. Formally, the camera, in its many mediating capacities (to which I later return), reinforces *The Wire*'s imperative to take a step back and observe. Similarly, the crosscutting between narratives and a persistent resistance to explanatory redundancy embrace a network perspective that registers unexpected connections and, at other times, disorients the viewer. To grasp interconnections among people and institutions, an American city and its myriad worlds, only soft eyes will do.

The social theorists Jeff Kinkle and Alberto Toscano have observed that by representing connections between individuals and institutions, *The Wire* produces something that aspires to Fredric Jameson's aesthetic of "cognitive mapping."[28] On the one hand, *The Wire* does indeed produce, in Jameson's terms, a "mental map" that links an "individual" to a "social and global totality."[29] The Major Crimes Unit even represents the changing Barksdale drug organization on a bulletin board filled with a webbed cartography of surveillance photos, suspect names, and crisscrossing lines of financial relationships among the known players (fig. 3.2). The changing Barksdale network emphasizes that police work is a prolonged process of connecting the dots and not, as is often the case in contemporary police procedurals like CBS's *CSI* or NBC's *Law & Order*, of merely solving episodic cases.

On the other hand, *The Wire* challenges the abstractions inherent in even experimental mapping practice by attending to the raw and intimate particularities of ordinary life in Baltimore. Instead of producing a stable grid of preestablished social types or a situational representation of global capitalist totality, *The Wire* explores, at most, an asymmetrical and frequently disorganized system. The series does not posit a comprehensive theory of the social, refusing the explanatory force of social categories such as class, race, or nation, even as it acknowledges that frequently its actors deploy these very classifications.[30] Numerous characters such as Omar Little—a gay black man who fearlessly rips off drug dealers, forms an alliance with the Major Crimes Unit, and lives by a code that keeps him from harming anyone outside of the drug trade—defy traditional sociological taxonomy and demand the persistence of soft eyes that never harden into

3.2. Bulletin board with network of suspects in *The Wire* (HBO, "Cleaning Up," 2002).

a disciplinary gaze. At other moments, existing mappings become impossible and characters lose their way. For example, in the first season, police become disoriented when they find that someone has moved around Baltimore street signs, as they search desperately for their undercover colleague Kima Greggs, who has been caught in the crossfire of an unanticipated shooting. In the second season, Jimmy McNulty's attentiveness to the unpredictable, difficult-to-map tides and wind currents allows him to shift the jurisdiction within which the investigation of a drifting body unfolds.[31] In the next section, then, I build on the ways that *The Wire* observes with soft eyes and forges, through this optic, what I call network realism.

Network Realism

To elaborate on *The Wire*'s aesthetic experimentation with social networks, I put forward the term "network realism." This term serves as an ideal organizing concept not despite but precisely because of the fact that both of its components—"network" and "realism"—are utterly opaque, polyvalent, and flexible in a way that parallels many of the formal techniques of *The Wire* itself. In relation to one another, the two words also animate a

tension between artifice (the concept or tool of a "network") and the real (the asymptotic aesthetic goal of realism). I posit this concept as an opening gambit or a heuristic that opens up a discussion of *The Wire*'s aesthetic method. "Network," in this usage, is not a concrete thing or an objective totality in the world that realism seeks to reproduce. It is, rather, a modifier that designates a field of intersecting actions and agencies, human and nonhuman actors, controversies and associations. If realism, as sometimes conceived, aspires to provide a reader or viewer with the most comprehensive possible experience of the world, then network realism preserves the ambition for a thicker understanding while avoiding the corresponding desire to posit reality as totality.[32]

If it is to remain a useful analytical category in our historical moment (as I believe it can), realism must have some relationship to the myriad networks that make up our world in all of their irreducible complexity. The term "network realism," however, also points to the fact that realism in the early twenty-first century cannot capture the realities of the present while evading the thickness of mediation that increasingly characterizes the everyday. Such hypermediation depends on the integration of older genres (e.g., the Greek tragedy and Victorian novel), but it also involves experimentation with new ones. Before elaborating on the importance of networks and a networked media ecology to *The Wire*, it is important first to think more generally about the mode of realism that the series suggests.

"Realism," of course, has never named a single literary or artistic movement but attaches to a broad range of styles that have sought to represent or channel versions of the real. Erich Auerbach, in his classic transhistorical study *Mimesis*, treats realism as "the interpretation of reality through literary representation or 'imitation.'" He traces realism through writers such as Stendhal and Balzac to the representation of daily life that makes up "modern realism"—a category that might now be said to encompass multimedia works from nineteenth-century realist novels to theatrical realist plays to cinematic neorealism to reality TV shows.[33] Focusing on literary works, Auerbach emphasizes that no text is somehow *more realistic* than another. It is instead the case that each era has a favored series of methods for representing everyday experience. As Peter Brooks posits, realism suggests a thirst not for "the lived, experienced reality of the everyday" but for "a reality that we can see, hold up to inspection, understand."[34]

Realism, then, is a somewhat flimsy category around which to build any analysis (one person's realism, after all, may be another's science fiction). At the same time, this category offers a way to think about how the cat-

egory of the real is figured in particular historical periods and expressed through media that are dominant at those moments.[35] *The Wire* serves as a promising candidate for this type of analysis for many reasons, including the frequency with which critical acclaim of the televisual series has celebrated its "authentic" representation of the urban realities of Baltimore in the early twenty-first century. The show's realism has been marked in a number of ways, in commentaries on its basis in ethnographic observation conducted by the show's creators, David Simon and Ed Burns, its realistic use of diegetic music and sound, its authentic and difficult-to-follow dialogue, and its casting of Baltimore locals instead of professional actors to play characters based on actual people (most notably Felicia "Snoop" Pearson). In all of these ways, *The Wire* captures something about everyday life in Baltimore.[36]

Such observations about *The Wire* are not wholly inaccurate, even if we might question aspects of the show's realism, for instance in depicting collective, bottom-up action, especially in light of later events such as the 2015 Baltimore uprising that followed Freddie Gray's death from injuries sustained during police arrest. Even so, celebratory accounts of the series rely too much on classical understandings of realism and do not account for the show's own ambivalence about key features of the concept. Lauren Berlant has described the early twenty-first-century situation of postindustrial America as being characterized by "the waning of genre, and in particular older realist genres (in which I include melodrama) whose conventions of relating fantasy to ordinary life and whose depictions of the good life now appear to mark archaic expectations about having and building a life."[37] Along these lines, *The Wire* stages a waning of older realisms through its complication of the novel as well as traditional melodrama. The show's relationship to older realisms is perhaps most palpable if we consider the charged formal relationship that the series has to the Victorian multiplot novel, a genre of serialized British literature that was most prominent in the period between the late 1840s and the late 1870s. In distinction to the unified narrative form advocated by later novelists such as Henry James, the multiplot depends on extensive branching that enables character inclusiveness, narrative multiplicity, and the dispersal of a reader's attention across a wide web of events.[38]

The aesthetics of the Victorian multiplot novel are one of many historical precursors to what I am calling network aesthetics.[39] Like a multiplot novel, *The Wire* foregrounds links, parallels, and patterns—often withholding explicit intersections until the end of a scene or episode. Of course, it emphasizes such connections not through text but through televisual

techniques. On several occasions, the camera swings around in a continuous shot, making a seamless transition between two characters who, unbeknownst to each other, occupy a shared physical space but are involved in different narrative threads. In other scenes, we see intercuts between Baltimore locales, parallel wordings by characters, and polyvalent episode themes—such as the use of "bug," in the first season's episode "The Pager," to refer simultaneously to HIV, surveillance devices, and a paranoid reaction of "bugging out."[40] These techniques emphasize overlapping protocols among different actors and institutions.

The commonalities between the Victorian multiplot novel and the American televisual form of *The Wire* are not just the result of Simon's idiosyncrasies as a literarily inclined writer or of the growth of narrative complexity in contemporary American television. More broadly, television inherited many features of the nineteenth-century novel through the intermediary of twentieth-century American cinema. Notably, Sergei Eisenstein's influential essay "Dickens, Griffith, and the Film Today" (1944) emphasizes the influence of the British realist novel on American cinema. Eisenstein insists on the profound influences that Dickens's protocinematic eye and parallel-narrative style had on the films of the pioneering American director D. W. Griffith. Key techniques of film economy later adopted by television, including the close-up, parallel action conveyed through montage, and the conjunction between atmosphere and character revelation, are prefigured in Dickens's "optical" and "aural" prose.[41]

The Wire draws heavily from the multiplot novel and the classical cinema it inspired, but what is more striking is how the show elicits these connections in order to depart from them all the more dramatically en route to its own network realism. In the fifth season, in an episode aptly entitled "The Dickensian Aspect," *The Wire* sharply contrasts the realist melodrama of the Dickensian multiplot novel with its own network realism. In a demonstrative scene, a newsroom debate at the *Baltimore Sun* tackles the representational strategy that the newspaper will take in its coverage of the failures of the city's school system. This scene—one of the show's most self-reflexive—features a debate that includes numerous staffers who take opposed positions about how best to depict the problems facing Baltimore's primarily black inner-city youth, many of whom end up on the corners selling drugs en route to early deaths. The primary clash between the executive editor, James C. Whiting III, an old-school journalist, and the forward-thinking city editor, Augustus "Gus" Haynes, requires an extended citation:

James C. Whiting III: The word I'm thinking about is Dickensian. We want to depict the Dickensian lives of city children and then show clearly and concisely where the school system has failed them.

Staffer: Not to defend the school system, but a lot of things have failed those kids. They're marginalized long before they walk into class.

Augustus "Gus" Haynes: You want to look at who these kids really are, you gotta look at the parenting or lack of it in the city. Drug culture. The economics of these neighborhoods. . . . Yeah, sure, we can beat up on city schools. Lord knows they deserve to be beat on every once in a while. But then we're just as irrelevant to these kids as these schools are. I mean, it's like you're on the corner of a roof and you're showing some people how a couple shingles came loose and meanwhile a hurricane wrecked the rest of the damn house.

Staffer Scott Templeton: You don't need a lot of context to examine what goes on in one classroom.

Gus: Oh really, I think you need a lot of context to seriously examine anything.

Whiting: No, I think Scott is on the right track. We need to limit the scope, not get bogged down in details.

Gus: To do what? To address the problem or to win a prize? I mean, what are we doing here?

Whiting: Look, Gus. I know the problems. My wife volunteers in a city school, but what I want to look at is the tangible, where the problem and solution can be measured clearly.

Staffer: There's more impediments to learning than a lack of materials or a dysfunctional bureaucracy.

Whiting: But who's going to read that?[42]

In this exchange, the "Dickensian" style advocated by Whiting offers a melodramatic depiction of the squalid lives of city youth, conveyed "clearly and concisely" alongside a digestible critique of the school system. Whiting wants to examine "tangible" problems and solutions that can be "measured clearly" and represented persuasively through the characterization of unmistakable villains and victims. As he later adds, "Now what do you want, an educational project or a litany of excuses? I don't want some amorphous series detailing society's ills. If you leave everything in, soon you've got nothing." The alternate approach, proposed by Gus, serves as a microcosm of the aesthetic favored by Simon and the other writers of *The Wire*. Describing a network of associated factors, including parenting styles, drug

culture, and the city's economic conditions, Gus contends that "a lot of context" is necessary to "seriously examine anything." In the end, Whiting dismisses this alternative by claiming that an overly complicated story will not ensnare readers and sell papers (a similar concern about alienating the audience through complexity arguably led to the eventual cancellation of *The Wire* itself).

The *Baltimore Sun* debate suggests a number of ways that *The Wire* departs from older realist genres, especially melodrama.[43] As the film critic Rick Altman notes, melodrama depends on dual-focus stories that set good and evil in opposition (in distinction to classical narrative with its single-focus plotting and solitary protagonist).[44] Thus even Eisenstein, who praises Dickens's complex parallelism at a formal level, observes that politically Dickens subscribes to a "slightly sentimental humanism" with overly clear-cut distinctions.[45] While Dickens is committed to representing different cross-sections and classes of Victorian society, the novelist simultaneously maintains a sharp split between the rich and poor in order to produce an explicit commentary.

The Wire's critique of melodrama is evident in both its treatment of characters and its narrative structure. The show's interest in modern character "types" builds on an earlier feature of the historical novel and the concurrent specialization of the economy in the eighteenth century. The show examines but also challenges the bourgeois individual subject that featured prominently in these earlier texts.[46] Indeed, realist typology coexists in *The Wire* with a modernist attention to singularity that is far less common in contemporary television programming.[47] Agency in this series does not belong to exaggerated melodramatic characters, especially a sovereign protagonist and a corresponding villain. Instead, it becomes distributed among assemblages of distinct actors (both human and nonhuman), unknowable histories, institutions, accidents, and contingencies. Agency is neither celebrated nor romanticized as individual will, for example as the capacity of the exceptional detective to crack open the "whodunit" that remains a popular television genre.

The organization of characters in *The Wire* similarly distinguishes the series from most televisual melodrama. The long-arc soap opera, for instance, focuses on personal home relationships and traditional gender roles. By contrast, *The Wire* shifts the attention of its characters and viewers alike to the workplace, where the source of greatest intimacy and collectivity is no longer the family but colleague groups. Kima, for example, starts out by trying to cultivate a home life with her lesbian partner Cheryl

and to secure a future for their family by earning a law degree. Gradually, however, she finds herself consumed by the job, uninterested in becoming a parent, and eventually asking McNulty (himself a work addict) to cover for her when she cheats on Cheryl. The show does not, then, like a great deal of televisual melodrama, merely redefine family structure with the goal of salvaging a version of it that inevitably contains cultural contradictions inherent in categories of race, class, gender, sexuality, and religion.

The Wire positions itself within a complex media ecology that includes the Victorian multiplot and Hollywood narrative but also, importantly, televisual melodrama. As the television scholar Lynne Joyrich observes, this variety of TV melodrama derives "a sense of wholeness, reality, and living history" from the "fragmented network of space and time" that characterizes postmodernity.[48] In one analysis, David Simon explains that his series challenges this model of TV narrative as a means of satisfying entertainment and distraction:

> Because so much of television is about providing catharsis and redemption and the triumph of character, a drama in which postmodern institutions trump individuality and morality and justice seems different in some ways, I think. It also explains why we get good reviews but less of an audience than other storytelling. In this age of Enron, WorldCom, Iraq, and Katrina, many people want their television entertainments to distract them from the foibles of the society we actually inhabit.[49]

Simon's critique of early twenty-first-century television programming targets conventional forms of "individuality and morality and justice." Exaggerated sentimentality may remain pleasurable to viewers in an "age of Enron, WorldCom, Iraq, and Katrina," as well as the decline of American hegemony, but it is nonetheless no longer adequate to its historical moment.

The Wire's networks, unlike those suggested by both realist and postmodern melodrama, offer neither wholeness nor closure. *The Wire* resists narrative resolution, particularly in the form of the triumph of good over evil. The temporal experience of *The Wire* resembles the narrative parallelism and character interconnection of the Victorian multiplot but serves different ends. In particular, the series challenges the linear development and closure characteristic of these earlier novels. Certainly, nineteenth-century writers such as Dickens often represent social networks through multiplot techniques, but those multiple vectors tend to converge, in the end, in unified resolutions. By distinction, *The Wire* avoids happy or con-

clusive endings in all five seasons. The Major Crimes Unit, despite earning occasional convictions, undertakes cases that do not end, much like the drug trade itself. Detective Sydnor recognizes this fact at the end of the first season, as he looks at the bulletin board of interconnections among major drug players. "This is the best work I ever did," he observes. "I never did a case like this. But it's not enough. . . . I just feel like this just ain't finished."

Mimicking the continuity of its serial form, *The Wire*'s narrative repeatedly spurns completion as unrealistic. It depicts ordinary lives made up not of neat beginnings and clear-cut endings so much as loose threads that bundle in an abundance of middles. When the show does eventually end, it is notably with a parody of closure: a going-away party for Detectives McNulty and Freamon at Kavanaugh's bar that takes the form of a mock wake complete with jovial eulogies. This challenge to definitive finales echoes the final shot of each of the other four seasons, depicting not a clear path but an open-ended crossroads. At the scale of both the individual episode and the entire season, the show also largely avoids a technique that has become nearly ubiquitous in complex television narratives: the cliffhanger.[50] Episodes of *The Wire* almost always end in ordinary moments. They do not produce narrative revelations meant to inspire either the heightened curiosity that attends broadcast-era serial pacing or the consumptive desire that feeds a more recent form of DVD- or web-enabled binging.[51]

The Wire departs, then, in a number of ways, from older forms of realism and melodrama. Nevertheless, realism remains a useful starting point for analyzing this series. In deploying this term, I am not drawing attention to the show's oft-noted naturalism (even as the series does arguably have more in common with the fiction of Theodore Dreiser than that of Dickens).[52] Instead, the show can be characterized as realist because of its account of social networks at both a thematic and a formal level. Instead of providing a global picture of such networks, as graphs or visualizations often seek to do through static network structures, the show follows actors and the dynamic associations that they form over time. In the next section, I examine how the show follows nonhuman actors — especially technology and capital — in order to animate *processes* of social connection and controversy that might otherwise go unobserved.

Objects, Associations, and Controversies

How, then, does *The Wire* generate a network realism that departs from the earlier realisms that I discussed in the previous section? Network for-

mations, in this television series, become visible through human social encounters but also, perhaps even more decisively, through nonhuman objects. These objects are neither agential subjects nor decorative minutiae. To borrow Latour's illustrative list, objects take on vivid lives in this series as they "authorize, allow, afford, encourage, permit, suggest, influence, bloc, render possible, [and] forbid" interactions among human actors.[53] Indeed, in this sense, the show's observation of objects has a close affinity with ANT's empirical impulse. At the same time, the show's attention to detail—captured in the taglines "Listen carefully" and "Read between the lines"—updates an earlier impulse of literary realism toward detailed description of objects that compose human life-worlds.[54] *The Wire*, then, forms an aesthetic experience of networks by tracing objects and the social networks that result from their associations.

To borrow Latour's categories, *The Wire* can be said to make objects visible through a variety of approaches: attending to moments of technological innovation, approaching objects from a defamiliarizing distance, concentrating on situations of breakdown or malfunction, and employing a variety of aesthetic audiovisual techniques that focus a viewer's attention.[55] Objects trace associations among characters and help the viewer keep track of Baltimore social networks that exceed the structural parameters of discrete institutions. One subplot in the fourth season, for example, forges a chain of relationships among characters by tracking the movement of a single object—an expensive ring—as it changes hands. The ring circulates through Baltimore over the course of several episodes, accruing meaning not through some ultimate revelation about its significance but rather because of its role as a facilitator of human associations. Across various power plays and thefts, the ring passes from the drug trafficker and grocery store owner Old Face Andre to the emerging Westside drug kingpin Marlo Stanfield to the stickup artist Omar Little to the corrupt patrolman Eddie Walker and, finally, to the fourteen-year-old middle school student Michael Lee. Though Marlo later notices the ring on Michael's finger, he does not request its return. This valuable object, which inspires different demonstrations and exchanges of power, provides the viewer with a stable marker that can be traced across an otherwise changing postindustrial topology.[56] Further, this sequence maps a process through which a network becomes, however provisionally and partially, visible.

Two of the primary nonhuman actors that blaze the trails of associations in *The Wire* are media technologies and capital (especially in the form of circulating cash). First of all, communications media and surveil-

lance technologies are practically omnipresent in the show. During their investigation of the Barksdale drug operation, the Baltimore Major Crimes Unit maps a social network through the use of walkie-talkies, cloned pagers, and wiretaps. Subsequent seasons feature cloned software, text message surveillance, decryptions of information-laden photographs, and computer-generated visual models of a disposable cell phone communication network. Unlike televisual police procedurals such as *CSI*, *The Wire* does not fetishize new technologies or treat them as black boxes that yield neat solutions to police cases. Eschewing technological determinism, the series dramatizes the way that these tools both improve and limit investigations into social structures.[57] For example, the first season juxtaposes investigations by the Baltimore Police Department and the Federal Bureau of Investigation. Unlike the FBI—an organization that works with computers, live video surveillance, and fiber-optic lenses—the underfunded Baltimore homicide division still relies on typewriters, even in the early years of the twenty-first century. Detective Jimmy McNulty of the Major Crimes Unit discovers that Barksdale's crew also uses low-tech, throwback pagers instead of cell phones. It turns out, however, that this Barksdale protocol has less to do with cost effectiveness than with strategy (pagers, unlike cell phones, are not directly traceable). Instead of establishing a sophisticated wiretap, McNulty proposes cloning the dealers' pagers by copying their frequency so that the police investigators register a page simultaneously with their targets.[58] Further complicating this internecine information warfare, the targeted drug traffickers respond by modifying their communication channels.

The investigative technologies of *The Wire* do not simply make visible the drug network that operates within and beyond Baltimore. These tools generate connections between police investigators and drug organizations. This distinction between discovering and generating a network becomes evident in the third season when Detective Lester Freamon explicitly employs the language and methods of network science. Briefing the Major Crimes Unit, he presents a network visualization that he has produced through a painstaking pattern analysis of discarded phones ("burners") that still retain recently dialed numbers in their memory. As Freamon explains, "This is the pattern of a closed communication network. Something you'd expect from a drug organization. . . . Our data shows that over 92 percent of the calls were made within this network, with the average call lasting less than a minute. Again, suggestive of drug trafficking." Even such detailed data, however, proves insufficient to catch the involved players. As

Freamon explains earlier in the episode, the data that the investigation can gather is all irredeemably "historical." "We can give you the network no problem," he tells his unit, "but by then it's a week old and they've dumped their phones."[59] Ultimately, arresting Avon Barksdale's business partner Stringer Bell for drug trafficking requires yet another technological adaptation. The Major Crimes Unit adopts a device called the Triggerfish machine to pull numbers immediately from cell phone towers and uses data analysis to build its case. Through this probe, the detectives are then able to produce a grouping of associates that turns Baltimore into a central node of the drug trade. This sequence of events emphasizes that the drug network is not a discoverable structure but rather a construction produced through overlapping technologies, quantitative analyses, police protocols, legal norms, and human interactions.

While *The Wire* traces associations within institutions that are central to its actors, such as the police department and Barksdale's drug operation, it also extends its analysis across different cross-sections of Baltimore. The program's eponymous wire, a technological mode of interinstitutional surveillance, comes up at a thematic, narrative, and audiovisual level to foreground these types of links. In the first season, Wallace (a sixteen-year-old "hopper" working for D'Angelo Barksdale's crew in the Baltimore low-rises) recognizes a boy named Brandon who has been robbing the crew's stash houses. He calls in the discovery to his superiors, thereby setting off the chain of events that leads to the target's death. Since this sequence takes place late in the evening, no one in the Major Crimes Unit is present to take notice of the multidirectional communication that unfolds surrounding the murder. Nevertheless, the computer that is automatically tracking the dealers' pagers registers the entire succession of exchanges among members of the Barksdale crew as they locate and murder Brandon. In the final moments of the episode, the camera cuts between the live pursuit of Brandon by the members of Barksdale's muscle and the Major Crimes Unit's computer, which is dramatized by close-up shots of numbers appearing on a display screen and corresponding modem audio. The computers in the office record all of the pages. Admittedly, these computers do not capture any of the affects involved in the scene (a task of another technology, the camera outside of the diegesis), but they do record a network mapping of the murder (fig. 3.3). The opening shot of the very next episode extends this metaphor by slowly tracking an electrical wire that runs above Brandon's dumped, lifeless body across a couple of backyards to Wallace's window. In this shot, the wire represents a material connection between

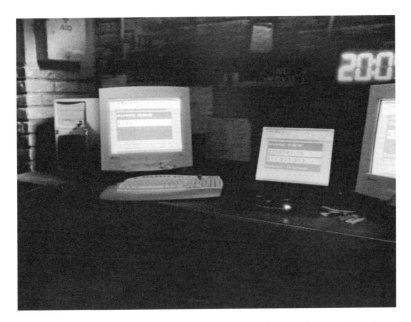

3.3. Mapping a network of Brandon's murder in *The Wire* (HBO, "The Pager," 2002).

Wallace and the deceased Brandon, which is otherwise obscured by the abstractions of computer data and the legal proceedings that this surveillance information legitimates.[60] Nonhuman technologies, in this scene, construct a social network that might have otherwise remained obscure, both to the Baltimore Police Department and to the viewer. The computer and wire that become the central actors of this sequence additionally complicate any straightforward sense of human agency.

Alongside technology, the primary nonhuman actor that connects characters from different socioeconomic and institutional backgrounds in *The Wire* is capital. In the first season, Detectives Greggs and Ellis Carver follow drug money passed from a Barksdale midlevel dealer to a man in an expensive car, discovering that the $20,000 they apprehend is headed to the office of State Senator Clay Davis. As the ties among law enforcement, the drug trade, and state politics dawn on Lieutenant Daniels (the head of the Major Crimes Unit), he offers a soft-eyed observation, "I'm bringing in a case that goes everywhere." In a moment of frustration, he tells his wife, "See, this is the thing that everyone knows and no one says. You follow the drugs, you get a drug case. You start following the money, you don't know where you're going. That's why they don't want wiretaps or wired CIs or anything else they can't control."[61] As this dialogue suggests, capital in *The Wire* op-

erates less as a standard cinematic causal agent that propels forward a linear chain of events than as a privileged actor that disrupts straightforward causality in favor of proliferation that no one can control.[62]

The focus on capital trails in *The Wire* is arguably central to a much broader realist narrative enterprise. Brooks observes "the importance of money, of the cash nexus, in realism." This nexus becomes manifest in a fascination with "investment, accumulation, wealth—and of course their collapse in bankruptcy" that already animates some eighteenth- and nineteenth-century fiction.[63] Similarly, as Leigh Claire la Berge writes of *The Wire*, realism is "always economic realism."[64] In this series, money does indeed connect characters (and viewers) who are separated by gulfs of race and class that might otherwise lead them to avoid the intersection points that capital produces. Yet it is easy to slide from an observation about realism's "cash nexus" or its "economic" character to a conclusion that all realist narratives are about "capitalism." In fact, this slippage is so effortless that Simon, in one interview, makes precisely that move. Simon observes that *The Wire* reveals a system that has neglected those perpetually impoverished people whom he (quoting Michael Harrington) calls "the other America." Instead of alleged threats such as drugs or terrorism, "what really ails America," he contends, is capitalism:

> Raw, unencumbered capitalism is an economic force and a potent one. But it is not social policy and amid a political culture of greed and selfishness, it is being made to substitute for social policy. The rich get richer, the poor get fucked, and the middle class of this country—the union-wage consumer class that constituted the economic strength of postwar America—is fast disappearing as the need for union-wage work disappears. Raw capitalism—absent the moderating aspect of a political system that cares for the great mass of voters (or non-voters) who uphold that system—is not good for most of us. It is great for a few of us. We are building only the America that we are paying for, and ultimately, it is going to be an ugly and brutal place, much like the city-state depicted in *The Wire*.[65]

Simon's polemic about postwar America is compelling, but it also misses something important about his own series. *The Wire* does not, in the end, posit any overarching theory of "raw capitalism." From episode to episode, it patiently follows particular actors (including capital) wherever they lead. Rather than a "raw" or unmediated capitalism, the series offers a mediated network of actors and perspectives that negotiate complex processes.

The Wire's network realism crystallizes around objects, but the show

also unfolds in a more dynamic manner, as it moves serially across controversies and perspectival misalignments.[66] The show engages the tensions inherent to institutions such as police departments, drug organizations, electoral processes, school systems, and mass media behaviors—disagreements that emerge, mutate, metastasize, and occasionally (though rarely) resolve. Two of the scenes I have already described—the Baltimore mayoral election in the fourth season and the *Baltimore Sun* newsroom debate in the fifth season—are notable for the ways that they open up rather than close down disagreements. Admittedly, both scenes include a privileged interlocutor who espouses the show's preferred perspective. Nevertheless, the controversy or debate itself, which takes up considerable screen time, allows a dispute to unfold without, as is the case in the Platonic dialogue, yielding resolution or consensus. Realism, in these scenes, is not the insistence on a proper reality—the ills of "raw capitalism" or the superiority of a heavily contextualized perspective—as much as a depiction of the discrepancies and paradoxes that themselves constitute the dynamic process of social life.

The Wire's network realism preserves complexity in its animation of controversies and associations among social actors, especially as they unfold around capital. Jameson, in his analysis of *The Wire*, observes that multifaceted sources of character motivation, prominent in older genres such as the detective story, "have become increasingly irrelevant in the permissiveness of contemporary society, its rootless and restless movement and postregionalism, its loss of individualism and of bizarre eccentric and obsessive—in short, its increasing one-dimensionality." In contemporary art, he adds, we are witnessing a passionless "flattening out of motivations to the sheerly financial," through which "money, which used to be interesting in the variety of its pursuits, [is] now becoming supremely boring as the universal source of action."[67] For him, only the show's utopian hints provisionally counteract the flatness of the financial.

Yet the network in process that *The Wire* stages is far from flat or boring. The series does not, as Jameson argues, treat money as a "universal" actor that confirms a ubiquitous or uniform system of capitalism. Contrary to a structuralist insistence on the centrality of "exchange" or "reciprocity" to all human systems—for Claude Lévi-Strauss, not only economics but also language and kinship—*The Wire* presents viewers with a more robust spectrum of economic behaviors and monetary processes.[68] In his work on the history of debt, David Graeber has challenged totalizing social theories of reciprocity (and corresponding economic exchange theories) by suggest-

ing three "moral principles on which economic relations can be founded": what he calls "exchange," "hierarchy," and "communism."[69] Perhaps not as fine-grained as *The Wire* itself, Graeber's principles nevertheless offer a starting point for thinking about the complexity of money, as an actor in process, in Simon's series. These terms also clarify how the show's human actors, despite participating in institutional protocols and being subject to economic constraints, can still defy (if often only fleetingly) what appears as a universal economic system.

First of all, *exchange* is at play in many of the scenes I have already noted. Through its network realism, *The Wire* gestures toward exchange systems from black markets to stock markets. As it moves among various scales, the series focuses on how relations play out through everyday conversations, procedures, and monetary exchanges. From the beginning, the show introduces the viewer to the protocols of the drug trade, which includes a manager, a moneyman, a drug runner, and security. Money both reinforces and alters relationships among human actors in ways that are neither universally simple nor boring. For example, in the first episode, Johnny Weeks (a white drug addict who is both naïve and unlucky) tries to exchange counterfeit money for heroin in the low-rise buildings held by Barksdale's drug crew. Johnny's attempted con suggests a complicated motivation that is tinged with economic necessity, addictive cravings, a desire for adventure that might break up the repetition of the everyday, a longing to impress his best friend Bubbles with a successful scheme, and many other impulses at which the viewer can only guess. This encounter begins as an exchange of counterfeit money for illegal drugs and ends in a proliferation of consequences. Indeed, a linear chain (Johnny is punished with a beating from the Barksdale crew and lands in the hospital) quickly branches out in unanticipated directions (the beating motivates a guilty and enraged Bubbles to become a police informant, setting off events that eventually result in the arrest of several key drug players as well as Johnny's discovery that he is HIV positive and requires a colostomy operation). Exchange, as this exemplary series of events suggests, is never a simple or merely episodic process.

Second, alongside reciprocal exchange, the series is overrun with centralized *hierarchies* that depend on formal inequality. Such stratification organizes both the narcotics and homicide divisions of the Baltimore Police Department. In the first season, Cedric Daniels is assigned to lead a special Major Crimes Unit detail in pursuit of Avon Barksdale and his drug circuit. As he takes command of the unit, Daniels tells the rebellious McNulty, "Chain of command, detective. That's how we do things down

this end of the hall." The police "chain of command" extends from "officers" to "lieutenants" all the way up to the "police commissioner." The drug dealers have comparable hierarchies that determine income levels and stretch from low-level "hoppers" to midlevel "dealers" up to top bosses like Barksdale. Indeed, the similarities between these leadership chains are highlighted in a number of montage sequences. Despite certain parallels, there are also organizational differences between the police department and the drug distribution circuit. Unlike the prohibitively bureaucratic police structure, the drug network uses more flexible protocols. In one scene, Lieutenant Daniels is ordered to hit a stash house and seize any drugs that are uncovered in the raid. The problem, as McNulty puts it, is that the dealers "change stash houses every other day." The warrant only allows a raid on a building that served as a drug stockpile several days prior and has since been vacated. Learning from this early inability to adapt, the Major Crimes Unit gradually begins to approach the Barksdale drug operation as an inconstant process rather than a set structure. All of the show's institutional hierarchies are depicted as perpetually changing, characterized by frequent promotions, demotions, and temporary exceptions.

Third, *The Wire* explores the relation of mutuality that Graeber calls *communism*. Communism, here, is not a macrolevel system opposed to capitalism but rather "the raw material of sociality" that is observable in everyday acts of nonreciprocal sharing, kindness, and collaboration.[70] Such acts are visible in the most ordinary interpersonal relations in *The Wire*, from unrequited favors between homicide detectives to shared heroin scores between addicts. In many cases, money or shared goods call these mutual relations to the viewer's attention. At the end of the first season, one such sequence concerns Detective Kima Greggs and Bubbles, a character who is many things—a heroin junky, a friend to others on the streets, and a reliable informant for Greggs. After struggling with his addiction, Bubbles attempts to clean himself up but finds that he is invariably caught between multiple worlds. The structural support that he needs to move off the streets (which includes shelter, a job, and a support network) is difficult to come by. Eventually, he turns to Greggs, who listens sympathetically and promises to give him a couple hundred dollars so that he can rent an apartment. They make an appointment to meet the next day, when she plans to give him the money. Greggs, however, is shot during an undercover operation that takes place that same night and is rushed to the emergency room. When she misses the meeting with Bubbles, he feels abandoned and regresses into his heroin addiction. In this sequence, *The Wire* dramatizes

the precariousness and difficulty of escaping one's social position in early twenty-first-century America.[71] Capital, across all three of Graeber's categories, animates processes that make up network realism. Money does not merely confirm a totality such as "capitalism" or "the social." Instead, it leads viewers to situations and scenes in which controversies, associations, and relations unfold.

This type of complexity requires "soft eyes." As a mode of experience and observation, it must be added, soft eyes suggest no preference between observing "global" and "local" scales. In Latour's succinct phrasing, "No place dominates enough to be global and no place is self-contained enough to be local."[72] The impulse of *The Wire* is to complicate both levels, tending instead toward something else—a networked awareness that travels across epistemological scales. Admittedly, the show sometimes seems to reject a global view in favor of local knowledge. We see in Freamon's philosophy of following the money or Major Howard Colvin's pedagogical insistence to all new officers in his Western District (to whom he gives compasses) that awareness of one's exact location, building and street orientation, is critical to survival. Though it militates against abstraction and a global scale, *The Wire* does not romanticize the local. The show never treats its scenes as transcendent sites meant to reveal the genesis of major social problems. All of its environments are layered with other times, places, and agencies.[73] Each season begins in medias res—not with origin stories but with interactions, associations, and objects that, if observed carefully, branch off to other histories. Detective Jimmy McNulty observes that to perform meaningful police work, the investigators need to "keep gathering string" until they "can find a way in." In place of seamless, open-and-shut cases narrated from an omniscient perspective, *The Wire* depicts a world that can only be accessed partially through acquisition of "string" that leads from actor to actor, association to association.

The Wire's realism thus depends on actor-networks that are in perpetual process. As Simon explains, "I decided to write for the people living the event, the people in that very world." He describes all of his shows, including NBC's *Homicide* and two HBO miniseries, *The Corner* and *Generation Kill* (we could also add *Treme*), as "travelogues" that immerse the viewer in "a new, confusing, and possibly dangerous world that he will never see." Simon speculates that the ideal viewer of his shows is likely a stumbling participant rather than an expert insider: "He likes not knowing every bit of vernacular or idiom. He likes being trusted to acquire information on his terms, to make connections, to take the journey with only his intelligence

to guide him."[74] *The Wire* conveys network realism through dialogue, narrative flow, and key themes. It also does so through its relationship to multiple forms and media (including television itself)—an aspect of the series to which I now turn.

Multimedia Networks and Television

The Wire's network realism becomes possible through, and not in spite of, its mediations and relationships to varied media. The fact that realism and mediation are always mutually generative requires emphasis, in this case, because commentary on the series often attributes its reality effects to its formal minimalism and alleged nonmediation, relative to most other contemporary television shows.[75] In a passage regarding *The Wire*'s realism, Kinkle and Toscano, for instance, comment on the series' "formal austerity" and "'style-less' style" that includes a "lack of non-diegetic sound" and "unobtrusive camera." Along these lines, it can be said that *The Wire* avoids the "stylistic excess" and "stylizing performance" that John Caldwell identifies as a characteristic quality of television in the 1980s and 1990s.[76]

Contrary to this common reading of *The Wire*, however, I do not see the show as downplaying style. Though nondiegetic sound is, in fact, largely absent, a soundtrack highlights the montage with which each season culminates. Additionally, visual effects, particularly camerawork and editing, are far from lacking. Along with standard stills and shot/reverse shots, *The Wire* includes various forms of camera movement, including handheld, pan, tilt, crane, and tracking shots that trail the show's human and nonhuman actors. Select scenes also include aerial helicopter views and photographic freeze-frames. Given the focus that the series takes on police investigation, there is an emphasis on mediation, especially through decidedly obtrusive surveillance shots in elevators, housing projects, and government buildings. At the level of editing, the series does largely avoid cutting techniques that call attention to themselves, such as dissolves.[77] On the other hand, cuts are frequent, with an average shot length of approximately four seconds in numerous episodes (median shot length of approximately three seconds)—a considerably quicker cut speed than even many contemporary network films such as *Syriana* employ.[78] Moreover, crosscutting is frequent, underscoring connections, equivalences, and stark contrasts.

The Wire's televisual mediation serves its depiction of social networks in twenty-first-century Baltimore. Equally important to the show's network

realism is its hyperawareness and incorporation of a wide range of forms and genres—a tendency that has been equally strong in network novels such as *Underworld* and *Cryptonomicon* (chapter 1) and network films such as *Syriana* (chapter 2). In attempting to categorize *The Wire*, scholarship about the series too often privileges a single artistic genre or medium. Realism in the early twenty-first century, however, depends fundamentally on a dense media ecology that resists labeling the series, for instance, as a "tragedy" or a televisual "novel." The show's myriad forms are central to its sense of realism. They suggest that our particular early twenty-first-century historical moment is, more than ever, saturated by a broad range of media through which we think.

The show's network realism also operates in relationship to its medium-specific parameters as a television series. Despite Simon's consistent criticism of "television entertainments," *The Wire* is acutely aware of its charged relationship to televisual form. Television is certainly thematized in the series—especially in the fifth season, which turns explicitly to news media. What is more remarkable is the visual omnipresence of screens. Though they are rarely at the center of the action, television screens appear everywhere, for instance in various homes and offices during the mayoral debate that takes place in the fourth season. In another scene, from the very first episode, D'Angelo sits at Orlando's strip club after a day of managing a drug crew at the low-rise towers. Immediately following a conversation with Stringer Bell about drug strategy, he looks up at a television mounted in the corner of the club (fig. 3.4). The short shot of the TV displays an "America at War" newscast that flashes NASDAQ, S&P, and DOW stock market data in the corner of the image and includes scrolling information about holiday movies and the Olympic torch at the bottom. This four-second digression, scarcely noticeable in the midst of a complex plot that challenges the viewer's capacity to follow all of its threads, integrates the television into the everyday environment of the bar. In this moment, we see a complex, unknowable present arrive from a distance via the live broadcast. At its periphery, the show invokes a network through imagery of an international war alongside live financial data that represents the world economy.

That television brings a sense of multiple sites and scales into the flow of everyday life is a defining feature of the medium that Raymond Williams already theorized in the 1970s. The opaque and unknowable levels of a complex late twentieth-century society, Williams observes, become accessible only tangentially, through news statistics (a tendency that sees

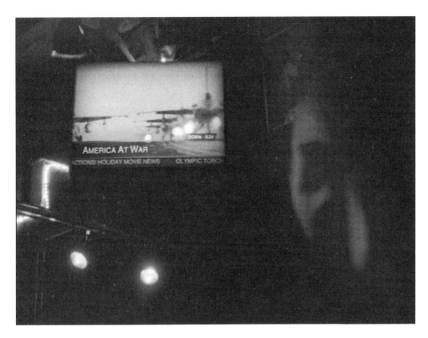

3.4. "America at War" television news story in *The Wire* (HBO, "The Target," 2002).

its twenty-first-century extension in big data). They also come through in fictional televisual dramatizations:

> Miner and power worker, minister and general, burglar and terrorist, schizophrenic and genius; a back-to-back home and a country house; metropolitan apartment and suburban villa; bed-sitter and hill-farm: images, types, representations: a relationship beginning, a marriage breaking down; a crisis of illness or money or dislocation or disturbance. It is not only that all these are represented. It is that much drama now sees its function in this experimental, investigative way; finding a subject, a setting, a situation; and with some emphasis on novelty, on bringing some of that kind of life into drama.[79]

Certainly the representation of contemporary types and sites is available in much earlier forms of realist fiction. However, the instantaneity, ubiquity, and frequency of televisual transmissions, as well as the simultaneity with which popular television shows are experienced as shared texts, belong to a new moment that Williams designates as an interconnected "dramatized society." What Williams famously called broadcast television's "flow"—the sequence of programs, advertisements, and other content that make up the

medium's nondiscrete continuity—already captures something of the temporality and composition of our network imaginary.[80] However, *The Wire*, in its quick turn toward the "America at War" news program, also registers something other than flow. The discontinuity of the television's brief appearance in the frame might better be captured with Feuer's notion of "segmentation without closure" that demonstrates how television interweaves forms of fragmentation with continuous seriality.[81] Moreover, the scene animates the everyday experience of moving in and out of televisual flow in an ordinary moment in order to highlight its own ambition to construct a different type of televisual experience. *The Wire*, then, can be read as the apotheosis of the emergent process of the "experimental, investigative" television drama that Williams first witnessed in the mid-1970s.

The Wire promotes a different sense of networks than the reified terrorist networks, economic networks, or political campaigns glimpsed in its background. Nevertheless, its ability to trail actors and track associations among them is intimately tied to the formal affordances of television. The show's capacity to dwell in contradiction and to revisit controversies—a key aspect of its network realism, explored in the previous section—is enabled, in part, by its televisual seriality. Whether experienced in weekly increments during their original broadcast dates (from June 2, 2002, through March 9, 2008) or through a series of DVD- or web-enabled binges, *The Wire*'s seriality promotes an integration of drama into the everyday life of a viewer over a longer durée than most other artistic forms, especially feature films.[82] Individual episodes of the show are never self-contained or suggestive of unambiguous moral lessons that frame discrete installments. At most, each episode offers the viewer more "string," or an additional institution or site that expands its world. Some critics, such as John Kraniauskas, have disapproved of this layering of sites as a technique that zooms out too far, losing some of its "socially explanatory" power.[83] On the contrary, I believe that this accumulation of institutions, which is often accomplished through astonishing cinematographic and narrative economy, constitutes a core aesthetic strategy of the series through which it makes complexity cognitively and affectively sensible. *The Wire* returns, again and again, to the same institutions at different moments in their development, especially when they intersect with other institutions. Seriality enables not narrative redundancy (a function of seriality that is more common in daytime soaps that must update distracted or irregular viewers) but greater depth. When Poot, for example, reiterates, at the end of the first season, the same lesson about drug distribution protocols to his young hoppers that D'Angelo deliv-

ers to him in the very first episode, this recurrence serves not as a mere reminder but as a commentary on the persistence of crime systems over time.

In his compelling reading of *The Wire*, Jason Mittell compares the show's procedural aspirations to the form of contemporary videogames but argues that it is more important to demonstrate "how the show operates televisually."[84] While I agree with Mittell, it is also important to stress that the show ultimately challenges any strict notion of medium specificity or even a limited comparative media studies approach. Despite Simon's polemics against the contemporary status of television, the show participates in a more expansive media ecology that involves interactions among numerous forms and genres, both old and new. *The Wire* poignantly attends to social processes in early twenty-first-century America by reconfiguring a host of other cultural forms: the distributed causality of the social network, the threaded subplots of the Victorian multiplot novel, the aporetic cyclicality of the Greek tragedy, the singular-though-generalizable case of the police drama, the self-contained episode of the TV sitcom, the procedural organization of the videogame, the patient participant observation of ethnography, the profane ordinariness of urban fiction, the haunting indeterminacy of Gothic horror, and, of course, the cumulative seriality of the long-arc narrative television drama.[85] All of these cultural and narrative forms invoke different aesthetic imperatives and historical temporalities. They exist on varied, though by no means incommensurable, scales. The concept of the network is, simultaneously, one of these orders of thought and a material metaphor for organizing the relationships among these distinct levels. In this way, *The Wire* operates less as a map of a social totality than as a means of modulating the relations between narrative forms within a dynamic and changing social environment. The series, then, is less impressive for its mimetic reproduction of social totality or its oft-mentioned naturalistic authenticity than for its self-reflexive and multiform struggle with the relations of part and whole, node and network, city and world.

The realist network aesthetics of the series, as a whole, reveal communications media and artistic forms to be investigative tools that can help us better understand our social environment. The media ecology in which *The Wire* locates itself creates difficulties for critics, leading simultaneously to fitting the show into various preexisting categories and to perpetually announcing its novelty. In my own reading, its network realism is a way of animating the contradictions that compose the social by situating itself within a network of older forms as well as new media. In conclusion, I turn

more precisely to the novelty that this series introduces to the social it seeks to investigate and, in turn, to transform.

Conclusion: Structures of Feeling and Affective Complicity

The Wire's realism, both its frequently mentioned gritty urbanism and the approach to social networks that I have been describing, retains a residue of romanticism. Insofar as the network has been a romantic form (e.g., a figure of democracy and human interconnection across numerous communications technologies), my term "network realism" captures a tension between the show's conflicting impulses. Jameson is right to observe that one of the qualities that makes this series exceptional is the way it calls our attention to "deliberate processes of transformation, to human projects, to the working out of Utopian intentions that are not simply the forces of gravity of habit and tradition."[86] A spirit of collective action and radical experimentation is visible, for instance, in the establishment of "Hamsterdam" (a peripheral zone in which the drug trade is tolerated in order to move trafficking away from urban residential areas) in the third season and in a special learning program for disruptive "corner kids" that challenges trivial Band-Aid reforms in the fourth. Lester Freamon's project, his charge to "follow the money" throughout the series, similarly establishes a community with a shared goal.

What may seem like separate impulses—realism and romanticism, description and prescription, empiricism and experimentation—are not ultimately separable in *The Wire*. As I have been arguing throughout this chapter, the series pursues an experience of the perpetual associations that form what we understand as networks. At the same time, it transforms the very networks it renders through its televisual mediation. It is less the case, then, that the show rehearses drug trade protocols, police surveillance procedures, or the structure of the inner-city school system (though it can be said to do all of these things) and more that it fosters sensitivity to an emerging present that is characterized by a network imaginary. Williams's term "structures of feeling" captures something of *The Wire*'s core aesthetic in this latter sense. Without altogether bypassing structure (in its dynamic and process-oriented sense), Williams's method attends to "meanings and values as they are actively lived and felt."[87] Historical changes in the present, which are often too emergent to systematize, are nonetheless felt and come to constitute social experience. Literature and art, Williams observes, often present audiences with forms, genres, and conventions that point to struc-

tures of feeling that are new in a particular moment. Such novel forms appear, as he puts it, at "the very edge of semantic availability." The network, in our moment, is one of these forms. That the word "network" exists and proliferates widely does not make the conditions that it names accessible. *The Wire* makes networks sensible, as they are conceived and perceived, often vaguely, by social actors, as material metaphors, investigative methods, reified structures, and generalized abstractions.

At the same time, *The Wire* accesses the emergent present in more directed political ways. As Williams again observes, "At times the emergence of a new structure of feeling is best related to the rise of a class . . . [and] at other times to contradiction, fracture, or mutation within a class."[88] *The Wire*'s "structures of feeling" are related principally to the failures of the political left in our time. These failures include policy decisions that have led to the breakdown of trade unions (represented by the tragedy of the stevedores in the second season) and to the adverse consequences of deindustrialization for urban black Americans (evidenced in each season of the show).[89] Moreover, the series indicts the American left for a politico-aesthetic failure of adopting a utopian politics. While the series gestures toward utopia several times, it shuts down its most promising and radical projects (Hamsterdam, the "corner kids" classroom, and its central pursuit of money trails) before they can achieve anything but the most fleeting successes.[90]

In place of a utopian impulse, *The Wire* adopts a tragic perspective. In a *New Left Review* essay, T. J. Clark has argued that the left has suffered a massive failure of perspective—an aesthetic lack that finds it without "a rhetoric, a tonality, an imagery, an argument, and a temporality" to confront the present. The left has become, he argues, fixated on a revolutionary past and a utopian future. In place of this perspective, he advocates a "tragic" politics that is "truly present-centered, non-prophetic, disenchanted, continually 'mocking its own presage.'"[91] Clark's political position here comes to resemble *The Wire*'s aesthetic orientation.[92] The series is saturated with tragic conditions: unanticipated betrayals, suicidal spirals, meaningless lives, and unceremonious deaths.[93] Detective McNulty devolves into a drunken, self-destructive mess, alienating even his friends and family. Stevedore Frank Sobotka's son Ziggy murders the black market retailer Glekas and his clerk because he's "tired of being the punch line to every joke." The young addict Sherrod accidentally swallows capsules that his friend Bubbles fills with sodium cyanide—drugs intended for a drug addict who has been stealing from him—thereby sending Bubbles into crippling sorrow and a desper-

ate suicide attempt. Baltimore is a crumbling city plagued by a self-serving political power structure, a drug trade that feeds parasitically on the impoverished (predominantly black) underclass, and a homelessness epidemic.

The Wire's tragic sensibility relies neither on the distance inherent in pity nor on the sublime awe that attends disaster pornography. The tragic, here, is not a tired litany against social ills, a perfunctory rehearsal of economic hopelessness, or a perverse exercise in political nihilism. "Tragedy," Clark again observes, "is a mystery not a chamber of horrors. It is ordinary and endemic." And such immanent ordinariness is precisely what *The Wire* offers. If hope persists, it is never a promise of optimism. Hope in the series remains deeply uncertain, available only at the level of adaptability that actors and communities demonstrate. In the show's temporary utopian zones, prospective greatness is, in a truly tragic mode, reduced to nothing. Hope, as in my reading of *Syriana* in the previous chapter, comes across not in breathtaking futures but in affective potentials that become sensible in the intersections among actors that animate *The Wire*'s network realism.

The Wire's sense of a historical present comes across through its attention to the affective encounters of its actors but also through its formal experimentation, especially with temporality. Time, in this drama, is rarely future oriented. The show refuses cliffhangers, closure, and utopian prolepses. If the spatial form of *The Wire* takes after a distributed network, its temporal form is simultaneously cyclical and serial. The cyclicality is evident, for instance, in the montage that concludes the entire series. Even as certain characters are fired from their jobs or killed off, others step in to adopt their roles, reinitiating a system we have already witnessed for five seasons. Once the rebellious Jimmy McNulty leaves his job, Detective Sydnor takes his place, violating the chain of command by visiting Judge Phelan in his chambers and applying pressure to reenergize a buried investigation. Detective Greggs channels her mentor Lester Freamon, immersing herself in a difficult murder investigation even when it is not her turn to take the case. Michael Lee robs Vinson of a bag full of drug money, stepping into the role held for years by the recently deceased Omar. Fatface Rick and Slim Charles meet with the Greeks, ready to fill in the gap left by drug boss Marlo's departure from the game, much as he once replaced Avon Barksdale and Stringer Bell. Dukie ends up in the streets and shoots dope in a back alley, destined to fill the role of Bubbles, who is now well on his road to recovery. These final recurrences (and many of the show's other structural repetitions) imply stasis for the characters.[94] For the viewer, however, a repetition that is revolving rather than revolutionary also emphasizes the problems with a politics predicated on utopian transformation.

At the same time, the coexisting seriality introduces a difference to *The Wire*'s cyclical repetition. Each season of the television show returns to the same tragic Baltimore mise-en-scène but adds layers of stories, perspectives, and institutions that alter the composition of its formal network—one that accrues complexity but never adds up to a closed totality. This process-oriented serial form captures historical change without merely yielding the dialectical model that has informed a great deal of leftist thought and its utopian aesthetics. Dialectical thinking, in both its idealist Hegelian and materialist Marxist versions, still exists in the service of the very progress narratives that have fueled the most tragic political developments of the contemporary world. Seriality in *The Wire* offers no teleological synthesis—only clashing paradox, irresolvable controversies, and spiraling doubts. Change is figured modestly as network emergence that introduces difference that is rarely under anyone's control. Thus the series remains sensitive to social actors and emergent affective atmospheres that are unexpected, queer, and new (without simply invoking the commoditized "newness" that the show associates with electoral politics, news media, and consumer goods).

As a television series, *The Wire* uses its intersecting forms to make the affective atmospheres of the present sensible and to situate the viewer, self-reflexively, in that environment. Detective Freamon, who tracks drug money through electoral politics and corporate enterprises, explains that he has always dreamed about "a case like this here where you show who gets paid behind all the tragedy and the fraud, where you show how the money routes itself, how we're all, all of us vested, all of us complicit." While the network realism of *The Wire* is more diligent and patient, and less exciting, than the thrilling action of many standard police dramas, it captures entanglements that are rarely seen, ones in which we are all "vested" and "complicit."[95] This complicity (a concept I revisit in my discussion of "collaboration" in chapter 5) may be related to the show's tragic sense, but it is neither depressing nor defeatist. Without allowing a redemptive or future-oriented hope, *The Wire* accentuates a sense of responsibility.

Though *The Wire* is a linear narrative, it can be said to adopt a participatory orientation that is more common to digital media via the oft-mentioned difficulty of its dialogue and its structural complexity (we are interpellated by the tag line to "listen carefully"). Though the quality of a great deal of contemporary programming has led many people to approach television as a passive form of entertainment, McLuhan's writing about television, when it was still a new medium in the 1960s, reminds us of its inherently absorptive and active dimensions. Whereas a medium such as

print is inclined toward explicit expression and elaboration, television compresses and condenses. Moreover, "TV acting," McLuhan observes, "is so extremely intimate, because of the peculiar involvement of the viewer with the completion or 'closing' of the TV image." The television image is a "mosaic form" that "demands participation" and takes on a "tactual" quality.[96] The participation that television invites happens at the level of perceptual closure, but it is also, importantly, collective. Televisual images, after all, are transmitted through the simultaneity of broadcast to millions of viewers or the near-simultaneity experienced through more recent forms of DVD or online streaming.[97] *The Wire*'s network realism may, then, finally, also refer to the social network of viewers and critics that it has brought into existence through its status as a privileged and popular shared narrative.

New media may require conceptual revisions of realism that more fully account for emergent publics and collective formations that experience and create them together. *The Wire*'s impulse to follow its actors through an unthinkably expansive web does not merely gesture toward politics but engages in it. As Latour observes, "To study is always to do politics in the sense that it collects or composes what the common world is made of."[98] The networked narrative forms that I have explored in the first half of this book (in the novel, the film, and the long-arc dramatic television series) mediate and compose the ordinary that sustains the network imaginary. In the second half of the book, I turn to participatory and procedural media (the videogame and the alternate reality game) that, in different ways, represent networks—but also actively and centrally encourage improvisations through them.

Part 2
Distributed Forms

Perhaps networked art is a way to imagine what networks
are for, a way of working things out by trying things out.
**Lucy Kimbell ("If Networked Art Is the
Answer What Is the Question?")**

Paul Sermon's *Telematic Dreaming* (1992), at once a new media installation
and a performance art piece, stands in instructive contrast to the literary,
cinematic, and televisual works that I explore in the first part of this book.
This artwork relies upon and plays with the relational and participatory
dimensions of networked technologies. Sermon sets up installations at
two separate locations, each of which includes a double bed, a camera, a
projector, and "customized video-conferencing systems" connected via In-
tegrated Services for Digital Network.[1] In one location Sermon lies in bed,
while in the other he invites museumgoers (originally in Kajaani, Finland,
but subsequently in several other exhibition spaces) to do the same. Along-
side the visual connection, the pillow on each bed includes a microphone
and loudspeaker that supports bidirectional vocal communication. Though
the projection of Sermon may initially look like an edited video, partici-
pants quickly realize that the artist is relating to them in real time. Depend-
ing on the dispositions and improvisations of the particular museumgoers,
the multisensory interaction that follows can evoke many feelings—from
intimacies associated with interpersonal contact to loneliness spurred by
limited tactility to uncertainty about the meaning of being alone together.
Sermon's artwork thus is not merely a representation or formal invocation
of a network. It relies fundamentally on relations between two people at

a distance, whose exchange is enabled by a network connection. This installation makes available a platform through which people can explore the affective atmospheres of life in the late twentieth century through participatory experimentation with technologies that tap into a networked infrastructure.

The emergence of a network imaginary in the late twentieth century brought with it a reworking of older cultural forms such as the novel and film, as well as illustrations, paintings, and static installations that I do not analyze in detail in this book, but it also introduced new works that were created specifically for networked platforms and social occasions. Networked art does not necessarily depend on computational resources or even on the Internet, but it does tap into the communicational and organizational resources of a culture in which network form is central. Nicolas Bourriaud (who does not himself offer a robust account of new media art) theorizes art beginning in the 1990s as taking on "relational aesthetics" that include "interactive, user-friendly and relational concepts."[2] Even decades before this moment, however, artists were already exploring similar concepts—from the post–World War II avant-garde productions of the 1950s to the postformalism and performance art of the 1960s. As Johanna Drucker observes, by the 1960s, "music, performance, and installation work made use of sensor devices and interactive elements," and by the 1970s, "electronic and digital media were conspicuous elements of a new visual arts landscape." With the growing availability of desktop computers in the 1980s and the popularization of the World Wide Web in the 1990s, new media and networked art practices became even more common and grounded in emerging technologies.[3]

New media studies, as it draws from art history and visual studies, often explores high-art interventions. These include interactive physical installations such as Sermon's, as well as online collaborative pieces such as Harrell Fletcher and Miranda July's *Learning to Love You More* (2002–9). Similarly, literary criticism has most often turned to what I have been calling network aesthetics through works of avant-garde electronic literature, including representational works such as Christine Love's *Digital: A Love Story*, "email fictions" such as Rob Wittig's *Blue Company* (2001–2), and live "netprov" such as Mark Marino's Twitter-based *The Ballad of Work-study Seth* (2009).[4] By contrast, the final two chapters of this book focus on networked art experiments that are more integrated into early twenty-first-century popular culture. The archival and methodological field from which these analyses draw most actively is game studies. The videogames and

alternate reality games to which I attend are not meant to be all-inclusive demonstrations of the aesthetics of networked cultural production. They are, however, intended to be exemplary of the types of procedural, interactive, nonlinear, and networked techniques made possible by digital media to explore a historical context framed by a network paradigm.

Digital games make for compelling cases in the study of network aesthetics because of the profound ways in which they influence human actions and shape affective atmospheres. Marshall McLuhan observes that electronic media alter subjective cognition and intersubjective processes by engaging in the "patterning of human relationships."[5] Like radio and television—media that are at the core of McLuhan's analysis—digital media "pattern" by forming a new sensorium and novel social habits. Like earlier forms, digital media expand aesthetic sensibility. They make available pleasures, forms of embodiment, varieties of immersion, modes of play, and affective intensities that depend not merely on text, images, and sound but also on computational interactions, social encounters, and ludic challenges. Unlike radio or television, however, digital technologies also pattern by simulating dynamic versions of the world. Matthew Kirschenbaum observes that computers are "engines for creating powerful and persuasive models of the world around us."[6] Videogames are arguably the most popular and diverse expressive medium to engage in such modeling.

Beyond simulation, games and networked gaming environments also provide players with shared spaces that they can explore, experiment with, and transform. Types of multiplayer practices in virtual environments may be of sociological interest, but they are also a central dimension of aesthetic experience. Hannah Arendt, whose theory figures prominently in my analysis in chapter 4, argues that intersubjectivity operates as the foundation of aesthetics. Both an interest in beauty and a determination of taste, Arendt observes, even more than thought, depend on others: "You must be alone in order to think; you need company to enjoy a meal." What she (drawing from Kant) calls *sensus communis* is a "common sense" or a "community sense" that is a fundamental dimension of human life, including the capacity for aesthetic encounter.[7] Indeed, in recent years, critics such as Christopher Castiglia and Russ Castronovo have similarly started to explore "the capacity for aesthetics to ground a post-identity collectivity."[8] Such collectivities become visible in spaces such as book clubs or the cinema but, increasingly, they are also an integral part of the aesthetic experience of online cultural works, such as videogames.

Given the importance of intersubjectivity to aesthetics, the following

chapters focus less on the underlying systems of digital games, attending instead to the affects that the networked affordances of these games evoke or make possible. This change in emphasis, occasioned in part by the affordances and effectivities of digital media, at times demands a different set of methods and modes of analysis than those I employed in the first part. My selection of games—with particular focus on Introversion's *Uplink* (2001), Jason Rohrer's *Between* (2008), thatgamecompany's *Journey* (2012), and alternate reality games such as *The Project* (2013), which I codesigned—allows me to juxtapose cultural works that belong to multiple genres, enable varied levels of multiplayer interaction, and have received differing levels of popular attention. What all of these games have in common, however, is attentiveness to the affective dimensions and networked aesthetics of early twenty-first-century digital media. The two chapters and coda that follow examine the participatory and the improvisational qualities of network aesthetics.

– 4 –
Participatory Aesthetics: Network Games

Shifting forms of commonality and difference are
wedged into daily interactions. There are hard
lines of connection and disconnection and lighter,
momentary affinities and differences. Little worlds
proliferate around everything and anything at all.
Kathleen Stewart (*Ordinary Affects*)

Producing a form is to invent possible encounters;
receiving a form is to create the conditions for an exchange,
the way you return a service in a game of tennis.
Nicolas Bourriaud (*Relational Aesthetics*)

The novel, the film, and the television series aestheticize networks primarily through linear narrative forms. In distinction, digital games (including computer, video, and mobile games), though not categorically nonnarrative, tend toward nonlinear or multilinear forms that are increasingly dependent on telecommunications networks for their key functions. Just as novels transformed alongside and in relation to print cultures, especially with the greater output and circulation of printed material in the eighteenth and nineteenth centuries, digital games emerged and developed in conjunction with technological shifts in computer and networking culture in the late twentieth and early twenty-first centuries.[1] For these reasons, in this chapter, I treat digital games as a paradigmatic cultural form of the current network era, as well as an instructive microcosm of the broader media situation taken up by new media studies.

The first digital games—experiments such as Steve Russell's *Spacewar!* (1962)—were created primarily by students at research universities.[2] In the United States in the 1960s, access to computers was limited to government research labs and to academic researchers at places such as the University of Utah, Stanford University, and MIT (where Russell created *Spacewar!*). The earliest game experiments, created in these settings, were followed by arcade and home videogames in the 1970s and 1980s. During these years, digital games began to borrow from other media and social forms. Some games were direct adaptations from other media (e.g., Atari's 1982 games *Star Wars: The Empire Strikes Back* and *E.T. the Extra-Terrestrial*).[3] Other games borrowed properties from other forms, remediating the narrative structures of novels, the representational condensation of poetry, the moving images and shot transitions of cinema, the seriality of television, the role-playing of theater, and the team dynamics of sports. At the same time, these games incorporated features unavailable in or secondary to these earlier forms, including interactive puzzles, enacted mechanics, and navigable spaces. Digital games introduced new aesthetic experiences and pleasures such as hypermediated immersiveness, user agency, and networked play.[4]

While computing accounts for many aspects of the development of digital games, the related expansion of computer networks has also been crucial. As Sherry Turkle describes this change in our relationship to computing, "Whereas in the 1980s that relationship was almost always one-to-one, a person alone with a machine, in the 1990s, this was no longer the case. By then, the computer had become a portal that enabled people to lead parallel lives in virtual worlds."[5] The rise of the World Wide Web in the 1990s and the rapid transition from local area networks (LANs) and dial-up connections to "always on" broadband Internet access around 2001 had a significant effect on the form, production, distribution, and culture of digital games. Though some earlier games relied on multiple participants or network connections, single-player games dominated the commercial digital game industry from the 1970s through the 1990s.[6] Since that time, the rise of networked games has reinforced the fact that across a longer history, the majority of games, whether analog or digital, have had manifestly social and multiplayer dimensions. The single-player videogame is thus, in some senses, a short-lived innovation of the first three decades of the form's commercial development. Despite the emergence of casual and independent single-player games, the high budgets of large-scale single-player videogames have increasingly restricted their production to AAA studios such as Electronic Arts.[7]

Online games date back to Richard Bartle's multiplayer text-based computer adventures *MUD1* from 1978. Early text-mode games such as *Snipe* (1983) and graphical multiplayer worlds such as *Habitat* (1985) were also important early experiments with online gaming.[8] In the 1990s, a number of games with 3D graphics that were created for personal computers, especially first-person shooters such as *Doom* (1993) and *Quake* (1996), began to popularize online play through so-called deathmatches in which multiple players competed. Online play did not gain popularity in console-based gaming, as it had in earlier computer games, until the sixth generation of systems that included Ethernet ports, built-in modems, or online compatibility. Consoles that supported online play to differing degrees included the Sega Dreamcast (1998), PlayStation 2 (2000), Xbox (2001), and GameCube (2001).[9]

It was not, however, until a few years later that online gaming would become a widespread phenomenon with entry into what is commonly called the Web 2.0 or the participatory media moment, characterized by the gradual proliferation of social networking sites, user-generated web content, bookmarking, microblogging, and cloud computing. In 2002, Microsoft launched the Xbox Live videogame distribution and communications platform for its Xbox console, followed closely by Valve's 2003 service Steam, which similarly made computer games available online. These services (along with others such as PlayStation Network and Nintendo Network) encouraged online discussions, content sharing, competitions, and achievement badges. By the seventh generation of consoles, including the Xbox 360 and PlayStation 3, a growing number of digital games were fully networked. During this period, massively multiplayer online games (MMOGs), such as *World of Warcraft* and *Star Wars: The Old Republic*, attracted millions of players who inhabited their colossal 3D worlds together.

Increasingly, digital games enable real-time interactions among players who often connect across considerable distances. If cinema flourished in the local theater, we might say that the twenty-first-century videogame adopts the space and time of the transnational Internet. Despite the growing centrality of networks in digital game culture, as well as a longer history of social analog games, a good deal of videogame analysis still focuses primarily on single-player productions and their unique aesthetics. For instance, one of the best available books about gaming culture, McKenzie Wark's *Gamer Theory*, almost exclusively studies the single-player experience. In his conclusion, Wark presciently speculates, "Perhaps the single-player game will become an anachronism, superseded by multi-

player worlds. . . . Perhaps, like silent cinema, the stand-alone game will be an orphaned form."[10] Regardless of what might happen to single-player productions, both the networked and social qualities of digital games alter how we can and should approach them. Games are not self-contained entities that can be treated solely through structural analysis. As Caroline Pelletier observes, "Games are enacted as objects of meaning" that must be understood as "ways of construing ideas, beliefs, and experiences, emerging from particular social relations."[11] The nature of those social relations shifts, yet again, when we move from predigital postal correspondence games such as chess or face-to-face games such as Texas Hold'em or side-by-side multiplayer digital games such as *Pong* to twenty-first-century online videogames played together from a distance in real-time.

The increasingly networked qualities of digital games in general, as well as the experimentation with network aesthetics in a subset of these games, complicate the uniformity implied by network visualizations. A number of participatory and procedurally oriented cultural works, especially games, have engaged in meaningful experiments with and within networks. For the remainder of this chapter, then, I turn to three game nodes to explore this claim. All of these games treat interconnection not as one feature among others but as a crucial representational form or aesthetic affordance. First, briefly, I consider the genre of simulation games through a reading of Introversion's *Uplink* (2001), which puts the player in the position of a hacker who must negotiate transnational computer networks. Though this single-player game promotes a reflection on the relation between individual agency and global totality, it represents networks predominantly as entities that can be managed through cerebral and controlled gameplay. Unlike this first popular game, the next two nodes belong to a category of experimental "artgames" or "serious games" that make sensible ordinary networked relations.[12] Jason Rohrer's two-player online game *Between* (2008) shifts the player's sense of networks as media objects and cognitive constructs to networks as processes of mediation. Similarly, thatgamecompany's PlayStation 3–exclusive game *Journey* (2012) uses networked connections to emphasize the affective and relational potentials of games, while also encouraging the production of emergent online narratives that intensify the game's aesthetics.

Overall, this chapter explores how digital games use participatory aesthetics to shake up a sense of networks as monolithic structures. Though the participatory quality of network aesthetics resonates most strongly with the networked cultural works that I explore in the second part of the

book, it is worth noting that the novels, films, and television series I discuss in the first part also inspire intense involvement and participation from their readers and viewers. The games I analyze in this chapter use participation to complicate a series of concepts that are immanent to contemporary forms of connectedness, especially "control," "action," "extimacy," "strangerhood," and "play." As each section takes up a different concept, it also models a distinct method for studying networked games. Thus, I analyze *Uplink* through close reading, *Between* through a personal account of gameplay, and *Journey* through analysis of an online archive (the Tumblr blog *Journey Stories*). These methods offer varied perspectives on games that, except for *Uplink*, do not only depict networks but invite players to participate in networked relations.

A prevalent understanding of videogames associates them with forms of sovereignty—for instance, management of an avatar through a controller or keyboard input, mastery of a game through a speedrun, or player agency through narrative and action-oriented decision making. Indeed, games such as *Uplink* actively celebrate these qualities of digital games. Both *Between* and *Journey*, however, trouble the concept of sovereignty and its centrality to digital media. These works complicate what it means, fundamentally, to be an agent in a networked space. Though agency is commonly figured as control, it is better characterized, in Kathleen Stewart's words, as "lived through a series of dilemmas: that action is always a reaction; that the potential to act always includes the potential to be acted on, or to submit; that the move to gather a self to act is also a move to lose the self; that one choice precludes others; that actions can have unintended and disastrous consequences; and that all agency is frustrated and unstable and attracted to the potential in things." Agency thus emerges from a complex affective field of actualizable potentials, "a network of transfers and relays."[13] Games such as *Between* and *Journey*, I argue, use design decisions and constraints both to open up a field of affective potentials and to make those potentials available to thought and relational play.

Network Simulations and Control Societies: *Uplink*

Even prior to the reliance of games on networked connectivity, digital games frequently demonstrated a representational relationship to networks. To elaborate this point, it is necessary to explain what most digital games *do*. Rather than reproducing the interior rhythms of human thought, as novels often do through psychological commentaries and stream-of-

consciousness techniques, digital games model worlds and create micro-cosms of dynamic systems, allowing players to interact with them.[14] Though the process of playing a digital game can be described as interfac-ing with graphical representations or participating in an interactive story, it more properly involves negotiating the parameters of a designed system. To complete a digital game, a player must functionally reverse-engineer its algorithm. As the designer Anna Anthropy notes, games excel at "exploring dynamics, relationships, and systems" and making sense of the "relation-ships between things, because the player does not merely observe the inter-actions; she herself engages with the game's systems."[15] Though the nature of player agency is complex and variable depending on the particular game in question, all games involve some combination of interactions with rules, procedures, objectives, other players, and (in digital games) software.

This system-oriented way of thinking about games is especially clear if we consider single-player system simulations that encourage users to ex-plore the dynamic operation of networks. Perhaps the most popular and widely recognized simulation is Will Wright's classic game *SimCity* (1989). This game requires players to think about processes of urban planning and organization. By adjusting numerous variables that control for factors such as crime and pollution, users attempt to build a successful metropolis.[16] Wright's second game, *SimEarth* (1990), expands the scale of its predeces-sor and examines global ecological networks through an interactive simu-lation of James Lovelock's Gaia hypothesis. Both of these early popular sim games engage with complex networks that are real but cannot be grasped by human players at a phenomenal level. Wright's games helped to popular-ize a gaming genre that now includes sports simulations such as the *Madden NFL* series (1988), social simulations such as *The Sims* (2000), "god games" such as *Black and White* (2001), medical simulations such as *Trauma Cen-ter: Under the Knife* (2005), and transnational political simulations such as *PeaceMaker* (2007).

Though most simulation games represent social assemblages and large-scale networks, one subset of these games—what we might call computer network simulations—is perhaps the most suggestive of dominant repre-sentational strategies of single-player digital games that seek to aestheticize networks. In these games, the user usually role-plays a hacker who must learn and negotiate computer networks, in order to develop professional experience, pursue financial gain, or simply execute exploits. These games range from 1980s cyberpunk-inspired titles such as *System 15000* (1984) and *Hacker* (1985) to simulators such as *Hacker Evolution* (2007) and *RVL*

Hacker (2009).[17] One of the most popular, influential, and fully realized of these games that includes several features of the subgenre is Introversion's *Uplink* (2001). Like many related simulations, *Uplink* is a single-player game that stages a network hacking experience instead of relying on actual real-time network interactions.

In *Uplink*, the player takes the role of a hacker—a "freelance" agent—who seeks out contract work through the Uplink Corporation. Though the game contains a narrative, its main mode is one of a simulator organized through a series of episodic missions that the player selects. At the beginning of the game, the player takes a low-interest loan of 3,000 credits with Uplink International Bank and accesses the Uplink Bulletin Board system to search for work. The game proceeds as a series of contracts that the player takes on to earn additional credits. The missions require the player to delete compromising information, steal data from one corporation for another, test security protocols, acquire government agent lists, and more. Rather than striving for realism, the game follows conventions, as the Introversion site suggests, of 1980s and 1990s Hollywood films such as *WarGames* (1983), *Sneakers* (1992), *Hackers* (1995), and *The Net* (1995).[18] The game does not promise an authentic hacking experience, but instead privileges action-oriented suspense and diegetic immersiveness. To achieve this effect, *Uplink* never announces itself as a game but interpellates the player as an actual user who dials into a public access Uplink server, chooses a username and password, and begins a career as a hacker.

Uplink's aesthetic approach to networks is made sensible to the player at two levels: the audio-visual interface and the game mechanics. The network in *Uplink*, then, takes two primary forms that map onto its audio-visual and interactive aspects: first as a representation or visualization and second as an actionable resource or technical challenge. In other words, the network is, at once, a map of interconnections and an instrumental infrastructure through which a hacker actively builds a career while negotiating new types of threats such as other human hackers, nonhuman firewalls, trace programs, and viruses. At both of these levels, the network becomes a flexible and polysemous figure that is accessible only indirectly, through mappings and actions.

First of all, the interface, especially at a visual level, is unusual for a 2001 game insofar as it uses a minimalist and menu-driven 2D layout at a moment when 3D graphics had already become dominant (fig. 4.1). The primary menu choices allow you, the player, to run a software application, examine the hardware installed in your "Gateway computer," check your

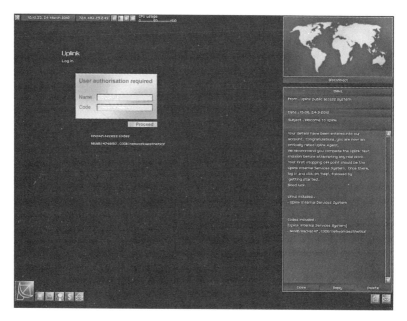

4.1. Main interface of *Uplink* (Introversion, 2001).

available memory banks for software and data storage, monitor your status in the world hacker rankings, receive an overview of your financial situation, or send an email to an employer. Additionally, you receive ongoing updates via a data and time display and a trace tracker. To hide your tracks and avoid capture, you must make sense of data, and do so quickly, in order to manage your network presence.

Uplink's visualization of computer networks is largely textual and numerical. The one major exception—a common feature of hacking simulators—is a standard cartographic equirectangular projection of the Earth that a player must access before any hack. Superimposed on this map, a total global space, one sees a distribution of major organizational nodes (fig. 4.2). At the start of the game, the player is assigned "a Gateway computer system in your chosen server room," which is located at one of these nodes, in a major metropolis: Los Angeles, Chicago, New York, London, Moscow, Tokyo, Hong Kong, or Sydney. These sites mark the network as aspirationally global but also identified with urban spaces and cultures. From the selected home location, the player can connect "to the rest of the world" and create links among the available nodes in order to "bounce" through intermediate systems en route to the ultimate target of any given hack. The primary Gateway node thus appears on the map interface along with other known servers. In any mission, the player may create a route

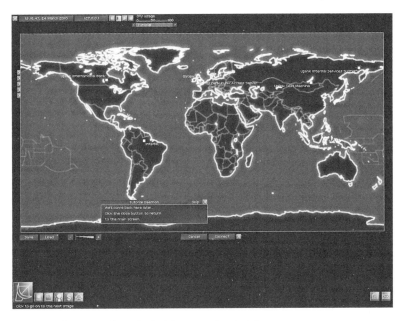

4.2. "Global" map interface of *Uplink* (Introversion, 2001).

that passes, for instance, from Chicago to South Africa to India to Mali and then to the southern United States. The vagueness of these intermediate locations—cities, countries, and regions marked only with their corporate affiliations—demonstrates that this map does more to communicate an aesthetic sense of the network than to produce a precise constellation of coordinates. This global interface marks a fantasy of totality: an objective space that can be comprehended, mastered, and hacked when overlaid by a synoptic network. In fact, the interface contains only a small subset of possible locations and includes only limited information about the available constellation, but the aesthetic conventions of the world map convey a sense of a totality known in advance. Moreover, maneuvers through the established network entail no sense of geographical or cultural specificity— the difference between Perth and Cairo is figured as little more than the difference between a hack of the "Elite Inc. Internal Services Machine" or the "International Academic Database." Nevertheless, network movements are not immaterial. Each time a player connects to a computer server, her location is "logged." These logs record the connection between the player's local host (e.g., the IP address 127.0.0.1) and the sites through which that connection is routed. From early on, the player learns to delete these concrete traces at every turn.

Important though the interface may be, *Uplink*'s game mechanics offer

arguably even greater insight into the ways that the game uses participatory aesthetics to explore computer networks. Mechanics and interactive procedures, after all, are a central method by which players take part in digital games. The network in *Uplink*, both in its visualized and actionable form, illustrates Jameson's observation about how computerized media technologies become "virtually the representational solution as well as the representational problem of this world system's cognitive mapping, whose allegories can now always be expected to include a communicational third term."[19] "Communication," in fact, becomes an unavoidable term in a world that is increasingly dependent on computer networks. In this game, communication actually operates as *the primary form of player action* (e.g., through emails that initiate and conclude each transaction) and suggests a distinctive form of control that becomes palpable in gameplay.

To make sense of how *Uplink* intertwines networks and control through its action orientation, it is helpful to turn for a moment to Gilles Deleuze's theory of "control" (introduced in 1990 and influenced by William Burroughs's earlier writing), which serves for him as a periodizing concept. Deleuze argues that late twentieth-century societies "no longer operate by confining people but through continuous control and instant communication."[20] In place of the institutional organization and discipline described in Foucault's work on the eighteenth and nineteenth centuries, Deleuze observes that power, in the late twentieth century, is no longer practiced primarily on "individuals" or "a mass," which are marked, respectively, by the technologies of the signature and the register. In control societies, we find instead "dividuals" and data "banks," which are managed through "codes indicating whether access to some information should be allowed or denied."[21] Building on Deleuze's narrative, we can add that the rise of computation and networking during this period introduced still other forms of control. These technologies distribute human identities across a matrix of network effects: usernames and passwords, but also "cookies" that track activities, social media "likes" and "upvotes" that record user preferences, and so on. Alongside new forms of control, Deleuze insists, emerging communications also make possible new "forms of delinquency or resistance." The figure of the hacker, in fact, serves as Deleuze's primary example: "Computer piracy and viruses," he writes, "will replace strikes and what the nineteenth century called 'sabotage' ('clogging' the machinery)."[22]

This brief reroute through Deleuze foregrounds the ways that computer network simulations might both embody the protocols of control societies and, in some cases, suggest forms of resistance that emerge from within a

networked present. As I have argued elsewhere, videogames, regardless of content, implicitly channel the form of control societies, inviting players to practice or manipulate modes of affective labor, finance capital, rapid management of information, and identity modulation.[23] Specifically in *Uplink*, it is crucial that the figure of the hacker already does not serve as a vision of opposition to control societies, as it did for Deleuze two decades earlier. Through game form, the act of hacking becomes a series of actions—a pattern of activity—necessary to succeed at the game. The game's action achieves primacy, almost immediately, over the interface. In other words, the speed and accuracy necessary to complete missions shift the player's attention from the visuals and fast-paced synthesized soundtrack, making them less noticeable and more naturalized from the start. The centrality of action, here, is closely connected to the game's objectives. *Uplink*'s goal is to become a top hacker and to rise in the global rankings but also, at the start, to get out of debt (paying back the 3,000-credit loan) and to earn enough money to afford the rental of the Uplink public access server (300 credits a month). For this reason, the player experience begins with a sense of urgency. After a brief tutorial, straightforward missions begin to feed into more difficult ones. To complete a successful hack requires knowledge of one's available tools, rapid navigation of menus, quick data processing, and timely replies to employer emails. In other words, hacking here is not resistance to the dominant order but a way of mastering a postindustrial workplace organized by constant management of one's network presence. The player, in *Uplink*, is essentially a freelancer or consultant who engages in corporate espionage, stealing data for whichever company pays best, and then moving on to the next job to compete with rival hackers who also work for the Uplink Corporation.

Through *Uplink*'s gameplay, the network and its forms of control become sensible not merely as a topology or a constellation of spatial coordinates but as a temporal concept.[24] During any hack, time is a finite quantity and a scarce resource. How much time one has to complete a mission depends on both the quality of one's purchased software tools and the plotted spatial route of connections. During a hack, time becomes explicitly spatialized. For example, a digital clock shows the passage of precious seconds. This interface comes to resemble the screens that dominate the environment of exchange traders. As Katherine Hayles has observed, while spatial locations of events are important to the work of traders and investment bankers, "the effect that dominates is watching time unfold." For a hacker, as for traders, "temporality becomes a place to inhabit."[25] One major ad-

vantage to a spatialized temporality is that it converts the standardized unidirectionality of time into multidimensionality. For instance, a skeuomorphic option enables the *Uplink* player to accelerate time at will, pausing the action or fast-forwarding it to make later missions available. Moreover, during hacks, the Trace Tracker converts remaining time into percentages, showing how close a security program or enemy is to securing a trace. In order to maximize password-breaking efficiency, a player must manage CPU time, assigning greater or lesser quantities of it to critical programs. The screen here serves as an action-oriented interface that encourages a desire for balance and control.

To be sure, hacking in *Uplink* maintains the countercultural cool and oppositional feeling that Deleuze ascribes to "computer piracy." The mechanics and objectives of the game, however, belong to the protocols of a control society. In theory, if the player leaves behind a log or fails to disrupt a trace, she risks a prison sentence and losing her job with the Uplink Corporation. In practice, many offenses lead only to fines that must be paid off to avoid losing the game. Therefore, the primary objective of the game is earning more money. The game's system privileges the threat of debt over player containment and offers the promise of upward mobility in one's hacking career, requiring the player to negotiate data banks and codes in a continuous fashion. To be a subject, in this game, means having a username and a password. When one selects missions, the involved actors remain largely anonymous. For instance, a client called "Digital Microsystems" may offer a mission to hack into a "CDU Microsystems Internal Services Machine" in northern Canada and to destroy a particular piece of data (identified only as an alphanumerical string) and all of its backups. The player learns nothing about the identity of the employer or the nature of the data. Successful network maneuvers, after the mission, yield primarily experience points and money.

Despite its data-based gameplay, *Uplink* does not completely privilege cerebral over affective engagement. Hacking leads to a range of affects: urgency, panic, paranoia, and intense attachment to the game screen. Indeed, the gameplay can be said to depend on the management of these affects, which represents a key dimension of postindustrial labor and life in a control society. In *Uplink*, a focused, well-organized, and calm player is more effective at the algorithmic operations that make up the core mechanics—namely, the sequence of steps necessary to break a password, follow a trace, locate a file in order to copy or delete it, erase all logs, disconnect from the network, and communicate with one's employer. These core mechanics,

however, instrumentalize the imagined network, approaching it as an infrastructure and a thing through which a hacker balances risks and rewards. More than anything, the network becomes an object to be mastered, modulated, and controlled through skillful actions.

Though Deleuze does not discuss digital games as such, he notes that game form is a core feature of control societies, in the transition from industrial factories to postindustrial businesses:

> There were of course bonus systems in factories, but businesses strive to introduce a deeper level of modulation into all wages, bringing them into a state of constant metastability punctuated by ludicrous challenges, competitions, and seminars. If the stupidest TV game shows are so successful, it's because they're a perfect reflection of the way businesses are run. . . . Businesses are constantly introducing an inexorable rivalry presented as healthy competition, a wonderful motivation that sets individuals against one another and sets itself up in each of them, dividing each within himself.[26]

Even as a single-player game, *Uplink* foregrounds competition through experience levels and hacker rankings. It would be premature and reductive, however, to conclude that all games are simply symptomatic of control societies and their relationship to networks. The remainder of this chapter, then, turns to two artgames that complicate control as a primary network mode and experiment with network affects and relations. In these games, networks are still aestheticized through both interfaces and gameplay. However, rather than serving as sublime totalities or tools for increased control, they operate as constantly changing indices of relationships between players and their uncontrollable others. These games, *Between* and *Journey*, do not merely *model* networks. Instead, they use actual Internet connections among players to access the relationality of networks, aesthetically and affectively, from the inside. Moreover, these games animate a series of concepts that offer insight into the often opaque nature of ordinary connectedness as it manifests in our historical present.

Action and Extimacy: In *Between*

Even as digital game design was, in its early decades, largely the work of computer engineers, the form has, in the early twenty-first century, attracted a wide range of creators coming from backgrounds in art, creative writing, design, education, and computer programming. This develop-

ment, which requires a short overview, has enabled some novel innova-
tions, including myriad experiments with network form. Shortly following
the early period of computer game experiments, which included innovative
"hacks" such as Russell's *Spacewar!*, digital games developed into a com-
mercial enterprise. As the game historian Steve L. Kent notes, "Steve Rus-
sell made no attempt to copyright his work or to collect royalties from it.
He was a hacker and had created his game to show that it could be done."
By contrast, the first coin-operated commercial game, *Computer Space*
(1971), a close imitation of Russell's *Spacewar!*, was produced to make
profits. The creators of the game, Nolan Bushnell and Ted Dabney, would
go on to found Atari in 1972, a start-up that would within ten years "grow
into a $2-billion-a-year entertainment giant, making it the fastest-growing
company in US history."[27] With the exception of the short-lived videog-
ame industry crash of 1983, games continued to expand quickly into the
multibillion-dollar industry they are today.

In the early twenty-first century, numerous transformations that accom-
panied the business practices of Web 2.0 and a broader participatory on-
line culture have affected the ways that digital games could be created and
disseminated online. Even though there are earlier examples, it was only
around 2007 that we saw a widespread expansion of the related, though
separate, phenomena of "artgames," "indie games," and "DIY game mak-
ing." This moment saw the rapid rise of an emergent game scene through
a new focus on auteur-style star game designers and the rise of local maker
movements supported by blogs and community events. The years 2007
through 2009 also gave rise to a greater number of successful artgames than
ever before, including *Passage* (2007), *The Marriage* (2007), *The Grave-
yard* (2008), *Braid* (2008), *Flower* (2009), and *Every Day the Same Dream*
(2009).[28]

A major figure in the artgames movement has been Jason Rohrer, who
released his first game, *Transcend*, in 2005. His groundbreaking produc-
tions have included *Passage* (which uses game rules to create a five-minute
memento mori) and *Inside a Star-filled Sky* (which explores infinity and
recursion through computational processes). In all of his work, Rohrer
has approached digital games as a medium of thought. His game *Between*,
which I analyze here, is an experiment with network aesthetics that re-
flects on concepts of action and extimacy (a term that captures the exteri-
orization and breakdown of intimacy) through online play. *Esquire* hosted
this game in 2008 and made it available for Windows, Mac OS, and Linux.
Instead of relying on the studio processes responsible for so many digital

games, Rohrer single-handedly produced the game's code, as well as its multilayered procedural music, pixel-art graphics, fonts, and animation. In 2009, *Between* won the Independent Games Festival's Innovation Award.

Unlike games such as *Uplink* that seek to simulate or trace network structures by putting players in the extraordinary role of expert hackers, *Between* entangles players in network interactions that are comparatively ordinary and epistemologically unprivileged. From its opening screens, *Between* makes it clear that it is a networked and multiplayer game. Once the player logs in, the game immediately communicates that it is locating the server. After initiating that connection, the game can only begin when the player chooses one of three options: "Create a new game for a friend to join," "Join a game that a friend has started," or "Join a game with a stranger." In a short introductory note, Rohrer counsels, "If you must play in the same room as your partner, do not look at your partner's screen—it will spoil the effect of the game." Once a player forms a connection with a friend or stranger, she sees a tiny pixelated figure in a pixelated landscape. The game offers instructions about how to move but does not offer any explicit directive or objective. The available controls allow the player to move the avatar on a horizontal axis across a bounded level. At the center of the level, the player discovers a tower composed of colored tiles. She also discovers that by pressing the *S* or *W* key (letters that arguably stand for "Sleeping" and "Waking"), she moves among three dream worlds that are identical except for varied environments of grass, soil, and tundra (fig. 4.3). Each terrain has its own tower.

The primary objective of the game itself is simple. The player must generate colored blocks by using a 2-by-2 wooden frame and an inventory of red, green, and blue blocks (fig. 4.4). Once the blocks match those on the tower template, they can be placed in the corresponding slot. For each correct placement, the player receives feedback in the form of a song that plays, rises in volume, and adopts new sonic layers with each added block. The goal of the game is to complete the tower.

By the time the player has worked out the basic controls and objective, uncertainty about the other player's role becomes unavoidable.[29] While the game makes a point of introducing itself explicitly as a two-player venture that requires a network connection, the second player does not appear anywhere on the screen. As a result of these frustrated expectations, playing *Between* can be a lonely experience, especially if the second player is not sitting at a computer that is located in the same physical space. The way that the potential role of the other player first becomes apparent is through

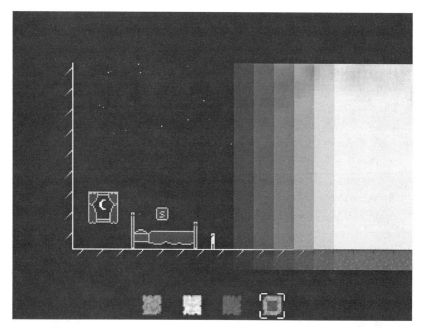

4.3. Moving between "sleeping" and "waking" in *Between* (Jason Rohrer, 2008).

4.4. Basic gameplay in *Between* (Jason Rohrer, 2008).

4.5. Expanded inventory in *Between* (Jason Rohrer, 2008).

the lack of resources needed to progress. Namely, there are squares on the tower that require combinations not only of available red, green, and blue blocks, but also of elusive magenta, yellow, and cyan blocks. The appearance of these three other blocks, it turns out, depends on the actions of the other player. Since the game provides two players with no means of direct communication, the precise mechanisms by which these blocks appear remain, in most sessions, a mystery. However, if each player continues, patiently, to build up the tower, in parallel, the other's actions will expand the inventory to include the required colors (fig. 4.5).

Between, then, is an unconventional multiplayer, networked game. Ian Bogost puts it well in a review when he writes, "When we talk about games, we normally use the language of conjunction, whether through accompaniment ('to play with') or conflict ('to play against'). Whether for competition, collaboration, or socialization, multiplayer games aim to connect people in the act of play itself." *Between* engages in a very different mode of what Bogost calls "disjunctive multiplay," one that, I would add, depends fundamentally on the affordances of networked play at a distance.[30] As Rohrer himself observes, "*Between* erects an almost impenetrable barrier between the two players and then still demands that they

somehow communicate through that barrier, at least minimally, in order
to progress in the game." Only on occasion does a player receive a glimpse
of her partner's work, and at those moments the tower appears distorted
and asymmetrical. As Rohrer puts it, in the interaction of *Between*, "Your
red is my cyan. Your music is my silence."[31] By making gameplay reliant
on computer networks, and requiring players to reflect on the specificity
of that connection, *Between* takes a different aesthetic approach than the
more common network visualization. The game is not a representation or
a static map of a network. It is instead an experiment with relationality and
the processes that make up networked mediation. In particular, *Between*
suggests a shift from thinking *about* networks as formal objects to thinking
through networks as perpetually changing formations that complicate the
way we imagine control and play in the historical present.

It is critical to emphasize that in *Between*, the Internet connection and
relationship to the other player become sensible and thinkable specifically
through game form that produces action-oriented players. This medium-
specific role carries with it various consequences about the type of engage-
ment with networks that the experience enables. In approaching digital
games as action-oriented media of thought, I find it useful to consider Han-
nah Arendt's theory of action. Though her distinction between "spectator"
and "actor" may speak more properly to the art form of theater, it opens up
a discussion about videogames in productive ways. Arendt observes that
the notion that "only the spectator but never the actor knows what it is all
about" is "as old as the hills; it is, in fact, among the oldest, most decisive,
notions of philosophy. The whole idea of the superiority of the contem-
plative way of life comes from this early insight that meaning (or truth) is
revealed only to those who restrain themselves from acting." The spectator,
Arendt explains, can gain insight and meaning through "his disinterested-
ness, his nonparticipation, his noninvolvement." If the spectator watches
from a distance in order to perceive the whole of an unfolding situation,
the actor "is dependent on the opinion of the spectator; he is not auton-
omous (in Kant's language); he does not conduct himself according to an
innate voice of reason but in accordance with what spectators would expect
of him."[32] Though this language of acting according to expectations might
imply conformity, for Arendt, it more directly entails a sense of interde-
pendence—a quality that makes action especially appropriate for thinking
through networks. Thus, whereas a spectator remains impartial, capable
of judgment, and sovereign, the actor is involved, uncontrolled, and de-
cidedly nonsovereign. The very idea of a "critical" game, then, seems to

complicate Arendt's distinction.[33] It appears, at least at first blush, that if "theory" means "to look at" (the Greek *theoros* is a "spectator") then the engagement that games provide is fundamentally nontheoretical. Games, after all, proceed through action. And yet Arendt's analysis suggests that an actor is capable of a different type of philosophical and aesthetic engagement that becomes evident in gameplay.[34]

While earlier literary and artistic forms open up to possible activities or interactions, digital games are distinctive, as Alexander Galloway observes, insofar as they are action-oriented and can *only* be enacted or experienced through a combination of player and machine actions.[35] Thus, actions and actors (that is, players) are absolutely integral to the operation of a digital game. It is important to point out, however, that the nonspectatorial and nonsovereign "actor" of Arendt differs from the player "actor" often mentioned by game designers and videogame theorists—or the one implied in games such as *Uplink*. Take, for instance, the type of action implicit in the oft-discussed application of Mihaly Csikszentmihalyi's concept of "flow." Flow is "the state in which people are so involved in an activity that nothing else seems to matter; the experience itself is so enjoyable that people will do it . . . for the sheer sake of doing it."[36] Csikszentmihalyi contends that games like chess are an excellent source of flow and that "play is the flow experience par excellence."[37] Digital game designers have, then, unsurprisingly, adopted the concept of "flow" to describe ludic challenges that players overcome through actions.

Flow relies on activity. However, it describes an active mode that departs in some key ways from the capacities of Arendt's "actor." For Csikszentmihalyi, happiness depends on "achieving control over the contents of our consciousness." We attain what he calls "optimal experience" when we develop a "sense of mastery" over our actions. In enhancing a feeling of control, flow contrasts with "psychic disorder—that is, information that conflicts with existing intentions, or distracts us from carrying them out" such as "pain, fear, rage, anxiety, or jealousy." Not only does flow require a feeling of control and order, but the achievement of happiness depends on the individual. Csikszentmihalyi admits the "limitation of consciousness" to process information but still insists on a subject who *directs* flow. "The mark of a person who is in control of consciousness," he observes, "is the ability to focus attention at will, to be oblivious to distractions, to concentrate for as long as it takes to achieve a goal, and not longer."[38]

Many digital games—from Atari's 1976 *Breakout* to Blizzard's 2010 *StarCraft II*—unquestionably interpellate a player who must achieve con-

centration, self-control, and precision in order to succeed. However, games such as Rohrer's *Between* invite a different kind of player who has much more in common with Arendt's partial "actor." Drawing on its dual legacies as a multiplayer computer game and a network art object, *Between* induces what we might describe as a flux (rather than a flow) between sovereignty and nonsovereignty, solitude and togetherness, task-orientation and chaos, a break (as a pause in videogame action) and a break (as a rupture in thought). Similarly, *Between* oscillates between a structured game and a process of play. If a game is, as Katie Salen and Eric Zimmerman put it, "a system in which players engage in an artificial conflict, defined by rules, that results in a quantifiable outcome," play is a perpetually changing activity, albeit one that is never free of rules or structure.[39]

I return to the concept of play later in this chapter; here, however, it is worth noting that *Between* playfully uses both its mechanics and its networked dimensions to confound control as a key condition of gameplay. Rohrer's game may initially appear competitive—a race between players to complete their respective towers first—but it increasingly takes on cooperative dimensions as players discover that they are dependent on each other for critical building blocks. Moreover, though *Between* has a central structure and rule set, it complicates Salen and Zimmerman's core game element of "a quantifiable outcome." Even if a player completes a tower (which is incredibly difficult and time-consuming), there is no teleological or extrinsic finality to the game. A player does not receive points, and the software does not acknowledge that the game has ended.[40] Instead of presenting a narrative arc that leads from alienation to fulfilled connection, the game promotes experiences of dysfunction and unbecoming that are less commonly acknowledged in network cultures. *Between* is much more likely, then, to end in quitting than in a feeling of coordinated victory (indeed, every time I teach this game, students quit midsession, usually after just a few minutes, because they are impatient with its difficulty and lack of transparency). As it unfolds, *Between* introduces unstructured play that is characteristic of what Roger Caillois calls games of vertigo, or "ilinx," that "destroy the stability of perception and inflict a kind of voluptuous panic upon an otherwise lucid mind."[41] Though the game seems to suggest a controlled method of play, it quickly confuses action, as block patterns become ever more intricate and the oscillation among dream states grows frustrating.

Action becomes a critical network concept, as I noted earlier, insofar as it depends fundamentally on an experience of interdependence. Arendt

points out, in *The Human Condition*, that philosophy's "instrumentalization of action . . . has of course never really succeeded in eliminating action, in preventing its being one of the decisive human experiences." In their role as actors, Arendt contends, human beings realize not their sovereign agency but rather their entanglement in a "web of human relationships"—an intersubjective messiness that becomes, as she extrapolates from Kant, the very ground of aesthetics. Contrary to much of the Western philosophical tradition, Arendt comes to associate freedom with nonsovereignty.[42] The actor's lack of autonomy, in other words—the fact that she is a networked being—opens up the capacity for new forms of intimacy, forgiveness, and promise-keeping.

In its dependence on both game rules and intersubjective play processes, *Between* remains an action-oriented artwork. It is difficult to make generalizations about the play experience of *Between* based simply on its form. Arguably that methodological difficulty is unavoidable when discussing a networked game that relies always on a player's particular experience and a specific connection to a singular other player. To analyze *Between*, one must adopt a partiality—a sense of "contingency," in its dual sense of an uncertainty characterized by chance and accident, as well as of a dependence on something that exceeds one's self. An experience of *Between* depends on the other, but also on varied expectations, moods, locations, hardware systems, experience with other digital games, and so on. The singularity of the game's relational experience makes anecdotal play details practically unavoidable.

In concluding this section, then, I would like to recount my own experience of *Between* when I played it for the first time in 2010, as a way into a deeper analysis of the game. Rather than engaging a stranger, I played with my romantic partner at the time. That fall, I was in Chicago while my partner was in Paris. I had not seen her, face-to-face, for two months and would not see her for two more. I went into the experience expecting to have a shared online experience with a loved one. Knowing practically nothing about Rohrer's game, I anticipated a direct communication interface similar to one available in a virtual world such as *Second Life*. Instead I experienced a ludic allegory of the very situation in which I found myself—a situation of complicated intimacy with all of the frustrations that accompany long-distance relationships. *Between*, for me, captured my situation— playing with an other across a communications network that stretched across the Atlantic Ocean—at both a representational and a participatory level. Controlled gameplay or interface mastery both proved impossible

and antithetical to the game's project. We only proceeded through *Between* resorting to clumsy trial and error, as if attempting to speak a foreign language in which we were not yet proficient, let alone fluent.

Thus, my first *Between* gameplay session did not achieve the utopian sense of linkage or flow that so often accompanies discussions of networks. It produced affects of mutual accomplishment and frustration, connection and disconnection, fusion and confusion, expectation and exhaustion. We left the experience with different impressions. In one sense, *Between*, for us, served as a platform of intimacy.[43] From my perspective, *Between*, unlike so many user-friendly or procedurally transparent games, hindered my desire and expectation for a satisfying connection with my partner. It made me aware of the implicit rules of the game at hand but also the rules of normative couplehood, which in this case led to assumptions of unproblematic play and support (e.g., my partner's generous participation in a frustrating game for longer than she might have wanted).

Though "intimacy" captures something of the desire that I felt in this play-through of *Between*, the concept that more thoroughly resonates with the experience is "extimacy" (*extimité*), coined by Jacques Lacan, which complicates sharp distinctions between interiority and exteriority. If extimacy yields any form of ecstasy, it is only through a process of perpetual exchange, not through a collapse of boundaries between self and other. Extimacy, in Lacan's sense, is not limited to relations between subjects. As David Pavón-Cuéllar explains, it also undergirds psychic processes "with oneself, with language, with the world, between things, between concepts, and so on." Even so, extimacy offers an appropriate frame for thinking through the paradoxes of network form and networked interaction with another person at a distance. Indeed, for Pavón-Cuéllar, the term also emphasizes "the human desire to show or exteriorize the intimate life."[44] *Between* figures this interior exteriority through its dreamscape level design and the virtually uncompletable tower at its center (which could, in a Lacanian psychoanalytic reading, operate as the Thing that exceeds language and belongs to the ungraspable real, approached but never reached here through gameplay). This sense of extimacy also finds one of its most common expressions in contemporary social media, which facilitate a performance and display of intimacy in a public setting.

Between does more than represent extimacy through its graphics; more profoundly, it deploys action-oriented aesthetics to occasion an extimate relation. In Tavia Nyong'o's adaptation of extimacy to an aesthetic context, it produces "an effect neither intimate nor remote" and sets "a scene palpat-

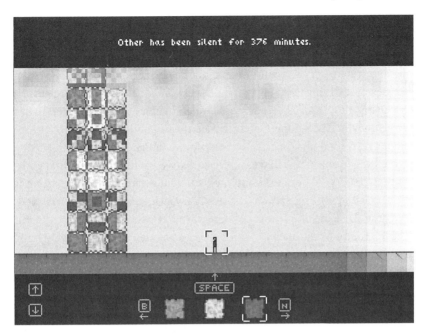

Other has been silent for 378 minutes.

4.6. The impossibility of direct encounter with the other player in *Between* (Jason Rohrer, 2008).

ing with the felt absence of connection."[45] In just this way, *Between* makes disconnection palpable and connection approachable through actions that open up an indirect exchange of the magenta, yellow, and cyan blocks needed for in-game progress. And yet the action of building the tower—the ostensible goal—comes to feel like an excuse for something else, perhaps an alibi for avoiding the fact that no amount of effort will culminate in a direct encounter with the other (fig. 4.6). In my play-through, this fact began as a suspicion that grew into a near certainty as I negotiated the game's difficulty and loneliness. By decentering its objective, then, *Between* does not reinstate reflection as superior to action. It promotes an *active reflection* undertaken through a player's experimentation with the affordances of the designed space via gameplay.

One of the crucial ways that Rohrer's game *activates* an extimacy that is neither intimate nor remote is through the act of waiting. When a player has raced ahead of the other in tower construction, as I did (being the more experienced videogame player) with my romantic partner, the only available choice is to wait for the other to catch up. This waiting game reveals that the dreamscape of *Between*, which oscillates between S(leep) and W(aking),

is more than decorative. As Jonathan Crary contends, "Sleep is the recurrence in our lives of a waiting, of a pause." The importance of sleep, as an act, is that it "affirms the necessity of postponement, and the deferred retrieval or recommencement of whatever has been postponed," including the "periodic disengagement from networks and devices in order to enter a state of inactivity and uselessness." Waiting, then, is not a passive action but a space in which postponement opens up the possibility, if never the promise, of a refreshed imagination and disrupted habits. While sleeping is one of the few actions in which we wait in early twenty-first-century life, without recourse to the networks and media that alleviate impatience, there is also a social significance to waiting. As Crary again notes, "The suspended, unproductive time of waiting, of taking turns, is inseparable from any form of cooperation or mutuality."[46] In *Between*, as in many games, players must take turns. Unlike in most other videogames, however, real-time response from another player cedes to periods of waiting during which players are encouraged to remain open to unplanned encounters, uncomfortable possibilities, and proliferating affects that arise within a shared time span.

Following up on the preceding analysis of *Between*, I turn to one final networked game in the next section. This artgame, *Journey*, problematizes network structure and engages in an aesthetic exploration of relation and affect as they unfold in online environments. In contrast to *Between*, which still allows play with a friend, *Journey* offers no option other than that of anonymous encounters with strangers.

Gaming Relationality and Affecting Strangers: *Journey*

Another artgame that experiments with network aesthetics—one that has garnered greater commercial success than Rohrer's *Between*—is thatgame-company's *Journey* (2012).[47] This game puts players in touch with many of the ways in which Internet users in the early twenty-first century already construct the networked processes that constitute everyday life. In *Journey*, the player guides a robed avatar through a series of levels that lead, over the game's approximately two-hour duration, across a vast desert to a mountain. The game's landscapes evoke a sense of sublime awe, as the player travels through the ruins of a seemingly lost civilization (fig. 4.7). The gameplay focuses on exploration and avoidance of occasional enemies as the player learns about the environment within which she finds herself— albeit only through visual and procedural features of the world, pictograms, and brief animations—never text. The "journey" on which the player

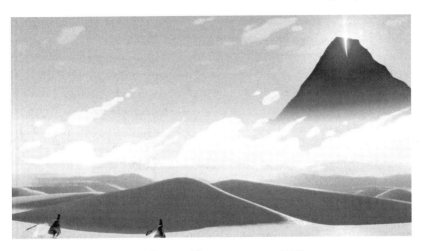

4.7. The sublime landscapes of *Journey* (thatgamecompany, 2012).

embarks is suggestive of an origin myth, a chivalric quest, and a spiritual pilgrimage, but it is ultimately unsolvable at a narrative level.[48] The player wears a scarf that enables her to surge and float through the air whenever it is properly charged. In relation to the game's aesthetic and technical intervention, this scarf might be said to contain echoes of the Jacquard loom — the mechanical, punch-card-driven device of the early nineteenth century that prefigured Charles Babbage's analytical engine and twentieth-century computation. Despite this suggestive sartorial detail, netlike textiles and sequenced operations ultimately gesture forward to the game's more central examination of early twenty-first-century computer networks.

Though *Journey* has received considerable praise for its graphics, audio, and experiential flow, what makes the game stand out most, as an artistic experiment, is the unusual nature of its multiplayer interactions. At different moments during the experience, the player discovers other players (their games intersecting for a time) but cannot communicate with them through language, either via voice chat or instant messaging. In other words, the game privileges creative constraints and subtractions of possible communication channels to the proliferation of features that is more characteristic of new media culture. The only available form of expression comes through avatar movement, the capacity to refill another player's scarf by producing a chime sound in close proximity, and a type of singing that Ian Bogost describes in his review as "a ping that can help a player find his companion and, when used improvisationally, might allow basic signaling."[49] One notable way in which *Journey* departs from *Between* is that

cooperation is completely optional and the completion of the eight major levels is not dependent on another player. As Jenova Chen, the game's creator, contends, "A true collaboration only happens when both sides are voluntary and a lot of co-op games force people to be in a collaborative situation."[50] Thus the interaction among players determines neither the completion of the game nor its narrative, only the relational experience itself.

Journey's transcendent landscapes may seem to gesture visually toward the network sublime often evoked by information visualizations. Through its participatory aesthetics, however, *Journey* points to something more ordinary, generating an awareness of computer networks and opening up novel affects—ambient sensations, passing curiosities, felt intimacies, and deep passions about shared experiences—that are unique to network culture. The game departs from the antiseptic link-node structures through which networks are so often conveyed and suggests a network imaginary composed of forms of both connection and disconnection. Even so, attending only to the game's world design and mechanics, important though these are, yields a limited understanding of how the game makes sensible different network forms. Thus, instead of focusing on a formal reading of the gameplay or a speculative reflection on possible modes of play, methods that I modeled in my analyses of *Uplink* and *Between*, I adopt a different approach in this section. Namely, I turn to a secondary archive that documents concrete player experiences and shows how networked games might help us think through concepts that are immanent to contemporary forms of connectedness, including intimacy and play.

Journey itself offers only a minimum of plotted events, except for the trajectory of the player's ambiguous voyage. Ever since its release, however, the game has generated modes of emergent narrative and reflection that exceed the space of the game proper. Unlike *Between*, which Rohrer created as an experiment oriented toward a small audience, *Journey* broke PlayStation Network sales records upon its release in 2012. The game also attracted an extensive online community. Some salient online documents from which I draw in this analysis include creator commentaries, game reviews, and player-created blogs. One particularly striking development has been *Journey Stories*, a Tumblr blog that was started in mid-March 2012, shortly after the game's release (fig. 4.8). This Tumblr is described as "a space to collect the stories of companionship, sadness, and joy experienced while playing the videogame *Journey*." Despite the nonlinguistic nature of *Journey*, this blog reinstates language, yielding elaborate stories, poems, and readings of the game's diegesis and, within a week of its launch, the

4.8. *Journey Stories* Tumblr blog (2012).

addition of various forms of fan art, including images, video play-throughs, cosplay, sculptures, musical performances, comics, and even tattoos. By May 22, 2013, the blog had accrued 1,260 stories and 131,017 followers.[51]

Before returning to the player interactions that the game affords and the forms of relationality that archives such as *Journey Stories* foreground, it is important to better establish the game's inherent narrative affordances and their relationship to player-generated stories. *Journey* suggests a bidirectional relationship between stories and space. As Michel de Certeau contends, "Narrative structures have the status of spatial syntaxes." Stories, he observes, "traverse and organize places; they select and link them together, they make sentences and itineraries out of them. They are spatial trajectories."[52] It is essential, for de Certeau, that stories do not merely describe

or document spaces. Instead, they actively create those spaces by both de-limiting them (topically) and introducing new mobilities and connections among them (topologically).

Though *Journey Stories* explicitly prompts players to produce experien-tial narratives about this nonlinguistic and spatially oriented game, *Journey* itself already establishes a relationship between stories and space. Just as stories are productive of spaces, spaces are generative of stories. This point is critical in the study of digital games and their spatial dimensions. Indeed, there is a considerable scholarship about games and narratives, including material from the infamous "ludology" versus "narratology" debate.[53] Even so, it is important to observe up front that numerous digital games, from *Tetris* (1984) to *The Marriage* (2007), do not include narrative dimensions and are primarily procedural, rule-based, and objective-oriented. Simi-larly, many analog games—card games like bridge or strategy board games like chess—do not depend on fictional scenarios or navigable worlds. At the same time, there has been a trend in digital games, from early text ad-venture such as *Adventure* (1976) to videogames such as *BioShock* (2007), *Heavy Rain* (2010), *The Walking Dead* (2012), and *Kentucky Route Zero* (launched 2013) toward interactive storytelling. Even when digital games are not narratives per se, they often possess what Marie Laure Ryan calls "narrativity" in their capacity to "evoke a script."[54] As Henry Jenkins has also explained, when games turn to narrative, whether in direct or gestural fashion, they do not tell stories in the same way as novels, films, or televi-sion series. Games tend to be nonlinear and spatially organized. For this reason Jenkins contends that game designers might be understood not as "storytellers" but as "narrative architects." Spatial navigation proves pri-mary to the real estate track of the board game *Monopoly* (1934), the text-based space of *Colossal Cave Adventure* (1976), the scrolling space of the platformer *Super Mario Bros.* (1985), and the massive three-dimensional realms of the online game *World of Warcraft* (2004–present).[55]

Stressing the narrative potential of digital media, Anthropy argues that in games, the "author has a lot of control over the pace at which information is revealed; therefore the author can pace the telling of a story."[56] Though digital games are unquestionably proving a major storytelling form in the early twenty-first century, Anthropy's formulation about authorial con-trol describes primarily a small subset of games that are "on rails" (that is, games in which player actions and pathways are predetermined) or organized through cutscenes (noninteractive segments). Decisions about editing and pacing are inherent in cinematic and televisual montage. In

distinction, total authorial management may inform certain digital games, but it is not characteristic of the art form. More often, the relationship between games and narrative is diffuse. As Jenkins has observed, games such as first-person shooters and platforming games sometimes *evoke* narrative associations through textually or graphically detailed worlds. Other genres, such as role-playing games, use quest-based formats to invite players to *enact* events that are part of a larger narrative. Still other genres, such as sandbox games and massively multiplayer online games, may even provide resources for *emergent* narratives. *Journey* uses all of these storytelling techniques through a narratively evocative world, levels in which a player can enact the ongoing voyage, and moments at which nonscripted narratives can emerge from player interactions. In part because of the nontextual interface between the player, on the one hand, and both the software and other players, on the other, the game experience privileges emergent narratives—what Lisbeth Klastrup calls "story-living" rather than "story-telling."[57] *Journey*, as Bogost has observed, suggests possible stories and, through its spatial orientation, conveys "the feeling of *being somewhere*, not . . . the feeling of solving something."[58]

If *Journey* is indeed about *being somewhere*, it is also, as the *Journey Stories* blog suggests, about the intense feeling of *being with someone*. The network connection of the game thus makes sensible relations among players. Its relational dimension suggests that this interactive artwork is perhaps best approached not through formal means but through the diverse human practices that emerge from its game structure. With this shift in analytical emphasis, *Journey* becomes less a game than a platform for play. This play is, in part, narrative, inviting players to imagine or enact a story where one is not given. But there is also an essential nonnarrative and nonrepresentational dimension to the game that is not merely reducible to the mechanics and rules that most concern ludologists. The game thus offers more than an allegory of a spiritual journey or even an "allegorithm" (to employ Galloway's neologism) of an interactive world that allegorically channels one process through another algorithmic one.[59] Namely, *Journey* calls the player's awareness, however subtly, to the affective dimensions of computer networks. Through its networking, which connects players without making them explicitly aware of the linkage or giving them a means to communicate verbally, *Journey* uses its uncertain relationality to encourage reflection on the atmospheric qualities of media.[60]

Journey encourages not only descriptions of easily nameable emotions but also atmospheric and subtle affects through its fundamental exclusion

of verbal language, a constraint that makes sensible more complex forms of relationality. Many players of the game have reported attempts to translate nonverbal movements and gestures into language. In one account on *Journey Stories*, a player describes a hope that a chirp will be interpreted by a companion as a message: "Sadly, on our way to the top, I was pulled away from that world by my family and some errands I had to do. I looked at him and chirped at him almost painfully, *'Please wait for me..I'll be back to be with you, I promise.'*"[61] Some players interpret actions within the game as shared emotions or reactions to the world, even developing temporary systems of communication by using the available chime or chirp sounds.[62] While the limitations of language and recourse to limited gestures may be frustrating to players who wish to establish concrete gameplay strategies with their companions, they open up creative communication avenues for others. One player expresses a feeling that *Journey* breaks through "the language barrier" and writes that "with our songs, it's almost like speaking a foreign language that you find so familiar, and so comforting."[63]

Journey Stories serves as a vast archive of player affects associated with different experiences of *Journey*. Most of the entries do not quite belong to the epiphenomenal category of fan fiction. That is, they are rarely derivative imaginings of the lives of characters or extensions of the game's world. Instead, these accounts attempt to process the game and its possibilities. For instance, some of these posts narrate gameplay sessions. Others describe metagaming practices, unplanned by the designers or secondary to the game, which include hide-and-seek, play-throughs that introduce arbitrary obstacles, and pursuit of trophies added through the PlayStation Network.[64] Most often, these posts offer documentation of particular user experiences and speculations about the game's affective resonances. As the curator of this archive observes in the inaugural March 15, 2012, post that doubles as a call for community submissions:

> Playing Journey was one of the most moving, beautiful, transcendent experiences any work of art has ever brought me. Not only was Journey visually captivating, but the social interaction with anonymous fellow players was unlike anything else I've ever experienced. . . . Through this, our deepest human need for connection and companionship is brought to the forefront, and the result is one of the most incredible experiences I've ever had in a game. This game brought me to tears on more than one occasion.[65]

The intensity of this post—its evocation of "our deepest human need for connection and companionship" and the inability to quite describe "what I

experienced"—recurs in many of the *Journey Stories* entries. Posts gesture toward affective experiences that resist description and lead players to feelings of wonder, isolation, and even embodied "crying" and "tears."[66]

Though the blog title of *Journey Stories* implies a narrative primacy, it is striking how many of the entries grapple with the game's affective atmospheres and the ways the game moves players at levels beneath thresholds of perception or understanding. Many contributors to *Journey Stories* express a similar sense, calling it an "indescribable experience" and a game that is "so hard to even explain."[67] As another user reflects, "It is hard to explain how the game evokes emotions. How masterfully it plays with the feeling of connectedness."[68] The imprecision of these comments gestures toward an experience of something that is at once profound and ordinary. *Journey* provides an intensified aesthetic access to the specific ordinary affects that make up the atmospheres in which human beings access early twenty-first-century networks. Networks here are not static structures or totalities but heterogeneous constellations of intensities, interactions, and transformations.[69]

Despite claims that *Journey* is an indescribable experience, posts about the game frequently attempt, however hesitantly, to describe the range of affects that the game inspires. It is noteworthy that *Journey* inspires exchanges that are much more affectively elaborate than comparable blogs for other popular videogames. Such forums tend more often toward gameplay advice, celebratory reviews, complaints about in-world activities, and all too often aggressive arguments, many of which adopt racist, homophobic, or sexist language.[70] *Journey Stories* is different. One post begins with a narrative description of the gameplay session before ceding to a list of emotions inspired by the breathtaking environment, including "wonder and curiosity then awe and joy as I was sliding through sand jumping and singing. Then uncertainty when the sky and mountain were gone from my view. And that end; so alive after the frozen landscape."[71] Other entries attribute the game's effects specifically to the cooperative, multiplayer mode.[72] In some cases, the game has made possible profound affective experiences that make accessible broader feelings of disconnectedness in our time. One player, for instance, frames the game's transformative effects through a personal narrative:

> I had just quit my job because my boss was insufferable, and I felt like I was taking steps backward. I felt stuck. . . . Not to mention, I had just moved to this tiny town, two hours away from my old job (which I loved), my

friends (that I *finally* made), and my town (that had way more things to do
than this town). . . . I didn't even really want to play Journey at the time, I
simply had nothing else to do. . . . When I burst into that beautiful area and
started flying around, it felt like that was exactly where I was supposed to
be. It felt like all the ups and downs of the game were intensified because
my terrible day had put me in a fragile, emotional state already. When I
flew around through the light, I suddenly felt okay with myself, my life..
everything. My terrible day meant nothing, all I had to do was keep moving
toward something better. . . . I've played it a few times since then, and I've
cried every time. Each time, it was a slightly different emotion; Accep-
tance, understanding, happiness.[73]

For this player, the game resonates with an experience of everyday life.
A "fragile, emotional state" leads to an intensification of "all the ups and
downs of the game." As for many other users, the game does not generate
a set of emotions but instead operates as a platform for the expression and
experience of different moods and affective atmospheres.

It is not enough to suggest—as some players, commentators, and even
the creator, Jenova Chen, have done—that *Journey* produces empathy and
cooperation.[74] Many players report not only this type of sublimity or con-
nection but also ugly or complicated feelings. One contributor to *Journey
Stories* describes a perilous journey with a random companion through a
cave in which a flying snakelike enemy begins to pursue the fellow player.
This player feels "a mixture of emotions, all at once," many of them de-
parting from the empathy that Chen and thatgamecompany had in mind
when designing the game. The player reports affects of panic, concern, fear,
horror, shame, anger, and regret.[75] Other players find impossible the pos-
sibility of cooperation that Chen isolates.[76] Still others describe feelings of
desired isolation, shyness, and painful abandonment by their companions.[77]

It is significant that many of the affects that players describe are unique
to relationships established over a network connection or through game
form. Some posts about *Journey* demonstrate this form of what the game
scholar Jane McGonigal has called "vicarious pride," which is captured
by the Yiddish word *naches*, or "the bursting pride we feel when someone
we've taught or mentored succeeds."[78] Though this prosocial bond is com-
mon to multiplayer games and a range of pedagogical situations, it takes
on an added dimension of difficulty and accomplishment in a game that
brackets linguistic communication between players. Given this communi-
cation obstacle, one player describes feeling "an untainted happiness to me

that has never happened before" in helping less experienced companions succeed and courageously taking enemy damage to protect fellow players.[79] Another player describes the pride of achieving the white robes of an experienced player and guiding a less experienced player: "I happily showed her everything I could and she chirped back gratefully every time. . . . She taught me to care for those I took under my wing, and it's not something I'm going to forget."[80] This language of sustained pedagogical influence appears across several entries in *Journey Stories*. The broader rhetoric of affecting other players and being affected by them also extends to simpler game actions. In narrating a passage through a dangerous snowy area, one player describes a tragic climb with a companion during which "we desperately tried to chirp and impart some last bit of energy to each other, but eventually that failed." This passage suggests affective hope and sensitivity to the possibility of having an effect on a companion—the attempt to "impart" some "energy."[81]

Just as *Journey* opens up to a range of shared affects, it also makes available varied durations and intensities. Since a player does not necessarily keep a single companion for an entire play-through, some connections in the game are ephemeral. "My first time through," one player observes, "I had 8 companions and only had the time to develop a little feeling for them."[82] Other connections are prematurely severed, as with one player who uses the *Journey Stories* blog to seek out a lost companion.[83] On the other end of the spectrum, some players undertake an entire two-hour journey with a single companion and even find ways to extend those relationships beyond the game. Careful observation of the game's closing credits reveals a list of encountered players, identified by their PlayStation Network handles, which occasionally prompts online friendships after gameplay.[84] One player from the UK describes the excitement of meeting a player from Egypt and adding him as a PlayStation Network friend, becoming "good game buds with him since" and playing other games together across the network.[85]

The complexity of affects generated by *Journey* and the absence of language in gameplay have encouraged some players to develop a vocabulary to describe the relationships they form with other players. Player descriptions of their others simultaneously overdetermine roles and suggest that the game encourages a robust relational imagination. The term "companion" is the most common, but even that term appears among others in entries that actively struggle to pin down the networked other in language, calling her a "partner," "buddy," big and little "sister," "student," and a vari-

ety of nicknames.⁸⁶ Though players often seek to describe their fellow play-
ers and share legs of their game journeys, it is significant that companions
invariably remain strangers through the entire game. As one player notes,
"In a strange, and magical way I've made friendships and bonds with the
players of this game. I found myself loving these complete strangers who I
never knew, and probably never will, and honestly that scared me. It scared
me that a game could bring out such emotions. *I loved my companions, my
friends like a mother, a sister, a friend, a lover*."⁸⁷ Despite the speculative de-
sire of this searching simile, the game's aesthetic depends on the players
remaining strangers to one another. This relation belongs to what Michael
Warner has described as modern "stranger sociability," in which "a stranger
is not as marvelously exotic as the wandering outsider would have been
to an ancient, medieval, or early-modern town" but instead belongs fun-
damentally to a shared world. Strangers, in this formulation, are neither
wholly excluded from the social order nor mere means to ends—stepping-
stones en route to a necessary state of friendship. Instead, common life
as such is defined and made possible by strangerhood.⁸⁸ This figure of the
modern stranger introduces a public sphere characterized by a breakdown
of the common opposition between intimacy and strangerhood—what Me-
lissa Deem calls "intimate strangeness."⁸⁹

Networked game environments such as *Journey* do not completely up-
end the centrality of this form of strangerhood, whose genesis Warner sit-
uates in earlier print cultures and their circulation of texts. Strangerhood
remains crucial to screen-based encounters as well a broader sense of pub-
lics in the present.⁹⁰ *Journey's* particular social landscape shares qualities of
a general relationship to strangerhood in the early twenty-first century. At
the same time, the game invites a more intense encounter with strangers
who might otherwise remain in the peripheries of our worlds. The game's
networked connectivity foregrounds a historically new sense of tempo-
rality and simultaneity, extended copresence at a distance, which alters
experiences of strangerhood. The network imaginary, the game suggests,
has generated a proliferation of new forms of life, genres of connection and
disconnection, and techniques of world making.

Journey, much like *Between*, puts the player in the position of Arendt's
partial or nonsovereign actor. The game does not emphasize a concrete
achievement or a necessary set of actions that might enable mastery or
complete knowledge of the game world. In my reading, the game demon-
strates that sovereignty, even decentralized sovereignty as it has been elab-
orated by theorists such as Hardt and Negri or Galloway and Thacker, may

limit visibility of the ordinary dimensions of networks in particular and new media in general. People's ambient relationships to social media, for example, make clear the place of digital media in sustained affective encounters that are often uncertain and nonsovereign. Affects, however, may be difficult to access, think about, or alter. *Journey*'s artistry, then, has much to do with the ways it produces self-reflexive feedback loops with player experiences of affect. In the conclusion that follows, I reflect on some of the ways that the aesthetic relation of play in *Between* and *Journey* mediates among control, a capacity for action, and affective experiences of online intimacy.

Conclusion: Networked Play and Online Intimacy

Networks fail all the time. We need only think of the Great Northeast Blackout that took place on November 9, 1965, or the information failure of the intelligence network on September 11, 2001. In a far less grand historical register, I sometimes reflect on the wireless network connection that failed during one of my sessions of *Between* during which I had spent ninety minutes building up a tower that was nearly complete—and then the game crashed without saving my progress. As these varied examples suggest, networks cannot be imagined merely as architectures of control. They are also metaphors for nonsovereign ways of being in the world. It is these forms of breakdown that constitute the common conditions for greater awareness of networks and, in some cases, provide opportunities to transform them.

One of the key relations through which nonsovereignty, including failure, becomes visible and mutable is play. *Between* and *Journey* foreground play, however implicitly, as a key concept for thinking of networks not exclusively as spaces of control but also as topologies of connection. It is true that digital games often blur play and control. Millions of people are said to "play" first-person shooters and real-time strategy games in which goals include mastery, resource management, and victory.[91] By contrast, *Between* and *Journey* help us envision forms of play that inspire curiosity, imagination, involvement, paranoia, apophenia, dissatisfaction, connection, and flexible optimism. These networked games suggest, without supplying, a formal and critical language for describing different orchestrations of play. They do not seek to tap into some ahistorical or universal form of play *as such* but rather require gameplay to unfold in the present with another person. In other words, they encourage and identify play as a quality that is immanent to contemporary connectedness and intimate strangerhood.

It is important to emphasize that, though it entails nonsovereignty, play is never wholly free of constraints. Play, even as it is often confused with "fun," cannot be reduced to a frivolous escape from the "real world" or an opportunity to let go completely.[92] Rather than that liberating force inherited from the longer aesthetic legacy of romanticism, play might be characterized fundamentally, as D. W. Winnicott has argued, by precariousness. As he notes, "The thing about playing is always the precariousness of the interplay of personal psychic reality and the experience of control of actual objects. This is the precariousness of magic itself, magic that arises in intimacy, in a relationship that is being found to be reliable."[93] Play relies on an interplay between a desire for control and the material impossibility of achieving control. Play, in this sense, takes on a pedagogical dimension in which we embrace the safe space—the ludic "magic circle"—to "play out" different potentials, experience varied affects, and encounter possible relations without wholly actualizing them. Play, in Winnicott's terms, also operates as an interface between interior and exterior reality. In an online environment, this relation may involve an oscillation between a network as a personal mapping technique, on the one hand, and an objective or infrastructural fact of the world, on the other.

Play is a crucial concept for thinking through networks insofar as it is always a space of interplay, either explicitly (when a play partner is present) or implicitly (when one plays alone).[94] The specific forms of play that might unfold via a computer network require trust in different forms of human and nonhuman linkage across a distance. Both *Between* and *Journey* make players aware of their dependencies on and interdependencies with others. They do not simulate those linkages but establish a platform for actual emergent interaction. That the bonds these games enable are sometimes disjunctive or may appear broken (by comparison to most computer-mediated forms of communication) makes them more available to thought and experimentation. The concept of play, as I have sketched it out here, is an important method for aestheticizing networks in our time. In place of a textual (network novel) or visual (network film) relationship to the network, the play of networked games introduces an aesthetic that is action-oriented, interactive, kinesthetic, and relational. Play obviates the representational crisis suggested by networks by taking us from the figural nature of network graphs to the thick messiness of networked relations. In rewiring our habits, even if only temporarily, play changes human perceptions and capacities for reception. Though play may resist analytical distance by putting the player in the midst of things, it invites thoughts and feelings different from those that follow from routine action.

If *Between* and *Journey* share an object that they mediate through their fields of play, it is arguably a historically specific sense of relationality that has emerged in our era of computer networks. Sherry Turkle has argued that digital technology, from networked computers to smartphones, "proposes itself as the architect of our intimacies." Drawing from field research and clinical studies of uses of mobile devices, instant messages, and social networks, Turkle concludes, "Our networked life allows us to hide from each other, even as we are tethered to each other." She continues, "As we instant-message, e-mail, text, and Twitter, technology redraws the boundaries between intimacy and solitude." In her study, Turkle returns repeatedly to the way that daily use of networked technologies reveals "a certain fatigue with the difficulties of life with people." "Today," she writes, "our machine dream is to be never alone but always in control. This can't happen when one is face-to-face with a person."[95]

If the Internet and networked media are, in Turkle's formulation, "uniquely suited to the overworked and overscheduled life [they make] possible," then one of the greatest interventions of *Between* and *Journey* may be to slow things down. In place of networked multitasking and controlled flow, these games call for thoughtful reflection and an encounter with linkages that limit our capacity to communicate with others. If SMS and email so often allow us to maintain a fantasy of perpetual connection, a game such as *Between* forces its player to return to difficult interdependence and to sit with the anxieties that accompany being alone together. If social media seek to ease intimacy (for example, through the instant affective intensities that come with "liking" a Facebook post) then *Between* and *Journey* both strive to make it difficult again.

Despite their departures from other new media technologies and games, *Between* and *Journey* do not, following Turkle, suggest that face-to-face exchanges are ultimately preferable to online encounters. These games take place, after all, in networked virtual environments. They experiment with alternative forms of intimate strangeness and strangerhood. So often networked relations and forms of play are offhandedly rejected, especially in popular journalistic accounts. Online relationships of all sorts are frequently approached through a language of lack, degeneracy, or comparative dismissal in distinction to normative face-to-face relations. This language comes up in the context of friendships mediated largely by Skype, long-term marriages that unfold entirely in the virtual world of *Second Life*, creative collaborations in online sandbox games such as *Minecraft* that may require nearly as much time as a full-time job, and quasi-anonymous and promiscuous forms of online sex in online social environments such

as *Red Light Center*. Even companionship in *Journey* takes on qualities of impersonal intimacy that resemble, structurally, the homosexual practice of cruising.[96] All of these forms of online intimacy are regularly treated as perverse, inappropriate, excessive, or indecorous.

Given normative reactions to forms of online intimacy, as well as the relational investments that participants in these activities often reveal, we can think of the communities that occupy these online spaces as, in Michael Warner's sense, "counterpublics." Counterpublics, which often entail stigma and risk, "fashion their own subjectivities around the requirements of public circulation and stranger sociability" and entail a "world-making project" that depends on "circulation among indefinite others."[97] The virtual worlds of networked games—"virtual" in the dual sense of a "simulated" space and a field of "potential" affects—have often been met with intense hostility, in part because they violate or blur the opposition between public strangerhood and private intimacy that remains a major normative value. Though networked games are usually played in the home, they entail interactions with unknown members of the game-playing public, giving rise to new interactions and intimacies among strangers. It is not that we should promote all of these practices while ignoring Turkle's observations about the false sense of safety and circumvention of intimacy that sometimes accompany digital communications. And yet, if an analysis of networked games and virtual environments begins with assumptions of neither prescriptive celebration nor dismissal, novelty nor inadequacy, but instead with an ambivalent sensitivity to the riskiness and complicatedness inherent to all intimacies, we may start to cultivate the capacity to access more robust and common forms of life that make up our present world and its network imaginary.

Improvisational Aesthetics: Alternate Reality Games

> Puppet strings, as a rhizome or multiplicity, are tied
> not to the supposed will of an artist or puppeteer but
> to a multiplicity of nerve fibers, which form another
> puppet in other dimensions connected to the first.
> **Gilles Deleuze and Felix Guattari (*A Thousand Plateaus*)**

> It is systemically impossible that there might be a clearing
> or pause in which a longer-term time frame of trans-
> individual concerns and projects might come into view.
> **Jonathan Crary (*24/7*)**

In 2007, Jim Wolff and Andrew Sides launched *Tomorrow Calling*, an "alter-nate reality game" that led players through a science fiction adventure com-posed of multiple forms and media, including Google Earth, websites and blogs, video and audio files, and email. The creators described the game as "a scalable viral marketing framework to increase digital earth usage, especially for educational and environmental purposes."[1] After its launch, a small group of collaborating players began to explore the game's media and solve its challenges. However, as soon as *Tomorrow Calling* shifted from its original puzzles to a more involved crowdsourced activity—one that re-quired players to take their own environmentally themed photographs and upload them to Flickr—the game came to a premature end. The player base of around one hundred players never grew after this point, and the existing participants lost interest and abandoned the project. Today, even the core website for the game has disappeared, along with most other traces of its history.[2]

The failure and eventual disappearance of *Tomorrow Calling* is surely not an unusual phenomenon. Countless new games and digital media art projects do not reach large audiences. Even so, this anecdote foregrounds a dimension of networks that often receives inadequate attention. Early twenty-first-century accounts of networks often focus on global interconnection or successful linkage across vast geographical distances. But networking also brings with it various forms of breakdown, such as link rot, fatal errors, data trash, streaming glitches, and flawed design.[3] The example of *Tomorrow Calling*, then, may suggest a number of questions: How do computer networks alter the fundamental values that determine what constitutes a success or a failure? Moreover, what do processes of creating and experiencing new media art pieces, especially those that involve collaboration, tell us about network art? Then, following the comparativist impulse of this book, how does the category of network aesthetics change with works that depart from the linear storytelling and largely individualistic reception practices of network novels, films, and television series, and instead emphasize multilinear, collective, interactive, and improvisational gameplay?

Computer networks have made possible myriad new cultural and art forms, across different scales. These forms include the email chain, the tweet, the sext, the webisode, the shared web-based collaborative document, the microblog post, the podcast, the Snapchat photo, the Twine hypertext game, the cell phone novel, the Flarf poem, the Twitter play, the vlog, the webcomic, the videogame deathmatch, the Internet meme, the geo-tagged photograph, the public volunteer computing project, the virtual world, the flash mob, the crowdsourced feature-length film, the networked art game, the museum-based telematic art piece, the collective intelligence Twitch Plays game event, and so on. In this concluding chapter, I focus on one particular form—the alternate reality game (ARG)—that may incorporate (at least potentially) all of these others. This form goes by several names, each of which stresses different features of the broader category. These designations include "pervasive games," "immersive games," "transmedia games," "search operas," "unfiction," and "chaotic fiction."[4] The most popular examples have included *The Beast* (2001), *I Love Bees* (2004), and *Year Zero* (2007).

Since the ARG may be unfamiliar to many readers, the following sections offer an analysis of its historical roots in the context of mid-twentieth-century network art and a systematic description of its key formal properties. Unlike the videogames and computer games that I discussed in

the previous chapter, ARGs are a more experimental form of gaming that emerged in the early years of the twenty-first century. ARGs can be understood, provisionally, as heavily mediated and narrative-driven scavenger hunts that unfold both in physical space and online, frequently amassing player collectives in the thousands or even millions. In another sense, they are transmedia storytelling platforms composed of some combination of text, video, audio, print, phone calls, websites, email, social networks, locative technologies, invisible theater, and other media. ARG players follow a single story or explore a coherent story world. However, this experience may unfold through the process of calling a phone number to hear a voicemail message or discovering a communication hidden in the source code of a website.

ARGs are games that rely upon computer networks and that experiment, through both their formal properties and social affordances, with network aesthetics. As the game theorist Roger Caillois has argued, there is "a truly reciprocal relationship between a society and the games it likes to play."[5] Perhaps even more than the artistic forms I have explored thus far, ARGs from Microsoft's *The Beast* (2001) to the Institute for the Future's *Superstruct* (2008) make the historical present accessible, sensibly and perceptually, by animating complex negotiations that take place about and through networks, a key form of our time. Rather than producing *a representation* of networks (e.g., the information visualization) or *an imagination* of networks that invariably exceeds human perception (e.g., the sublime of ecological or social totalities), these games use their aesthetics to generate *an experience* of networks. To traverse these games, players join online communities, use social media, and negotiate a range of network affects such as paranoia. Through active gameplay, the ARG makes palpable major shifts in the quality of connection that have unfolded through the proliferation of networked media since the beginning of the twenty-first century. As the media critic José van Dijck observes, the growth of social media that achieved a transnational scope with Facebook and Twitter (and quickly exceeded these platforms) has unfolded through a transition from community-oriented "connectedness" to owner-centered "connectivity." The rapid transition to Web 2.0, van Dijck notes, has yielded platforms that make social relations technical and manage everyday human interactions. Connectivity, then, becomes, with the rise of social media, not merely a state but oftentimes "a valuable resource."[6]

Like many other new media forms, ARGs convey ambivalence in their simultaneous exemplarity and subversion of connectivity. On the one hand,

many ARGs adopt the elements of so-called viral marketing and spreadability (terms that I complicate later in the chapter), converting social relations into a resource. Fitting into a social media ecology that is contemporaneous to them, they often combine elements of social network sites, user-generated content, trading and marketing sites, and play and game sites.[7] On the other hand, these games give players some practicable capacities to experience and intervene in moments of both connectedness and connectivity that are a regular feature of online interactions. Because ARGs are often improvisational and entail ongoing interplay between designers and players during their real-time duration, their social networks are not wholly preconstituted. These games frequently address a collective (and propose a vision of the commons) that has yet to appear. An ARG, then, can be conceived of as both the effect and cause of social networks.

Similarly to videogames that make networks sensible (such as *Between* or *Journey*), ARGs explore qualities of connection through game form. As I noted in chapter 4, networked videogames are quickly supplementing or even supplanting single-player games as the norm. This transition is not a complete novelty but rather reminds us of the longer multiplayer history of games. As Marshall McLuhan observes, games "are extensions, not of our private but of our social selves, and . . . they are media of communication."[8] In most cases, games are social technologies. They may operate as icebreakers (e.g., party games), as occasions for maintaining relationships with friends and family (e.g., social media games), as media for group learning (e.g., serious and educational games), and as team-building opportunities (e.g., sports and virtual worlds). Games, then, both model and enable social interactions. Though all play carries a dimension of interplay, ARGs depend fundamentally on collective interactions across media. An ARG is an ephemeral form that is enacted, in so-called real time, through collaborative groups that engage in conversations, narrative discoveries, puzzle solving, and content creation. These games are never single-player events and can only be experienced individually in their post facto archived form.

The ARG is itself a historically rich and still understudied cultural form. In this chapter, however, it also offers an opportunity for thinking with greater care about the political and ethical dimensions of networks. Jodi Dean has made the provocative claim that in our network society the ubiquity of communication and entertainment networks fails to promote democracy, instead yielding "communicative capitalism."[9] Though the intersections between neoliberal capitalism and digital media remain a central critical problem, I want to put some pressure on Dean's overarch-

ing claim. As Lauren Berlant observes, numerous cultural critics have converted "the heuristic 'neoliberalism' into a world-homogenizing sovereign with coherent intentions that produces subjects who serve its interests," while at the same time positing radical singularities that resist or overcome this system. This critical orientation does not, however, account for "the messy dynamics of attachment, self-continuity, and the reproduction of life that are the material scenes of living on in the present."[10] As I have argued throughout this book, we might fruitfully approach networks not as control structures but as forms for experiencing the present and inhabiting it differently. The category of "communicative capitalism," then, even with its critical valence, does not attend sufficiently to the ways that networks reload the affective field of the early twenty-first century and transform the ways in which we understand success and failure—rather than merely reinforcing an older understanding of capitalist totality. ARGs, in my reading, are one key form that uses game-based interactions and collective interplay to access ordinary affects. They do so by animating relations among media and by emphasizing the quality of networked relations among the designers and players of these games. Through their improvisational aesthetics, and the forms of failure that they occasion, ARGs make networks approachable as tentative and transformable processes.

Following a substantive introduction to ARGs, this chapter examines how the improvisational aesthetics of these games open up thinking about concepts that are key to making sense of networks—especially "process," "collaboration," and "failure." Networks are not merely a novel object of study; they also alter the very categories through which we think and know. Our network imaginary calls for transdisciplinary methods that draw from literary criticism, media studies, and critical theory, as well as social network analysis and participant observation. In this final chapter, I take up the emerging method of practice-based research. Though I refer to several commercially produced games along the way, my primary node is an ARG entitled *The Project* that I cocreated and directed in Chicago in April 2013. There are both practical and conceptual reasons that I turn to practice-based research.

From a practical standpoint, ARGs have largely resisted in-depth scholarly analysis because most designers do not produce or encourage the creation of extensive archives of these games once they have run their course. Thus the ephemeral and minimally documented status of these games often limits description, let alone interpretation. One of the occasional exceptions has been the smaller subset of educational ARGs that have

emerged from the serious games movement and have spurred research in fields such as education and the social sciences.[11] As a way of better analyzing these games, I have experimented for several years with designing and documenting a number of my own games, produced collaboratively with university-based developers.[12] By creating *The Project* and making documentation a priority from the beginning, I was able to track subtleties of the form that are often only accessible to the most devoted players who play ARGs from start to finish, as they unfold in real time. Another research challenge that ARGs present concerns their improvisational qualities—and especially the ways they blur conventional divisions between creators and consumers, designers and players, and (especially in the case of educational games) artists and researchers. Thus a researcher's desire to maintain a disinterested distance from these games and their communities can limit access to their dynamics or, in some cases, make detailed analysis operationally impossible.

From a conceptual perspective, practice-based research has enabled me to explore both media creation and collective play as processes of thought that can supplement distanced description and interpretation. The process of creating *The Project* helped me to attend to this ARG not as *a network*—that is, an object that could be categorized in some final form—but as an unfolding movement of *networking*. Indeed, my initial desire for comprehensive documentation of the process proved ultimately naïve and impossible. As Tim Ingold has observed, when we merely conduct a study *of* something, the impetus is largely "documentary," but when we study *with* a group, the results can also be transformational for all involved parties.[13] This ARG, then, taught me a responsiveness through which I began to encourage increasingly greater interplay between my design team and the players who took part in the game. The form of the ARG allowed me to experiment with networked relations and media across several months. It also encouraged me to embrace a position of involvement and embeddedness within networks. By relating to networks from an insider perspective—that is, observing, building, curating, and participating in networks—I was able to follow processes that might otherwise have been imperceptible. As the designer Lucy Kimbell suggests, "Perhaps networked art is a way to imagine what networks are for, a way of working things out by trying things out."[14] That tentative and experimental attitude is precisely what practice-based research opened up for me.

Though practice-based research of the type that I undertook surely brings with it biases and blind spots, it also introduces advantages for new

media studies and the digital humanities. With my group of designers, I approached *The Project* as a mode of what Matt Ratto calls "critical making." A combination of "critical social issues and design methodologies" taught us to confront "a deeper disconnect between conceptual understandings of technological objects and our material experiences with them." In Seymour Papert's sense, *The Project* ARG can be thought of as a "transitional object" that connected the lived experience or embodied knowledge of designers and players to more abstract theories about social media and creative networks that I will discuss here. Instead of constructing a finished object that could be monetized or disseminated like a conventional videogame, we focused on "the act of shared construction itself as an activity and a site for enhancing and extending conceptual understandings of critical sociotechnical issues."[15] This process demonstrated in a deeply material way that in a historical moment at which networks represent the infrastructural basis of our thought and communication, they can perhaps best be accessed through an active project of collaborative formation. I track this process through formal analysis but also mark it with the more personal voice that I adopt, especially in my discussion of *The Project*. Through an account of theoretically oriented making in which I was involved, I mark the problems and possibilities of improvisational network aesthetics, which depend on experiments in ongoing networking that relinquish a sense of control that is still implicit in the external vantage of traditional cultural criticism.

Alternate Reality Games: Prehistory and Form

To better understand what makes the ARG an artistic form that helps us access an early twenty-first-century transmedia ecology sustained by computer networks, it is valuable to consider its precursors. The common observation that ARGs are completely new to the early twenty-first century—a sensationalist claim that is made for or assumed by so many "new media" forms—ignores a rich historical web of influences and parallel developments. As platforms of play, ARGs draw from and perpetuate two primary genealogies: the ludic and the literary. First of all, ARGs extend experimental gaming and play practices. Key gamelike precursors include nineteenth-century English letterboxing, the Polish tradition of *podchody*, the Situationist practice of *dérive*, invisible theater, scavenger hunts, assassination games, live-action role-playing games, and smart street sports.[16] Arguably, the participatory, inventive, improvisational, and large-scale nature of such games received its most substantive consolidation in the 1970s

New Games Movement.[17] Second, alongside these origins in gaming and play traditions, ARGs have deep literary roots. Notable precursors include literary texts that depend on mathematical constraints and programmatic dimensions, stretching from the European literary collective of the OuLiPo (e.g., Georges Perec's lipogrammatic novel *La disparition*) to later electronic literature (e.g., Kate Pullinger and Chris Joseph's *Flight Paths*) and transmedia novels (e.g., Sean Stewart's *Cathy's Book*). As narrative forms, ARGs are also indebted to numerous fictional genres, including mystery fiction (e.g., G. K. Chesterton's *The Club of Queer Trades*), paranoid fiction (e.g., Thomas Pynchon's *V.* and *The Crying of Lot 49*), conspiratorial puzzle films (e.g., David Fincher's *The Game* and David Cronenberg's *eXistenZ*), and science fiction (e.g., William Gibson's *Pattern Recognition*).

Here, I hope to make a case that ARGs also belong to a third category: network art. ARGs are rarely considered within conversations about categories such as network or Internet art—arguably because of disciplinary biases that lead to separations between popular culture and fine art. However, these games share a great deal with this tradition. The art critic Nicolas Bourriaud theorizes art beginning in the 1990s as taking on "relational aesthetics" that include interactive and networked components.[18] Several decades before this moment, however, artists were already beginning to explore similar concepts. Members of the post–World War II avant-garde, including John Cage, Nam June Paik, and Wolf Vostell, as well as members of the Situationist International, were experimenting with "intermedia" production and network thought in the 1950s.[19] By the 1960s, several movements, including conceptual art, performance art, and postformalism, began to approach art that privileged process to the production of tangible objects that might be exhibited in museums. Several interrelated developments from this period include cybernetic art, mail art, EAT (Experiments in Art and Technology), happenings, and Fluxus. These art collectives and practices introduced key techniques that were taken up by ARGs in the 2000s, including intermedia production, transnational associations, collaboration, participation, real-time responsiveness, and play beyond prescribed boundaries.

Though several 1960s collectives already attempted to define relational and participatory practices as art, digital computers and networking were only peripheral to what were, at the time, predominantly conceptual experiments. As Johanna Drucker observes, "The concepts of interactivity, algorithmic processes, and networked conditions were not fully distilled as principles of digital art until more recently, but their broad outlines were already apparent by the 1970s." From the 1960s through the 1980s, artists

began to incorporate print mail, fax, and satellite transmissions into their work. Computer networks, however, were still in a fledgling state in this period. After all, the military-built ARPANET was not online until late 1969, and the popularization of the Internet did not come until the spread of the web in the 1990s. In later years, network art came to involve creating and circulating work through networked spaces. Such processes were not yet technically and culturally unavailable in the 1960s and 1970s.[20]

Even with artistic experiments with online bulletin board systems (BBSs) and multiuser dungeons (MUDs) in the 1980s, the fully formed configuration of network or Internet art did not emerge until the 1990s. This movement expanded with the spread of technical capacities and the cultural and economic adoption of the web — as well as the widespread embrace of networks as metaphors and material infrastructures. Network art that explored the intersection of technologies and human relations during this period included the work of net.art practitioners such as Vuk Ćosić and Jodi, cyberfeminist artists such as Eva Grubinger and the VNS Matrix collective, and tactical media groups such as the Electronic Disturbance Theater and etoy.[21] In parallel to visual and performance art, this moment also saw the expansion of electronic literature from the CD-based hypertext fictions of the late 1980s and early 1990s to the web-based literary works created starting in the mid-1990s by writers such as Michael Joyce, Stuart Moulthrop, Christine Wilks, and Caitlin Fisher.[22] Similarly, the artgame movement, which included numerous network-oriented experiments, took off in the 2000s with work from artists such as Frank Lantz and Jason Rohrer.

Games, whether analog or digital, are generally excluded or marginalized in art-historical accounts of network art that draw more directly from avant-garde traditions. However, an examination of ARGs suggests numerous intersections between game and network art forms. Like the network art that I have reviewed, games invoke and experiment with aesthetic qualities such as relationality, participation, and improvisation. The five specific characteristics of ARG form that I will introduce and analyze here are reliance on a transmedia flow, integration of play with everyday life, production of an "alternate reality," breakdown of distinctions between designers and players, and organization around collective gameplay. I do not mean these elements to serve as a definitive list. Similarly, not all of these qualities are equally emphasized in all existing ARGs. However, to different degrees, all such games include or play with these five elements. More importantly, each of these qualities highlights the unique network aesthetics of ARGs.

The first key quality of ARGs is their transmedia flow. At the outset, it is

crucial to distinguish my usage of "transmedia" from both the "intermedia" imagination of Fluxus artists such as Dick Higgins and the "multimedia" work that was already available prior to the expansion of the web—for instance in CD-ROM, videogame, and museum exhibition contexts. In 1966, Higgins described "the intermedial approach" as emphasizing "the dialectic between the media."[23] As one Fluxus member, Ken Friedman, has written, intermedia involve "the melding of aspects of different media into one form" that exceeds existing formal categories and, in this way, serves as "a precursor to media convergence."[24] "Intermedia," then, comes to describe limited intersections between existing media such as poetry and music. By contrast, the term "multimedia," which came into greater vogue surrounding the rise of personal computing, describes a combinatory form. Whereas intermedia art, especially as practiced by Fluxus, was often process-oriented and not fully realized, multimedia art tends to be a complete and polished melding of components. Multimedia art, for instance in the form of an installation art piece or a CD-ROM work, might combine text, audio, moving images, and an interactive interface. As Anna Munster has noted, multimedia art has much in common with Richard Wagner's earlier concept of *Gesamtkunstwerk*, or "total artwork": "Like the *Gesamtkunstwerk*, multimedia seemed to offer the dream of total experience (albeit upon the rather constrained stage of the computer desktop) by synthesizing the various elements of audio, visual, text, and graphic files with interactive gesture, all orchestrated via digital code."[25] One limitation that accompanies this sense of totality, however, is that it deemphasizes processes that exceed publishable multimedia works or prescripted performances.

The transmedia dimension of ARGs relates both to the intermedia of early network art and to later multimedia, but it also entails some key differences. Transmedia captures a relationship between media that is proliferating rather than additive. ARGs tell a single story that passes through and alternates between media in order to make sensible the differences and intersections between those media. Rather than reinforcing absolute distinctions, however, transmedia works such as ARGs show mediality to be, in Marie-Laure Ryan's sense, "a relational rather than an absolute property."[26] Within these games, computer networks operate simultaneously as a privileged infrastructure, as well as one of many media. Unlike the products of multimedia franchise universes such as *The Matrix* or *The Lord of the Rings*, which often erase media distinctions in favor of the diegetic totality of a seamless world, the transmedia aesthetic of ARGs depends on narrative fragmentation and transitions between multiple interfaces (a

technique that corresponds with the comparative media method I employ throughout this book).[27] At the same time, the transmedia flow of these games, which unfolds at least semi-improvisationally across time, foregrounds mediation as an active process. Additional media can always be added via network updates to the cumulative experience as it unfolds, by designers or sometimes by players. In this respect, transmedia ARGs, like intermedia, promote transcoding and transformation over time. Moreover, the experience of moving among media in these games encourages both designers and players to adopt a comparativist analytic.

The second formal quality of ARGs is their integration of play with everyday life. This quality pushes against Caillois's position that gameplay takes place in a zone that is separate from everyday experiences. He insists that a game's domain is "a restricted, closed, protected universe: a pure space."[28] Indeed, many games have a cordoned-off space and time—what the play theorist Johan Huizinga called the "magic circle."[29] The chessboard, the basketball court, and the screen-based videogame play session all involve spatiotemporal coordinates that depart from the everyday. ARGs, however, complicate the concept of the magic circle by blurring the boundaries of gameplay in a variety of ways that resonate with the earlier Situationist notion, articulated by Guy Debord, of "ludic ambiances" that transcend the opposition "between play and ordinary life."[30] One unique feature of an ARG that accomplishes this blurring is the "This Is Not a Game" aesthetic that suggests to players that the shared experience into which they are entering is not a designed ludic fiction but instead an aspect of the real world.[31] For example, a game such as *The Beast*, which ran for three months in 2001, was designed as a promotional tie-in to Steven Spielberg's film *A.I. Artificial Intelligence*. Instead of launching with an open invitation or the "press start" screen that one might see at the opening of a videogame, *The Beast* began with a series of "rabbit holes" that provided subtle entry points into the experience. For example, both theatrical trailers and posters for the film included, in the credits, a contributor named "Jeanine Salla" who was credited as the "Sentient Machine Therapist." Some viewers, perplexed and intrigued by this position, searched for this name online and found several websites (created by the designers) that served as the initial steps of the game's trail. These sites staged the play experience but never revealed explicitly that they were part of a game.

ARGs have blurred ludic boundaries in a variety of ways. For example, *Prosopopeia Bardo 2: Momentum*, which was based in Stockholm in 2006, required participants to role-play both their ordinary selves and dead rev-

olutionaries, to learn fictional rituals that had to be performed in public urban spaces, and to observe no set spatial borders to the game.[32] This ARG opened up two uncommon types of play. First of all, it tapped into "deep play" (a concept derived from Jeremy Bentham and developed by Clifford Geertz), which describes a form of seductively absorbing play in which "the risks to the player outweigh the potential rewards." Indeed, *Momentum* frequently asked players to engage in publicly compromising actions without offering a clear sense of what might be gained in the completion of the game. The second mode of "dark play" (described by Richard Schechner, following Gregory Bateson) is a condition in which "some of the players don't know they are playing." This form of play may include "fantasy, risk, luck, daring, invention, and deception."[33] For some theorists, dark play falls outside of the domain of games. McLuhan, for instance, disqualifies activities such as war or stock trading, which adopt game metaphors, from being games because their rules are neither known nor accepted by all participants. And yet, despite an ARG's subversion of the metacommunicative message, communities learn the form's conventions and generally approach the experience as a game (even if the precise status of the experience is being perpetually constructed and renegotiated). Nevertheless, especially with games that unfold in public spaces, some spectators may still not realize that what they are observing is a designed game.

The confusion of gameplay and everyday life in ARGs becomes possible, in large part, because of the time and space of networking. High-speed Internet and participatory media contribute to always-on communications that take place roughly in real time. The combination of personal computers and the Internet blurs older divisions between day and night, local and global, work and play, and public and private realms. These sociotechnical conditions make possible the full realization of art forms such as the ARG. Earlier related games that are trail-based but nondigital, such as Polish *podchody*, usually run for a single session that lasts for a few hours and play out across a continuous physical field. ARGs, on the other hand, circumvent such compression and can stretch on for several months (as players receive and discover clues at irregular times). They also regularly unfold across numerous online and physical terrains. The immersive nature of these games derives in large part from their networked qualities.[34] For instance, the muddling of real life and gameplay that takes place across such an experience often inspires a sense of paranoia. Such experiences are made possible by the very pervasiveness of computer networks. Digital and networked media are surely not universal or evenly distributed, but they

do frequently give *the impression of ubiquity*.[35] ARGs rely on this sense of networked omnipresence and try to reinforce it at every turn.

The third key element of ARGs, which is closely connected to their confusion of the everyday and the ludic, is the production of a so-called alternate reality. Though an ARG is tightly integrated into everyday life, nearly all such games begin with a speculative or counterfactual premise that marks a departure from empirical reality. As such, science fiction (e.g., *I Love Bees*), occult (e.g., *Last Call Poker*), and mystery (e.g., *Mystery on Fifth Avenue*) narrative genres are especially common in ARGs and the related form of pervasive games. As Henry Jenkins has observed, the broad category of transmedia storytelling is closely linked to a participatory culture that privileges both serialization and world making. These elements certainly have a much longer history that stretches back to science fiction and fantasy literature, comic books, and televised soap operas. However, as Jenkins, Sam Ford, and Joshua Green note, these worlds, which have become more visible and prominent in the heavily networked early twenty-first century, often include several elements, among them "large backstories that cannot be neatly summarized; an ensemble of characters within the current narrative and across its larger history; substantial reliance on program history; a wide variety of creative forces over time; a serialized structure of storytelling; and a sense of permanence and continuity within the fictional universe."[36] Media that open up into extensive and flexible worlds are especially popular within network-based participatory cultures, including fan fiction communities that debate and contribute to these worlds. In a more specific way, the "alternate" dimension of "alternate reality games" allows players who belong to a seemingly total network to experiment with other ways of being in their milieu. Through their intersection with everyday life, ARGs initiate a production of belief (rather than a traditional suspension of disbelief) in prospective players that may last several days, weeks, or even months.[37] In other words, instead of giving themselves over temporarily to a ready-made narrative, ARG participants more often co-produce a world that gains meaning and depth through collective play.

A fourth formal quality of ARGs is the breakdown of absolute distinctions between game designers and players through ongoing adaptation to the emergent gameplay. While ARG designers are often dubbed "puppet masters," the puppet strings of such a game are, as the first Deleuze and Guattari epigraph to this chapter suggests, "tied not to the supposed will of an artist or puppeteer but to a multiplicity of nerve fibers." In many senses, ARGs are networks in process. An ARG develops across a longer dura-

tion and numerous nodes, allowing designers to adjust the game to player responses. Since content appears online—often just in time for player consumption—designers are not limited to the uniform typesetting and publication schedules of novels or even videogames, which often cannot be altered significantly (except for supplements, add-ons, new editions, and network updates) after release. A frequently cited example of a major ARG adaptation comes up in discussions of *The Beast*. In 2001, the ability of this game community to collaborate as effectively as it did surprised the game designers. Initially, the creators constructed what they believed would be three months' worth of game content, but the community of millions banded together to solve all of those puzzles in a single day, requiring the team to go immediately back to the drawing board in order to adjust the game's difficulty.

In addition to technical modifications to pacing and game balance, ARGs encourage creative forms of interplay between designers and players. Thus, along with an alternate or fictional world (the third quality that I emphasized), the improvisation inherent in an ARG also involves a correspondence with the everyday world across which the game unfolds. Admittedly, all games, insofar as they are never played exactly the same way twice, include a quality of chance and inventiveness. Nevertheless, in an ARG, the improvisations may be more substantial. The writer and designer Sean Stewart divides forms of possible ARG interaction into three categories that he calls "power without control," "voodoo," and "jazz." In "power without control," designers allow players to add to a narrative in strictly defined ways without allowing them to shape the game's core development. Challenges that incorporate user-generated content, such as the Flickr task in *Tomorrow Calling*, belong to this category. With "voodoo," designers invite players to contribute new assets from which the designers compose the shared narrative. For example, *Speculation*, a multicity ARG that I created with Katherine Hayles and Patrick LeMieux in 2012, allowed players to create characters, images, and situations that became part of the game's central mythology. Finally, "jazz" offers to players a considerable stake and collaborative role in the game by building "blank spaces" into the narrative that players can fill in. Though Stewart does not specify the variety of jazz he has in mind, the best analogy might be the kind of collective improvisation most common in free jazz pioneered by musicians such as Ornette Coleman and John Coltrane. In a game, such emergent cocreation of a world requires responsiveness across a network and may therefore be difficult to manage. The extended example of *The Project* will offer some examples of jazz interaction.[38] All of these improvisational techniques would, admittedly, be pos-

sible with a performance art piece or a live-action game that did not depend on computer networks to connect its players. However, the speed and ease of response, as well as the quality of inherent distance between designers and players enabled by the web, encourages a regularity of interplay. This quality of ARGs suggests that while networked life involves numerous habits (e.g., checking email and posting on social media), it also allows for new forms of spontaneity and improvisation.

The fifth and final formal quality of ARGs that I would like to emphasize is their inherently collective dimension. In contrast to the largely individualistic reader or viewer experience of the forms I discussed in the first part of this book, including the network novel, film, and television series, ARGs are inherently participatory and community-based. More than that, the realization and completion of these games *rely* on collective intelligence and collaboration. Certainly, we can see an artistic precursor to this idea in Robert Filliou's Fluxus concept of the "eternal network" that tries to capture the limits of individual knowledge within an increasingly transnational and transdisciplinary world. At the same time, the network for these earlier artists was arguably more an experimental proposition or conceptual possibility than a sociotechnical infrastructure that would both enable and limit participation.

Two common design conventions that make collective engagement necessary in ARGs are scale and difficulty. A central pleasure of ARGs concerns the discovery and reconfiguration of pieces of a fragmented narrative. Players must search for and compile narrative elements across media, for instance by coordinating individual players to answer pay phones across the United States at a precise date and time, as in *I Love Bees* (2004), or by decoding complicated slow-scan television images, as in *Potato Fool's Day* (2011). In many senses, an ARG embeds a story across a transmedia network and then requires a network of players to make sense of it. Individual players not only benefit from the help of others but, in many cases, are dependent on it. Given the speed and simultaneity of events, no single player is likely to have a total experience of any ARG. In this way, ARGs resemble interactive theater works such as Punchdrunk's *Sleep No More* (2011), in which the company invites the audience to explore a restored hotel in which a distributed performance of *Macbeth* is taking place. Audience members cannot, of course, be in each room of the hotel at once and so can achieve only a partial experience of the total performance. Similarly, ARGs rely on distributed and nonlinear narratives that encourage information sharing and interaction among participants.

Though ARGs tell collective narratives, there is also a nonnarrative, lu-

dic dimension that gives rise to collective networks of players. ARGs are, after all, "games" that include puzzles, codes, and challenges that must be solved to enable progression. Such trials may require knowledge of website architecture, social media, specialized software, formal logic, game conventions, and other types of discipline-specific content. As such, it is unlikely that any single player could have the multidisciplinary range to traverse every challenge. Though close reading, for instance, plays a part in some puzzles that make up an ARG, these games more regularly reward forms of distributed cognition, hyperattention, and large-scale collaboration that make up networked life. In other words, though ARGs may include highly specialized skills proper to industrial-era division of labor, these games exist in a broader framework that is more proper to the postindustrial era and its forms of affective and collective labor.

The five key qualities of ARGs that I have outlined all demonstrate the formal dependence of these games on computer networks and their participatory cultures. With this overview in mind, I now turn to the specific case of *The Project*, which incorporates these elements but also opens up a more specific analysis of the experience of networks through three key network concepts: process, collaboration, and failure.

The Project: An Alternate Reality Game

The Project was a Chicago-based ARG that unfolded as a collaboration with the new media artist Sha Xin Wei, the Montreal-based Topological Media Lab, and students at the University of Chicago. This ARG, which took place between April 1 and April 25, 2013, conveyed a single transmedia story through social media, performative role-playing, responsive media environments, and live-action events.[39] Over the game's three and a half weeks, players explored three conspiracy groups that were involved in a shared yet mysterious enterprise. The experience that unfolded came, in both intended and unexpected ways, to serve as an allegory of the game design and production process itself. This game explored the possibilities and limits of play in an early twenty-first-century media ecology that is characterized by screen-based entertainments, social media networks, and a blurring of work and play. *The Project* was networked in several senses, inviting the emergence of different player communities throughout its duration.

Like other ARGs, *The Project* began with a series of rabbit holes, entry points by which players could join the experience both offline and online. Prospective players discovered, for instance, a live-action marionette that

5.1. Marionette "rabbit hole" from *The Project* (2013, photograph by Bea Malsky).

was walking around the University of Chicago campus, distributing post-cards with the location and time of the game's first live event (fig. 5.1). Other rabbit holes included a Facebook page belonging to the game's antag-onist (named Pophis), mysterious audio played on the 88.5 FM community radio station, a website announcing something called *The Project*, strange circulating videos, paper flyers of various designs, Twitter announcements by a group called the Documentarians who recorded all live events, and listening stations with recordings located around the Hyde Park neighbor-hood of Chicago. All of these rabbit holes pointed to the dates, times, and locations of the game's opening events.

This early rabbit hole period of the game, which lasted for approxi-mately four days, represented the period of greatest ambiguity and spec-ulation for prospective participants, who were not yet sure what these seemingly related signs indicated—or whether they were, in fact, even part of the same experience. Early comments on the online forum indi-cated possible patterns without a form. In line with other ARGs, during the twenty-five days of continuous activity of *The Project*, designers did not ac-knowledge a distinction between the game experience and everyday life. At any moment, an event, a game, an object, or an atmosphere in Hyde Park could belong to the space and time of *The Project*. In fact, as the game un-folded, players experienced both paranoia and apophenia (i.e., the human tendency to see meaningful connections everywhere). This aesthetic of embeddedness in broader patterns, a common feature of ARGs, had much

to do with the pervasiveness of networked technologies and the designers' distribution of rabbit holes and challenges. Players began drawing connections among various narrative and game elements that were released in numerous locations. The underlying meanings of accumulating events became a key topic, for instance on the primary game discussion forum. As the game continued, players also posited links between game artifacts and phenomena that were not part of the intended game design, extending the possible play space in unexpected ways.

The experience that followed these initial rabbit holes involved a process of infiltrating the three conspiracy groups involved in the eponymous "project." Each group fetishized a different element—sound (Sonos), objects (Ortgeist), and movement (Ilinx)—and offered a divergent perspective on the central science-fiction mystery of the game, which involved a strange portal into another world. Along with its central narrative, *The Project* was composed of a series of games and puzzles. For instance, a media manipulation challenge aligned with the Sonos conspiracy required players to acquire audio files online and reconfigure them in order to crack a code. A different task began online with the release of a numerical cipher that, once decrypted, yielded a Regenstein Library call number. If players then left their computers and located that book, they would find critical information about the narrative hidden between its pages. Other games included live-action exchanges with actors, such as an event we called "The Grand Ort's Game," a variation of the inductive logic game Zendo. In this game, the Grand Ort (the leader of the conspiracy group known as Ortgeist) assembled a series of toys according to an unspoken taxonomic rule, required players to create their own object series according to the same rule, and finally asked them to articulate the rule. Yet another live-action game, this one aligned with the Ilinx conspiracy, included a remix of Capture the Flag that allegorized, via its mechanics, the central narrative of the ARG. Overall, then, *The Project* invited players to interact with multiple media (including radio, videos, and social media), narrative (both sequential and nonlinear events), role-playing (a variety of interactions with characters), and gameplay (rules, mechanics, and objectives). At different moments, the designers characterized the creation and execution of this ARG as research, practice-based humanities work, art practice, game design, media theory, and social intervention. I attempt to keep the multiplicity of these categories alive throughout my analysis of the game.

Though many aspects of the *Project* ARG invite interpretation, the most crucial for an understanding of the game's aesthetics has to do with its rela-

tionship to emergent networks. In what follows, I attend to three concepts that were central to this ARG and its network form. These concepts, which are related in a variety of ways, are process, collaboration, and failure.

Process

The first key concept, process, reframes network form as something other than a static, distributed structure and instead enables us to think in terms of ongoing practices of networking.[40] As Anna Munster observes, "It is never going to be possible to 'see' networking—to diagram the coming (in)to experience of networking—although we might look at diagrams of the network."[41] Networking thus resists the synoptic aspirations of the diagram. Whereas multimedia work (especially that which operates as a continuation of Wagner's *Gesamtkunstwerk*) often promises a total visible field, ARGs privilege a course of development through which a partial play experience unfolds. Process undergoes blackboxing, or is at least difficult to reverse engineer, in a number of art forms that foreground the published text or ultimate performance. ARGs, however, are predicated on continued interplay between designers and players—and a renegotiation of the shared experience across time. Networks, then, do not suddenly become seeable or imaginable as soon as one attends to process. Rather, an experience of becoming networked increases sensitivities to multidimensional changes and affects that exceed linear causalities.

A concrete example from *The Project* may help illustrate this concept. As the game evolved, the design team realized that we were not creating a flat play experience that would involve all participants in roughly equivalent ways, as in a traditional theatrical production in which an audience observes a single action sequence from start to finish. We grasped an inevitable variability of engagement, for the first time, in one of the initial rabbit holes, which involved an actor playing a marionette that interacted with people passing by on the street at several locations on the University of Chicago campus. We discovered that though a few people were willing to engage in public play, either by manipulating the marionette's strings or taking the postcards that the figure was passing out, the majority seemed too busy or uncomfortable to participate, even if they observed the scene from a distance. During this event, we realized that the network of players who might make up our game would have to be divided across several tiers of engagement. In addition to the discomfort surrounding public play, *The Project* would roll out through myriad other offline and online media. Thus,

we needed to create different rabbit holes and pathways for spectators or lurkers (who might follow the story or particular activities without making contributions), moderately involved players (who might participate in certain game activities), and finally what we might call gamers or hardcore participants (who might be involved in many of the more challenging and time-consuming challenges).[42] Moreover, from our original observation of the marionette set piece, we recognized that players might move in and out of different roles throughout the game, depending on their interest and availability. Thus, though we originally imagined that the rabbit holes would attract a fairly stable group, it turned out that the player network would be perpetually in flux, understood as a process and pace of networking rather than a set group that would merely change its composition of nodes over time.

The process by which players negotiate the shape of their social network and the forms of communication that they will undertake is arguably not just an aspect of ARG form but also a critical aspect of its aesthetic. A key sensuous experience and pleasure of ARGs, in other words, depends not on the narrative or game form but on the emergence and organization of relations with others. Drawing from Bateson's writing on ecology, Munster emphasizes a point that becomes particularly palpable in ARGs. As she puts it, "The human, for instance, is not an object 'in' the environment; rather, human-environment is a coupling that, already a network/relation, generates a network/relationality of interactions."[43] Similarly, in an ARG, players are not actors invited to join a wholly prescribed game or fully established environment. Instead, the interplay of numerous factors—designer scripts and plans, player actions and gameplay, responsive actor performances, play environments, daily weather conditions, Internet access, and so on— constitutes what might heuristically be called *a network* but is more like a process of improvisational networking that gives rise to emergent relations and a common purpose.[44]

The Project included many unexpected relations that became possible through processes of collective dilation and contraction, as well as more substantial forms of entanglement and disconnection. On numerous occasions during the April 2013 run, designers created new games or narrative artifacts in response to the ways in which participants were playing. One example involved robust interplay between the game's antagonist, Pophis (the owner of the game's Facebook page, who was managed and played by two designers), and a single player. This player continued to email Pophis, via Facebook, throughout the entire game, assuring him that she was on

5.2. Final event from *The Project* (2013, photograph by Bea Malsky).

his side. As Pophis tested the player's loyalty through challenges composed specifically for her, she completed them. Finally, to return that trust, Pophis swore the player to secrecy and revealed his "true name," the only signifier that could undo him after he had taken power. Toward the end of the game's final event, the large crowd of players finally encountered the antagonist in what is called, in videogames, a "boss battle" (fig. 5.2). In this encounter, the player collective discovered that they could only keep Pophis from opening a destructive portal by speaking his true name aloud. Thus this part of the finale depended upon trusting a single player to attend the event, remember Pophis's true name, and defy him by sharing that name with the group. Though the collective nature of much of the gameplay did not initially predict a climax that depended on one player's contribution, this unexpected relation and the designers' growing sense of the multitiered play affordances of ARGs led us to embrace contingency and responsiveness to players in the final event design.

Process in *The Project* came to be treated by the group not as a means of reaching an optimal end but as an ethic of response and a mode of inquiry predicated on making. "Making," a method that has gained traction in fields ranging from the digital humanities to anthropology, is not a prelude to thought or research but rather a process of developing, testing, iterating, and transforming concepts. As Hayles observes, "The work of making—

producing something that requires long hours, intense thought, and considerable technical skill—has significant implications that go beyond the crafting of words. Involved are embodied interactions with digital technologies, frequent testing of code and other functionalities that results in reworking and correcting, and dynamic, ongoing discussions with collaborators to get it right."[45] The responsiveness necessary to involve participants in play yielded a design process that was perpetually humbling, entailing everything from unpredictable human actions to the unplanned breakdown of nonhuman technologies. We learned to approach the player network not as an object that could be made to engage with the designed ARG in a controlled or foreseeable fashion but as an assemblage of unfolding relations to which the designers also belonged. Along the way, the smallest changes in that network—greater or lesser turnouts to events, new posts on the game's discussion forum or Facebook page, or overheard player discussions during live events—spurred rapid adaptations. The involvement and embeddedness of designers in the game did not provide critical distance *from* player networks, but it did create an experiential play *within* networks.[46] Rather than reflecting a top-down diagram of a network, then, the game's aesthetics of process and play made networking both experientially and reflexively accessible.

Collaboration

A second key network concept that I draw from *The Project*, collaboration, is closely related to process as I have been describing it. Admittedly, "collaboration" is often deployed as a buzzword of the network society that describes a flexible and productive mode of teamwork. In directing *The Project*, I did not discount this organizational connotation, but I also invited the designers to think about collaboration in two other ways: as a form of critical complicity and as a transindividual relation that privileged provisional contact over corporate networking. In their theory of networks, Galloway and Thacker observe that a key step toward determining an ethics and politics of networks requires an answer to the question: "What would a network form of praxis be like?"[47] In response, I would propose collaboration as a key network practice that belongs as much to the ethical and political as to the organizational. Collaboration in *The Project* can be understood in the dual sense of "complicity" and "collectivity."

The first sense of complicity became especially apparent in the ARG production process. The title of the game, *The Project*, foregrounded what

Manuel Castells has described as the fundamental unit of our postindustrial economy and a networked mode of organization. As he explains, "The network enterprise is the specific set of linkages between different firms or segments, organized ad hoc for a specific project, and dissolving/reforming after the task is completed. . . . This ephemeral unit, The Project, around which a network of partners is built, is the . . . one that generates profits or losses, the one that receives rewards or goes bust."[48] The project, then, is a networked organizational form but one that tends toward what José van Dijck calls owner-centered "connectivity" rather than community-oriented "connectedness." In order to produce and complete a project within a limited period of time, corporations often instrumentalize interconnected groups and their creative capacities.

The project form is not, however, limited to the corporation. Artistic collectives, for instance, undertake projects that are similarly "ad hoc" and "ephemeral," even as they do not necessarily generate the same kinds of "profits or losses." One relevant example would be Fluxus. As Craig Saper has argued, Fluxus took the form of a "laboratory" that would "organise social networks, networks of people learning." The Fluxus method was not completely unrelated to corporate research and development practices. However, instead of pursuing quarterly profits, the members of Fluxus approached their work with more intrinsic motivations. More than an art movement, as it is often described, Fluxus was "a research methodology" for "networked ideas"; individuals received credit for their contributions, but the overall network and collaborative process were valued over and above the discrete inputs.[49]

Drawing from Castells's formulation of "the project" and aspiring to the Fluxus "laboratory" model, the *Project* game brought together a group that would be not only ephemeral in its composition but also largely coterminous with the game itself. The ARG both adopted and interrogated the flexibility of the project form in order to produce an augmented reality through sited experiences and emergent networks of play. On the one hand, the game production accepted and relied upon this form. The design team was organized as a distributed collaboration made up of faculty, artists, and students coming from a broad range of disciplines and practices for the purpose of creating something like a final product: a shared game. On the other hand, *The Project* interrogated its own mode of production by exploring whether a collaborative "project" that relies on both networked media and game form is inevitably compromised by communicative capitalism. Despite a commitment to exploring possible alternatives to the corporate

"network enterprise," we remained open to generative parallels between that organizational structure and the types of team dynamics that made up our "ad hoc" production. Like the economic activity that Castells describes, the collaboration of *The Project* demanded flexibility and constant communication via electronic media, including email, instant messenger, and networked Google documents that were often written and edited by designers working simultaneously from several cities. The ephemeral laboratory of creators spent several months designing, writing, developing, and rehearsing the game, and then engaged in twenty-five days of execution that involved a process of always-on and just-in-time game design. Through this process, the group underwent a somatic experience of the postindustrial period's blurring of work and play. At the same time, the project privileged responsiveness to and respect for player contributions over a common corporate preference, as in the case of many videogames, for a polished product that allows players only insubstantial forms of "customization."

A related complicity into which we entered through this artistic project had to do with our fundamental reliance on game form. From the beginning of the design process, we often reflected on the difficulties of using a game to explore alternative forms of social life and challenge aspects of contemporary capitalism, including its privileging of restorative leisure and fun over engaged play and improvisation. Beginning in the early twenty-first century, the design strategy known as "gamification" has sought to produce forms of motivation that build on the extrinsic aspects of games—especially leaderboards, achievement systems, badges, and points. Gamification has played a major part in areas such as consumption, education, and employment. Uses of gamification have included the customer engagement of the Foursquare mobile application, the physical fitness development game Zamzee, and the employee engagement of the Nitro for Salesforce application.[50] Critics have accused such products and curricula of relying largely on extrinsic motivations and of pursuing behavior modification rather than the playfulness that games can foreground. While earlier forms of social play, such as the practices developed by the Situationists or Fluxus, often departed from or resisted industrialized labor, work and play blur increasingly in the postindustrial period of information economies and cognitive capital in which Castells situates networks. Indeed, gamification has thrived in conjunction with the rise of networked media. Each year, Internet users are spending an increased number of hours online (a *Global Web Index* study reports an all-time high of 6.15 hours a day in 2014), engaging in activities such as work, manage-

ment of personal finances, communication, social networking, television watching, new consumption, and videogame play.[51] This activity has made available unprecedented quantities of data that can both be organized and processed in real time to offer various forms of feedback to users, including through the interactivity of digital games. This contemporary use of games, and its expanding role in data-driven and networked culture, thus introduced complications to using a game form for sociopolitical critique in *The Project*.

Through its reliance on both networked media and game form, *The Project* invited designers and players to inhabit the contradictions and tensions of their historical present in a reflective way. "Collaboration," here, took on connotations of collective labor but also of impure association or cooperation with a problematic system. Rather than seeking to avoid such complicity, we embraced it. Admittedly, as Jacques Derrida has observed, "even if all forms of complicity are not equivalent, they are irreducible. The question of knowing which is the least grave of these forms of complicity is always there—its urgency and its seriousness could not be overstressed—but it will never dissolve the irreducibility of this fact."[52] Without trying to avoid complicity with the forms of the network, project, and game, the aesthetic work of our ARG thus became, in part, an intellectual process of adjudicating, as a transitory collective, among various nonequivalent types of complicity.

The Project represented a sociopolitical intervention insofar as it sought to reintroduce play into the temporal conditions of everyday life, to produce novel experiences of overly familiar environments, and to place art making at the center of ordinary social relations. This ARG, however, was not an act of "refusal" in the sense of Nick Dyer-Witheford and Greig de Peuter's "counterplay," which entails a complete rejection of political, economic, and military foundations of what they call capitalist "Empire," or of Alexander Galloway's formal category of avant-garde "countergaming."[53] Similarly, this ARG departed slightly from Rita Raley's category of "tactical media," which imagine "an outside, a space exterior to neoliberal capitalism," through means that are "not spatial but temporal," though it did share with these media an experience that was "diffused, networked, multiple, and a-territorial."[54] In place of total refusal or local resistance, *The Project* operated from a participatory and reflexive inside that allowed networked processes and complicities to *play out*. As Jenkins, Ford, and Green have pointed out, the language of "resistance" reached its height in discussions within critical theory and cultural studies beginning in the 1980s. They add:

Today, academics are much more likely to talk about politics based on "participation," reflecting a world where more media power rests in the hands of citizens and audience members, even if the mass media holds a privileged voice in the flow of information. Syntax tells us all something key about these two models. We are resistant *to* something: that is, we are organized in opposition *to* a dominant power. We participate *in* something, that is, participation is organized *in and through* social collectivities and connectivities.[55]

This mode of participation, then, is not nihilistic, suggesting there is no way out of one's embeddedness within power structures. Instead, participation can be a process of reflective entanglement that oscillates between possible involvements and transformations.

The collaborative sense of participatory complicity was not only limited but also, in other ways, enabled by *The Project*'s reliance on game form. Games are an aesthetic form that invites an involved reflection on the experience of complicity and the perspective of the collaborator. Games, unlike most novels or plays, require us to participate in an action rather than to observe a situation that plays out among characters at an imagined or physical distance. Jesper Juul observes this complicity, for instance, in his reading of Brenda Brathwaite's board game *Train*, in which players are asked to pack boxcars with people, only to realize that they are participating in a modeling of the Holocaust. As he notes, "This use of deception and revelation opens up a whole range of new experiences, where the discomfort of having worked for something unpleasant turns out to be a strong emotional device unique to games."[56] The player enters into still other forms of complicit collaboration in videogames such as *Shadow of the Colossus* and *Braid*. In all of these cases, the game does not merely represent an ethical situation through narrative devices but rather models and activates it through the willingness of the player to play (and continue playing) the game, even if she feels ambivalent about that participation.

The Project included several moments of uncertain collaboration among the designers as well as the players. For example, at roughly the midpoint of the game, players were invited to explore a "blanket fort" that included an elaborate set and several actors. Upon arriving at the announced location, players were greeted by the character named the Grand Ort who read an "official decree" (fig. 5.3). This decree operated as both the narrative premise for this episode of the game and the rule set for the gameplay that would follow. The Ort revealed that the characters known as the mario-

5.3. The Grand Ort from *The Project* (2013, photograph by Bea Malsky).

nettes (played by live actors) had "abandoned their duties" at the bureau-
cratic Ortgeist organization, taken a group of precious objects, and escaped
to a University of Chicago dining hall (which had been transformed into a
set). Without forcing them to participate, the Grand Ort read a set of rules
to the players, instructing them, for instance, to walk through the playing
field instead of running, to seek shelter in built forts, and to avoid darkness
whenever possible. Ultimately, the goal of the game was to "recover the ob-
jects, disable the marionettes."

 Upon receiving these instructions, players entered enthusiastically into
the play space. Some visitors actively took part in the play fort and its many
interactive puzzles; others stood on a second-floor balcony that looked
down upon the field and yelled out advice to players on the ground. Af-
ter players completed the course and captured all of the marionettes, the
Grand Ort thanked them. Though the nature of the event had never been
kept from players, the Ort now foregrounded that the players had just par-
ticipated in bringing down a revolt staged by a group of marionettes that
were functionally being enslaved by the Ortgeist conspiracy. At this mo-
ment, the jovial feeling of gameplay was replaced by a more somber tone
that was reinforced by a room darkened in the movement from sunset (at
the start of the game) to nightfall. The experience of complicity with an
unjust group affected players visibly—in part because they had listened to
rules and followed orders in order to progress in the game, despite having
received a clear indication of their complicity with an organization that un-

justly incarcerated a group of people who wished to escape. The embodied experience of participating in this game, including the curiosity, puzzle-solving, interactive storytelling, and growing realization of complicity, spurred, for both designers and players, a different form of reflection on embeddedness within forms of power that can be both problematic and seductive.

The Project also foregrounded "collaboration" in its more common sense of collective experience. In the quotation that serves as the second epigraph of this chapter, Crary notes that it becomes increasingly more difficulty in the early twenty-first century to imagine a pause that might allow "a longer-term time frame of trans-individual concerns and projects" to "come into view." In part, *The Project* organized and enabled an experience of networks in order to encourage a break from an American everyday that relies heavily on individualism.[57] As I explained above, ARGs are of formal interest because their network aesthetics tend to serve collective rather than individualist ends. ARGs rely on group gameplay because of their scale (i.e., a distributed narrative too large for a single player to traverse) and their difficulty (i.e., the need for players who cover a wide range of disciplinary knowledge and skills). Such group gameplay resonates with Arendt's notion of *sensus communis*, which I discussed in the overview to the second part of the book. It is worth adding, however, that *The Project* did not posit its aesthetic qualities as a way of collectivizing players or conveying a sense of community to an already-established group. Instead, the game treated the very process of collective becoming as a quality of the aesthetic experience that was shared in common.[58]

The Project sought to infuse art making and gameplay with a sense of community in which the continuation and completion of the experience required interdependence and mutual responsibility. Despite an ambitious schedule of rabbit holes, twelve major game events, and a two-hour finale, design teams had to complete their games and events, while also responding to players, in order to allow the game to progress. Similarly, in order to avoid the fate of *Tomorrow Calling*, with which I began this chapter, players had to show up to events and to participate actively. Networking operated as a process of cocreating events via an emergent collective. As the architect Christopher Alexander argues, making anything requires a sense of involvement and obligation that adjusts to relational and environmental factors over time. In the context of architectural design, he notes, "In a good process, each person working on the building is—and feels—responsible for everything. For design, schedule, structure, flowers,

feeling—everything."[59] This sense of collective responsibility was one that we mutually nurtured among designers and players of *The Project*. At the same time, the formation and maintenance of these networks was not always successful.

Failure

A third network concept that *The Project* ARG opened up is failure. Given a number of external pressures (e.g., the game was funded by a Mellon grant and supported by the University of Chicago's Gray Center for Arts and Inquiry) and internal expectations (e.g., the desire to build an audience and avoid the premature ending of ARGs such as *Tomorrow Calling*), this concept was the most difficult to reflect upon and put at the center of our shared collaborative practice, especially prior to the game's completion. Theoretically, too, failure ran counter to a dominant language of tight interconnectivity that informs networked games. As I noted earlier, networks are often invoked as infrastructures that successfully link their nodes. *The Project* challenged this notion by giving rise to and exploring a topology of nonsovereign failure that included unviable or disconnected networks.

Given this chapter's focus on a transmedia game, it is important to specify that my present interest in failure departs, in some respects, from the way it is discussed in both game studies and game-based learning scholarship. As Juul observes, failure is a central feature of game form not only because players frequently fail at games but also because players *expect* failure as a likely outcome when they play games of competition and chance. Moreover, he adds, games allow us to treat failure as a productive consequence: "Games are a perspective on failure and learning *as* enjoyment, or satisfaction."[60] In other words, games invite players to approach failure not as a sign of unachieved success but as a key component in a process of learning. Games, then, promote the acquisition of skills necessary for completion or victory insofar as they promote what Shira Chess and Paul Booth call "safe failure."[61] Though both players and spectators may take some games, such as professional sports, quite seriously, most games limit the consequences of a loss or allow players to seek success through replay.

Interdisciplinary scholarship about games tends to approach failure as a stepping-stone to eventual success. Arguably, however, failure also has intrinsic merits, difficult though they may be to articulate. It can operate, as Jack Halberstam suggests, as a pedagogy or an epistemology that reveals values that run counter to the overarching American obsession with suc-

cess: "Under certain circumstances failing, losing, forgetting, unmaking, undoing, unbecoming, not knowing may in fact offer more creative, more cooperative, more surprising ways of being in the world." Such forms of failure, and others, open up common perspectives on networks ("common" both in the sense of ordinary and as a basis for a shared experience). Computer networks, for instance, often produce the boredom that may accompany unsatisfying web surfing, the impatience that comes with a 404 error message about an inability to reach a server, the disappointment of an empty (or overfull) email in-box, or the rudeness that accompanies voice chat banter in a networked game. Admittedly, in these examples, failure still often feels like *something that happens to us*. Halberstam, however, suggests the more attentive and deliberate undertaking of "practicing failure."[62]

What would it mean, then, to *practice* failure as a way of thinking through networks? *The Project* undertook precisely this challenge, for instance by appropriating existing social media platforms such as Facebook and encouraging players to experiment with these networked spaces. In many ways this ARG was not a game in the sense that either chess or *Super Mario Bros.* is a game. It did not include fixed rules, mechanics, and objectives that stayed consistent from start to finish. *The Project* instead used the transmedia and improvisational affordances of the ARG to create a serial, multiscalar, and modular platform for experimenting with both network and game form. Different microevents would give players the opportunity to cooperate or to compile shared notes about an experience that was, in its entirety, too time-consuming and distributed for individuals to undertake alone. Some of these experiments led to failure, especially when they were unable to generate new or lasting social networks. In some cases, players for whom we designed a particular event simply did not arrive.

For example, a refusal of public play was most evident in the rabbit hole that unfolded on the University of Chicago campus and involved the live-action marionette with which very few participants interacted. In one sense, the designers *did* interpret the tendency of people to pass by or watch from a distance as a lack of success that would require the creation of additional rabbit holes to reach a greater number of participants. At the same time, the designers took this failure as something other than a temporary setback en route to an eventual success. We reflected on the reasons that the transindividual experience of an ARG might not be wholly practicable in our time, even as it emerges from it. This failure, then, raised a question that became a central project of *The Project*: In a world compromised by an overscheduled series of individual itineraries (of which the

University of Chicago is truly an exemplary microcosm), how might one create a substrate within which networked play can emerge?

Our initial failure to encourage play in public spaces thus exceeded an instrumental function or recuperative opportunity to attract players. More substantively, this experience helped us better understand an early twenty-first-century environment in which routine movement across a city, the blurring of work and play, and disconnection from immediate surroundings (often via networked media) make public play difficult both to imagine and to join. Even some players who responded to our public rabbit holes were deterred by the challenge of a game that could not be completed with a single disciplinary orientation or by an individual (and was not linked to a major commercial property). Our game drew inspiration from the practices and projects of the earlier Letterist International and the Situationists, while simultaneously modifying them to resonate with the problematics of contemporary social networks. Borrowing McKenzie Wark's formulation, *The Project* can be said to have inhabited "a practice of play and strategy which invents a way of being, outside of commodified time and outside of the separate disciplines of knowledge."[63] Unfortunately, observers and participants did not always find such play desirable or possible.

A similar process of calling out to potential player networks unfolded online as in physical space—and this, too, was occasionally unsuccessful. For instance, at the start of the game, the designers planned to tweet the events of the game (with embedded Vine images) as they unfolded. These tweets, we hypothesized, might attract new players while offering a summary to players who were interested but could not attend a particular event (fig. 5.4). We also created an online bulletin board for player exchanges, a feature of many ARGs. While these two spaces did not go completely unused, both the Twitter account and the bulletin board attracted only a small number of users. Upon realizing the limitations of these forms of social media for our ARG and our emerging group, designers adjusted by creating a Facebook page that proved better suited for a player community that was made up heavily of university students, many of whom used Facebook (fig. 5.5). Given the relative popularity of this page (some of the posts and media shared via Facebook received responses and as many as 1,400 views), and its development into one of the few hubs of an otherwise distributed experience, we decided to align the Facebook owner with the game's villain, who, at a critical moment late in the game, revealed that he had deliberately tricked players into furthering his malicious plan. We found

5.4. Twitter account (@chicagowormhole) for *The Project* (2013).

5.5. Facebook page (https://www.facebook.com/themaroonrabbit) for *The Project* (2013)

Facebook to be an ideal network infrastructure for our multipart narrative, falling somewhere between the short-form constraints of Twitter (i.e., 140 characters or fewer) and the form of the bulletin board, which often encourages a proliferation of text (e.g., the 42,209 messages produced by the Cloudmakers group at the end of the *Beast* ARG in 2001).[64] Our Facebook posts negotiated these extremes, enabling a balanced communication platform for a group that had limited attention and time, while also conveying the subtleties of a game that required collective play and reconfiguration of a fractured narrative.

Moments of failure also allowed us to think conceptually about dom-

inant models of network change and media reception, especially the metaphors of "viral" and "spreadable" media. Both of these models have their limits in capturing the full range of networked participation in the early twenty-first century. As Jenkins, Ford, and Green argue, the language of viral media, which we encounter for instance in discussions of memes, accounts for "the speed with which new ideas circulate through the Internet." The limitation of this formulation, however, is that it treats media as a wholly nonhuman force. As they conclude, "The concept of 'self-replicating' culture is oxymoronic, though, as culture is a human product and replicates through human agency." In other words, the idea of viral media minimizes the active role of people in assessing and sharing media. In place of viral media, these authors propose the category of "spreadable" media, which emphasizes the distributed agency of human networks in circulating media texts. As they note, "The spreadability paradigm assumes anything worth hearing will circulate through any and all available channels, potentially moving audiences from peripheral awareness to active engagement."[65]

The spreadability model captures something about collective human intelligence online that the viral model marginalizes. Especially the uneven nature of spreadability—the circulation of media texts by different people for numerous audiences and for a wide range of reasons—accords well with the ways in which players often discover, gloss, and archive ARG content. At the same time, another aspect of this paradigm is epistemologically limiting. The spreadability paradigm introduces a value system in which the absolute worth of media content is determined through bottom-up "circulation" by the people (rather than top-down "dissemination" by corporations). In the authors' pithy phrase, "Our message is simple and direct: if it doesn't spread, it's dead."[66] Though this paradigm may represent a beneficial heuristic for media entrepreneurs, its conflation of value with success is surely of limited use to media scholars, many of whom are interested precisely in "dead" media and media art pieces that have conceptual value even as they find limited circulation.[67] Networks, if we approach them exclusively from the perspective of spreadability, give access only to a homogenous field of capitalist successes. While spreadability does admittedly push against the centralization of power and capital in media corporations, it does little to encourage a pedagogy and practice of failure that might open up divergent perspectives about networks and make alternatives to capitalism conceivable, experiencable, and ultimately livable.

Something like the spreadability paradigm has, in fact, infiltrated the

specific realm of ARG design. In an influential discussion about forecasting games and ARGs, Jane McGonigal asserts (without offering a much of a rationale): "One thousand participants seems to me to be a critical threshold to allow for an online game to get interesting—to ensure enough diversity among players, to have enough participants to tackle missions on an epic scale, and to produce enough chaotic interaction to generate complex and surprising results."[68] This claim is problematic for at least four reasons. First, it is difficult to determine what constitutes "participants" and precisely how many of them take part in any given ARG, especially given the wide range of play styles from distant online lurking to engaged offline participation in key events. Second, McGonigal's notion of "diversity" is undertheorized and limited given that successful games will often draw players who are already familiar with ARG form and looking for their next mainstream experience. Third, the loose insistence on "epic" gameplay disqualifies a wide range of ARG subgenres or smaller-scale experiences that promise to be equally thought-provoking and transformative. Fourth, though I sympathize with and share the goal of generating "complex and surprising results," there is no reason that complexity emerges exclusively from "chaotic interaction." This point becomes evident when we realize that free play is not opposed to game structure. Instead, rules and constraints, which are a core feature of games, make play, in all of its diverging and creative forms, possible in the first place.[69]

Imbuing practices of nonsovereign failure with value does not mean romanticizing breakdown as such. In considering the contribution of failure to the study of networks, it is worth noting that not all failures are equally illuminating. Moreover, one's understanding of and response to failure becomes crucial if it is truly to be a "practice." In this regard, it is useful returning to the ARG *Tomorrow Calling*. This game, we might say, failed ultimately to meet both Jenkins's and McGonigal's criteria of "spreadable" media and "interesting" games. *Tomorrow Calling* dissolved in part because of a failure of design that took players too far outside of their "alternate" diegetic space in order to complete an undermotivated task. But what if the designers had responded improvisationally to the frustration that their players communicated via message board discussions? Or, instead of pursuing the "epic scale" that the game originally intended (the creators promise that player actions would "actually affect real-world outcomes")— what if the designers had used the moment of network breakdown to think through their assumptions about the "real world" or the game's media ecology?[70] Finally, what if the game designers had accepted the nonspread-

ability of their network game but had created a different quality of experience for the remaining players? Indeed, these types of questions came up throughout *The Project*, especially when elements of the game were not acting as expected. The participation throughout the game was variable and, by some measures, could have been dubbed a failure. Though the ultimate postmortem trailer for the game, for instance, received over two thousand online views, there was also at least one event during which there were as many members of the design and actor team as participating players.

The experiments of *The Project*, including the failed ones, had to do with knowledge production but also with embodied practices. Aesthetic experiment, it is worth noting, is not identical to scientific experiment. As Wark contends, "While science extends knowledge and expands the materialist worldview, art creates a way of life by shaping material characteristics according to desire."[71] Art, then, does not merely represent or highlight desire (e.g., *The Project*'s revelation that participants lacked the desire to engage in unscheduled public play) but, in an embodied fashion, seeks to produce or reconfigure desire. While artistic experimentation may involve a type of hypothesis testing, it also serves as an encounter with uncertainty that involves a surrender of control and embraces a willingness to undergo transformation.

Rather than representing a network, *The Project* sought perpetually to bring one into existence. Through interactive game form that responded to improvisational play, this ARG sought to remind players that networks are perpetually changeable and reconfigurable. Throughout the creation of *The Project*, design and development were not figured as wholly prescripted precursors to play. The designers decided, in advance, that they would have to adapt particular actions and narrative developments to the emergent network of players. This meant that designers would be attentive to moments of noncorrespondence with players and would be open to change along with them. The network of the game—both the player and technological assemblage—would thus emerge, uncertainly, through performance.

The process-oriented and collaborative dimensions of ARGs open up thinking about politics—including reflections on organization, governance, the commons, and the future of public life in a historical moment constituted by networks. Failure, by distinction, has more to do with ethics. Perhaps Dean is right that networks promise not future democracy but only communicative capitalism. Or, as she puts it elsewhere, perhaps the "affective charges we transmit and confront reinforce and extend affective networks

without encouraging—and, indeed, by displacing—their consolidation into organized political networks."[72] And yet political organizations are only one form of relation—and arguably not the most crucial in a moment when political centralization, including many institutions of representative democracy, has been complicated by networked technologies. William Mazzarella advocates a turn to the ethical rather than the political in his reflection on the much longer history of the politics of crowds and multitudes. As he asks, "Rather than galloping ahead in the name of politics, why not dwell more experimentally in the places where a social field rippled by the reverberations of embodied affects is mediated and re-mediated through more or less authorized narratives and practices?"[73] Given the short history of computer networks, the instinct to consolidate a network politics—or to determine its inextricable interrelation with capitalism—seems premature. In *The Project*, it was the relation of play that made possible an experimental dwelling within different relations—between designers and players, between forces of power and resistance, between people exploring their mutual dependences and fragile connections to one another. As Debord observed, play is an "experimentation with ludic novelties" that is "not at all separate from ethics."[74] Network play, in particular, helps us experience ethics not as a restrictive code but as a collaborative process that opens up various, if often unsuccessful, ways of being and becoming together.

Conclusion: Exhaustion and Ephemera

Despite the disembodied fantasies that saturate some early cyberpunk novels, computer networks produce myriad bodily effects. The network sublime may suggest a form that exceeds experience, but networks become accessible, first and foremost, via the senses. Indirectly, they tether us to devices that may cause neck pain, eyestrain, wrist injuries, and prolonged periods of immobility. More directly, especially in the overdeveloped world, such networks introduce an era of always-on computing in which emails, texts, and social media notifications might arrive at any time of night or day, sometimes encouraging Internet addiction or sleeplessness. Among other things, such networks serve as an index of the blurring of work and play in our time. In the United States and other parts of the overdeveloped world, seemingly omnipresent laptops and smartphones give users the opportunity to play in a virtual world in one window while running financial algorithms in another. If networks produce a world where everything is connected, then it is also a world in which a greater number of activities may grow indistinct, homogenous, and even tedious.[75]

The Project approached art and design as routes to inquiry, enabling a series of experiments with computer networks. At the same time, it produced numerous forms of exhaustion. ARGs belong to a category of transmedia productions that Jenkins, Ford, and Green call "the total engagement experience."[76] For many months of production preceding the game's launch and especially during the twenty-five days of gameplay, some game designers were perpetually on call, tracking player activity through online and offline sites, crafting improvisational replies, and maintaining a responsiveness through an unfolding design process. Similarly, the players of the ARG were called on to check in regularly and post on social media, to discover and attend events, and to solve daily puzzles and challenges during the period of play.

Even amidst the exhaustion felt by the designers and some players, the project of *The Project* was not identical to the project of contemporary capitalism and the network society. Players, for instance, were asked to garner attentiveness and energy that are often unavailable in what Crary calls a homogenizing "24/7" world that is characterized by perpetual work, ceaseless consumption, and an erosion of sleep. Thus, for all of the timeliness of ARGs in their correspondence to the networked culture of the early twenty-first century, they are also profoundly untimely. As Crary observes of our 24/7 world, and as can easily be said of computer networks more specifically, there is an "equivalence between what is immediately available, accessible, or utilizable and what exists." A world of near-immediate connection entails "a generalized inscription of human life into duration without breaks, defined by a principle of continuous functioning."[77] In other words, utility, productiveness, busyness, and efficiency—not to mention spreadability—become paramount values in our world.

By identifying play as its modus operandi, *The Project* challenged these dominant ideals of success. This ARG was a break, but not a break in the sense of a pause offered by leisure that is meant to prepare one for subsequent labor. Instead this game was a break that offered an interruption of the perpetual insistence on utility. As Huizinga observes in his groundbreaking theory of play, the social activity of play can be "connected with no material interest."[78] Similarly, Bernard Suits insists that play is an orientation that is inherently noninstrumental and "intrinsically valuable."[79] In a closely related sense, the play of *The Project* provided an "interval" from which different collective formations could emerge. Put even more strongly, this ARG produced an "alternate reality" that was not an escapist fiction but a vibrant ecology and cocreated world that would coexist, in numerous tensions, with the 24/7 world.

Networks, in so many ways that I have highlighted in this book, can be exhausting. However, even with numerous reflections on networked life, especially since the rise of the World Wide Web, network science, and unprecedented transnational flows in the 1990s, this form has been far from intellectually exhausted. For all of its limitations in enabling complex thought about alternative forms of relationality or connectedness, network form promises to be a major problematic of new media studies and the digital humanities for at least decades to come. Network aesthetics, which include formal and experiential analyses that are never disconnected from sociopolitical or ethical considerations, are a critical approach to imagining, making sense of, and sensing networks. Such aesthetics open up forms of the connectivity that has become a core aspect of early twenty-first-century culture, as well as a community-oriented connectedness that may have receded in the Web 2.0 movement (with its proprietary platforms, set templates, and resistance to net neutrality) but has certainly not disappeared entirely.

Though networks can be exhausting, early in this chapter I offered a partial list of artistic and literary forms that suggest a simultaneous artistic replenishment and proliferation associated with computer networks. I read ARGs as a useful limit case, insofar as these games simultaneously participate in and potentially rewire an era of networked "connectivity." For example, one of the ultimate failures of *The Project*, which is common to many ARGs, was the failure of memory. Given its scale and distributed nature, *The Project* at least partially resisted an archival impulse. Even as the designers sought to document considerable parts of the game via video, photography, and online forums, a great deal of this ephemeral experience could not be captured or stored on a server, and much of it was forgotten. In a historical moment of big data when so much information is preserved and analyzed, memory may itself become, as Halberstam observes, "a disciplinary mechanism." In the early twenty-first century, the networked form of the ARG becomes untimely in its tendency toward loss and forgetting.[80]

In the early years of digital studies, scholars often dismissed "new media" for being mere ephemera. Since that time, the ephemeral nature of these objects has been substantially complicated, and this field has emerged as a major early twenty-first-century interdiscipline. Yet perhaps we can hold on to the category of the ephemeral as something more than a marker of the limited and the unsuccessful that disables serious thought. In our long era of technological reproducibility and perpetually newer media, ARGs recapture the aesthetic force of transience. At the other end of ex-

haustion, ARGs generate a space for embodied processing, reflection, and reconfiguration. At a historical moment when the network sometimes exhausts our imagination of a social life in which everything is allegedly interconnected, ephemeral art, even in its failed instances, introduces a thought, an experience, a perspective, perhaps a possibility that this too shall pass.

Coda
After Networks
(Comes Ambivalence)

After art comes the logic of networks where links can cross
space, time, genre, and scale in surprising and multiple ways.
David Joselit (*After Art*)

Is there any outside anymore, when
networks encircle the globe?
Alexander Galloway (*The Interface Effect*)

Myriad books written about networks, especially since the beginning of the
twenty-first century, regularly naturalize their form. The network scientist
Albert-László Barabási celebrates that researchers are "shedding new light
on our weblike universe" and "all the complex networks that surround us."[1]
Indeed, it is not only scientists who make such claims. Manuel Lima, a visual
artist and information visualization designer, observes that networks "are,
in essence, the fabric of life." Lima subsequently posits an even stronger ver-
sion of this claim, speculating about what fields such as empirical aesthetics
or neuroaesthetics might teach us about the essential nature of network
form. He suggests, "Perhaps we have a propensity for structures similar to
our own brain—at its most basic cellular level—turning us into victims of a
dopaminelike neurotransmitter every time we view systems that roughly
resemble a neural network."[2] Lima locates such intrinsic structures in the
artistic movement of "networkism," which includes the paintings of Sha-
ron Molloy and Emma McNally and installation pieces from Tomás Sara-
ceno and Chiharu Shiota. Such claims, whether coming from scientists
or artists, demonstrate an indistinction between model and world, and

between a sense of interconnection—an experience most often grasped as a network—and a claim that reality itself is structured as a network.

In contrast to a view of networks as the universal, originary, or necessary form that promises to explain everything from neural structures to collective animal behaviors to online traffic, I end this book by emphasizing the contingency of those imaginaries. Knowledge, as Foucault has demonstrated, always depends on a particular historical a priori, an episteme, that shapes it and makes it possible.[3] Networks are arguably a dominant episteme and ubiquitous form of our time, rather than an intrinsic property of the universe. There are, after all, formal precursors that signal an outside to networks. Lima himself identifies the tree as a crucial epistemological form that predates networks and enables representations of complex systems. Throughout the disciplines, trees have served as a basis for figures such as the tree of knowledge, classificatory metaphors such as the "branches of science," and genealogical representation such as Darwin's diagram of evolutionary divergence in *The Origin of Species*.[4] Famously, in their 1980 book *A Thousand Plateaus*, Deleuze and Guattari declare, "We are tired of trees," arguing instead for the value of networked rhizomes. Despite its admitted overuse, this formal precursor to the network might serve as a cautionary reminder that while networks (whether they take the form of metaphors, figures, visualizations, or infrastructures) can help us apprehend various types of complexity, they are nonetheless grounded in the scientific, political, social, and aesthetic preferences of our time.

Network aesthetics—a concept that I have divided heuristically into maximal, emergent, realist, participatory, and improvisational qualities— are by no means opposed to scientific appropriations of networks, which are themselves inseparable from the network imaginary. Aesthetic works, as I have argued, are not merely enhancements to or illustrations of scientific knowledge but are themselves a way of thinking and knowing. A television series like *The Wire*, for example, both relies upon and complicates social network analysis. But whereas scientific work often seeks to solve problems and to clarify knowledge, aesthetic works present networks to us in ways that put existing problems in a new light, without necessarily resolving them. This book has explored many problems proper to network form. I end now with one more problem that, though it exceeds this formal exploration, nevertheless emerges from it.

Network form, in its role as our current cultural dominant, makes scarcely imaginable the possibility of an alternative or an outside uninflected by networks. This raises a series of questions: If so many things and

relationships are figured as networks, what is *not* a network? Or, if so much can be treated as interconnected, does anything escape connectivity? If, as David Joselit observes in the first epigraph to this coda, the paradigm of networks comes "after art," what comes after networks? And, finally, if a network points toward particular logics and qualities of relation in our time, what others might we envision in the future? In many ways, these questions are unanswerable from the position of the present. They inspire speculative and asymptotic reflections that may resonate more fully with network aesthetics than with network science. Riffing on Donald Rumsfeld, the literary critic Katherine Hayles proposes that some of "the purposes of literature are to reveal what we know but don't know that we know, and to transform what we know we know into what we don't yet know."[5] The literary and art works that I take up in this book convey knowledge about networks. But also, at times, they defamiliarize the omnipresent form of the network that we believe we know so well, transforming it into something else that "we don't yet know." That unknown animates the difficulty of thinking through our contemporary world, in all of its layers of past retentions and future protentions.

Though the realm of that which we don't yet know may suggest a future orientation, the problem of an outside to network form has more to do with the challenge of thinking about an immanent historical present that in different ways appears to be, feels as if it is, and is in fact complex. In the early twenty-first century, complexity is not some sublime phenomenon, as it still appeared in the cyberpunk aesthetic of the 1980s. It arrives in a variety of ordinary scenes. Complexity becomes more apparent and present through the omnipresence of digitally networked technologies. Various devices make available complex phenomena, whether through ambient exposure or stumbling into endless Internet k-holes. We encounter global climate change, financial markets that exceed human monitoring, and the proliferation of terrorist groups—all of which are figured in network terms that mark a present teeming with historical residue. This is a present characterized, in Lauren Berlant's terms, by an "affective experience not of a break or a traumatic present, but of crisis lived within ordinariness."[6] That "crisis" need not be anything as apparent as systemic injustice against disadvantaged populations or an identifiable event like the 2008 subprime mortgage market collapse. The scene of such crisis can also include the thick atmosphere of affects that opens up as soon as one picks up a smartphone or signs into a Google hangout to communicate with a distant friend or family member who even a few decades earlier might not have been so readily

accessible. Even our most casual networked technologies or normalized software may evoke what Harry Harootunian describes as our present's "constant concourse of mixed temporalities mingling and coexisting with each other—the historical uncanny that has always remained in the shadow of capital and 'our' modernity."[7] Indeed, a periodic breakdown of wireless service may link us to a telecommunications corporation that outsources customer service to call centers in India and the Philippines. An ordinary smartphone may connect us to electronics producers who distribute networked devices using tantalum capacitors created from coltan that is mined in the Democratic Republic of Congo, amidst human rights abuses, including forced child labor. Network form, as it appears through numerous imaginaries and everyday experiences, situates us within and shapes our historical present, without necessarily yielding a grasp on it.

How is it possible, then, to gain any perspective or critical distance from within a world in which everything is figured as a network? In the closing pages of *The Interface Effect*, Alexander Galloway considers two possible responses to networks that seem to lack any outside. The first proposition is the avant-garde approach of discovering new political tactics and aesthetic forms that may challenge the totality of networks, especially as they are commonly constituted through discussions within network science, digital communications, and global finance. Of this approach, Galloway concludes, "No politics can be derived today from a theory of the new."[8] Novelty, in other words, is the logic of capitalist accumulation, not political rejuvenation. Indeed, the "newness" of so-called new media—including networks—too often becomes assumed, fetishized, celebrated, and assimilated by market forces. It frequently takes the form of innovation that must contribute, even if indirectly, to progress.

More promisingly, Galloway puts forward a second proposition for reaching an outside to networks that falls under the keyword of the "whatever," a concept that he draws most directly from the philosophers Gilles Deleuze and Giorgio Agamben. In place of the supercession of the "post" inherent in the search for new possibilities, Galloway suggests the negation of the "non." "Seek not the posthuman, but the nonhuman," he declares. "Be not post identity, but rather subtractive of it."[9] He contends that within a culture that encourages perpetual speech—even forces it within a digital class that has the cultural knowledge and capacity to contribute to social media posting, user-generated content creation, and network participation—a promising stance is one of disengagement and indifference via the "whatever." It is worth emphasizing, however, that fatigue,

whether with social media or other types of networks, may not be a universal position, even as it is becoming increasingly more common; it is a privileged stance available primarily to people (myself included) with sufficient technological access and leisure time to develop such weariness.

Though Galloway arguably has in mind a more comprehensive political and aesthetic strategy, we see something of the "whatever" at play in everyday discussions about "opting out" of social media.[10] Certainly, people in many parts of the world cannot or choose not to "opt in" to services such as Twitter or Facebook in the first place. However, those who use these networks often accrue numerous reasons for leaving them behind. People may want to withdraw from a culture of publicized narcissism; combat their addiction to the high of instant gratification that comes with likes, upvotes, comments, and check-ins; minimize the loneliness, alienation, or envy associated with social comparison on such networks; eliminate the affective uncertainties associated with posts that arrive on one's stream or wall according to an unknown logic of proprietary algorithms; challenge the threat of corporate surveillance that undermines any semblance of privacy; resist fantasies of political participation that alleviate guilt through low-touch interactions with questionable efficacy; and so on.[11] For people who opt out, or wish to do so, social media networks offer too much connection or connection of the wrong kind. Though opting out of social media may be a last resort for some, even that tactic may feel ultimately unsatisfying given the ubiquity of contemporary communication networks. Choosing not to participate may run counter to the dominant ideology of our time, but it may simultaneously require the sacrifice of digital literacy and critical thought about the present. At the same time, subtraction, opacity, and disappearance may be indispensable tactics in certain sociopolitical struggles — for instance, as realized in the artist Zach Blas's queer mask-making actions, *Facial Weaponization Suite*, which oppose networked surveillance and biometric facial recognition.[12]

Instead of adopting novel avant-garde aesthetics (to move beyond networks) or opting out of networks (in some cases, to recover elements of prenetworked existence), I would like to propose a third orientation: one of *ambivalence*, which operates instead as a mode of extreme presence. Ambivalence, for me, is a crucial critical position from which to think within an uncertain present that is also ongoing. It is in some respects contrary to the satisfying forms of knowledge promised by network visualizations of big data or the always-on, perpetually available mode encouraged by contemporary communication networks. It also departs from the critical certainty

of negation suggested by the "whatever." The type of response to networks that I have in mind more closely resembles the one that Berlant evokes in her description of Eve Sedgwick's work as preparation for bearing ambivalence that cannot be dispersed or repaired. Such uncertainty, which does not require an evacuation of one's passions and convictions, requires being present to an unsatisfying present. It demands risking nonsovereign experiences of absence, uncertainty, boredom, complexity, and disconnection—without promises of instant gratification, certainty, discovery, closure, or reconnection. As Berlant observes, difficult though this stance may be, "without allowing for ambivalence, there is no flourishing."[13] Though "flourishing" betrays floral roots, perhaps a concept that is more proper to trees than to networks, it nonetheless offers room to maneuver beyond what may seem to be the stalemate of the present, making available opportunities to think, feel, and act in unanticipated and unhabituated ways.

Ambivalence is not a variety of opting out. If anything, it suggests a process of opting in completely. Going all in, however, need not be reduced to naïve complicity or the hyperbolic extremism of strategies such as accelerationism. The problem of network totality can be approached through ambivalence without yielding to apathy, cynicism, disengagement, or hopelessness. Rather, it takes the form of a deliberate intensity, patience, and willingness to forgo quick resolution or any finality at all. Ambivalence, then, is a process of slowing down and learning to inhabit a compromised environment with the discomfort, contradiction, and misalignment it entails.[14] This stance need not be radical or romantic. It becomes tangible, for instance, through the humanities (digital or otherwise) and arts (new media and old) that dwell in traces of histories, memories, and possible futures. Such work becomes more difficult and, to me, more precious amidst networked technologies that encourage greater speeds of information processing and communication. In this present, thoughtful reflection is often too rare.

Thinking alongside and through networks, in the years that I have worked on *Network Aesthetics*, has encouraged me to engage in thought that is ambivalent in its openness to numerous disciplines, methods, forms, and affects. As I emphasized in the introduction, a network paradigm and its associated imaginaries do not yield any one thing. Instead of an "either-or," the works analyzed in this book more often confront a "both-and" and a "what else?" Networks are not absolutely determinate either of dystopia or utopia, corporate networking or human contact, technological disconnection or relational connection. Nevertheless, networks do offer a robust language for thinking through ambivalence via processes of decentralization,

simultaneity, proliferation, complexity, and emergence. Networks suggest constant change and reconfiguration that exceeds any individual's imagination and leaves open possibilities.

The mode of ambivalence that I have been sketching out can play a role not only in theory but also in concrete humanities practice. Between 2012 and 2014, I cocreated and ran an alternate reality game called *Speculation* with Katherine Hayles and Patrick LeMieux. Much like *The Project* (analyzed in chapter 5), this game was a transmedia production that was distributed across HTML pages, Unity games, PDF documents, PHP forum software, and live performances. This large-scale game responded in myriad ways to the 2008 financial crisis and the Occupy movement that began in 2011, but it took as its primary political scene contemporary digital networks and the social collectives they might or might not make possible. The game served simultaneously as a pedagogical exercise that included students at multiple universities, a new media art project, and a form of practice-based research about serious games. *Speculation* put forward several critiques of the gender and race discrimination of Wall Street banks, the lack of regulation of complex derivatives, and forms of high-frequency trading in which faster fiber-optic cables that shave mere milliseconds off an exchange can lead to annual profits in the billions. However, instead of simply condemning such practices, both the designers and players of *Speculation* began to reflect on parallels between the technological logics of the game and the financial logics that it explored. Players were able to juxtapose different complicities, both their own and those of the game designers, without settling for the paralysis or passivity that sometimes accompanies critique. Networked collaboration, exploratory metagaming, and shared aesthetic production emerged as ways of inhabiting and experimenting with the ambivalent situation of networks that the game foregrounded (fig. 6.1).[15]

Projects such as *Speculation*, as well as many of the cultural and art works I have explored in this book, lead to a place of humble dwelling within uncertainty. Such works emphasize that there is a great deal that we do not yet (and may never) know about networks, while also emphasizing that we can still aspire to go beyond them. It is worth noting that the network paradigm may have triumphed since the late twentieth century, for the time being, but its cultural discourses often remain astoundingly individualistic and consumer-oriented. As Jodi Dean observes, "Media, even smaller and more integrated, are not just many-to-many, as early internet enthusiasts emphasized, but me-to some-to me."[16] Social media networks cater to individual expression, minimizing circulation and maintaining

6.1. Collaborative collage, created by players of the *Speculation* alternate reality game (2012), that depicts the transgender protagonist, JP.

homogeneous groups that limit exposure to cross-ideological content.[17] Moreover, as Jonathan Zittrain argues, contrary to the early promise of the Internet as "a generative network," an increasing number of technologies such as computers, smartphones, and videogame consoles are closed to user experimentation and tethered to particular companies.[18]

Even as network metaphors so frequently smack of tired clichés, we may be a long way off from coming to terms with networks, aesthetically, technically, and politically. Older frameworks of individualism and consumption frequently overshadow the profound implications that networks suggest for ontology and epistemology, politics and ethics. Networks may make individuals obsolete or irrelevant. They may tap into James Surowiecki's "wisdom of crowds" that comes from aggregated data about actions of discrete group members as well as Pierre Lévy's "collective intelligence" that depends on exchanges within a shared community.[19] Networks help us better understand, without ever wholly comprehending, the behavior of nonhuman superorganisms like ant colonies. Networked interactions also defamiliarize human behavior, as with the phenomenon of upwards of

121,000 participants collaborating, in real time, to complete a single video-game together in the "Twitch Plays *Pokémon*" example that I describe in the introduction. A great deal remains unknown, and perhaps even truly unknowable, about how and why such networked collaborations can yield emergent order rather than utter chaos.

Finally, network aesthetics multiply the possible forms that thought itself might take. Thought need not be put in the service of perpetuating progress through innovation or yielding negation through critique. It can also be a state of experiencing, negotiating, affecting, inhabiting, and playing with the mixed feelings inherent in ambivalence. Ambivalent thought, it is important to specify, does not necessarily belong to a divided individual. It can also unfold through collectives. Rather than paralyzing an individual in indecision, collaboration changes not only how we think but also how we work and act in groups. Such collectively ambivalent thought may surface in heated seminar discussions (in physical or online classrooms) during which conflicting voices cannot draw nearer to resolution but nonetheless begin to better describe the coordinates of a shared problem. It may give shape to decentralized political groups, as with the Occupy movement, which was organized through an email list, a blog, and social media. It may also emerge in more casual contexts, such as raids or large-group campaigns in virtual worlds or long-duration alternate reality games during which players undertake a shared activity but maintain divergent goals.

Throughout this book, I have explored network aesthetics in order to model a pedagogy and analytic style of ambivalence. Such a stance is not meant to encourage political quietism. Admittedly, I am wary of claims of political heroism—of analytic subversion, opposition, and resistance—that are common among scholars and critics writing primarily for an established in-crowd within the humanities. At the same time, I believe that scholars have much to offer in a world of high-speed networking, rapid oscillation among media, and proliferation of opinions from anyone with laptop or smartphone access. Aesthetic works encourage us, despite the discomfort it may entail, to slow down thought, oscillate among divergent perspectives, inhabit complex contradictions, and enter into uncertain collective configurations. If network aesthetics have something crucial to contribute to ongoing thought, feeling, and play with networks from an immanent inside that promises no outside, it is the patience, modesty, dissatisfaction, empathy, and thoughtfulness that are necessary, if never wholly sufficient, conditions of politics in the early twenty-first century.

Notes

Introduction

1. E. M. Forster, *Howards End* (New York: Knopf, 1921), 214.
2. E. M. Forster presciently imagines and interrogates this second form of connection in his science fiction story "The Machine Stops" in *The Collected Tales of E. M. Forster* (New York: Knopf, 1947).
3. sanslimits (anonymous forum user), *Journey Stories*, March 20, 2012 (emphasis mine).
4. I am drawing here on numerous overviews of network science. For a summary of the approach and its ubiquity across disciplines, see Albert-László Barabási, *Network Science* (http://barabasilab.com/networksciencebook, 2012) and Mark Buchanan's *Nexus: Small Worlds and the Groundbreaking Theory of Networks* (New York: Norton, 2002). Also see Aura Reggiani and Daniele Fabbri, eds., *Network Developments in Economic Spatial Systems: New Perspectives* (Aldershot: Ashgate, 1999). Reggiani and Fabbri foreground the disciplinary range of network science when they note that the network "has become the 'key' universal concept in several disciplines, such as economics, geography, transportation, operational research and spatial/ social sciences. In the light of current transformation processes, networks can be identified as a blend of 'interdisciplinary' concepts, including complex systems, space-time dynamics, self-organization, synergy, interconnectivity, sustainability, resilience" (xvii).
5. Bruno Latour, *Reassembling the Social: An Introduction to Actor-Network-Theory* (Oxford: Oxford University Press, 2005), 129.
6. Friedrich Nietzsche, *The Gay Science: With a Prelude in Rhymes and an Appendix of Songs*, trans. Walter Arnold Kaufmann (New York: Vintage Books, 1974), 301.
7. Instructive here is Gilles Deleuze and Félix Guattari's approach to "rhizomatic" networks in *A Thousand Plateaus: Capitalism and Schizophrenia* (Minneapolis: University of Minnesota Press, 1987). Each of the chapters in this

book uses the unit of a "plateau" to animate the problems and affordances of network formations without seeking to define or systematize them. As Deleuze and Guattari explain, "A plateau is always in the middle, not at the beginning or the end" (21). In place of network totality, they suggest various modes of rhizomatic thought.

8. See, for instance, Ken Hillis, Susanna Paasonen, and Michael Petit, *Networked Affect* (Cambridge: MIT Press, 2015).

9. Kathleen Stewart, "Cultural Poesis: The Generativity of Emergent Things," in *The Sage Handbook of Qualitative Research*, ed. N. Denzin and Y. S. Lincoln (London: Sage, 2005), 1015.

10. For my definition of a network, I draw from the excellent overview that Alexander Galloway lays out in "Network," in *Critical Terms for Media Studies*, ed. W. J. T. Mitchell and Mark B. N. Hansen (Chicago: University of Chicago Press, 2010). As he contends, networks are "systems of interconnectivity" that hold their parts "in constant relation." Moreover, networks "assume a certain level of complexity" (283). Particular nodes and links can consist of practically any elements or actors. I am also building on the definition offered by the network scientists M. E. J. Newman, Albert-László Barabási, and Duncan J. Watts in *The Structure and Dynamics of Networks* (Princeton: Princeton University Press, 2006). As they explain, "In its simplest form, a network is nothing more than a set of discrete elements (the vertices), and a set of connections (the edges) that link the elements, typically in a pairwise fashion" (2). Indeed, the abstracted structure of the network has become one of the most generalized models of the twentieth and twenty-first centuries. For a discussion of network types, see David Singh Grewal, *Network Power: The Social Dynamics of Globalization* (New Haven: Yale University Press, 2008). Grewal discusses chain or line networks, hub or wheel networks, and clique or full matrix networks (183).

11. Manuel Castells, *The Rise of the Network Society* (Chichester: Wiley-Blackwell, 2010), 501–2.

12. Alexander R. Galloway and Eugene Thacker, *The Exploit: A Theory of Networks* (Minneapolis: University of Minnesota Press, 2010), 61. Galloway and Thacker note that while one might imagine a potential network, an inactive network would be a contradiction in terms.

13. An earlier articulation of this problem appears in Theodor Adorno's discussion of "identitarian thinking" that marks a concept that is inadequate to the complexity of the object it seeks to name. For more, see *Negative Dialectics*, trans. E. B. Ashton (London: Routledge, 1973), 144–45. The problem of naming that Deleuze and Guattari describe in their concept of a "body without organs" is also similar to the difficulty of naming a network. A network, like a body without organs, may cause "asignifying particles or pure intensities to pass or circulate, and attributing to itself subjects that it leaves with

nothing more than a name as the trace of an intensity" (*A Thousand Plateaus*, 4). Galloway and Thacker illustrate this point by highlighting the nominalist difficulties that adhere to large-scale organizations such as the "United Nations" or the "United States" (*The Exploit*, 11–12).

14. Latour, *Reassembling the Social*, 129.

15. Armand Mattelart, "Mapping Modernity: Utopia and Communications Networks," in *Mappings*, ed. Denis E. Cosgrove (London: Reaktion Books, 1999), 170–71. Even in the latter half of the eighteenth century, in the period during which Denis Diderot and Jean le Rond d'Alembert's *Encyclopédie* was published, "network" (*réseau*) still referred primarily to threads of cloth and anatomical structures, rather than communication technologies. This latter sense would not become available until the semaphore telegraph of the late eighteenth century. For more on the usage of *réseau* in the late eighteenth century, see Robert Morrissey, *ARTFL Encyclopédie Project*, https://encyclopedie.uchicago.edu/, accessed October 20, 2015.

16. *Oxford English Dictionary Online*, s.v. "network, n. and adj.," accessed March 8, 2015, http://www.oed.com. For a detailed exploration of nineteenth-century social interactions, across information, neural, and communications networks, see the work of Laura Otis, especially *Networking: Communicating with Bodies and Machines in the Nineteenth Century* (Ann Arbor: University of Michigan Press, 2002) and *Membranes: Metaphors of Invasion in Nineteenth-Century Literature, Science, and Politics* (Baltimore: Johns Hopkins University Press, 1999).

17. Mattelart, "Mapping Modernity," 176–78.

18. Friedrich Kittler, "Gramophone, Film, Typewriter," *October* 41 (Summer 1987): 101–18.

19. Luc Boltanski and Eve Chiapello, *The New Spirit of Capitalism* (London: Verso, 2005), 151. Boltanski and Chiapello offer a compelling reason for the post-1945 historical frame for thinking about networks. At the same time, historical study of networks as such could easily span several centuries. In the study of American culture alone, network form can certainly be traced back to formations as diverse as the US Postal Service, the Atlantic slave trade system, the first transcontinental railroad, the oppositional Underground Railroad, and the segregationist Jim Crow system. The language of networks has even been used to characterize communications systems between English settlers and Native Americans in colonial New England, as Matt Cohen demonstrates in *The Networked Wilderness: Communicating in Early New England* (Minneapolis: University of Minnesota Press, 2010). Moreover, specifically aesthetic analysis of networks plays a role in historical studies of earlier media. See, for instance, Douglas Kahn's *Earth Sound Earth Signal: Energies and Earth Magnitude in the Arts* (Berkeley and Los Angeles: University of California Press, 2013), which tracks energy across nineteenth-

and twentieth-century technologies, attending to aesthetic invocations of the telegraph, telephone, and radio that confront energy at the scale of a global network.

20. In 1736, the pioneering Swiss mathematician Leonhard Euler proved the impossibility of a popular riddle called the Königsberg Bridge Problem by using a protonetwork representation called a graph. On systems theory, an interdisciplinary approach proposed by the Austrian biologist Karl Ludwig von Bertalanffy, and its aesthetic consequences, see Bruce Clarke, *Posthuman Metamorphosis: Narrative and Systems* (New York: Fordham University Press, 2008).

21. Newman, Barabási, and Watts, *The Structure and Dynamics of Networks*, 11. A crucial contribution to network science was Anatol Rapoport and Ray Solomonoff's influential 1951 paper about the "random graph"—arguably the foundational concept of contemporary network science. This paper eschewed the abstractions of earlier graph theory by turning to three material systems—neural networks, epidemic disease networks, and an early version of a genetics network—to discuss distributed structure.

22. Ibid. The "small world" experiment is closely linked to earlier aesthetic work. One of the earliest literary engagements with protonetwork thought dates back to the Hungarian writer Frigyes Karinthy's 1929 short story "Chain-Links." In this noteworthy tale, a group of friends engages in a thought experiment. One character instructs the others to "select any person from the 1.5 billion inhabitants of the Earth—anyone, anywhere at all." As the narrator explains, "He bet us that, using no more than *five* individuals, one of whom is a personal acquaintance, he could contact the selected individual using nothing except the network of personal acquaintances." As it turns out, "nobody from the group needed more than five links in the chain to reach, just by using the method of acquaintance, any inhabitant of our Planet" (Karinthy in Newman, Barabási, and Watts, *The Structure and Dynamics of Networks*, 22–23). One character links himself to a Swedish novelist and Nobel Prize winner (Selma Lagerlof) through just two intermediaries. The narrator links himself to "an anonymous riveter at the Ford Motor Company" in four steps. The "small world" thesis posited by Karinthy would later be explored more systematically by the mathematicians Ithiel de Sola Pool and Manfred Kochen in the 1950s and tested by Stanley Milgram in 1967.

23. Ibid., 4. Since that time, the network paradigm has transformed along with efforts to study systems architectures and human interactions. Newman, Barabási, and Watts identify three major differences between earlier areas of network research and these later developments. First, earlier graph theory was concerned primarily with elegant mathematical structures, whereas network science approaches are more focused on real-world interconnec-

tions and empirical properties of networks. Second, older studies tended to treat networks as static structures, whereas network science sees networks as evolving systems that are not merely capable of but actually defined by change. Third, researchers have shifted to studying the internally asymmetrical dimensions of networks, including dynamic interactions that take place among constitutive nodes. A fourth difference that we might add to this list is that in an earlier moment of "complexity science," researchers relied on sampling-based methods to study complex systems, whereas with the rise of "big data," which is a near-contemporary of network science, researchers could mine, map, and analyze complete data sets. These conceptual shifts have all given rise to a well-organized field of network science. For an overview of complexity science, see Melanie Mitchell, *Complexity: A Guided Tour* (New York: Oxford University Press, 2009). For more on the move from sampling to big data, see Viktor Mayer-Schönberger and Kenneth Cukier, *Big Data: A Revolution That Will Transform How We Live, Work, and Think* (Boston: Houghton Mifflin Harcourt, 2013).

24. Manuel Castells, *The Rise of the Network Society* (Oxford: Blackwell, 1996), 469.

25. Anthony H. Cordesman and Justin G. Cordesman, *Cyber-threats, Information Warfare, and Critical Infrastructure Protection: Defending the U.S. Homeland* (Westport, CT: Praeger, 2002), 13.

26. For this overview, I am drawing, for instance, from Tim Berners-Lee and Mark Fischetti, *Weaving the Web: The Original Design and Ultimate Destiny of the World Wide Web by Its Inventor* (San Francisco: HarperSanFrancisco, 1999); Janet Abbate, *Inventing the Internet* (Cambridge: MIT Press, 1999); James Gillies and Robert Cailliau, *How the Web Was Born: The Story of the World Wide Web* (New York: Oxford University Press, 2000); and Paul E. Ceruzzi, *A History of Modern Computing* (Cambridge: MIT Press, 2003).

27. For a discussion of the "global village," see: Marshall McLuhan, *The Gutenberg Galaxy: The Making of Typographic Man* (Toronto: University of Toronto Press, 1962). Also see Marshall McLuhan, *Understanding Media: The Extensions of Man* (New York: McGraw-Hill, 1964), 3, 5. Though I focus on computational media and networks here, television is also crucial to McLuhan's own theorization of the global village.

28. It is worth noting, however, that despite these technological advances, even by 1981 the existing network consisted of only 256 computers. For an extended discussion of ARPANET, see Arthur L. Norberg, Judy E. O'Neill, and Kerry J. Freedman, *Transforming Computer Technology: Information Processing for the Pentagon, 1962–1986* (Baltimore: Johns Hopkins University Press, 1996), 159–62. I am also drawing from the history provided by Peter Krapp, *Noise Channels: Glitch and Error in Digital Culture* (Minneapolis: University of Minnesota Press, 2011), 5.

29. Thomas Streeter, *The Net Effect: Romanticism, Capitalism, and the Internet* (New York: New York University Press, 2011), 14.

30. Tiziana Terranova, *Network Culture: Politics for the Information Age* (London: Pluto Press, 2004), 41.

31. Streeter, *Net Effect*, 119. Also see 126–33 for a discussion of graphical web browsers.

32. See especially Todd Gitlin, *The Whole World Is Watching: Mass Media in the Making and Unmaking of the New Left* (Berkeley and Los Angeles: University of California Press,1980). Also see Marshall McLuhan and Quentin Fiore, *War and Peace in the Global Village: An Inventory of Some of the Current Spastic Situations That Could Be Eliminated by More Feedforward* (New York: McGraw-Hill, 1968).

33. See Kathleen Fitzpatrick, *The Anxiety of Obsolescence: The American Novel in the Age of Television* (Nashville: Vanderbilt University Press, 2006). While certain continuities can be drawn between the prevailing machine metaphors of industrialism and the network metaphors of postindustrialism, the differences are noteworthy. Though network metaphors often involve communications technologies, they do not always concern mechanical apparatuses. Instead, as Fitzpatrick has argued, networks evoke "the wiring that connects [machines], and the impulses, both electronic and cultural, that those wires carry" (150). Moreover, "the network is not simply a machine but an interconnection of machines, its signals a language whereby transmitters speak to receivers" (151). Machine metaphors, then, privilege technological objects, whereas network metaphors focus on the relations among those objects. Just as networks depart from the machines of industrialization, so they differ from the organizational structures at the heart of 1940s systems theory. As Fitzpatrick contends, unlike the study of ecologies and systems, which "originates in the natural, and particularly the biological sciences," the contemporary network is imagined as "an unnatural imposition on natural systems" (152). This historical distinction is useful, but the boundaries between "natural" and "unnatural" systems in network science have increasingly blurred. For instance, while a global viral spread could be read as a "natural" development, the apparatus of organizations and technologies established to track and curb such a proliferation might be seen as decidedly "unnatural." Deleuze and Guattari's vocabulary also marks a provisional distinction between these metaphors, noting the capacity of "machines" to both produce and interrupt flows, and a "network" that brings them together in a synthesis (Gilles Deleuze and Félix Guattari, *Anti-Oedipus: Capitalism and Schizophrenia* [London: Continuum, 2012], 1–13).

34. Alan Liu, *The Laws of Cool: Knowledge Work and the Culture of Information* (Chicago: University of Chicago Press, 2004), 141. Liu dates the beginning of this paradigm to 1982. While this shift did begin to take place in scientific, ac-

ademic, and even business communities during the 1980s, it did not resonate with popular experience until the 1990s. Regarding the distinction between "system" and "network," Liu writes: "Where system from the time of Taylor through the mainframe age had meant an externally imposed, hierarchically organized, and self-consistent structure of work assignments and procedures aligning technology with technique, 'network' defined an entirely new kind of self-organizing and complexity-generating system or, more accurately, unclosed aggregate of systems" (146).

35. See especially Wendy H. K. Chun, *Control and Freedom: Power and Paranoia in the Age of Fiber Optics* (Cambridge: MIT Press, 2006) and Alexander Galloway, *Protocol: How Control Exists after Decentralization* (Cambridge: MIT Press, 2006).

36. Bill Gates, Nathan Myhrvold, and Peter Rinearson, *The Road Ahead* (New York: Viking, 1995), 181.

37. For more on hacktivism, see, for instance, Galloway and Thacker, *The Exploit*; Rita Raley, *Tactical Media* (Minneapolis: University of Minnesota Press, 2009); and Brian Kim Stefans, "Hacktivism? I Didn't Know the Term Existed before I Did It," in *Before Starting Over: Selected Writings and Interviews, 1994–2005* (Cambridge, UK: Salt, 2006). For an exploration of social movements inspired by networks and social media, see Manuel Castells, *Networks of Outrage and Hope: Social Movements in the Internet Age* (Cambridge, UK: Polity, 2012). For a discussion of the "multitude," see Michael Hardt and Antonio Negri, *Multitude: War and Democracy in the Age of Empire* (New York: Penguin, 2004). For an account of the longer history of connections between political movements and digital culture, see Fred Turner, *From Counterculture to Cyberculture: Stewart Brand, the Whole Earth Network, and the Rise of Digital Utopianism* (Chicago: University of Chicago Press, 2006).

38. For a discussion of networks in area studies and world literature, see Vilashini Cooppan, "Net Work: Area Studies, Comparison, and Connectivity," *PMLA* 128, no. 3 (2013): 615–21. Édouard Glissant's use of network metaphors is most evident in *Poetics of Relation*, trans. Betsy Wing (Ann Arbor: University of Michigan Press, 1997).

39. Deleuze and Guattari, *A Thousand Plateaus*. This text characterizes the unconscious—contrary to the object produced through Freud's "hierarchical graphs" and "practice of calculation and treatment"—as "a machinic network of finite automata" (17–18). For a connection between Deleuze and Guattari's rhizomatic networks and contemporary digital networks and biotechnologies, see Mark S. Poster and David Savat, eds., *Deleuze and New Technology* (Edinburgh: Edinburgh University Press, 2009).

40. In his 1969 book *Archaeology of Knowledge* (London: Routledge, 2009), Michel Foucault complicates "total history" (10) with a dynamic sense of "recurrent redistributions" of the historical that "reveal several pasts, several

forms of connexion, several hierarchies of importance, several networks of determination, several teleologies" (5). Later, in the 1975 *Discipline and Punish: The Birth of the Prison* (New York: Vintage Books, 1995), he describes the microphysics of power as being composed of "a network of relations, constantly in tension, in activity, rather than a privilege that one might possess" (26). In a later essay, Foucault explicitly comments on the network as a crucial metaphor for describing the late twentieth century when he notes, "We are at a moment, I believe, when our experience of the world is less that of a long life developing through time than that of a network that connects points and intersects with its own skein" ("Of Other Spaces," *Diacritics* 16 [Spring 1986]: 22).

41. For more on social network analysis in the humanities, see Scott B. Weingart, "Demystifying Networks, Parts I & II," *Journal of Digital Humanities* 1, no. 2 (Winter 2011), http://journalofdigitalhumanities.org/1-1 /demystifying-networks-by-scott-weingart/, accessed May 12, 2015. For more on "relational sociology," see Mustafa Emirbayer, "Manifesto for a Relational Sociology," *American Journal of Sociology* 103, no. 2 (September 1997): 281–317. For specific applications of social network analysis methods in the humanities, see, for instance, the "Mapping the Republic of Letters" project at Stanford, which compiled "a database of thousands of letters exchanged between prominent intellectuals in the 17th and 18th centuries known as the Republic of Letters" and produced visualizations of them, as described in Daniel Chang, Yuankai Ge, Shiwei Song, Nicole Coleman, Jon Christensen, and Jeffrey Heer, "Visualizing the Republic of Letters," 2009, http://web.stanford.edu/group/toolingup/rplviz/papers/Vis_RofL_2009, accessed May 12, 2015. Also, for an example of the use of social network analysis in the field of literary studies, see Richard Jean So and Hoyt Long, "Network Analysis and the Sociology of Modernism," *boundary 2* 40, no. 2 (2013): 147–82.

42. Geert Lovink, *My First Recession* (Rotterdam: V2/NAi Publishers, 2003). As Geert Lovink describes media archaeology, this approach involves reading media into history instead of the other way around. This method resists using historical narrative in the service of producing and justifying the present. Similarly, Lisa Gitelman observes, "The media archaeologist seeks a built-in refusal of teleology, of narrative explanations that smack structurally of the impositions of metahistory" (*Always Already New: Media, History, and the Data of Culture* [Cambridge: MIT Press, 2008], 11). For more on media archaeology, see Siegfried Zielinski, *Deep Time of the Media: Toward an Archaeology of Hearing and Seeing by Technical Means* (Cambridge: MIT Press, 2006). Also see Erkki Huhtamo and Jussi Parikka, *Media Archaeology Approaches, Applications, and Implications* (Berkeley and Los Angeles: University of California Press, 2011), and Jussi Parikka, *What Is Media Archaeology?*

(Cambridge: Polity, 2012). I also have in mind the media archaeologies produced by scholars such as Adrian Johns, Lisa Gitelman, Bernhard Siegert, and Nicole Starosielski.

43. For interdisciplinary research on virtual worlds, see, for instance, Edward Castronova, *Synthetic Worlds: The Business and Culture of Online Games* (Chicago: University of Chicago Press, 2005), and Hilde G. Corneliussen and Jill Walker Rettberg, *Digital Culture, Play, and Identity: A World of Warcraft Reader* (Cambridge: MIT Press, 2008). For more on social media networks, see Geert Lovink, *Networks without a Cause: A Critique of Social Media* (Cambridge: Polity, 2011), and José van Dijck, *The Culture of Connectivity: A Critical History of Social Media* (Oxford: Oxford University Press, 2013).

44. See especially Galloway, *Protocol*; Galloway and Thacker, *The Exploit*; and Steven Shaviro, *Connected; or, What It Means to Live in the Network Society* (Minneapolis: University of Minnesota Press, 2003).

45. I explore an early version of the concept of network aesthetics in Patrick Jagoda, "Terror Networks and the Aesthetics of Interconnection," *Social Text* 28, no. 4 (2010): 65–89. There are other noteworthy uses of this or related terms. See, for instance, Sianne Ngai, "Network Aesthetics: Juliana Spahr's *The Transformation* and Bruno Latour's *Reassembling the Social*," in *American Literature's Aesthetic Dimensions*, ed. Cindy Weinstein and Christopher Looby (New York: Columbia University Press, 2012). In focusing on network aesthetics, I am proposing something more capacious than David Ciccoricco's category of "network fiction," which designates only digital texts that have been discussed under the rubrics of "hypertext fiction" and "electronic literature" (*Reading Network Fiction* [Tuscaloosa: University of Alabama Press, 2007]). Finally, in art history, see Anna Munster, *An Aesthesia of Networks: Conjunctive Experience in Art and Technology* (Cambridge: MIT Press, 2013). Munster emphasizes that she "does not attempt to create a new network aesthetics, to systematize network experience" (8). Though I am interested in aesthetics, I am not trying to systematize network aesthetics either.

46. Weinstein and Looby, introduction to *American Literature's Aesthetic Dimensions*, 4. For a more detailed delineation of the term's various usages, see, for instance, Leonard Koren, *Which "Aesthetics" Do You Mean? Ten Definitions* (Point Reyes, CA: Imperfect Publishing, 2010). It is worth noting that the concept of "form" has a similarly broad range of usage. Arjun Appadurai offers just such a capacious definition when he writes, "By 'forms' I mean to indicate a family of phenomena, including styles, techniques, or genres, which can be inhabited by specific voices, contents, message, and materials" ("How Histories Make Geographies: Circulation and Context in a Global Perspective," *Transcultural Studies* 1 [2010]: 9).

47. For an exploration of the resurgence of aesthetics, see, for instance, the

American Literature special issue "Aesthetics and the End(s) of Cultural Studies," edited by Christopher Castiglia and Russ Castronovo (vol. 76, no. 3, September 2004). For parallel discussions of formalism, see W. J. T. Mitchell, "The Commitment to Form; or, Still Crazy after All These Years," *PMLA* 118, no. 2 (2003). Also see Marjorie Levinson, "What Is New Formalism?" *PMLA* 122, no. 2 (2007): 558–69. The robust presence of a renewed interest in formalism has been evident not only in theory but also in a growing interest in new media, among literary critics, that has expanded the study of graphic narratives, Twitter plays, videogames, and more. For a discussion of the relationship of form and politics, see Ellen Rooney, "Form and Contentment," *MLQ: Modern Language Quarterly* 61, no. 1 (2000): 17–40.

48. See, for instance, Emory Elliot, Louis F. Caton, and Jeffrey Rhyne, eds., *Aesthetics in a Multicultural Age* (New York: Oxford University Press, 2002), and Michael Bérubé, ed., *The Aesthetics of Cultural Studies* (Malden, MA: Blackwell, 2005). Along with such turns to aesthetics and cultural studies, a great deal of work in affect theory, coming from scholars such as Ben Anderson, Lauren Berlant, and Brian Massumi, has explored the political dimensions of aesthetics and affect.

49. Jacques Rancière, *Aesthetics and Its Discontents* (Cambridge, UK: Polity, 2009), 11, 4, 11, 44.

50. Jacques Rancière, *The Politics of Aesthetics*, trans. Gabriel Rockhill (London: Continuum, 2006), 9, 45.

51. Ibid., 13.

52. Ibid., 19.

53. I am building on Galloway and Thacker's observation that network form suggests a broad range of political affordances: "Networked power is based on a dialectic between two opposing tendencies: one radically distributes control into autonomous locales; the other focuses control into rigidly defined hierarchies" (*The Exploit*, 19).

54. See, for instance, the neoliberal forms of "governmentality" discussed by Michel Foucault and subsequently by theorists such as Giorgio Agamben.

55. Rancière, *Aesthetics and Its Discontents*, 23, 25.

56. Lev Manovich, "What is Visualization?" *Visual Studies* 26 no. 1 (March 2011), 38–39. Reduction involves using "graphical primitives" or "vector graphics" to schematize data and make complexity comprehensible (38). Spatial properties, including "topology and geometry," also tend to be privileged over other visual elements such as "tones, shading, patterns, colors, or transparency of the graphical elements" (39).

57. Alexander R. Galloway, *The Interface Effect* (Cambridge, UK: Polity, 2012), 82, 83.

58. Ibid., 85. Galloway does also mention attempts at visualization that depart from the predictable network maps, including Jodi's glitch art and Frank

Gehry's Stata Center. Though artists such as Jodi *aspire* to alternative aesthetics, Galloway still finds them less engaged in algorithmic and informatic experimentation that responds to the specificity of our early twenty-first century network society.

59. Such formal diversity includes static visualizations such as the common maps of the Internet, interactive cartographies such as Josh On's *They Rule*, cyberpunk novels such as *Islands in the Net* and films such as *The Matrix*, and rhetorical depictions of networks by proglobalization economists.

60. Liu, *The Laws of Cool*, 42. This double sense of networks is already marked by the way that the sublime, for Kant, destabilizes the sense of self only to later motivate a reformulation of that self on more secure grounds. Similarly, for Edmund Burke, "the sublime is an idea belonging to self-preservation" (*A Philosophical Enquiry into the Origin of our Ideas of the Sublime and the Beautiful* [Oxford: Oxford University Press, 1990], 79). The same duality is present in network visualizations, which so often captivate and awe the viewer but also seek to comprehend their complex object. To put this differently, such visualizations produce an interface between both the material and sensible qualities of art, as well as the conceptual dimensions of computation and science.

61. In his popular book *The Human Use of Human Beings: Cybernetics and Society* (Garden City, NY: Doubleday, 1954), Norbert Wiener describes cybernetics as "the study of messages as a means of controlling machinery and society" (15). He adds that the purpose of cybernetics is "to develop a language and techniques that will enable us indeed to attack the problem of control and communication in general" (17). For more, see Norbert Wiener, *Cybernetics; or, Control and Communication in the Animal and the Machine*, 2nd ed. (Cambridge: MIT Press, 1961). I also discuss this sense of cyberspace in greater detail in Patrick Jagoda, "Speculative Security," in *Cyberspace and National Security: Threats, Opportunities, and Power in a Virtual World*, ed. Derek S. Reveron (Washington: Georgetown University Press, 2012). Etymologically, the word "cybernetics" derives from the Greek word for "steersman" and metaphorically describes a "guide" or "governor" (*Oxford English Dictionary Online*, s.v. "Cybernetics, *n.*" accessed March 8, 2015, http://www.oed.com). This sense of control carries forward to Gibson's neologism of "cyberspace" as a zone that is governed by myriad protocols and patrolled by the Intrusion Countermeasures Electronics in "Burning Chrome" and *Neuromancer*. This sense of a controlled, geometrical computational space flourished in the 1980s and 1990s. Even in the early twenty-first century, a central sense of control persists in common terms such as "cyberwar" and "cybersecurity."

62. Streeter, *Net Effect*, 20 (emphasis mine).

63. Galloway and Thacker, *The Exploit*, 4, 38, 14, 20.

64. Lauren Berlant, *Cruel Optimism* (Durham: Duke University Press, 2011), 97.

65. Stewart, "Cultural Poesis: The Generativity of Emergent Things," 1015.
66. Hannah Arendt, *The Human Condition* (Chicago: University of Chicago Press, 1998), 235–36, 244. Building on Hannah Arendt's earlier sense of "nonsovereignty," Lauren Berlant elaborates the concept.
67. Galloway and Thacker, *The Exploit*, 34.
68. In a sense, the "beautiful"—a feeling experienced in response to smaller and pleasing things that Edmund Burke juxtaposes with the grand and terrible feelings produced by the sublime—could map onto the network ordinary (*A Philosophical Enquiry into the Origin of our Ideas of the Sublime and the Beautiful*, 103). I do not, however, take up the beautiful as a central category of my analysis. Though Burke departs from a normative view of beauty, and considers flaws and weaknesses to be inherently beautiful, I am also interested in forms of ambivalence and breakdown that might not be included in this category but nonetheless belong to what I am calling network aesthetics.
69. Jennifer Egan, *A Visit from the Goon Squad* (New York: Alfred A. Knopf, 2010), 176, 243. I do not mean to underplay the novel's network content in favor of its form. In fact, the novel attends carefully to the language of a network society. In the near-future chapter, for instance, Lulu explains to Alex that "no one says 'viral' anymore. . . . I mean, maybe thoughtlessly, the way we still say 'connect' or 'transmit'—those old mechanical metaphors that have nothing to do with how information travels. See, reach isn't describable in terms of cause and effect anymore: It's simultaneous" (317).
70. Rancière, *Aesthetics and Its Discontents*, 96, 98, 99.
71. For a discussion of this paradox, see Mark Goble, *Beautiful Circuits: Modernism and the Mediated Life* (New York: Columbia University Press, 2010), 11.
72. I am thinking here especially of Michel Serres, *The Parasite*, trans. Lawrence R. Schehr (Baltimore: Johns Hopkins University Press, 1982). Serres writes, "Saying that this system includes the telephone, the telegraph, television, the highway system, maritime pathways and shipping lanes, the orbits of satellites, the circulation of messages and of raw materials, of language and foodstuffs, money and philosophical theory, is a way of speaking clearly and calmly. And looking to see who or what intercepts these different flows is also a way of speaking clearly and calmly. It is a complicated way of speaking, but it is really an easy way" (11).
73. Fredric Jameson, *Postmodernism, or the Cultural Logic of Late Capitalism* (Durham: Duke University Press, 1991), 415, 51.
74. Ibid., 410–13.
75. Fredric Jameson, "Postmodernism, or, The Cultural Logic of Late Capitalism," *New Left Review* 1, no. 146 (July–August 1984): 92. This passage reappears in Jameson, *Postmodernism*, 54.
76. Galloway, *The Interface Effect*, 98. In the preface, Galloway notes that his "method shares a great deal with what Fredric Jameson calls *cognitive mapping*" (vii).

77. Nicolas Bourriaud, *Relational Aesthetics* (Dijon: Les Presses du Réel, 2002), 19, 21. Also see Raymond Williams, *Television: Technology and Cultural Form* (New York: Schocken Books, 1975), 86–96.

78. Munster, *An Aesthesia of Networks*, 3, 4. Deleuze and Guattari also imagine that a network—a "rhizome" in their terminology—"is composed not of units but of dimensions, or rather directions in motion" (*A Thousand Plateaus*, 21). Here, too, motion and duration precede the spatial considerations of graph theory.

79. For a clarifying discussion of the disciplinary distinction between usages of "media," see Marie-Laure Ryan, ed., *Narrative across Media: The Languages of Storytelling* (Lincoln: University of Nebraska Press, 2004), and the introduction to Mitchell and Hansen, *Critical Terms for Media Studies*.

80. For key discussions of media specificity, see Rosalind E. Krauss, "Reinventing the Medium," *Critical Inquiry* 25, no. 2 (1999): 289–305. In seeking medium specificity, Krauss describes a medium as "a set of conventions derived from (but not identical with) the material conditions of a given technical support, conventions out of which to develop a form of expressiveness that can be both projective and mnemonic" (296). Also see N. Katherine Hayles, "Print Is Flat, Code Is Deep: The Importance of Media-Specific Analysis," *Poetics Today* 25, no. 1 (2004): 67–90. For an elaboration on the idea of comparative media studies, see N. Katherine Hayles and Jessica Pressman, *Comparative Textual Media: Transforming the Humanities in the Postprint Era* (Minneapolis: University of Minnesota Press, 2013). Though I take up the interplay between medium specificity and a transmedia ecology in a late twentieth- and early twenty-first-century context, I am also indebted to André Bazin's earlier concept of a "mixed" or "impure" cinema that is, at once, a mature enough form to play with its own affordances while also drawing extensively from other forms such as the novel and theater. For more, see André Bazin, "In Defense of Mixed Cinema," in *What Is Cinema?* trans. Hugh Gray (Berkeley and Los Angeles: University of California Press, 1967).

81. Appadurai, "How Histories Make Geographies," 2.

82. Henry Jenkins, *Convergence Culture: Where Old and New Media Collide* (New York: New York University Press, 2006), 3.

83. Appadurai, "How Histories Make Geographies," 3.

84. It is worth noting that, with the exception of the forward-looking McLuhan, many of these thinkers are speaking to processes of technogenesis and human relations to media in the 1990s and 2000s, around the same period that the network form becomes a cultural dominant. I am referring especially to McLuhan, *Understanding Media*; Friedrich A. Kittler, *Gramophone, Film, Typewriter*, trans. Geoffrey Winthrop-Young and Michael Wutz (Stanford: Stanford University Press, 1999); N. Katherine Hayles, *How We Think: Digital Media and Contemporary Technogenesis* (Chicago: University of Chicago Press, 2012); Andy Clark, *Natural-Born Cyborgs: Minds, Technologies, and*

the Future of Human Intelligence (New York: Oxford University Press, 2003); Brian Rotman, *Becoming beside Ourselves: The Alphabet, Ghosts, and Distributed Human Being* (Durham: Duke University Press, 2008); Bernard Stiegler, *Technics and Time* (Stanford: Stanford University Press, 1998); Bernhard Siegert, *Cultural Techniques: Grids, Filters, Doors, and Other Articulations of the Real* (New York: Fordham University Press, 2015); and Mark B. N. Hansen, *Embodying Technesis: Technology beyond Writing* (Ann Arbor: University of Michigan Press, 2000).

85. The expansive category of the "nonhuman" has garnered interest across numerous humanities disciplines and programs of study. Analytic philosophy and science studies, from Alfred North Whitehead's "process philosophy" to Bruno Latour's "actor-network theory," have explored dynamic systems and orders of being that exceed human experience. Ecological perspectives, from James Lovelock's Gaia hypothesis to the journalist Alan Weisman's popular book *The World without Us*, have imagined the Earth as a holistic ecosystem that surpasses and outlasts human beings. Critical animal studies, from Donna Haraway's *Primate Visions* to Cary Wolfe's *Zoontologies*, to Jacques Derrida's *The Animal That Therefore I Am*, grapple with animals as beings that do not conform to human modes of knowledge. The interdisciplinary study of things, from William Carlos Williams's poetry to Bill Brown's "thing theory," has attempted to think beyond the parameters of human interiority. In the early twenty-first century, we have also seen sustained interest in the philosophies of "speculative realism" or "speculative materialism" that are associated with the work of such thinkers as Quentin Meillassoux, Ray Brassier, Iain Hamilton Grant, and Graham Harman. Despite their many differences, the thinkers associated with this approach have defended a form of metaphysical realism that entails orders of reality that exceed complete human understanding. This philosophy is an attempt, as Meillassoux explains in his book *After Finitude: An Essay on the Necessity of Contingency* (London and New York: Continuum, 2009), to imagine "the possibility of thinking what there is when there is no thought" (36). A key attempt to analyze human aesthetic production in relationship to realms of the nonhuman, in the realm of speculative realism, is Ian Bogost, *Alien Phenomenology; or, What It's Like to Be a Thing* (Minneapolis: University of Minnesota Press, 2012).

86. Kittler, *Gramophone, Film, Typewriter*, xxxix.

87. Bernhard Siegert, *Relays: Literature as an Epoch of the Postal System* (Stanford: Stanford University Press, 1999), 19.

88. Mark B. N. Hansen, *New Philosophy for New Media* (Cambridge: MIT Press, 2006), 3, 12, 7. Also see Mark B. N. Hansen, "Foucault and Media: A Missed Encounter?" *South Atlantic Quarterly* 111 no. 3 (2012), 522.

89. N. Katherine Hayles, *Electronic Literature: New Horizons for the Literary* (Notre Dame: University of Notre Dame, 2008), 88.

90. See, for instance, van Dijck, *The Culture of Connectivity*, 12. Beyond the realm of media studies, Latour also explores the ways in which many networks depend on the interaction between human actors and nonhuman objects. See Bruno Latour, *Science in Action: How to Follow Scientists and Engineers through Society* (Cambridge: Harvard University Press, 1987), and Latour, *Reassembling the Social*. In his actor-network theory, Latour pursues a theory of social connections that takes nonhuman elements seriously as *actors* that are "not simply the hapless bearers of symbolic projection" and human desire (*Reassembling the Social*, 10).

91. Siegert, *Relays*. Siegert already imagines aesthetics at play in the disorder, delays, interruptions, and noise of the earlier postal network. Nonhuman networks, he insists, do not disrupt human art but, on the contrary, represent the very "site of aesthetics." He notes, "The impossibility of technologically processing data in real time is the possibility of art. Literature, as an art of human beings, is a gift of interception, which operates on the basis of feedback loops between human senses and the postal materiality of data processing known as the alphabet" (12).

92. In this book, I draw more directly on affect theory than on phenomenology. Given the distributed nature of networks, I am interested in qualities of the nonconscious, atmospheric, and interpersonal that affect theory regularly interrogates. I am less invested in delving into the structures of consciousness that are the central concern of philosophers such as Edmund Husserl. Even so, certain lessons from phenomenology inform my argument, even if I privilege the language of affect. For example, bodies remain important throughout the book. Affect theory, dating back to Baruch Spinoza's work, is invested in what the body can do and how bodies relate to one another. The return of affect theory in the early twenty-first century, including in the humanities and arts, focuses on a body's capacities to affect and be affected. The art historian Jennifer Doyle notes, for instance, "The more a[n art] work looks like a relationship, the more important the place of affect and emotion may be to critical engagement with it" (*Hold It against Me: Difficulty and Emotion in Contemporary Art* [Durham: Duke University Press, 2013], 89). Given that the metaphor of the network crosses boundaries between the human and nonhuman, affect theory becomes especially critical, as Robert Seyfert observes, because it posits "the potential social relevance of all sorts of bodies (organic, inorganic, artificial, imaginary, etc.)" ("Beyond Personal Feelings and Collective Emotions: Toward a Theory of Social Affect," *Theory, Culture and Society* 29, no. 6 [2012]: 28). Finally, the concept of the "horizon," as it carries over from phenomenology, where it marks the persistence and scope of a world, is related to the way I think about a network imaginary that implies scales and experiences that are perpetually outside the individual's immediate grasp. For more on the phenomenological hori-

zon, see Jan Patočka, *Body, Community, Language, World*, ed. James Dodd, trans. Erazim Kohak (Chicago: Open Court, 1998).

93. Eric Shouse, "Feeling, Emotion, Affect," *M/C Journal* 8, no. 6 (2005), http://journal.media-culture.org.au/0512/03-shouse.php, accessed March 12, 2015.

94. Brian Massumi, *Parables for the Virtual: Movement, Affect, Sensation* (Durham: Duke University Press, 2002), 30, 86.

95. Some existing approaches to the study of communication take human affects seriously but nonetheless limit themselves to easily nameable emotions or feelings. Castells, for instance, argues that the "theory of affective intelligence in political communication" across social media depends mostly on fear and anger. See Castells, *Networks of Outrage and Hope*, 219. Some critics have already started to explore more vibrant and dynamic "vitality affects" as they unfold in online environments. In the closing pages of *Network Culture*, Tiziana Terranova notes, "As with the masses, this political mode cannot but start with affects—that is with intensities, variations of bodily powers that are expressed as fear and empathy, revulsion and attraction, sadness and joy" (156–57). Anna Munster takes up this suggestion in greater detail in *An Aesthesia of Networks*.

96. Massumi, *Parables for the Virtual*, 18. My sense of nodes here is also informed by the discussion of the case study in the *Critical Inquiry* special issue "On the Case" (vol. 33, no. 4, Summer 2007), especially Lauren Berlant's introduction, "On the Case."

97. Walter Benjamin, *The Work of Art in the Age of Its Technological Reproducibility, and Other Writings on Media* (Cambridge: Belknap Press of Harvard University Press, 2008).

98. Streeter, *Net Effect*, 88.

Part 1

1. Fredric Brown, *Angels and Spaceships* (New York: Dutton, 1954), 36–37 (emphasis mine).

2. Ronald D. Moore and Glen A. Larson, "Miniseries," dir. Michael Rymer, *Battlestar Galactica*, Sci Fi Channel, 2003.

3. Scott Bukatman, *Terminal Identity: The Virtual Subject in Postmodern Science Fiction* (Durham: Duke University Press, 1993), 2. Steven Shaviro also builds on the idea that science fiction is the key genre for exploring critical theory and a networked society in *Connected; or, What It Means to Live in the Network Society* (Minneapolis: University of Minnesota Press, 2003).

4. Gardner R. Dozois, *Living the Future: You Are What You Eat*, Writer's Chapbook Series, #31 (Eugene, OR: Writer's Notebook Press, Pulphouse Publishing, 1991). I explore the importance of science fiction to understanding

networks in greater detail in Patrick Jagoda, "Speculative Security," in *Cyberspace and National Security: Threats, Opportunities, and Power in a Virtual World*, ed. Derek S. Reveron (Washington: Georgetown University Press, 2012).

5. Throughout American culture during the Cold War, threatening Communist proto-networks became personified in the form of collective figures that threaten human (or specifically American) individuality. Such organic bodies include the monster ants of Gordon Douglas's film *Them!* (1954), the alien seed pods of Jack Finney's novel *The Body Snatchers* (1955), the enemy Bugs of Robert Heinlein's novel *Starship Troopers* (1959), and the Buggers of Orson Scott Card's novel *Ender's Game* (1985). Later multimedia representations of collective threats have included the iconic Borg in Gene Roddenberry's television show *Star Trek: The Next Generation* (1989), the Zerg Swarms in Blizzard Entertainment's hit multiplayer online game *StarCraft* (1998), and the alien Hydra in Jim Krueger's comic book series *Earth X* (1999).

6. For more about the ways that old media adapt to new media contexts, see Jay David Bolter and Richard Grusin, *Remediation: Understanding New Media* (Cambridge: MIT Press, 2000). Also, for an analysis of the importance of analyzing analogies and continuities between older and newer forms, see Marsha Kinder, "Designing a Database Cinema," in *Future Cinema: The Cinematic Imaginary after Film*, ed. Jeffrey Shaw and Peter Weibel (Cambridge.: MIT Press, 2003). Kinder cites Sergei Eisenstein and Henry Fielding as key examples of artists who produced multimedia genealogies in the process of developing new forms.

7. Walter Benjamin, "The Storyteller," in *Illuminations* (New York: Schocken Books, 1986), 90.

8. Bernard Stiegler, "Memory," in *Critical Terms for Media Studies*, ed. W J. T. Mitchell and Mark B. N. Hansen (Chicago: University of Chicago Press, 2010), 78, 80.

Chapter 1

1. I have in mind here what Denis Cosgrove calls "acts of *mapping*," which evoke "imagination and projection, efficacy and disruption," or "processes of mapping rather than . . . maps as finished objects" (1). See Denis Cosgrove, *Mappings* (1999).

2. Each writer's oeuvre can be said to exceed these respective categories. Even so, DeLillo has been seen as a major contributor to postmodern literature and Stephenson to contemporary science fiction. Many of DeLillo's novels, especially *The Names* (1982), *White Noise* (1985), and *Libra* (1988), which cemented his status as a major twentieth-century American writer, adopt stylistic and thematic features generally associated with postmodern

literature. In *The Cambridge Companion to Don DeLillo*, ed. John Duvall (Cambridge: Cambridge University Press, 2008), Peter Knight ("DeLillo, Postmodernism, Postmodernity") raises the problem of whether DeLillo's writing is "a symptom, a diagnosis, or an endorsement of the condition of postmodernity" (27). In Stephenson's case, his breakthrough works, including *Snow Crash* (1992) and *The Diamond Age* (1995), have been considered primarily as contributions to science fiction (with further breakdowns of second wave cyberpunk and postcyberpunk). Neither *Underworld* nor *Cryptonomicon* fits comfortably, or indeed at all, into these previous rubrics.

3. Edward Mendelson, "Encyclopedic Narrative: From Dante to Pynchon," *MLN* 91, no. 6 (1976): 1267, 1269, 1270. Instead of calling the texts I discuss in this chapter "network narratives," thereby maintaining a parallel to Edward Mendelson's term "encyclopedic narratives," I have selected "network novels" in order to emphasize the medium specificity of the novel form and its contribution to the network imaginary.

4. The form of the modern encyclopedia dates back to a number of eighteenth-century projects, most notably national encyclopedias such as Jean le Rond d'Alembert and Denis Diderot's *Encyclopédie*, the *Encyclopædia Britannica*, and the German *Conversations-Lexikon*.

5. Edward Mendelson, "Gravity's Encyclopedia," in *Mindful Pleasures: Essays on Thomas Pynchon*, ed. George Levine and David Leverenz (Boston: Little, Brown, 1976), 178. For more on the connection between encyclopedic archives and imperialism in the context of *Gravity's Rainbow*, in particular, see Thomas Richards, "The Archive and Its Double," in *The Imperial Archive: Knowledge and the Fantasy of Empire* (London: Verso, 1993).

6. A great deal of the scholarship about *Underworld* observes the centrality of connectedness to its aesthetic, but, except for readings of the final chapter and its treatment of the Internet, this work rarely offers analyses of the novel's indebtedness to a historical moment characterized by a broader network imaginary. In *UnderWords: Perspectives on Don Delillo's Underworld* (ed. Joseph Dewey, Steven G. Kellman, and Irving Malin [Newark: University of Delaware Press, 2002]), Joseph Dewey offers among the most capacious descriptions of the novel's connectivity when he writes, "*Underworld* is a book about connections, a book that is itself relentlessly aware of its fascination with coincidences, with patterns that go unsuspected amid the rolling ad-lib of the day to day. Thus, willing readers are intrigued, taunted, and impressed by the apparently inexhaustible strategies of connections deployed amid the vast narrative lines, a rococo exercise in coincidences that recovers, like those colored stones in a turning kaleidoscope tube, a stunning and satisfying sense of design" ("A Gathering under Words: An Introduction," 12).

7. Tiziana Terranova, *Network Culture: Politics for the Information Age* (London: Pluto Press, 2004), 56.

8. *Underworld* (unlike DeLillo's 1988 novel *Libra*) is more a historical novel
 than what Linda Hutcheon calls the category of postmodern "historio-
 graphic meta-fiction" (*Poetics of Postmodernism: History, Theory, Fiction*
 [New York: Routledge, 1988]). *Underworld* certainly calls attention to itself
 as fiction, and blurs the lines between history and fiction, but it does not en-
 gage in the distancing strategies of either modernist parody or postmodern
 pastiche. Kathleen Fitzpatrick, in particular, offers a sustained argument
 against *Underworld* operating as a postmodern or metafictional text. She ob-
 serves, "Metafiction requires a certain continuing faith in the power of myth
 and particularly in the mythical power of history. In *Underworld* myth is lost;
 the novel instead acts to dismantle the genre of historiographic metafiction
 and its preconceptions, working not to create the past out of its narratives
 but instead to excavate and deconstruct the traces a reified history has left
 in the present" ("The Unmaking of History: Baseball, Cold War, and *Un-
 derworld*," in Dewey, Kellman, and Malin, *UnderWords*, 151). DeLillo has
 himself disavowed that the novel is postmodern, observing, "I don't see
 Underworld as post-modern. Maybe it's the last modernist gasp" (Richard
 Williams, interview, *London Guardian*, October 1, 1998). On the other hand,
 critics such as John Duvall insist that even as DeLillo "does not hit the high
 notes of ludic style or press the boundaries of representation as does Thomas
 Pynchon or Donald Barthelme," his subject matter is still "postmodernity—
 what it feels like to live in the contemporary moment" (*Don DeLillo's Under-
 world: A Reader's Guide* [New York: Continuum, 2002], 22). While I do not
 deny the modernist and postmodern features of the novel, I contend that
 Underworld's historicity is more closely aligned with the network imaginary.
9. Dewey, "A Gathering under Words," 10–11.
10. Timothy L. Parrish, "Pynchon and DeLillo," in Dewey, Kellman, and Malin,
 UnderWords, 79. Among new media scholars, the Internet has often been
 characterized as a combinatory infrastructure that standardizes, absorbs,
 and remediates all other media, including print texts, audio recordings, films,
 and digital games. For example, Friedrich Kittler argues that with fiber-optic
 networks, "the previously separate media of television, radio, telephone,
 and mail will become a single medium, standardized according to transmis-
 sion frequency and bit format" ("Gramophone, Film, Typewriter," *October*
 41 [Summer 1987]: 101). Similarly, Lev Manovich observes that unlike the
 printing press or photography, "the computer media revolution affects all
 stages of communication, including acquisition, manipulation, storage, and
 distribution; it also affects all types of media—texts, still images, moving im-
 ages, sound, and spatial constructions" (*The Language of New Media* [Cam-
 bridge: MIT Press, 2001], 19).
11. For more on the relationship between the "death of the novel" discourse
 and postmodernism, see Kathleen Fitzpatrick, *The Anxiety of Obsolescence:*

The American Novel in the Age of Television (Nashville: Vanderbilt University Press, 2006).

12. Duvall, *Don DeLillo's Underworld*, 76.

13. In *The Geopolitical Aesthetic: Cinema and Space in the World System* (Bloomington: Indiana University Press, 1992), Fredric Jameson discusses such an impulse to know systems that exceed individual human knowledge in his analysis of conspiracy films. I turn to his claims in greater detail in my discussion of network films in the second chapter of this book.

14. Alan Liu refers to this accumulation of data as the "data sublime." For more, see Alan Liu, "Transcendental Data: Toward a Cultural History and Aesthetics of the New Encoded Discourse," *Critical Inquiry* 31, no. 1 (2004): 49–84. In a later article, Liu speaks directly to network visualizations, describing them as "beautifully mystifying galaxies of nodes and links" ("The Meaning of the Digital Humanities," *PMLA*, 128 no. 2 [2013]: 412). For a discussion of the technological sublime, also see Scott Bukatman, *Terminal Identity: The Virtual Subject in Postmodern Science Fiction* (Durham: Duke University Press, 1993), 4. Caroline Levine links the network to the sublime, in an explicitly literary context, at the end of her essay about *Bleak House* and network science where she imagines the novel as a "narratively networked sublime" ("Narrative Networks: *Bleak House* and the Affordances of Form," *Novel: A Forum on Fiction* 42, no. 3 [2009]: 523).

15. Edmund Burke characterizes the sublime as an intense feeling of astonishment that is tinged with terror (*A Philosophical Enquiry*). Elaborating on this feeling, Kant differentiates the sublime from the beautiful, explaining, "The Beautiful in nature is connected with the form of the object, which consists in having boundaries. The Sublime, on the other hand, is to be found in a formless object, so far as in it or by occasion of it *boundlessness* is represented, and yet its totality is also present to thought." For more, see Immanuel Kant, *Critique of Judgment*, trans. J. H. Bernar (New York: Hafner, 1951), §23.

16. Jean-François Lyotard, *The Postmodern Condition: A Report on Knowledge* (Minneapolis: University of Minnesota Press, 1984), 77. Also see Jean-François Lyotard, "The Sublime and the Avant-garde," *Artforum* 22, no. 8 (April 1984): 36–43, and *The Inhuman: Reflections on Time*, trans. Geoffrey Bennington and Rachel Bowlby (Stanford: Stanford University Press, 1991).

17. Joseph Tabbi, *Postmodern Sublime: Technology and American Writing from Mailer to Cyberpunk* (Ithaca: Cornell University Press, 1995), ix. For a history of the technological sublime in America, see David E. Nye, *American Technological Sublime* (Cambridge: MIT Press, 1994). I am also indebted here to Scott Bukatman's work on the postmodern sublime in cinema. See Scott Bukatman, *Matters of Gravity: Special Effects and Supermen in the 20th Century* (Durham: Duke University Press, 2003).

18. William Gibson, *Neuromancer* (New York: Ace Books, 1984), 51. This defi-
nition comes from the novel's diegesis, where it is part of a "kid's show," sug-
gesting that the text contains embedded layers of knowledge about networks
that a reader can perhaps at most begin to grasp through this type of remedial
gloss. Elsewhere, Gibson's text, and a good deal of other cyberpunk litera-
ture from this period, expresses network form through geometrical abstrac-
tions, impressionistic images, sensory prose, dystopian rhetoric, hardboiled
style, and fragmented passages. Cyberpunk represents perhaps one of the
earliest genres to generate network aesthetics. Given its extensive coverage
of this genre by other critics, I do not spend considerable time on it in this
book. It is worth noting, however, that Fredric Jameson observed, in 1991,
that cyberpunk represents "for many of us, the supreme *literary* expression if
not of postmodernism, then of late capitalism itself" (*Postmodernism, or, The
Cultural Logic of Late Capitalism* (Durham: Duke University Press, 1991],
419). For an elaborate reading of the genre of cyberpunk in relationship to
networks, see Sabine Heuser, *Virtual Geographies: Cyberpunk at the Intersec-
tion of the Postmodern and Science Fiction* (New York: Rodopi, 2003).

19. Don DeLillo, *Underworld* (New York: Scribner, 1997), 289. As Timothy
Parrish points out, DeLillo seems to borrow the idea of everything being
connected from Pynchon. The difference between *Gravity's Rainbow* and
Underworld, Parrish suggests, is that Pynchon's characters believe they can
escape systems, whereas DeLillo's characters have largely come to terms
with them ("Pynchon and DeLillo," in Dewey, Kellman, and Malin, *Under-
Words*).

20. This observation comes up across *Underworld* scholarship, including Rob-
ert McMinn's "Underworld: Sin and Atonement." McMinn notes, regarding
Marvin Lundy, "It is the narrative he chases not the ball, not the physical ob-
ject but something metaphysical, the connections themselves, and the links"
(in Dewey, Kellman, and Malin, *UnderWords*, 38).

21. DeLillo, *Underworld*, 131, 175.

22. Peter Knight suggests that as the novel unfolds, events cede to connectivity,
in his essay "Everything Is Connected: *Underworld*'s Secret History of Para-
noia," *Modern Fiction Studies* 45, no. 3 (1999): 811–36. While Knight sees
conventional historical events (such as the fall of the Berlin Wall) gradually
giving way to a general interconnectedness in *Underworld*, I see events and
atmospheres coexisting throughout the text.

23. DeLillo, *Underworld*, 332.

24. Ibid., 622.

25. Ibid., 622–23, 634, 636.

26. See, for instance, Albert-László Barabási, *Linked: How Everything Is Con-
nected to Everything Else and What It Means for Business, Science, and Every-
day Life* (New York: Penguin, 2003). Barabási notes, "It is easy to forget how

dependent we are on modern technology. To appreciate it, we must witness its occasional failure, like this one in the summer of 1996, when everything powered by electricity went silent between the crest of the Rockies and the Pacific. Experts had long feared a repeat of the Great Northeast Blackout of 1965, which left 30 million people without electricity for thirteen hours. In terms of financial impact, the 1996 failure of the western power system was much more devastating. . . . Compared to today's system, the 1965 grid was much less connected" (109). For Barabási, the Great Northeast Blackout operates as a protonetwork event, which is far less severe than the network failures of our globally connected world in which technology, society, and finance are inextricably interrelated. The earlier event becomes historical as part of an origin story of the emergence of the network era. The 1965 blackout is used in numerous other texts as well as a historical precursor to the 2003 blackout. See S. P. Gorman, *Networks, Security, and Complexity: The Role of Public Policy in Critical Infrastructure Protection* (Northampton, MA: Edward Elgar, 2005).

27. DeLillo, *Underworld*, 335.

28. Lauren Berlant, "Thinking about Feeling Historical," *Emotion, Space and Society* 1, no. 1 (2008): 4–9. Berlant identifies several other categories of affective experience that exceed rational thought and make the historical present accessible. The modes of association, distraction, and disavowal in this passage belong precisely to an affective mode of encountering history.

29. DeLillo, *Underworld*, 183.

30. In a later passage, the highway system becomes associated with the "end of history" that Lenny Bruce envisions during the Cuban Missile Crisis. The comedian reflects, "Where else would [his audience] go to rehearse the end of history, or actually see it—this was the meaning of the freeways and always had been and they'd always known it at some unsounded level" (ibid., 508).

31. Ibid., 183–85.

32. Jameson, *Postmodernism*, 415.

33. DeLillo, *Underworld*, 183, 423–45.

34. Fredric Jameson, *The Political Unconscious: Narrative as a Socially Symbolic Act* (Ithaca: Cornell University Press, 1981), 19–20.

35. DeLillo, *Underworld*, 408–9.

36. Ibid., 421. James Woods criticizes DeLillo for writing a paranoid history in his review "Underworld" in the *New Republic* (November 10, 1997). Matt certainly experiences a form of paranoia in this passage that takes on qualities the cultural critic Timothy Melley calls "agency panic," which is an "intense anxiety about an apparent loss of autonomy" (*Empire of Conspiracy: The Culture of Paranoia in Postwar America* [Ithaca: Cornell University Press, 2000], vii). The network that Matt comes to articulate, however, departs from a fundamental belief in individual agency and suggests a less controllable and more decentralized system.

37. Robert N. Proctor, "Agnotology: A Missing Term to Describe the Cultural Production of Ignorance (and Its Study)," in *Agnotology: The Making and Unmaking of Ignorance*, ed. Robert Proctor and Londa L. Schiebinger (Stanford: Stanford University Press, 2008), 2. Agnotology does not mark merely what is "not yet known" or what is metaphysically beyond our knowledge (3). Instead, it seems to establish "the historicity and artifactuality of nonknowing and the non-known" (27).

38. DeLillo, *Underworld*, 465.

39. Ibid.

40. A search of the novel reveals the following frequency of these words: "edge" (69), "edges" (18), "edged" (11), "edgy" (5), and "edging" (4). Moreover, the two Edgars (J. Edgar Hoover and Sister Edgar) could also be considered as characters who both inhabit and characterize different "edges" in the novel. Robert McMinn points out the frequency of edges in the novel in "Underworld: Sin and Atonement" (in Dewey, Kellman, and Malin, *UnderWords*). However, he treats "edges" primarily as a marker of the novel's concern with boundaries. While this element is important, I emphasize the word's polysemous deployment that aligns with a dominant network discourse in the 1990s.

41. DeLillo, *Underworld*, 228–29, 240, 505.

42. In *The Image of the City* (Cambridge: MIT Press, 1960), Kevin Lynch offers an extensive discussion of "edges" both in the sense of boundaries and of connections between regions: "Edges are the linear elements not used or considered as paths by the observer. They are the boundaries between two phases, linear breaks in continuity: shores, railroad cuts, edges of development, walls. They are lateral references rather than coordinate axes. Such edges may be barriers, more or less penetrable, which close one region off from another; or they may be seams, lines along which two regions are related and joined together. These edge elements, although probably not as dominant as paths, are for many people important organizing features, particularly in the role of holding together generalized areas, as in the outline of a city by water or wall" (47).

43. DeLillo, *Underworld*, 479.

44. Ibid., 672, 683.

45. Don DeLillo, "The Power of History," *New York Times Sunday Magazine*, September 7, 1997.

46. DeLillo, *Underworld*, 810, 785, 786.

47. Ibid., 808, 825–27. One of the fuller discussions of this scene appears in Christian Moraru's *Cosmodernism: American Narrative, Late Globalization, and the New Cultural Imaginary* (Ann Arbor: University of Michigan Press, 2011). Moraru celebrates DeLillo's critique: "A fully integrated and serialized system whose cut-to-size pieces spend their lifecycle quoting one another, DeLillo's cyberspace is a postdifferential world that paints a symmetrically totalistic picture of the late-global world" (273).

48. For an extended discussion of the relation between these utopian and dystopian aspects of globalization, see Jacques Derrida, "Globalization, Peace, and Cosmopolitanism" in *Negotiations: Interventions and Interviews, 1971–2001*, ed. Elizabeth Rottenberg (Stanford: Stanford University Press, 2002). In this address, Derrida coins the term "homo-hegemonizations" to describe processes of idealized "homogenization" that accompany a utopian vision of globalization but in fact conceal "old and new inequalities and hegemonies" (373). Armand Mattelart traces a more concrete historical chronology of the conjunction between communications networks and peace ("Mapping Modernity: Utopia and Communications Networks," in *Mappings*, ed. Denis E. Cosgrove [London: Reaktion Books, 1999], 176). Alongside such utopian visions of networks, he also identifies a dystopian imagination of global interconnection that appears in the early twentieth century, including the fiction of writers such as Yevgeny Zamyatin, Aldous Huxley, and George Orwell (183–84).

49. Neal Stephenson, *Cryptonomicon* (New York: HarperCollins, 2003), 1–3.

50. In an interview with *Wired*, Stephenson notes, "*Cryptonomicon* is explicitly a historical novel" (Robert Levine, "Neal Stephenson Rewrites History," *Wired*, September 2003).

51. For the most part, *Cryptonomicon* is silent about the events of the Cold War, thereby defamiliarizing this period of American history. For a discussion of the role of the Cold War in the novel, see Jay Clayton, "Convergence of the Two Cultures: A Geek's Guide to Contemporary Literature," *American Literature* 74, no. 4 (2002): 807–31. Clayton argues that the Cold War "haunts the stories of the generations on either side" (818). He adds, "The burden of the Cold War years becomes more haunting for being unnarrated. And the uncanniness is transferred to the negative undercurrents in the stories on either side. The Cold War lends its oppressive aura to the hackers' paranoia, while at the same time serving as a warning against unthinking optimism" (819).

52. Stephenson downplays the geopolitical and military concerns of the Cold War in favor of the web of technoscientific and financial developments of this period. As he explains in an interview, he sees technoscience as the animating force of this period, and the predominant reason for American power: "For much of the 20th century it was about science and technology. The heyday was the Second World War, when we had not just the Manhattan Project but also the Radiation Lab at MIT and a large cryptology industry all cooking along at the same time. The war led into the nuclear arms race and the space race, which led in turn to the revolution in electronics, computers, the Internet, etc. If the emblematic figures of earlier eras were the pioneer with his Kentucky rifle, or the Gilded Age plutocrat, then for the era from, say, 1940 to 2000 it was the engineer, the geek, the scientist" (Mike Godwin, "Neal Stephenson's Past, Present, and Future," *Reason* 36, no. 9 [February 2005], 42).

53. Rita Barnard, "Fictions of the Global," *Novel: A Forum on Fiction* 42, no. 2 (Summer 2009): 207–15.
54. The range of international feelings toward the United States comes up several times in Randy's travels through Asia. While in the Philippines, for instance, he reflects on the multifaceted attitude, "the mixture of love, hate, hope, disappointment, admiration, and derision that Filipinos express toward America" (Stephenson, *Cryptonomicon*, 939).
55. N. Katherine Hayles, *My Mother Was a Computer: Digital Subjects and Literary Texts* (Chicago: University of Chicago Press, 2005), 118.
56. For a critique of the Orientalism in cyberpunk novels such as *Neuromancer* and films such as *Ghost in the Shell*, see Wendy H. K. Chun, *Control and Freedom: Power and Paranoia in the Age of Fiber Optics* (Cambridge: MIT Press, 2006).
57. Stephenson, *Cryptonomicon*, 37, 32. Computer networks figure heavily in Randy's interdisciplinary background. In the early 1990s, Randy becomes a graduate student in astronomy but leaves the program after three years. During this time, he is put to work doing a good deal of programming work for the department: "Astronomy had become a highly networked discipline, and you could now control a telescope on another continent, or in orbit, by typing commands into your keyboard, watching the images it produced on your monitor. Randy was now superbly knowledgeable when it came to networks. Years ago, this would have been of limited usefulness. But this was the age of networked applications, the dawn of the World Wide Web, and the timing couldn't have been better" (97). Both the Internet and network science recur throughout the novel.
58. Stephenson, *Cyrptonomicon*, 131.
59. Stephenson attributes a decidedly transnational history to Kinakuta—a German colony that is handed over to the Japanese after World War I before gaining independence after World War II. "The population is Muslim or ethnic Chinese around the edges, animist in the center, and it's always been ruled by a sultan. Once known for its oil wealth, the country now seeks to move its economy toward the more sustainable resource of information and networking" (ibid., 236).
60. Ibid., 232, 234, 346, 703.
61. *Cryptonomicon*'s maximalism extends to technical and discipline-specific discussions of a wide range of topics, including the mechanical architecture of pipe organs, the history of mathematics, laptop hardware, encryption software, cryptanalysis procedures, cultural studies scholarship, polyalphabetic ciphers, early computing experiments, engineering and geology methods, corporate law, and so on.
62. Stephenson, *Cryptonomicon*, 165–66.
63. For a materialist analysis of networks and protocols, see Alexander Galloway, *Protocol: How Control Exists after Decentralization* (Cambridge: MIT Press,

254 Notes to Page 67

2006). For more on the materiality of undersea communications cables, in particular, see Bernard Finn and Daqing Yang, eds., *Communications under the Seas: The Evolving Cable Network and Its Implications* (Cambridge: MIT Press, 2009). As Finn and Yang observe in their introduction, "For all the excitement about new technologies such as Wi-Fi, mobile networks, and communication satellites, the bulk of its long-distance communication remains dependent on what one newspaper called 'altogether older technology: cables under the earth's oceans'" (3).

64. Stephenson, *Cryptonomicon*, 391, 392. In an interview, Stephenson observes, "Much of what has gone on since 9/11, not only here but in other places, like the Netherlands, looks to me like a reversal of the trends of the previous couple of decades. Government is getting more powerful, and its (perceived) usefulness and relevance to the average person is more obvious than it was 10 years ago" (Godwin, "Neal Stephenson's Past, Present, and Future," 40). Along with Stephenson's own insistence on both government and corporate power in an era of an allegedly global Internet, there are several books from the late 1990s and early 2000s about the political and legal dimensions of the expanding Internet, including Lawrence Lessig, *Code and Other Laws of Cyberspace* (New York: Basic Books, 1999), and Jack L. Goldsmith and Tim Wu, *Who Controls the Internet? Illusions of a Borderless World* (New York: Oxford University Press, 2006).

65. Stephenson, *Cryptonomicon*, 787, 788. DeLillo's novels, particularly since the early 1980s, have reflected extensively on the space-time of American capitalist networks and their topography of uneven geographical development. DeLillo's spatial concerns are arguably allegorized by the shrinking geography of his novels. In 1982, *The Names* tracks American capital and investments around the entire globe by focusing on James Axton and his fellow world travelers. In 1997, *Underworld* reduces the scope of this exploration to the territorial borders of the United States. In 2003, *Cosmopolis* packs its action into the space of a single city that is traversed by Eric Packer's limousine. Then 2007's *Falling Man* limits the analysis of global systems to a devastated New York street ("It was not a street anymore but a world, a time and space of falling ash and near night") that haunts the even more compact space of Keith Neudecker's traumatized mind (New York: Scribner, 2007, 3). The spatial problematic that these novels thematize through shrinking space predates contemporary American capitalism. In David Harvey's terms, capitalism has historically thrived through a "production of space" that he calls a "spatial fix." Capitalism requires a grounding "fix" in order to enable expansion from a home base, but it also encounters a "fix," a dilemma or crisis, at those moments when overaccumulation requires new territory for reinvestment (*The New Imperialism* [Oxford: Oxford University Press, 2003], 101).

66. DeLillo marks the global aspect of American power most clearly through the formulation of the "Shot Heard 'Round the World"—a designation coined by Ralph Waldo Emerson to describe the breakout of the American Revolutionary War and then later applied by several periodicals to describe Bobby Thomson's home run that gave the Giants their famous victory over the Dodgers in the 1951 National League title game. (*Underworld*, 44). In the novel, the BBC producer Jane Farish observes skeptically that the name is "a little bit of American bluster" (*Underworld*, 95). Regardless of the accuracy of the phrase, however, the gesture to elevate a national sports phenomenon into an international news story points toward the global aspirations of American power in the 1950s.

67. DeLillo, *Underworld*, 88.

68. Stephenson, *Cryptonomicon*, 127.

69. I draw this sense of the interplay of past and present from Jameson, *The Political Unconscious*.

70. Stephenson, *Cryptonomicon*, 170.

71. Ibid., 550, 551. Lawrence begins to see information networks everywhere, suggesting that a "network" is not merely a material technology, in this instance, but also a discursive formation with varied, and often competing, applications. In another passage from this same section, he uses the language of information, for instance, to make sense of a spiderweb: "Spiders can tell from the vibrations what sort of insect they have caught, and home in on it. There is a reason why the webs are radial, and the spider plants itself at the convergence of the radii. The strands are an extension of its nervous system. Information propagates down the gossamer and into the spider, where it is processed by some kind of internal Turing machine. Waterhouse has tried many different tricks, but he has never been able to spoof a spider. Not a good omen!" (174).

72. *Oxford English Dictionary Online*, s.v. "crypt, *n.*," accessed February 2012, and s.v. "nomos, *n.*" accessed March 08, 2015, http://www.oed.com. *Cryptonomicon* offers various wordplays on "crypts" and "encryption." Similarly, "terminals" come to signify both death and computers (261). Hidden and unknown orders and conspiracies come up repeatedly in the novel, as in the case of Enoch Root's secret society (118).

73. Stephenson, *Cryptonomicon*, 200.

74. Neal Stephenson is often accused of a libertarian politics. Certainly Epiphyte's goals and Randy's technophilia often tend in this political direction, as does the way that the novel romanticizes the figure of the hacker. Even so, *Cryptonomicon*, as a whole, reveals a more ambivalent and complex relationship to America's global role. For more, see Michael Tratner, "Crypto-economics: Neal Stephenson, Milton Friedman, and Post-postmodernism," in *Tomorrow through the Past: Neal Stephenson and the Project of Global*

Modernization, ed. Jonathan P. Lewis (Newcastle-upon-Tyne: Cambridge Scholars, 2006).

75. Georg Lukács, *The Theory of the Novel: A Historico-Philosophical Essay on the Forms of Great Epic Literature* (Cambridge: MIT Press, 1971), 17, 62.

76. David Cunningham, "Capitalist Epics: Abstraction, Totality and the Theory of the Novel," *Radical Philosophy* 163 (2010): 13.

77. Jameson, *The Geopolitical Aesthetic*, 23.

78. Terranova, *Network Culture*, 51.

Chapter 2

1. In this chapter, I focus on films that adopt a narrative form that expresses and intervenes in the network imaginary, as opposed to films that thematize network technologies by means of traditional cinematic techniques. Films that fall into the latter category might include films about social media, such as *The Social Network* (2010) and *Catfish* (2010). These also have much to say about the cultural dominant of networks, but I am interested in the specific ways that cinematic form invokes network form. For "around 150 films," see David Bordwell, "Seduced by Structure," *Observations on Film Art* blog, October 11, 2010, http://www.davidbordwell.net/blog/2010/10/11/seduced -by-structure/, accessed June 9, 2015.

2. Though these terms do not refer to a single canon of films, they provide alternate emphases for what I am calling network films. The term "hyperlink cinema" was first used by Alissa Quart ("Networked,'" *Film Comment* 41, no. 4 [July–August 2005: 48–51]) and taken up by Roger Ebert ("Syriana," *Chicago Sun-Times*, December 9, 2005). The term "criss-crossers" appears repeatedly around the same time, especially in *Variety* magazine, including reviews by Derek Elley ("Istanbul Tales," *Variety*, April 26, 2005). María del Mar Azcona, in *The Multi-Protagonist Film* (New York: Wiley-Blackwell, 2010), describes "a contemporary tendency to abandon the single-protagonist structure on which most film narratives have traditionally relied and replace it by a wider assortment of characters with more or less independent narrative lines" (1). While it is significant that network films replace the focus on a single protagonist or hero with multiple protagonists, this structural innovation represents only one of several features of this genre. For an earlier theory of multiple protagonists in film, see Margrit Tröhler, *Offene Welten ohne Helden: Plurale Figurenkonstellationen im Film* (2007). Putting the emphasis on scientific theoretical precursors, Wendy Everett also discusses a narrower category of what she calls "fractal films" in "Fractal Films and the Architecture of Complexity," *Studies in European Cinema* 2, no. 3 (December 2005): 159–71. As she puts it, "fractal" films "both illustrate and explore the complex architecture of chaos" and "are structured as a series of

apparently unrelated stories that intersect and interact with each other in random, unstable, and unpredictable ways" (160). Marsha Kinder's category of "database narrative" refers to films, such as *Groundhog Day*, *Memento*, and *Run Lola Run*, that foreground the selection and combination implicit in all storytelling. Database cinema also includes new media experiments that require viewer participation or a reconfiguration of discrete segments. This genre is distinct from the network films that interest me, but it similarly grapples with intersections among distributed elements, as described in Marsha Kinder, "Designing a Database Cinema," in *Future Cinema: The Cinematic Imaginary after Film*, ed. Jeffrey Shaw and Peter Weibel (Cambridge: MIT Press, 2003). "Network narratives" was coined by David Bordwell in *The Way Hollywood Tells It: Story and Style in Modern Movies* (Berkeley and Los Angeles: University of California Press, 2006). While I draw most consistently from Bordwell's framing, I use the term "network films" rather than "network narratives" in order to emphasize cinema's medium specificity in deploying network aesthetics. It is, finally, worth noting that these films also have certain overlaps with what Tom Zaniello calls the "cinema of globalization" in *The Cinema of Globalization: A Guide to Films About the New Economic Order* (Ithaca, NY: ILR Press, 2007). My reason for deemphasizing that category is that it speaks more to content than form. As Zaniello explicitly puts it, his classification is based "on the subject matter of the films" (16). Moreover, in organizing the category around the concept of "globalization," Zaniello's guide, even in its inclusion of "antiglobalization" films, limits alternate ways of imagining and speculating about the contemporary world order.

3. Bordwell, *The Way Hollywood Tells It*, 73.

4. Henry Jenkins, *Convergence Culture*.

5. Bordwell, *The Way Hollywood Tells It*, 103.

6. David Bordwell, *Poetics of Cinema* (New York: Routledge, 2008), 191. As he puts it, he prefers not to frame these films "in a zeitgeisty way" (244).

7. I draw this formulation of genre from David Edgar, *How Plays Work* (London: Nick Hern, 2009), 66.

8. Robert Baer, *See No Evil: The True Story of a Ground Soldier in the CIA's War on Terrorism* (New York: Three Rivers, 2003).

9. It is striking, and in need of additional analysis, that all of the major characters in the film are men. As Azcona observes, "The victimized, beleaguered individual who is the focus of attention in *Syriana* is exclusively male. Women are a glaring absence in the movie, a point that becomes even more blatant given the potentially democratic status of multi-protagonist films" (*Multi-Protagonist Film*, 136). It is not only the lack of women in the film, however, that proves problematic to its democratic potential (as well as a symptom of the deterioration of democracy that it charts) but also the lack of

strong relationships in any form. All of the male protagonists belong to families, but ones that are, in one way or another, fractured or in the process of disintegrating. Moreover, nonfamily collectives and queer assemblages are entirely missing from the film.

10. Jameson, *The Geopolitical Aesthetic*, 2.

11. Ibid., 9. Also see Krapp, *Noise Channels*. Krapp observes, "The interesting thing about conspiracy theory is surely not only that it represents a paranoid expression by normal people but that it is also, in fact, a mode of theorizing" (35).

12. Another way in which the multiprotagonist composition of the network film departs from single-protagonist films is in its complication of "agency panic." Timothy Melley uses this term to describe an "intense anxiety about an apparent loss of autonomy, the conviction that one's actions are being controlled by someone else or that one has been 'constructed' by powerful, external agents" (*Empire of Conspiracy*, vii). Network films still explore distributed agency but in an immanent sense that is rarely attributed to external agents. Some films, such as Steven Soderbergh's *Contagion* (2011), come to use individual agents primarily as a way of elaborating broader global networks and introducing paranoia, but this differs from the form of panic that animates the conspiracy form.

13. Jameson, *The Geopolitical Aesthetic*, 66. One film that thematizes the collective nature of conspiracy but also, contrary to the convention that Jameson observes, stresses the importance of community in exposing conspiracy is *Missing* (Costa-Gavras, 1982). After the disappearance of the American expat Charlie Horman (John Shea) in the aftermath of the Chilean coup of 1973, his father Ed (Jack Lemmon) arrives on the scene to locate him. While he spends much of the film criticizing Charlie's wife Beth (Sissy Spacek) for her "anti-establishment paranoia" and the strange community of radicals she and Charlie have joined, Ed's experience of the American government's cover-up of Charlie's death leads him toward a deep appreciation of this collective.

14. Azcona, *Multi-Protagonist Film*, 138, 127.

15. Arguably, cinema as such enables a novel mode of reflection on accident by stressing the shock and suddenness that it entails through audiovisual means. As Virilio puts it, "general history has been hit by a new type of accident, the accident in its perception as visibly present—a 'cinematic' and shortly 'digital' perception" (*The Original Accident* [Malden, MA: Polity, 2007], 25). Ross Hamilton makes this point even more directly when he writes, "media technologies gave renewed importance to catastrophic accidents. Repetitions expanded the scale of dangerous events, while photographs could capture the sensory impact of ephemeral sights and sounds and films could replicate their shocking suddenness. By bringing train wrecks, airplane crashes, and collapsing bridges or buildings vividly before the mind, the new media al-

tered the function of reflection" (*Accident: A Philosophical and Literary History* [Chicago: University of Chicago Press, 2007], 273).

16. *Syriana*'s Bob Barnes is also, at core, an information agent. As Stephen Gaghan explains in an interview, human intelligence has less to do with spying, as it is represented in numerous Hollywood films, than with "a whole series of relationships predicated on longstanding friendships." CIA agents, such as Barnes, are thus archives of information (*Charlie Rose*, December 5, 2005).

17. Everett, "Fractal Films and the Architecture of Complexity," 160.

18. Bordwell, *Poetics of Cinema*, 205.

19. The detail of Stinger antiaircraft missiles is historically significant as these are the same weapons with which the US government supplied Afghan fighters who battled Soviet troops in the 1980s. Since late 2001, the US attempted to retrieve a large quantity of Stinger missiles that had been appropriated by Taliban fighters.

20. Paul Virilio and Sylvère Lotringer, *Pure War* (New York: Semiotext(e), 1997), 38.

21. For an extended reading of Aristotle's theory of accident and the longer history of the concept, see Hamilton, *Accident*. For Aristotle, accidental qualities are linked to accidental events. As Hamilton notes, "Although later philosophers treated accidental events as distinct from accidental qualities, we recognize the logic for linking the two. . . . Changes in quality imply an occurrence or an act taking place in time, such as getting a tan, standing up, reading, or speaking, while changes in circumstances have the power to alter accidental qualities" (16).

22. Kinder, "Designing a Database Cinema," in *Future Cinema*.

23. James Der Derian, *Virtuous War: Mapping the Military-Industrial-Media-Entertainment Network* (Boulder, CO: Westview Press, 2001).

24. Office of Force Transformation, US Secretary of Defense, *The Implementation of Network-Centric Warfare* (Washington, DC: US Government Printing Office, 2005), 7–10. For a similar account from the early 2000s, see David Stephen Alberts, *Information Age Transformation: Getting to a 21st-Century Military*, Information Age Transformation Series (Washington, DC: CCRP Publication Series, 2002).

25. Mike Hill, "'Terrorists Are Human Beings': Mapping the U.S. Army's 'Human Terrain Systems' Program," *differences* 20 (2009): 269, 257.

26. This concept is developed in John Arquilla and David F. Ronfeldt, eds., *In Athena's Camp* (Santa Monica, CA: Rand Corporation, 1997).

27. Galloway and Thacker, *The Exploit*, 27.

28. Arthur K. Cebrowski and John J. Garstka, "Network-Centric Warfare: Its Origin and Future," *Proceedings* (Annapolis, MD: US Naval Institute, 1998). As military strategists Cebrowski and Garstka put this point, adapting to new

enemy threats requires a "shift from viewing actors as independent to view-
ing them as part of a continuously adapting ecosystem."

29. Ben Anderson, in particular, highlights some of the important parallels be-
tween the affective organization of World War I as a "total war" and the early
twenty-first century war on terror in "Modulating the Excess of Affect: Mo-
rale in a State of 'Total War,'" in *The Affect Theory Reader*, eds. Melissa Gregg
and Gregory J. Seigworth (Durham: Duke University Press, 2010). In total
war, "distinctions between civilian and soldier, combatant and noncomba-
tant, tend to fade or be eliminated as mobilization for war is 'total.'" (170).
Total war comes to threaten a population: "a mass of affective beings" (172).

30. Siva Vaidhyanathan, *The Anarchist in the Library: How the Clash Between
Freedom and Control Is Hacking the Real World and Crashing the System* (New
York: Basic Books, 2004), 171.

31. Brian Massumi, "The Future Birth of the Affective Fact: The Political Ontol-
ogy of Threat" in *The Affect Theory Reader*, 53. Massumi suggests that threat
inherently carries certain networked or "ecological" dimensions: "Threat's
ultimately ambient nature makes preemptive power an *environmental*
power. Rather than empirically manipulate an object (of which actually it has
none), it *modulates* felt qualities infusing a life-environment" (62).

32. For more on the history of the Salafi jihad, see Marc Sageman, *Understand-
ing Terror Networks* (Philadelphia: University of Pennsylvania Press, 2004).
Sageman argues that Saddam Hussein's invasion of Kuwait in August 1990
constituted a key historical turning point for this jihad. Although Salafists
were opposed to the invasion and even offered assistance in combating it, the
movement became offended by the US intervention in what was perceived
as a local rather than global affair (37–38). Even after the fall of Kabul in 1992,
carried out with Saudi and US support, "the militant Islamist movement was
not a coordinated global jihad but a collection of local jihads, receiving train-
ing and financial and logistic support from the vanguard of the movement, al
Qaeda" (38). During this period, most efforts by al Qaeda and related groups
concerned the liberation and protection of Muslim territories. It was not un-
til the mid-1990s that al Qaeda transitioned from a Middle Eastern faction to
a global movement, deciding to actively target the "far enemy," the United
States (39). Also, see Chalmers Johnson, "Blowback," *Nation* (October 15
2001), 13–15 and Chalmers Johnson, *Blowback: The Costs and Consequences
of American Empire* (New York: Metropolitan Books, 2000).

33. Mahmood Mamdani, *Good Muslim, Bad Muslim: America, the Cold War, and
the Roots of Terror* (New York: Pantheon Books, 2004), 99, 137, 87, and 13.
Also see Naomi Klein, *The Shock Doctrine: The Rise of Disaster Capitalism*
(New York: Metropolitan Books/Henry Holt, 2007). As Klein observes, such
worldwide conflicts contributed to a larger American strategy to "advance a
fundamentalist version of capitalism" (7).

34. Sageman, *Understanding Terror Networks*, 59.

35. Ibid., 139.

36. Steven Johnson, *Emergence: The Connected Lives of Ants, Brains, Cities, and Software* (New York: Scribner, 2001).

37. While complexity science did not itself take a coherent disciplinary form until the 1970s, there are many scientific and philosophical precursors to it. In the eighteenth century, many writers compared society to complex mechanisms such as clocks. Darwin's evolutionary theory, in the nineteenth century, provided still other evolutionary metaphors of complexity, including tree structures. Following World War II, the gradual exploration of computer networks provided still other metaphors. For more about this history, see R. Keith Sawyer, *Social Emergence: Societies As Complex Systems* (2005). The term "emergence," as a philosophical concept, dates back to George Henry Lewes's 1875 book *Problems of Life and Mind*. For more on this early history, see Philip Clayton and Phillip Davies, *The Re-Emergence of Emergence: The Emergentist Hypothesis from Science to Religion* (2006).

38. In the context of cybernetics, N. Katherine Hayles discusses the movement from "homeostasis" (1945-1960) to "reflexivity (1960-1980) to "emergence" (1980-present) in *How We Became Posthuman: Virtual Bodies in Cybernetics, Literature, and Informatics* (Chicago: University of Chicago Press, 1999). The focus on open systems and change comes up in the work of Ludwig von Bertalanffy, James Miller, and Niklas Luhmann. The processes of emergence, however, are not taken up in greater detail until the 1980s and 1990s.

39. *Social Emergence*, 23 and 2. Despite the use of multi-agent systems in the social sciences, the 1980s interest in chaos theory was ill suited to fields like sociology. As Sawyer notes, "Although providing a useful set of metaphors for thinking about social systems—nonlinearity, self-organization, nonreducibility—the substance of chaos theory itself, its mathematics and its underlying physical theory, has limited applicability to the social sciences" (19).

40. John H. Holland. *Emergence: From Chaos to Order* (Reading, Mass: Addison-Wesley, 1998), 3.

41. Sawyer, *Social Emergence*, 26.

42. Johnson, *Emergence*, 38-39.

43. Galloway and Thacker, *The Exploit*, 33.

44. The relationship between war and speed is a central concern of the film, but also informs the broader history of cinema. The gradual speeding up of cinematic cuts can be traced to earlier changes following World War II. As Dudley Andrew observes, "The world to be represented had become too vast, too rapid, too complex and violent for standard cinematic representation. Thrust outside the studio, cinema struggled to grasp a confusing reality through portable cameras, specialized lenses, tape-recorders, fast

stock, color, even infrared" (38). International war brought with it tempo-
ralities that required different editing techniques that "dared filmmakers and
audiences to open themselves to worlds of experience whose temporal co-
ordinates are disturbingly and revealingly variable" (38). Arguably, *Syriana*
belongs to a further intensification of these types of film techniques. Net-
work films, like many postwar films, "force the spectator to be alert to hap-
penings whose causes are invisible, or too minute or oblique to be noticed.
Such films must be grasped on the run" (39). For more on changes in postwar
cinema, see Dudley Andrew, *What Cinema Is! Bazin's Quest and Its Charge*
(Chichester, West Sussex, UK: Wiley-Blackwell, 2010).

45. As Douglas Kellner observes, "The political thriller is often a conservative
genre that idealizes government officials or intelligence agents pitted against
Evil Enemies in a Manichean duality of Good vs. Evil, in which the country
of the film's origin embodies goodness." Conspiracy films, however, offer ex-
ceptions or liberal alternatives to this tendency. For more, see *Cinema Wars:
Hollywood Film and Politics in the Bush-Cheney Era* (Chichester, West Sus-
sex, UK: Wiley-Blackwell, 2010), 165.

46. François Truffaut and Alfred Hitchcock, *Hitchcock* (New York: Simon and
Schuster, 1967), 79-80.

47. Jameson, *The Geopolitical Aesthetic*, 23.

48. It is notable that Bryan and Julie form the only romantic couple in *Syriana*—
and even this relationship becomes strained after their son's death. A turn
to other network films, however, reveals a reliance on the couple form and
romance as the genre for revealing the centrality of accident. As Roland
Barthes notes, "Throughout any love life, figures occur to the lover without
any order, for on each occasion they depend on an (internal or external)
accident." A lover confronts "incidents (what 'befalls' him)" (*A Lover's Dis-
course: Fragments* [New York: Hill and Wang, 1978], 6). Indeed, love plots
regularly rely on accidental encounters. *Syriana* also proceeds through a
series of accidents but the film's major subjects—the CIA agent, the energy
analyst, the attorney, and the migrant worker—have no time for the specific
accidents of romance that structure network films such as *Revolving Doors*.

49. David Bordwell, "Intensified Continuity Visual Style in Contemporary
American Film," *Film Quarterly* 55 no. 2 (2002).

50. Azcona, *Multi-Protagonist Film*, 131.

51. Massumi, *Parables of the Virtual*, 30.

52. The tracking shot and, more generally, a moving camera are key features of
the "intensified continuity" that Bordwell discusses ("Intensified Continuity
Visual Style in Contemporary American Film," 20). The moving camera, in
this case, contributes to a suggestion of several pathways that cannot be si-
multaneously followed.

53. I borrow this wording from Paul Virilio's description of deterrence and ex-

tend it to the war on terror: "The art of deterrence, prohibiting political war, favors the upsurge, not of conflicts, but of acts of war without war." See Virilio and Lotringer, *Pure War*, 32.

54. Paul Virilio also invokes "Total War," a situation in which distinctions between "civilians" and the "military" blur, as a precursor of this contemporary condition. In *Pure War*, Virilio observes that World War I was the first European total war, while in the United States the Civil War had already played this role. The atomic bomb, Virilio contends, was instrumental in making permanent the order of total war in the period after World War II; the nuclear stakes have not lessened following the official conclusion of the Cold War. Moreover, a state of perpetual warfare became even more evident through the alternate frame of an American war on terror (16–17, 24), as well as various forms of cyberwarfare. See also Retort Collective [Iain A. Boal, T. J. Clark, Joseph Matthews, and Michael Watts], *Afflicted Powers* (London: Verso, 2005). The Retort Collective dates permanent war in the American context to an even earlier moment at the end of the War of 1812, which gave the United States lasting power over its territory against Britain and resulted in expansion to the south and the west (80).

55. Hardt and Negri, *Multitude*, xi, 3–4.

56. Giovanni Arrighi, *Adam Smith in Beijing: Lineages of the Twenty-First Century* (London: Verso, 2007). Arrighi argues that overaccumulation of capital and the mounting revolt against the West led to a US hegemonic crisis in the 1960s and 1970s (8). This "signal crisis" of hegemony eventually resulted in a "terminal crisis" that was marked by the overextension of the war in Iraq as well as various domestic complications from Hurricane Katrina to the 2008 economic crisis.

57. Virilio and Lotringer, *Pure War*, 10.

58. It is worth noting that this scene is directly preceded by yet another accident. Prior to Barnes's arrival, a Bedouin goatherd who is crossing the road stalls Nasir's caravan for the first time. During this unexpected break, Bryan Woodman gets out of Nasir's car and allows the prince's family to take his place. This small kindness saves his life.

59. I find instructive, here, Brian Massumi's sense of "images as the conveyors of forces of emergence, as vehicles for existential potentialization and transfer" (*Parables for the Virtual: Movement, Affect, Sensation* [Durham: Duke University Press, 2002], 43). Regarding the perceptual excess of affect, Massumi also notes, "The vast majority of the world's sensations are certainly nonconscious. . . . Whereas the feeling of the relation may be 'too small' to enter perception (it is *infraempirical*), the relation it registers, for its part, is 'too large' to fit into a perception since it envelops a multiplicity of potential variations (it is *superempirical*)" (16).

60. This bombing sequence is suggestive of a videogame play session, with the

CIA agent holding a joystick in hand as he guides the missile to its target across a screen. A deleted scene from the film reinforces this point by showing Barnes's son playing the Atari shooter videogame *Asteroids* in a restaurant while Bob and his wife have a conversation. Arguably, *Syriana* presents the videogame as a rival medium that fails, from the film's perspective, to achieve the perceptual subtlety of cinema in rendering its contemporary landscape and its network of actors.

61. This scene emphasizes the CIA's technophilia, engaging in a critique that is also central to Robert Baer's book on which the film was loosely based. There, Baer notes, "Like the rest of Washington, the CIA had fallen in love with technology. The theory was that satellites, the Internet, electronic intercepts, even academic publications would tell us all we needed to know about what went on beyond our borders" (*See No Evil*, xvii).

62. Thomas P. M. Barnett, *The Pentagon's New Map: War and Peace in the Twenty-First Century* (New York: Putnam, 2004), 298.

63. For an extended version of this critique of precision targeting, see Caren Kaplan, "Precision Targets: GPS and the Militarization of U.S. Consumer Identity," *American Quarterly* 58, no. 3 (2006): 693–714.

64. Caren Kaplan, "'Everything Is Connected': Aerial Perspectives, the 'Revolution in Military Affairs,' and Digital Culture," in *Electronic Techtonics: Thinking at the Interface*, Proceedings of the First International HASTAC Conference (online, Lulu Press, 2008), 148.

65. We might read the suicide bomber, here, as belonging to the longer history of "displaced persons" and "stateless" asylum seekers who are central to Hannah Arendt's reading of the political situation around World War II. See Hannah Arendt, *The Origins of Totalitarianism* (New York: Harvest Books, 1973), 279.

66. I am drawing here on the language of affect theory, which offers a way of capturing the interpersonal relations that unfold across networks. See especially Gregg and Seigworth, *The Affect Theory Reader*. Seigworth and Gregg express affect as a potential, "a body's *capacity* to affect and to be affected. How does a body, marked in its duration by these various encounters with mixed forces, come to shift its affections (its being-affected) into action (capacity to affect)?" (2).

67. David Graeber, *Debt: The First 5,000 Years* (Brooklyn, NY: Melville House, 2011), 365–66. As Graeber adds, "When Saddam Hussein made the bold move of singlehandedly switching from the dollar to the euro in 2000, followed by Iran in 2001, this was quickly followed by American bombing and military occupation. How much Hussein's decision to buck the dollar really weighed into the US decision to depose him is impossible to know, but no country in a position to make a similar switch can ignore the possibility. The result, among policymakers particularly in the global South, is widespread terror" (367).

68. Ashley Dawson, "Combat in Hell: Cities as the Achilles' Heel of U.S. Imperial Hegemony," *Social Text* 91 (2007), 175.

69. Retort Collective, *Afflicted Powers*. Retort problematizes the common liberal "Blood for Oil" political position by noting that "a narrow focus on oil qua commodity cannot grasp the larger capitalist complex of which oil is a constitutive part. It substitutes oil capital for a wider capitalist nerve center" (59).

70. Barabási, *Linked*, 224.

71. Judith Butler, *Precarious Life: The Powers of Mourning and Violence* (London: Verso, 2003), xv.

72. Dominic Fox, *Cold World: The Aesthetics of Dejection and the Politics of Militant Dysphoria* (Winchester, UK: O Books, 2009), 7, 8 (emphasis in original).

73. Graeber, *Debt*, 382.

74. Bordwell, *The Way Hollywood Tells It*, 98.

75. Brian Massumi, "Navigating Movements," in *Hope: New Philosophies for Change*, ed. Mary Zournazi (New York: Routledge, 2003), 235. Seigworth and Gregg also speak to the aesthetic politics of affect: "The political dimensions of affect generally proceed through or persist immediately alongside its aesthetics, an ethico-aesthetics of a body's capacity for becoming sensitive to the 'manner' of a world: finding (or not) the coordinating rhythms that precipitate newness or change while also holding close to the often shimmering (twinkling/fading, vibrant/dull) continuities that pass in the slim interval between 'how to affect' and 'how to be affected'" (*The Affect Theory Reader*, 14–15).

76. Massumi, *Parables for the Virtual*, 10.

77. Fred Moten, *In the Break: The Aesthetics of the Black Radical Tradition* (Minneapolis: University of Minnesota Press, 2003), 99, 38.

78. As Judith Butler contends, the losses suffered on 9/11, for example, show us that "an inevitable interdependency" must be acknowledged "as the basis for global political community" (*Precarious Life*, xii–xiii). Even so, it is worth remembering that the aftermath of the 2001 attacks revealed that, in practice, mourning does not always result in an acknowledgment of commonality or a desire for another world.

Chapter 3

1. For more on television as a precursor to cinematic multi-protagonist films, see María del Mar Azcona, *The Multi-Protagonist Film* (New York: Wiley-Blackwell, 2010), 27.

2. Jane Feuer, *Seeing through the Eighties: Television and Reaganism* (Durham: Duke University Press, 1995), 82. In British television, serials such as *Upstairs, Downstairs* (1971–75) also saw success in the 1970s (15). It was not until the 1980s, however, that prime-time serial melodrama became a commercially viable form.

3. Jason Mittell, "Narrative Complexity in Contemporary American Television," *Velvet Light Trap* 58, no. 1 (2006): 30–32.

4. Marshall McLuhan and Quentin Fiore, *War and Peace in the Global Village: An Inventory of Some of the Current Spastic Situations That Could Be Eliminated by More Feedforward* (New York: McGraw-Hill, 1968), 77.

5. The serial film series has admittedly become more common in the early twenty-first century with trilogies (e.g., the *Matrix, Lord of the Rings, Dark Knight,* and *Hunger Games* series) and extended serials (e.g., the eight-film *Harry Potter* series). However, even the longest film series can rarely match the running time of a television series of average length.

6. Jeffrey Sconce, "What If? Charting Television's New Textual Boundaries," in *Television after TV: Essays on a Medium in Transition,* ed. Lynn Spigel and Jan Olsson (Durham: Duke University Press, 2004), 95.

7. I mean neither to dismiss nor conflate the varied types of reception that come with all of these formats and their variants, which have had a considerable impact on television studies. The type of binging enabled by DVDs, TiVo, and online streaming produces a different temporal experience than the weekly engagement with a television series in a traditional broadcast format. Despite these differences, a strict adherence to format specificity may lead to the dismissal of commonalities that the experience of viewing a show might have in all of these formats. For more about binging practices enabled by contemporary formats, see Jostein Gripsrud, ed., *Relocating Television: Television in the Digital Context* (New York: Routledge, 2010).

8. Raymond Williams, "Drama in a Dramatised Society," in *Raymond Williams on Television: Selected Writings,* ed. Alan O'Connor (New York: Routledge, 1989), 4.

9. Sconce, "What If?" 94. Also, Jane Feuer observes that many critics who are not trained in television studies have been inattentive to both television's general textuality and its particular works. For example, in a critique of Linda Hutcheon's characterization of television as a form of commodified and realist complicity, she notes, "The most naive regular TV viewer is more qualified to judge this than the more sophisticated—but televisually naive— literary critic" (*Seeing through the Eighties* [Durham: Duke University Press, 1995], 9). In this chapter, I attempt to attend both to televisual form in a general sense and the particular attributes of *The Wire.*

10. For an exploration of kinship networks in the series, see Stephen Lucasi, "Networks of Affiliation: Familialism and Anticorporatism in Black and White," in *The Wire: Urban Decay and American Television,* ed. Tiffany Potter and C. W. Marshall (New York: Continuum, 2009). In the same volume, also see Ted Nanniceili, "It's All Connected: Televisual Narrative Complexity." Applying Mittell's sense of complex television to *The Wire,* this essay focuses on the high expectations that the series places on viewer attention

and recall. This analysis, however, is more focused on narrative complexity than the social network analysis and media ecologies that interest me here.

11. David Mills, "Soft Eyes," *The Wire*, season 4, episode 2, dir. Christine Moore, originally aired September 17, 2006.

12. Nigel Thrift, "Lifeworld Inc—and What to Do about It," *Environment and Planning D: Society & Space* 29, no. 1 (2011): 17.

13. Anmol Chaddha and William Julius Wilson, "'Way Down in the Hole': Systemic Urban Inequality and *The Wire*," *Critical Inquiry* 38, no. 1 (2011): 164.

14. Rosa Silverman, "Sociology degree students to study 'The Wire,'" *Independent*, May 16, 2010, www.independent.co.uk/news/education/education-news/sociology-degree-students-to-study-the-wire-1974850.html, accessed March 12, 2015. Sociology and cultural anthropology courses at Harvard University (William Julius Wilson), Duke University (Anne-Maria Makhulu), and the University of York (Roger Burrows) have also used *The Wire* as a central text. The series has also served as a key centerpiece in media studies courses at UC Berkeley (Linda Williams) and the University of Chicago (Patrick Jagoda).

15. The roots of this methodology can be traced back to Georg Simmel's work at the turn of the twentieth century as well as to research in psychology and anthropology beginning in the late 1930s. See Georg Simmel, *Sociology: Inquiries into the Construction of Social Forms* (1908; Brill Online, 2009). It was not until the late twentieth century, however, that the study of social networks was popularized by the psychologist Stanley Milgram's "small world" or "six degrees of separation" thesis ("The Small World Problem," *Psychology Today*, May 1967, 60–67).

16. David Knoke and Song Yang, *Social Network Analysis* (Los Angeles: Sage, 2008), 4.

17. The impulse to decenter a single protagonist or develop a multiprotagonist structure can be tracked back to the nineteenth-century realist novel. See, in particular, Alex Woloch, *The One vs. the Many* (Princeton: Princeton University Press, 2003). Also see Fredric Jameson's discussion of the "deterioration of protagonicity" in the novels of Pérez Galdós in *The Antinomies of Realism* (London: Verso, 2013), 96.

18. For an extended critique of broader structuralist methods (via structural linguistics), including the assumption of the categories of the "individual" and the "social," see Raymond Williams, *Marxism and Literature* (Oxford: Oxford University Press, 1977), 27–28. In their sociological analysis of *The Wire*, Chaddha and Wilson rely on an implicit distinction between individuals and structural social forces, advocating a shift from the former to the latter: "By examining the institutions that shape the characters, it convincingly demonstrates that the outcomes of the lives of the black poor are not the result of individual predispositions for violence, group traits, or cultural defi-

cits. Through a scrupulous exploration of the inner workings of drug-dealing gangs, the police, politicians, unions, and public schools, *The Wire* shows that individuals' decisions and behavior are often shaped by—and indeed limited by—social, political, and economic forces beyond their control" ("'Way Down in the Hole,'" 187). While individual attributions of the kind that Chaddha and Wilson describe are indeed problematic, they are neither opposed to nor wholly explained by amorphous social "forces" or structures.

19. Bruno Latour, *Reassembling the Social: An Introduction to Actor-Network-Theory* (Oxford: Oxford University Press, 2005), 1, 5. It is worth noting that both Latour and *The Wire*'s creator, David Simon, use the metaphor of an "ant" to describe their methods. Latour writes, "The acronym A.N.T. was perfectly fit for a blind, myopic, workaholic, trail-sniffing, and collective traveler. An ant writing for other ants, this fits my project very well!" (9). In a *Baltimore Sun* article ("The Metal Men," September 3, 1995) that directly prefigures his book *The Corner*, Simon describes men with metal carts who travel around Baltimore, stripping metal from buildings, carrying it off, and selling it for drug money: "Behold the ants. Step back a moment and see that there are dozens upon dozens of them—hundreds, in fact—spread across the city, rattling back and forth with their metal carts, each in the service of the same elemental economics." The article follows "the Metal Kings," "the scrap-yard owners," and "the people behind the scales" to outline a network that is not unlike Latour's approach to the history of science.

20. Latour, *Reassembling the Social*, 9, 155, 238.

21. Ibid., 57, 125.

22. Although ANT is a social scientific method, Latour frequently mentions works of literature and art, quoting from novelists such as Richard Powers at length. He praises "novels, plays, and films from classical tragedy to comics" because they "provide a vast playground to rehearse accounts of what makes us act." Commenting on the important insights that can be gained from literature, he contends that "the diversity of the worlds of fiction invented on paper allow[s] enquirers to gain as much pliability and range as those they have to study in the real world" (ibid., 55).

23. Ibid., 149.

24. I borrow the language of cinematic gaze versus televisual glance from Chris Chesher, "Neither Gaze nor Glance, but Glaze: Relating to Console Game Screens," *Scan: Journal of Media Arts Culture* 4, no. 2 (August 2007), http://scan.net.au/scan/journal/print.php?j_id=11&journal_id=19, accessed May 15, 2015.

25. Mills, "Soft Eyes."

26. Dennis Lehane, "Refugees," *The Wire*, season 4, episode 4, dir. Jim McKay, originally aired October 1, 2006.

27. The show's most consistent figure of this type of attentiveness is perhaps

Omar, who watches the Barksdale drug distribution system at the low-rises and, later, at all of its stash houses. Whereas the police see Barksdale's system as a tight operation, Omar's patient observation reveals its flaws and allows him to exploit those errors for profit. At times, this method makes Omar appear omniscient to the dealers he rips off.

28. Alberto Toscano and Jeff Kinkle, "Baltimore as World and Representation: Cognitive Mapping and Capitalism in *The Wire*," *Dossier* (April 2009), http://www.dossierjournal.com/read/theory/baltimore-as-world-and-representation-cognitive-mapping-and-capitalism-in-the-wire/, accessed March 8, 2015.

29. Fredric Jameson, *Postmodernism, or the Cultural Logic of Late Capitalism* (Durham: Duke University Press, 1991), 415.

30. David Simon, "Exclusive David Simon Online Q&A," August 16 2006, www .borderline-productions.com/TheWireHBO/exclusive-1.html. In this interview, Simon notes, "The other aspect that takes up a lot of discussion on the internet seems to be race. I'm not particularly interested in race as a point of discussion." He then argues that *The Wire* "speaks to sociopolitics, economics and issues of class more than race. Even when the racial aspect is referenced in the plotting, it is usually in a manner that mocks someone's over-obsession with it, or messes with someone's racial preconceptions."

31. David Simon, "The Cost," *The Wire*, season 1, episode 10, dir. Brad Anderson, originally aired August 11, 2002, and "Ebb Tide," *The Wire*, season 2, episode 1, dir. Ed Bianchi, originally aired June 1, 2003.

32. In 1993, David Foster Wallace described "metafiction" as a form of postmodern realism that is "deeply informed by the emergence of television," including its irony and self-consciousness. Building on Wallace's formulation, it is possible to think of the network realism that I am describing here as a form of early twenty-first-century post-postmodern realism that organizes itself around network form. See David Foster Wallace, "E Unibus Pluram: Television and U.S. Fiction," *Contemporary Fiction* 13, no. 2 (Summer 1993): 161.

33. Erich Auerbach, *Mimesis: The Representation of Reality in Western Literature* (Princeton: Princeton University Press, 1953), 554. The objection could be made that reality TV does not belong to even the broadest understanding of realism because it depends on substantial editing and gamelike rules that, at most, distantly simulate reality. Of course, every work of literature and art that sees itself as "realist" depends on various levels of constructedness.

34. Peter Brooks, *Realist Vision* (New Haven: Yale University Press, 2005), 1. In one sense, every era has its realism. Foregrounding this insight, Lukács argues that "realism is not one style among others, it is the basis of literature; all styles (even those seemingly most opposed to realism) originate in it or are significantly related to it" (György Lukács, *Realism in Our Time: Literature and the Class Struggle* [New York: Harper & Row, 1964], 48). Even mod-

ernism, which Lukács distinguishes sharply from realism, maintains for him a modicum of realism and an impulse toward the real.

35. Here, I am invoking a more capacious sense of realism than its usage as a periodizing concept. Though an interest in literary realism, for instance, can be shown to have emerged with the rise of the novel and ebbed with the advancement of modernism, we have seen many realisms since that time that have attached themselves to film, television, videogames, and indeed subsequent forms of the novel.

36. For more on the show's ethnographic roots, see Linda Williams, "Ethnographic Imaginary: The Genesis and Genius of *The Wire*," *Critical Inquiry* 38, no. 1 (2011): 208–26. For more on the show's music and focus on diegetic sound, see Adrienne Brown, "Constrained Frequencies: *The Wire* and the Limits of Listening," *Criticism* 52, nos. 3–4 (2010): 441–59. For more on the show's realism, see Margaret Talbot, "Stealing Life: The Crusader behind 'The Wire,'" *New Yorker*, October 22, 2007, http://www.newyorker.com /magazine/2007/10/22/stealing-life, accessed March 10, 2015. Talbot comments especially on the realism of the show's dialogue. Simon is also quoted as stressing the realism achieved by hiring nonprofessional Baltimore actors for key parts: "These are faces you don't see on television, the faces and voices of the real city."

37. Lauren Berlant, *Cruel Optimism* (Durham: Duke University Press, 2011), 6. The transformation of older genres in the present has much to do with economic and cultural changes but also, as I show later in the chapter, with changes in the affordances of new media. Changing television production methods and audiovisual conventions, for instance, alter how we think about such older categories as "drama" or "tragedy."

38. *The Wire* has various precursors in literary fiction. David Simon has himself reflected, "If *The Wire* resembles a novel for television . . . I will claim that it at least has the pretensions of a literary novel" (AOL Interview, 2007, http:// www.borderline-productions.com/TheWireHBO/exclusive-20.html, accessed March 12, 2015). A number of television critics have offered similar comparisons between the series and the Victorian novel. Nick Hornby, in an interview with Simon, also draws a parallel between *The Wire* and the novels of Charles Dickens (Interview with David Simon, *Believer*, August 2007, http://www.believermag.com/issues/200708/?read=interview_simon, accessed March 10, 2015). For more on the multiplot novel, see Peter K. Garrett, *The Victorian Multiplot Novel: Studies in Dialogical Form* (New Haven: Yale University Press, 1980). Some of the most prominent Victorian multiplot novels include William Thackeray's *Vanity Fair* (1847–48), Charles Dickens's *Bleak House* (1852–53), George Eliot's *Middlemarch* (1871–72), and Anthony Trollope's *The Way We Live Now* (1875). Multiple plots can be traced back to other sources, including the Elizabethan use of subplots, which stands in distinction to French neoclassicism. Such early modern sub-

plots, however, are read as threads belonging to the unity of a central plot (Garret, *The Victorian Multiplot Novel*, 3). In distinction to this narrative form, Victorian multiplot novels disperse their plots.

39. In a reading of Dickens's *Bleak House*, Caroline Levine suggests the mutually generative nature of narrative and network form in the Victorian multiplot novel. She argues that its interconnected structure paves the way for such twenty-first-century films as *Traffic*, *Syriana*, and *Babel* ("Narrative Networks: *Bleak House* and the Affordances of Form," *Novel: A Forum on Fiction* 42, no. 3 [2009]: 517). She expands this reading in *Forms: Whole, Rhythm, Hierarchy, Network* (Princeton: Princeton University Press, 2015).

40. Ed Burns, "The Pager," *The Wire*, season 1, episode 5, dir. Clark Johnson, originally aired June 30, 2002.

41. Sergei Eisenstein, *Film Form [and] The Film Sense: Two Complete and Unabridged Works* (New York: Meridian Books, 1957), 211. Griffith's *Intolerance* (1916), for example, represents an early attempt at a multiplot film that uses techniques such as montage to move across numerous histories and geographies. Another early example of a film that plays with multiple plots is Edwin S. Porter's *The Kleptomaniac* (1905) (242). Notably, Porter made *The Great Train Robbery* (1903), on which Griffith based his *The Lonedale Operator* (1911). According to Eisenstein, the most important innovation that Griffith drew from Dickens was "a montage progression of parallel scenes, intercut into each other" (217).

42. Ed Burns, "The Dickensian Aspect," *The Wire*, season 5, episode 6, dir. Seith Mann, originally aired February 10, 2008. The debate between James C. Whiting and Gus Haynes is also marked visually along racial lines. Whiting, as his name suggests, is a white man with a prestigious route through the journalistic establishment. Haynes, on the other hand, is played by the mixed-race actor Clark Johnson.

43. My position here differs from that of critics who maintain that *The Wire* is simply another Dickensian melodrama. For that argument, see, for instance, Amanda Ann Klein, "'The Dickensian Aspect': Melodrama, Viewer Engagement, and the Socially Conscious Text" in Potter and Marshall, *The Wire: Urban Decay and American Television*.

44. Rick Altman, "Dickens, Griffith, and Film Theory Today," in *Classical Hollywood Narrative: The Paradigm Wars*, ed. Jane Gaines (Durham: Duke University Press, 1992), 14. Altman contextualizes cinematic melodrama in relationship to the earlier melodramas of the nineteenth-century Victorian novel and early twentieth-century theater.

45. Eisenstein, *Film Form [and] The Film Sense*, 233.

46. For a classic study of the novel form and its character types, see Ian P. Watt, *The Rise of the Novel: Studies in Defoe, Richardson, and Fielding* (Berkeley and Los Angeles: University of California Press, 1957).

47. Fredric Jameson makes this point well in his essay "Realism and Utopia in

The Wire," *Criticism* 52, nos. 3–4 (2010): 359–72. As he suggests, the show balances between modernist originality and mass culture formula (366). I return, in the conclusion, to the remainders of romanticism and modernism in *The Wire.* Nevertheless, the series does not dwell extensively in the type of interiority that characterizes many modernist novels. The show instead privileges social relationships, dynamic institutions, and emergent networks through associations among actors.

48. Lynne Joyrich, *Re-viewing Reception: Television, Gender, and Postmodern Culture* (Bloomington: Indiana University Press, 1996), 65. Also, for a discussion of the role of family in televisual melodrama, see 99–103.

49. Hornby, "Interview with David Simon."

50. Emily Nussbaum, "Tune in Next Week: The Curious Staying Power of the Cliffhanger," *New Yorker,* July 30, 2012, http://www.newyorker.com /magazine/2012/07/30/tune-in-next-week, accessed March 12, 2015. Cliffhangers have been a major feature not only of contemporary television but also of earlier serial forms, including radio detective dramas, superhero comic books, and early films such as *The Adventures of Kathlyn* (1913).

51. *The Wire* complicates the desires of both the broadcast and networked television eras. See, for instance, Charlotte Brunsdon, "Bingeing on Box-Sets: The National and the Sigital in Television Crime Drama," in Gripsrud, *Relocating Television.* Brunsdon observes that with *The Wire,* "it can be both unbearable to watch and unbearable to stop watching" (69). By contrast, conventional crime fiction, including in its novelistic form, is made for rapid consumption, a race to the "whodunit" revelation. Unlike some popular fiction serials, Simon's series is intended to be watched numerous times and lived with over an extended period, an active experience that was attested to by extensive online conversations and debates about the show's complex narratives. This complexity made DVDs an ideal viewing format: instead of binging, viewers could register and review the show's complex character webs, patient thematic development, and multinodal plot.

52. For more on *The Wire* and naturalism, see Jason Mittell, "All in the Game: *The Wire,* Serial Storytelling, and Procedural Logic," in *Third Person: Authoring and Exploring Vast Narratives,* ed. Pat Harrigan and Noah Wardrip-Fruin (Cambridge: MIT Press, 2009). Also see Brown, "Constrained Frequencies." In line with a great deal of American fiction, the show takes a somber and even tragic naturalist attitude in its depiction of the class and race relations in a contemporary American city.

53. Latour, *Reassembling the Social,* 72.

54. These taglines come from season 1 and season 5 of *The Wire,* respectively. On objects and literary realism, see especially Bill Brown, *A Sense of Things: The Object Matter of American Literature* (Chicago: University of Chicago Press, 2003).

55. Latour discusses techniques to foreground objects, to "make them *talk*," in *Reassembling the Social*, 79–82. Although this account suggests methods intended primarily for social science, *The Wire* employs many of these approaches.

56. The network surrounding the ring builds on a long novelistic tradition. The circulation of objects, as a way of tracking social associations, is central to popular eighteenth-century texts such as *The Adventures of a Bank-Note* (1770) and *The Adventures of a Cork-screw, in Which the Vices, Follies and Manners of the Present Age Are Exhibited* (1775). For more on this novelistic subgenre, see Deidre Lynch, *The Economy of Character: Novels, Market Culture, and the Business of Inner Meaning* (Chicago: University of Chicago Press, 1998). A number of nineteenth-century novels, including Anthony Trollope's *The Way We Live Now* (1875), also employ multiplot techniques and careful attention to objects, in order to represent industrialism's international dispersal. The literary descriptions of objects in these texts are already highly visual in nature. *The Wire* continues this visual impulse, now in a postindustrial setting that is even more informed by network metaphors. We see a parallel interest in the path that objects travel in cinema, as David Bordwell observes (*Poetics of Cinema* [New York: Routledge, 2008], 202). Films that track objects across an ensemble of characters include *Adventures of a Ten Mark Note* (*Die Abenteuer eines Zehnmarkscheines*, 1926), *L'argent* (*Money*, 1983), *Twenty Bucks* (1993), and *The Red Violin* (1998).

57. For the most part, technologies augment or complicate investigations. One unequivocally negative representation of technological tools, however, appears in the third season when police majors are required to use PowerPoint presentations during COMSTAT meetings to update the commissioner and deputy commissioner about criminal activities in their districts. This software seductively displays falsified statistics that fail to depict the dynamic systems of crime in Baltimore.

58. David Simon, "The Buys," *The Wire*, season 1, episode 3, dir. Peter Medak, originally aired June 16, 2002.

59. David Simon, "Back Burners," *The Wire*, season 3, episode 7, dir. Tim van Patten, originally aired November 7, 2004.

60. Ed Burns, "The Pager," *The Wire*, season 1, episode 5, dir. Clark Johnson, originally aired June 30, 2002; and David Simon, "The Wire," *The Wire*, season 1, episode 6, dir. Ed Bianchi, originally aired July 7, 2002. Similar wire-tracking shots recur later in the series. For example, in the fifth season, a winding shot follows an illegally established pink police wire to a corresponding modem; see David Mills, "React Quotes," *The Wire*, season 5, episode 5, dir. Agnieszka Holland, originally aired February 3, 2008. In this context, the twisting wire invokes the tangled lie that McNulty and Freamon create in order to deceive the police department into offering them the personnel and surveillance gear they need to put down a major case.

61. David Simon, "Lessons," *The Wire*, season 1, episode 8, dir. Gloria Muzio, originally aired July 28, 2002. Lester Freamon similarly explains, "You follow drugs, you get drug addicts and drug dealers. But you start to follow the money, and you don't know where the fuck it's going to take you" (David H. Melnick and Shamit Choksey, "Game Day," *The Wire*, season 1, episode 9, dir. Milčo Mančevski, originally aired August 4, 2002).

62. Freamon, like Daniels, uses financial imprints and monetary traces to discover a web of corruption that seems to extend everywhere. Working from one of Barksdale's confirmed Baltimore properties, Freamon (whose curiosity resembles that of the show's ideal viewer) pursues a paper trail that leads him to a network of limited liability companies and other fronts that are owned legally by the drug kingpin. However, the investigation is curbed shortly after it begins. As soon as State Senator Davis discovers that the Major Crimes Unit is jeopardizing his own interests, he calls a meeting with Lieutenant Daniels and Major Burrell. After trying to reason politely with an obstinate Daniels, who insists on continuing the investigation, Davis snaps, responding with a pragmatic justification of his dubious dealings: "Fool, what do you think? That we know anything about who gives money? That we give a damn about who they are or what they want? We have no way of running down them or their stories. We don't care. We just cash the damn checks, count the votes, and move on." For more, see George Pelecanos, "Cleaning Up," *The Wire*, season 1, episode 12, dir. Clement Virgo, originally aired September 1, 2002.

63. Brooks, *Realist Vision*, 17, 15.

64. Leigh Claire La Berge, "Capitalist Realism and Serial Form: The Fifth Season of *The Wire*," *Criticism* 52, nos. 3–4 (2010): 548.

65. Simon, "Exclusive David Simon Online Q&A."

66. Accomplished realist works, it can be said, achieve their realism by dwelling similarly in complexity and controversy. In his classic essay "Reality in America," Lionel Trilling notes, "A culture is not a flow, nor even a confluence; the form of its existence is struggle or at least debate—it is nothing if not a dialectic. And in any culture there are likely to be certain artists who contain a large part of the dialectic within themselves, their meaning and power lying in their contradictions; they contain within themselves, it may be said, the very essence of the culture, and the sign of this is that they do not submit to serve the ends of any one ideological group or tendency" (*The Liberal Imagination: Essays on Literature and Society* [London: Secker and Warburg, 1951], 9).

67. Jameson, "Realism and Utopia in *The Wire*," 366–67.

68. Claude Lévi-Strauss, *Structural Anthropology*, vol. 1, trans. Claire Jacobson and Brooke G. Schoepf (New York: Basic Books, 1963).

69. David Graeber, *Debt: The First 5,000 Years* (Brooklyn, NY: Melville House, 2011), 94.

70. Ibid., 99.

71. David Simon, "The Cost," *The Wire*, season 1, episode 10, dir. Brad Anderson, originally aired August 11, 2002.

72. Latour, *Reassembling the Social*, 204. As Latour puts it elsewhere, "Whenever anyone speaks of a 'system,' a 'global feature,' a 'structure,' a 'society,' an 'empire,' a 'world economy,' an 'organization,' the first ANT reflex should be to ask: 'In which building? In which bureau? Through which corridor is it accessible? Which colleagues has it been read to? How has it been compiled?'" (183). Latour adds, "Capitalism is certainly the dominant mode of production but no one imagines that there is some *homunculus* CEO in command, despite the fact that many events look like they obey some implacable strategy" (167). The benefit of this approach is that, unlike the totalizing or macrotheoretical view, it makes alternatives to capitalism thinkable. For a similar critique of categories such as "capitalism" and the "market," see Karen Z. Ho, *Liquidated: An Ethnography of Wall Street* (Durham: Duke University Press, 2009).

73. Latour, *Reassembling the Social*, 166. Latour explains that local interactions are never isotopic, synchronic, synoptic, homogenous, or isobaric (200–202). They overflow with histories and things that are not proper to them. In its choice to avoid flashbacks, for example, *The Wire* admittedly provides minimal historical context about how the urban conditions that it depicts came into existence, only revealing key precursors through historical sedimentations in the present.

74. Hornby, "Interview with David Simon."

75. Margaret Talbot, for instance, comments on the show's minimal camera work in her essay about the series' realism: "'The Wire' did not rely on the jumpy handheld-camera shots and the blurry 'swish pans' that a lot of network cop shows had adopted. The camera remained locked, for minutes at a time, on people talking." ("Stealing Life"). Erlend Lavik also links the minimalism of *The Wire*—a style that is "unusually basic and unselfconscious in this day and age"—to its realism ("Forward to the Past: The Strange Case of *The Wire*," in Gripsrud, *Relocating Television*, 79). However, he later notes that *The Wire* is a stylized and "carefully structured piece of fiction" (81). Indeed, style and diegesis (including narration) are as important to *The Wire*'s realism as any straightforward mimesis.

76. John Thornton Caldwell, *Televisuality: Style, Crisis, and Authority in American Television* (New Brunswick: Rutgers University Press, 1995), 4–5.

77. Regarding minimal transitions, the show's coexecutive producer Joe Chappelle notes, "We never even fade to black between scenes. . . . We fade up at the beginning of the show and we fade to black at the end. There's no dissolves, just cuts. Very straightforward and simple. That's a stylistic choice. Keep it lean" (Nick Griffin, "Inside HBO's *The Wire*," *Creative Cow Magazine*,

https://library.creativecow.net/articles/griffin_nick/hbo_the_wire.php, accessed March 12, 2015). While the show includes mostly simple cuts, Chappelle's assessment is not absolutely correct: there are occasional midepisode fades, as when the volume lines from a live drug feed fade in a cut to the next scene in David Simon, "The Target," *The Wire*, season 1, episode 1, dir. Clark Johnson, originally aired June 2, 2002.

78. Average shot lengths (ASL) and median shot lengths (MSL) have been captured using Cinemetrics software (http://cinemetrics.lv/). For example, "The Target" (season 1, episode 1) has an ASL of 4.2 seconds and an MSL of 3.1 seconds. A later episode, "Margin of Error" (season 4, episode 6) has an ASL of 4.3 seconds and an MSL of 3 seconds. By comparison, *Syriana*, a network film, has an ASL of 5.4 seconds and an MSL of 4.2 seconds. I am grateful to my research assistant, Eran Flicker, for recording this data.

79. Raymond Williams, "Drama in a Dramatised Society," 5–6.

80. Raymond Williams, *Television: Technology and Cultural Form* (New York: Schocken Books, 1975), 86–96.

81. Jane Feuer, "The Concept of Live Television: Ontology as Ideology," in *Regarding Television*, ed. E. Ann Kaplan (Frederick, MD: University Publications of America and American Film Institute, 1983), 15.

82. Caroline Levine suggests that the extended length of the most successful Victorian multiplot novels is what allows them to eschew narrative economy in favor of intricate connections among major and minor characters. Something similar takes place on television shows such as *The Wire*. Contrasting a Victorian multiplot with a feature film, Levine writes, "But the sheer length of *Bleak House* allows the Victorian novel to do two things that the feature film cannot. First, the filmic narratives tend to rely on what theorists call chain networks, where one event prompts another in a sequence of effects — more like dominoes than like the Internet" ("Narrative Networks," 520). Moreover, "the films typically rely on a single principle of interconnection, like the drug trade or the oil industry, to undergird their plots, whereas Dickens layers on multiple principles of interconnection, linking the same individuals and families over and over again through different channels" (521). A similar type of layering in *The Wire* allows for characters from previous seasons to return for brief moments in subsequent seasons, creating a kind of cumulative narrative ecology that produces a world and not merely a story.

83. John Kraniauskas, "Elasticity of Demand: Reflections on *The Wire*," *Radical Philosophy* 154 (March/April 2009): 25–34.

84. Mittell, "All in the Game."

85. As I noted earlier, a great deal of scholarship about *The Wire* seeks to classify it under the rubric of a single genre or form. Diverging from this approach, I am emphasizing its connection to all of these forms as central to its aesthetic and its serial reflection on form itself. For a discussion of social networks

in *The Wire*, see Patrick Jagoda, "Wired," *Critical Inquiry* 38 no. 1 (Autumn 2012): 189–99. The relationship of the series to the novel form, including Victorian and mystery novels, comes up repeatedly in Simon's own commentaries and in the majority of writing on *The Wire*, including Laura Miller and Rebecca Trasiter, "The Best TV Show of All Time," *Salon*, September 15 2007, http://www.salon.com/2007/09/15/best_show/, accessed March 12, 2015. For reflections on tragedy and *The Wire*, see Chris Love, "Greek Gods in Baltimore: Greek Tragedy and the Wire," *Criticism* 52, nos. 3–4 (2010): 487–507. For an analysis of *The Wire*'s televisual influences and the ways it borrows from the videogame, see Mittell, "All in the Game." For a discussion of the show's relation to a police procedural, see Alasdair McMillan, "Heroism, Institutions, and the Police Procedural," and Ryan Brooks, "The Narrative Production of Real Police," in Potter and Marshall, *The Wire: Urban Decay and American Television*. For an analysis of *The Wire*'s relation to and complication of ethnography, see Linda Williams "Ethnographic Imaginary." For the link to urban fiction, see Hornby, "Interview with David Simon," in which he mentions the influence of the urban crime writers George Pelecanos and Richard Price on the series. I do not know of any essay that confronts the influence of Gothic horror on the series, but for the episode that most clearly demonstrates the connection, see Ed Burns, "Alliances," *The Wire*, season 4, episode 5, dir. David Platt, originally aired October 8, 2006. In this episode, the schoolchildren tell each other ghost stories, mistake a drug addict for a zombie, and liken Chris Partlow's ability to kill without being caught to voodoo magic.

86. Jameson, "Realism and Utopia in *The Wire*," 365.

87. Williams, *Marxism and Literature*, 132. Williams develops the concept of "structures of feeling" on 128–35.

88. Ibid., 134.

89. For a careful political reading of *The Wire* that attends to both of these failures, and the relationship between them, see Kenneth Warren, "Sociology and the Wire," *Critical Inquiry* 38, no. 1 (2011): 200–207.

90. Jameson, "Realism and Utopia in *The Wire*," 372. Jameson ends his essay on *The Wire* by observing that the show's realism closes down its utopian experiments. This foreclosure of utopia pushes against La Berge's observation that *The Wire* engages in "the regressive fantasy that lurks throughout every season of *The Wire*: namely, the fantasy of a better capitalism, of a return to the Keynesian days of yore when community policing reigned, newspapers were robust sources of information, unions were powerful, schools taught children to read, and the CIA had not yet facilitated the importation of heroin into the United States from Southeast Asia" ("Capitalist Realism and Serial Form," 563). Though the downfall of these policies contributes to the show's tragic environment, the past is rarely romanticized, and the

series does not leave possible even a dream of any kind of return to a previous order. The show is insistent on its depicted failures. Arguably, one limitation of *The Wire*'s emphasis on failure is a political imaginary that omits the possibility of events such as the 2015 uprising in Baltimore in which protests broke out after the death of Freddie Gray following a brutal police beating. These successfully organized events took place through bottom-up activism that included a majority of black Baltimore residents, not through top-down restructuring by politicians or reformers.

91. T. J. Clark, "For a Left with No Future," *New Left Review* 74 (March–April 2012): 54, 57–58.

92. Jameson speaks to the political value of a narrative of defeat. He argues, "Successful spatial representation today need not be some uplifting socialist-realist drama of revolutionary triumph but may be equally inscribed in a narrative of defeat, which sometimes, even more effectively, causes the whole architectonic of postmodern global space to rise up in ghostly profile behind itself, as some ultimate dialectical barrier or invisible limit" (*Postmodernism*, 415).

93. *The Wire* is more properly "tragic" than, as it is sometimes dubbed, a "tragedy." It is true that Simon himself notes, "*The Wire* is a Greek tragedy in which the postmodern institutions are the Olympian forces" (Hornby, "Interview with David Simon"). There are, however, too many alternate formal influences for the series to remain a tragedy in the traditional dramatic sense. Instead, following Rita Felski, I use the word "tragic" to elicit a mode rather than a genre (*Rethinking Tragedy* [Baltimore: Johns Hopkins University Press, 2008], 14).

94. Admittedly, tragic art is founded on a belief in the regeneration of life through cyclical renewal. Rejuvenating as this cyclicality might be, however, it does not allow the individual deliverance or accomplishment. The tragic privileges immanent networks over individual heroes.

95. Eighth grader Namond Brice, who is relegated to an experimental classroom for problematic "corner kids," points out the hypocritical complicity of those in power (here, primarily white Americans) with the ills that are more often blamed on the impoverished underclasses (here, primarily black Americans): "Yeah, like y'all say," he announces. "Don't lie, don't bunk, don't cheat, don't steal, or whatever. But what about y'all, huh? What, the government? What's it—Enron? Steroids, yeah. Liquor business? Booze is the real killer out there. And cigarettes—oh, shit" (Richard Price, "Corner Boys," *The Wire*, season 4, episode 8, dir. Agnieszka Holland, originally aired November 5, 2006).

96. McLuhan, *Understanding Media*, 423, 442. For a related discussion of television's lack of visual clarity that requires viewer participation, including in the social unit of the family, see André Bazin, "A Contribution to an *Erotologie*

of Television," in *André Bazin's New Media*, ed. Dudley Andrew (Oakland: University of California Press, 2014).

97. Though I do not discuss it here, it is also important that many contemporary television shows encourage online responses through both official and unofficial forums, reviews, and blog analyses. Given its complexity, *The Wire* yielded an extensive online discussion community.

98. Latour, *Reassembling the Social*, 256.

Part 2

1. Paul Sermon, "Telematic Dreaming—Statement," June 1992, http://www.paulsermon.org/dream/, accessed May 15, 2015.

2. Nicolas Bourriaud, *Relational Aesthetics* (Dijon: Les Presses du Réel, 2002), 8.

3. Johanna Drucker, "Interactive, Algorithmic, Networked: Aesthetics of New Media Art," in *At a Distance: Precursors to Art and Activism on the Internet*, ed. Annmarie Chandler and Norie Neumark (Cambridge: MIT Press, 2006), 38.

4. For more on "netprov," see Mark C. Marino and Rob Wittig, eds., *hyperrhiz: new media cultures*, "Special Issue: Netprov," Spring 2015, http://www.hyperrhiz.io/hyperrhiz11/, accessed October 20, 2015.

5. Marshall McLuhan, *Understanding Media: The Extensions of Man* (Berkeley, CA: Gingko Press, 2003), 19.

6. Matthew Kirschenbaum, "Hello, Worlds," *Chronicle of Higher Education* 55, no. 20 (2009). Ian Bogost similarly contends that videogames and virtual worlds engage in "procedural representation" by generating meaning "not through a re-creation of the world, but through selectively modeling appropriate elements of that world" (*Persuasive Games: The Expressive Power of Videogames* [Cambridge: MIT Press, 2007], 46).

7. Hannah Arendt, *Lectures on Kant's Political Philosophy* (Chicago: University of Chicago Press, 1992), 67, 27.

8. Christopher Castiglia and Russ Castronovo, "A 'Hive of Subtlety': Aesthetics and the End(s) of Cultural Studies," in "Aesthetics and the End(s) of Cultural Studies," ed. Christopher Castiglia and Russ Castronovo, special issue, *American Literature* 76, no. 3 (September 2004): 427.

Chapter 4

1. I take the phrase "print cultures" from Andrew Piper and Jonathan Sachs, "Introduction: Romantic Cultures of Print—from Miscellaneity to Dialectic," in "Romantic Cultures of Print," ed. Andrew Piper and Jonathan Sachs, special issue, *Romanticism and Victorianism on the Net* 57–58 (February–

May 2010), doi:10.7202/1006508ar. Though they use this phrase to describe the multiplicity of print during the Romantic period as such, it more broadly points out the limitations of "a conception of print in which print is too often seen as a single and singular outcome, effect, or action" and suggests "a more process-based understanding of an activity that includes diverse networks of advisors, collaborators, printers, publishers, editors, booksellers, and multiple communities of readers (as well as listeners)—networks that merge and separate as they shift and change over time" (4, digital). Piper and Sachs thus already use the metaphor of the network to emphasize the complex, multiactor process of publication, dissemination, and reception. I turn to a parallel network (albeit one that depends on digital protocols and cultures) in my discussion of videogames in this chapter.

2. *Spacewar!* is widely considered to be the first computer game that introduced novel aesthetics and mechanics. Historians also note earlier computer games such as William Higinbotham's *Tennis for Two* (1958).

3. Nick Montfort and Ian Bogost, for instance, discuss various early videogame adaptations from Mike Mayfield's text-only game *Star Trek* (1971) through Atari VCS games such as *E.T. the Extra-Terrestrial* (1982) and *Star Wars: The Empire Strikes Back* (1982). For more, see *Racing the Beam: The Atari Video Computer System* (Cambridge: MIT Press, 2009), 119–35.

4. One of the first systematic explorations of these digital aesthetics was Janet Murray's crucial *Hamlet on the Holodeck: The Future of Narrative in Cyberspace* (Cambridge: MIT Press, 1998).

5. Sherry Turkle, *Alone Together: Why We Expect More from Technology and Less from Each Other* (New York: Basic Books, 2011), xi.

6. Some of these games have also included multiplayer modes, allowing players to play with or against each other, albeit in front of a shared screen. However, from the 1970s through the 1990s, the single-player mode dominated, with multiplayer options often considered to be secondary features to extend the game's replay value. It is worth noting, however, that the earlier *Spacewar!* (1962) was designed as a two-player game because "there wasn't enough computing power available to do a decent opponent" (Steve Russell quoted in Steven L. Kent, *The Ultimate History of Video Games* [New York: Random House International, 2002], 19).

7. For more on this point, see Tom Bissell, "Promises, Promises: On Arkane Studios' *Dishonored*: A Look at the Uncertain Fate of Single-Player Narrative Video Games," *Grantland*, October 16, 2012, http://www.grantland.com /story/_/id/8507895/looking-uncertain-fate-single-player-narrative-video -games-arkane-studios-dishonored, accessed March 8, 2015.

8. For more on early MUDs, see Allucquère Rosanne Stone, *The War of Desire and Technology at the Close of the Mechanical Age* (Cambridge: MIT Press, 1995). Also see Mark J. P. Wolf and Bernard Perron, introduction to *The*

Video Game Theory Reader (New York: Routledge, 2003), 1–24. For an overview of virtual worlds, see Gregory Lastowka and Dan Hunter, "The Laws of the Virtual Worlds," *California Law Review* 92, no. 1 (January 2004): 3–73.

9. Though the sixth console generation saw the popularization of online play, there were earlier unsuccessful attempts in the fourth console generation that already signaled this possibility. An early experiment in interconnected consoles was Nintendo's Satellaview, released in 1995 for the Super Famicom system in Japan, which relied on a broadcasting model and made streaming data available. In the United States, the Sega Channel (initiated in 1994 and abandoned by 1998) also represented an experiment in online content delivery. Neither of these innovations, however, experimented with networked gameplay.

10. McKenzie Wark, *Gamer Theory* (Cambridge: Harvard University Press, 2007), 25.

11. Caroline Pelletier, "Games and Learning: What's the Connection?" *International Journal of Learning and Media* 1 no.1 (2009): 89.

12. Jason Rohrer, "The Game Design of Art," *Escapist*, June 24, 2008. Rohrer argues that artful games focus on medium-specific qualities, especially game mechanics, as a means of expression. In my own close analysis of two art-games, I discuss mechanics but also networked qualities.

13. Kathleen Stewart, *Ordinary Affects* (Durham: Duke University Press, 2007), 86, 21.

14. One of the most powerful features of games is their ability to animate concepts, procedures, and processes that make up systems. Chris Crawford, in an early analysis of games, discusses them in terms of formal systems (*The Art of Computer Game Design* [Berkeley, CA: Osborne/McGraw-Hill, 1984]). Additionally, as critics such as Ian Bogost have observed, games are capable of modeling complex systems and allowing players to interact with and analyze these dynamic simulations (*Persuasive Games: The Expressive Power of Videogames* [Cambridge: MIT Press, 2007], vii, 9) As the game designers Katie Salen and Eric Zimmerman explain, both analog and digital games can be treated as systems at several levels, including rules ("the organization of the designed system"), play ("the human experience of that system"), and culture ("the larger contexts engaged with and inhabited by the system"). For more, see Katie Salen and Eric Zimmerman, *Rules of Play: Game Design Fundamentals* (Cambridge: MIT Press, 2004), 6.

15. Anna Anthropy, *Rise of the Videogame Zinesters: How Freaks, Normals, Amateurs, Artists, Dreamers, Dropouts, Queers, Housewives, and People like You Are Taking Back an Art Form* (New York: Seven Stories Press, 2012), 49.

16. Any simulation game, of course, makes a host of particular political and procedural assumptions. As Noah Wardrip-Fruin observes in his reading of *SimCity*, this simulation models "some relationships (e.g., crime and police

presence) and not others (e.g., crime-related death and weapons availability)" (*Expressive Processing* [Cambridge: MIT Press, 2009], 310).

17. In addition to these single-player commercial examples, the hacker simulation genre also includes a number of free games available online such as *Hacker Skills* (http://hackerskills.com/) and *Hack: The Game* (http://www .hackerforever.com/hackthegame/?htg=main). Most hacker simulators are single-player enterprises, though some later designs, such as *Hacknet* (2012), *Codelink v2* (2012), and *Hack Wars* (2012), have started to experiment with online multiplayer modes. These games continue to emerge, for instance with the puzzle game *Quadrilateral Cowboy* (2015), which includes elements of simulation.

18. "The Genesis of Uplink," http://www.introversion.co.uk/uplink/genesis /genesispart1.html, accessed March 8, 2015. As *Uplink*'s creator, Chris Delay, explains, real-life hacking can often be tedious, especially in terms of its pace: "The first thing you'll probably do is a port scan on a device. You scan every single open port. It'll probably have a hundred open ports; you need to look at every one. It could be hours of work to get there and it might not even work" (quoted in Owen Hill, "The Making of Uplink," *PC Gamer UK*, December 15, 2012, http://www.pcgamer.com/2012/12/15/the-making-of -uplink/, accessed March 12, 2015).

19. Fredric Jameson, *The Geopolitical Aesthetic: Cinema and Space in the World System* (Bloomington: Indiana University Press, 1992), 10.

20. Gilles Deleuze, "Control and Becoming," in *Negotiations, 1972–1990* (New York: Columbia University Press, 1995), 174. One of the most compelling analyses of control in the context of computing and networking systems is Alexander Galloway's *Protocol: How Control Exists after Decentralization* (Cambridge: MIT Press, 2006).

21. Gilles Deleuze, "Postscript on Control Societies," in *Negotiations*, 179, 180.

22. Deleuze, "Control and Becoming," 175.

23. Patrick Jagoda, "Gamification and Other Forms of Play," *boundary 2* 40, no. 2 (Summer 2013): 113–44.

24. The spatialization of time in *Uplink* shares many elements with contemporary engagements with control societies, such as the television show *24*, which Alexander Galloway discusses in *The Interface Effect* (Cambridge, UK: Polity, 2012). The gameplay aspects of *Uplink*, however, produce a different range of affective reactions in the player compared to the television viewer.

25. N. Katherine Hayles, *Electronic Literature: New Horizons for the Literary* (Notre Dame: University of Notre Dame, 2008), 95–96.

26. Deleuze, "Postscript on Control Societies," 179.

27. Kent, *The Ultimate History of Video Games*, 21 and 38.

28. For more on these movements, see Anthropy, *Rise of the Videogame Zinesters*, and Emma Westecott, "Independent Game Development as Craft," *Load-*

ing . . . 7, no. 11 (2013): 78–91. Also on the historical expansion of artgames, see Felan Parker, "An Art World for Artgames," *Loading . . .* 7, no. 11 (2013): 41. I explore the aesthetics of these games in greater detail in Patrick Jagoda, "Fabulously Procedural: *Braid*, Historical Processing, and the Videogame Sensorium," *American Literature*, 85 no. 4 (December 2013): 745–79.

29. Uncertainty is an important aspect of gameplay, as Greg Costikyan argues in *Uncertainty in Games* (Cambridge: MIT Press, 2013). Games generate numerous forms of uncertainty, such as performative uncertainty (linked to mechanical performance) and solver's uncertainty (linked to one-time puzzles). *Between* takes up player uncertainty, making opaque the effects that players have on each other. Thus it is not only the decisions of the other player that are uncertain in advance but also the fundamental rules and parameters of the other player's actions.

30. Ian Bogost, "Persuasive Games: Disjunctive Play," *Gamasutra*, November 8, 2008, http://www.gamasutra.com/view/feature/132247/persuasive_games _disjunctive_play.php, accessed March 8, 2015. Another networked game genre that operates differently from *Between* is what we might call an asynchronous networked game. *We the Giants*, which I discuss in the introduction, is an example of such a game.

31. Patrick Jagoda, "Between: An Interview with Jason Rohrer," *Critical Inquiry*, Fall 2011, criticalinquiry.uchicago.edu/the_jason_rohrer_interview, accessed March 8, 2015.

32. Hannah Arendt, *Lectures on Kant's Political Philosophy* (Chicago: University of Chicago Press, 1992), 54–55.

33. Digital games have increasingly been discussed as including "critical" dimensions, for instance in Mary Flanagan, *Critical Play: Radical Game Design* (Cambridge: MIT Press, 2009).

34. Arendt, *Lectures on Kant's Political Philosophy*, 55.

35. Alexander Galloway, *Gaming: Essays on Algorithmic Culture* (Minneapolis: University of Minnesota Press, 2006), 2.

36. Mihaly Csikszentmihalyi, *Flow: The Psychology of Optimal Experience* (New York: Harper Perennial, 2008), 4.

37. Mihaly Csikszentmihalyi, *Beyond Boredom and Anxiety* (San Francisco: Jossey-Bass, 1975), 37.

38. Csikszentmihalyi. *Flow*, 2, 3–4, 36, 28, 31.

39. Salen and Zimmerman, *Rules of Play*, 80.

40. I confirmed this point in an email exchange with Jason Rohrer that took place January 29–31, 2012.

41. Roger Caillois, *Man, Play, and Games* (Urbana: University of Illinois Press, 2001), 23.

42. Hannah Arendt, *The Human Condition*, 230, 233, 235.

43. As Lauren Berlant has observed, intimacy "involves an aspiration for a nar-

rative about something shared, a story about both oneself and others that will turn out in a particular way." Berlant complicates this position by noting, "Intimacy reveals itself to be a relation associated with tacit fantasies, tacit rules, and tacit obligations to remain unproblematic" (*Intimacy* [Chicago: University of Chicago Press, 2000], 1, 5, 7).

44. For a discussion of extimacy, see Jacques Lacan, *The Ethics of Psychoanalysis, 1959–1960*, trans. Dennis Porter (New York: Norton, 1992). Here, I also draw from David Pavón-Cuéllar, "Extimacy," in *Encyclopedia of Critical Psychology*, ed. Thomas Teo (New York: Springer, 2013), 664, 661.

45. Tavia Nyong'o, "Brown Punk: Kalup Linzy's Musical Anticipations," *Drama Review* 54, no. 3 (2010): 73.

46. Jonathan Crary, *24/7: Late Capitalism and the Ends of Sleep* (London and New York: Verso, 2013), 126, 123–24.

47. Jenova Che, "Journey Breaks PSN Sales Records," *PlayStation Blog*, March 29, 2012, blog.eu.playstation.com/2012/03/29/journey-breaks-psn-sales-records/, accessed March 8, 2015.

48. Among other intertexts, *Journey* evokes Dante's *Divine Comedy* through a journey that includes a dark descent to a ruined underground city and an ultimate ascension of a heavily illuminated mountain.

49. Ian Bogost, "A Portrait of an Artist as a Game Studio," *Atlantic*, March 15, 2012, http://www.theatlantic.com/technology/archive/2012/03/a-portrait-of-the-artist-as-a-game-studio/254494/, accessed March 12, 2015. Regarding the nature of the interaction among players in *Journey*, Bogost writes, "For another part, you don't really play with these other players. They are there with you, doing what you do, helping at times and hindering at others, plodding senselessly toward a mountain peak that has no meaning save for those imbued by a few foreboding, pregnant camera pans. You're comforted by their presence. It's like sitting on the couch close to someone, watching TV." Though this kind of ambient relationship to another player is available, perhaps even common, I attempt to analyze a greater range of interplayer relationships that the game makes available.

50. Jenova Chen, "Jenova Chen on Journey's Philosophy," *Edge Magazine*, April 11, 2012, republished at http://journeystories.tumblr.com/post/21264500264/jenova-chen-on-journeys-philosophy, accessed March 15, 2015.

51. In an email correspondence with the owner of the *Journey Stories* blog in March 2015, she informed me that the blog has over 170,000 followers. It is worth noting, too, that the length of these posts is variable, ranging from a single image to stories that are over two thousand words long, along with accompanying screenshots of gameplay. The text is written primarily in English but includes entries written in Spanish, Mandarin Chinese, and other languages.

52. Michel de Certeau, *The Practice of Everyday Life* (Berkeley and Los Angeles: University of California Press, 1984), 115.

53. I have in mind especially the discussions about "narratology" and "ludology" that appeared in game studies in the late 1990s and early 2000s. At the core of these exchanges were scholars such as Espen Aarseth, Markku Eskelinen, Gonzalo Frasca, and Jesper Juul, who argued, in different ways, in favor of a field of "ludology." Many of these arguments suggest a form of game studies that focuses on mechanics instead of narrative. See, for instance, Gonzalo Frasca, "Simulation versus Narrative: Introduction to Ludology," in Wolf and Perron, *The Video Game Theory Reader*. Also see Markku Eskelinen, "The Gaming Situation, in Game Studies," *The International Journal of Computer Game Research* 1, no. 1 (2001), http://gamestudies.org/0101/eskelinen/, accessed March 12, 2015.

54. Marie-Laure Ryan, introduction to *Narrative across Media: The Languages of Storytelling*, ed. M.-L. Ryan (Lincoln: University of Nebraska Press, 2004, 9.

55. Henry Jenkins, "Game Design as Narrative Architecture," in *First Person: New Media as Story, Performance, and Game*, ed. Noah Wardrip-Fruin and Pat Harrigan (Cambridge: MIT Press, 2003), 121.

56. Anthropy, *Rise of the Video Game Zinesters*, 52.

57. For this distinction, see Lisbeth Klastrup, "A Poetics of Virtual Worlds," presentation, Digital Arts and Culture Conference, RMIT Univeristy, Melbourne, 2003, http://www.hypertext.rmit.edu.au/dac/papers/Klastrup.pdf, accessed March 8, 2015. For additional analysis of the distinction, see Geoff King and Tanya Krzywinska, *Tomb Raiders and Space Invaders: Videogame Forms and Contexts* (London and New York: I. B. Tauris, 2006). "Storyliving," in *Journey*, also resembles what Ryan calls "virtual stories"—the potential stories that are made possible through a text's narrativity (introduction to *Narrative across Media*, 13–14).

58. Ian Bogost, "A Portrait of an Artist as a Game Studio."

59. Galloway, *Gaming*, 91.

60. Mark B. N. Hansen writes about the "atmospheric" media of the early twenty-first century, including social media such as Facebook and Twitter. As Hansen contends, in distinction to twentieth-century recording media, networked media are characterized by "their capacity to solicit our engagement beneath the threshold of attention" ("Foucault and Media: A Missed Encounter?" *South Atlantic Quarterly* 111, no. 3 [2012]: 498). For more on atmospheric media, also see Mark B. N. Hansen, "Microtemporal Model of Media," in *Throughout: Art and Culture Emerging with Ubiquitous Computing*, ed. Ulrik Ekman (Cambridge: MIT Press, 2012).

61. theclassictasteofsin, *Journey Stories*, April 1, 2012. This quotation and all subsequent passages from this blog are attributable to quasi-anonymous user handles. I include quotations with original grammatical mistakes and styles.

62. One player describes letting out "a gasp" and feeling worry upon witnessing a coplayer trip and fall down: "I chirped softly asking if he was okay. He then got up and started to chirp wildly as if he was laughing at himself for falling that way. I thought about it and I started to laugh too, chirping wildly at him" (theclassictasteofsin, *Journey Stories*, April 1, 2012). Some forms of make-shift communication even prove functional. One player describes a companion's habit of chirping whenever they would reach a ledge together. "I didn't realize right away why they would chirp when we reached a ledge we would have to jump from, but after a few times it finally clicked: my partner was counting to three so we could jump at the same time. So many stories feature companions drawing each other hearts in the sand and snow. My companion and I didn't do this, but I knew this journey meant as much to them as it did to me because of their counting. . . . It's a quirk I hope I can use in all my journeys to make it more special for my future companions the way it was made special to me." (geekethefreak, *Journey Stories*, April 8, 2012).

63. whoabutt, *Journey Stories*, April 12, 2012.

64. One user notes, "Tonight, I played hide and seek in the seaweed room with another journeyer" (feffu, December 26, 2012). Another contributor to the blog describes trying to complete the game by introducing the arbitrary obstacle of only the minimal possible scarf: "one scarf: this kind.. im not sure if it even exists, but what i saw marked me. It was a guy who refused to get any symbols, so his scarf was as when you begin. So after that, my next journey i did the same. The whole way with that little scarf. That way i could test my flying skills, and i gotta admit it was fun!" (ilustracionesrevueltas, *Journey Stories*, April 10, 2012). Another user describes deriving replay value by pursuing bonus achievements: "I had already played through it three times so I desperately wanted to work on the trophies. My first and ultimate goal was the Transcendence trophy, collect all unique glowing symbols across one or more journeys." (pleasantterror, *Journey Stories*, April 11, 2012).

65. journeystories, *Journey Stories*, March 15, 2012.

66. An astonishingly high number of posts refer to physical responses to the game that involve "tears" and "crying"—a revelation that is unusual among gamers in online forums. A number of users reflect on the game's relationship to their masculinity: "I'm a man . . . and I cried like a small child when my best friend's scarf was torn away" (Harry wright, *Journey Stories*, March 23, 2012). Another user reflects on the sadness of losing a partner in the game: "Moving on, I quickly found another companion, but tears were still rolling down my cheeks, mourning the loss of my partner, the death of our friendship." (journeystories, *Journey Stories*, March 15, 2012). Still other users describe crying together with other players or observers of the game who are present in the same physical space. One player notes, "Never did my girlfriend realize that her companion was another human player. . . . While

the credits were rolling, I finally told my girlfriend that our companion had been a human player all along. Every time you fell, it was a player that came to save you. Every time you chimed, it was a player that responded, replicating the pattern that you just had signaled. . . . It might seem crazy, but it was a truly magical moment that actually caused us to tear up. The game had played with our feelings too perfectly" (sanslimits, March 20, 2012). The moments of crying in journeystories often accompany moments of affect that precisely cannot be narrativized.

67. journeystories, *Journey Stories*, March 22, 2012 and BeRight, *Journey Stories*, March 28, 2012. One reviewer, Leon Hurley, describes the power of the game coming from the "sense of uncertainty" that it produces through its nonverbal orientation. See "Official PlayStation's Journey memories." *PlayStation Magazine UK*, April 12, 2012. This entry was reposted on *Journey Stories* by hirasawalyrics on April 13, 2012.

68. sanslimits, *Journey Stories*, March 20, 2012. Though many contributors to the blog link the ineffability of the game's effects to its network elements, it is worth noting that some entries also remark on the role of Austin Wintory's soundtrack as being responsible for their transformative and not fully accessible experience. The emotional complexity suggested by the soundtrack is expressed, for example, in a post by theclassictasteofsin, who writes, "The first time I listened to it, while reaching the top of the mountain. I had felt such a rush emotions. My chest felt heavy and my vision was haunted with the scenery. This combination was such a shock to my senses.. That whenever I listen to it now, I can't help but cry. Not the sobbing, or sniffling kind of cry. But more of the silent kind, where I forget I need to breathe and tears just flow out. I could not describe the emotion I feel when I listen to this song. It's not happiness or sadness. Not rage or forgiveness. Not envy or compassion. But if I could try to describe this to you, I feel like it would be emotion of knowing I am meant for something. That I have a purpose and a direction in which to go. It's like the feeling of knowing you are truly alive. That I have a beating heart and a soul. That I am human" (*Journey Stories*, March 23, 2012).

69. *Journey* taps into what Kathleen Stewart calls "ordinary affects," which are at once "abstract and concrete" and tend to be "more fractious, multiplicitous, and unpredictable than symbolic meaning." As Stewart notes, "Bottom-line arguments about 'bigger' structures and underlying causes obscure the ways in which a reeling present is composed out of heterogeneous and noncoherent singularities" (*Ordinary Affects*, 3–4).

70. For instance, see Lisa Nakamura, "Gender and Race Online," in *Society and the Internet: How Networks of Information and Communication Are Changing Our Lives*, ed. Mark Graham, William H. Dutton, and Manuel Castells (Oxford: Oxford University Press, 2014), 81–98. Nakamura writes, "Video

games, particularly networked games, create social practices and belief systems that license and permit uses of racialized and racist speech that are not believed to apply to or carry over into the 'real world,' but instead stay within the 'magic circle' of the game" (84).

71. vellummoon, *Journey Stories*, March 16, 2012.

72. Dave Meikleham, "Official PlayStation's Journey memories," *PlayStation Magazine UK*, April 12, 2012, republished at http://journeystories.tumblr .com/post/21078111816/official-playstations-journey-memories, accessed March 12, 2015. This entry was reposted on *Journey Stories* by hirasawalyrics on April 13, 2012. Meikleham describes the game as "the most fragile, delicate sense of actual co-operation I've ever experienced in a co-op game," producing a "sense of companionship and genuine connection."

73. paper-eight, *Journey Stories*, April 4, 2012.

74. Chen, "Jenova Chen on Journey's Philosophy." Chen contends, *"Journey* manages to cultivate empathy and cooperation, while straining out the impurities."

75. panzertron, *Journey Stories*, March 15, 2012.

76. toadtamer, *Journey Stories*, March 16, 2012. This user describes meeting a competitive companion who seems "intent on getting to the next part of the game" and being uncomfortable about trying "my companion's patience" by taking a slower and more exploratory approach. A different player (Eric Frey, *Journey Stories*, March 28, 2012) expresses the frustration of collaborating with a companion who solves the levels for both of them, seeking no cooperation and leaving no room for exploration: "That player is like a parasite eating the enjoyment I expected to get later solving the level."

77. Regarding a desired sense of isolation, one reviewer notes, "My Journey was an intensely lonely one. But that's the way I wanted it to be: my natural reaction to meeting anyone over the internet is to run a mile. . . . Companionship just isn't for me, at least when it comes to games, and I was content to enjoy this in splendid isolation" (Wilson, "Official PlayStation's Journey memories"). Another player describes feeling "shy" about interacting with more experienced players (theclassictasteofsin, *Journey Stories*, April 1, 2012). Still other players describe loneliness and a sense of abandonment. One player reflects, "I've never been so lonely as I was when my partner left me before the shrine that shows your journey. As I waited for my partner, chirping for him to come and meet me on the stairs, I got that sinking feeling in my stomach and I knew he was gone. . . . I sat down in the snow and cried. I had never felt so alone" (eragale, *Journey Stories*, March 30, 2012). Another player describes an isolating realization that he or she has been playing not with one companion, consistently through the game, but rather with ten different users: "The experience was almost heartbreaking, to be honest. I went through over ten companions in the first half of the game alone. I didn't realize so

many people had come and gone so quickly until I got the trophy for it. . . . I thought it was pretty ironic that a game meant to bring people together was instead telling me that I couldn't trust other human beings to be reliable" (geekethefreak, *Journey Stories*, April 2, 2012).

78. Jane McGonigal, *Reality Is Broken: Why Games Make Us Better and How They Can Change the World* (New York: Penguin, 2011), 83–87.

79. theclassictasteofsin, *Journey Stories*, March 16, 2012.

80. backwardso, *Journey Stories*, March 19, 2012. In fact, the ethic of helping newer players has developed into "an unspoken rule" among some "white cloaks" (that is, advanced players) that suggests one cannot play with another white cloak but only a novice "red cloak" who requires help (theclassictasteofsin, *Journey Stories*, April 1, 2012).

81. panzertron, *Journey Stories*, March 15, 2012.

82. Sister_Okami, *Journey Stories*, April 1, 2012.

83. journeystories, *Journey Stories*, April 1, 2012. This player writes, "I was just playing Journey with a companion when I lost my internet connection suddenly. . . . I had just shown you where the desert flower is, and as soon as we reached the large tower at the end of that level, my connection cut out."

84. scheduledfordeletion, *Journey Stories*, March 16, 2012. This player writes, "I was delighted to see a list of people I'd encountered after the end, and hesitantly sent my companion a friend request over PSN. They accepted it within seconds, and instantly sent me an apology for losing track of me at the end. We've chatted for a bit about Journey since, and it seems I've in fact made a few friend out of such an amazing game (experience?) after all!"

85. Ged, *Journey Stories*, March 20, 2012. Some postgame connections between *Journey* players have also been initiated indirectly through online discussions. For example, one contributor to *Journey Stories* offers the following response to a story: "Hey, what is your PSN [network handle]? Your Journey experiences are very interesting and I would like to know if I meet you in one of mine. My PSN is Imposcillator. :)" The response is "My PSN username is tamchronic. I'll be sure to keep an eye out for your name when I play the game in future!" (journeystories, *Journey Stories*, March 22, 2012). Though the possibility of following up with a companion exists, some posts express an uncertainty about lost anonymity or continued communication. One player describes sending a thank-you message after an intense session and receiving a reciprocal reply of gratitude. The player then wonders about whether to continue the correspondence: "Could we be real life friends? Or would that ruin the magic of Journey" (shornb, *Journey Stories*, March 17, 2012).

86. One player addresses a player whom he or she will never know: "You're my partner- No. You're my companion, and it's my job to look out for you" (chiazu, *Journey Stories*, April 5, 2012). Many entries suggest that *Journey* fos-

ters quick attachments from a distance, as when one player uses the phrase "my buddy" to describe an in-game companion who is neither a PlayStation Network friend nor a face-to-face relation (rawowner333, *Journey Stories*, March 15, 2012). Other terms for coplayers suggest projection, imaginative analogy, or mere playfulness, as when one player refers to a companion as "my big sister" and talks about herself becoming "the big sister" in another play-through and having to "watch out for my little brother" (croik, *Journey Stories*, March 15, 2012). Other players determine their relationship with the other based on in-game experiences, as when a player calls a less advanced companion "my student" (entil-zha, *Journey Stories*, April 10, 2012). Still other players assign a specificity to their companions by creating nicknames for them, as with one player who describes a Wi-Fi failure that leads to him becoming disconnected from "Lines," observing, "I mean, even though I didn't know this person at all, I felt very sad I couldn't find Lines again" (blackbirdsofrye, *Journey Stories*, March 21, 2012).

87. Whoabutt, *Journey Stories*, April 12, 2012. The invocation of other players as "strangers" appears in numerous posts on the *Journey Stories* blog.

88. Michael Warner, *Publics and Counterpublics* (New York: Zone Books, 2002), 75.

89. Melissa Deem, "Stranger Sociability, Public Hope, and the Limits of Political Transformation," *Quarterly Journal of Speech* 88, no. 4 (2002): 445.

90. For a reflection on encountering strangers in *Journey*, see Kevin Nguyen, "I've Been through the Desert with a Friend with No Name," *Bygone Bureau*, March 26, 2012, http://bygonebureau.com/2012/03/26/ive-been-through -the-desert-with-a-friend-with-no-name/, accessed March 8, 2105. Nguyen observes about his experience of the game, "Our impressions of people in real life are colored by the way people look and act; to speak to a stranger is a risk. *Journey* deliberately hides those features of a person; its desert is designed to draw you toward a person you've never met and know nothing about."

91. For an argument that these types of videogames are not generative of play, see David Golumbia, "Games without Play," *New Literary History* 40, no. 1 (Winter 2009): 179–204.

92. For an analysis of the role of play in capitalism, see Bill Brown, *The Material Unconscious: American Amusement, Stephen Crane, and the Economies of Play* (Cambridge: Harvard University Press, 1996). Also, elsewhere, I argue that play, even in its most transgressive or unexpected forms, can never wholly exceed a capitalist system that absorbs it and converts it into surplus value. For more, see Jagoda, "Gamification and Other Forms of Play."

93. Donald W. Winnicott, *Playing and Reality* (London: Routledge, 2005), 64.

94. As Winnicott again observes, "Playing implies trust, and belongs to the potential space between" (ilid., 69).

95. Turkle, *Alone Together*, 1, 11, 10, 157.

96. See Leo Bersani, "Sociability and Cruising," in *Umbr(a): Sameness*, no. 1 (2002): 9–24. Bersani writes, "Cruising, like sociability, can be a training in impersonal intimacy." In "ideal cruising," participants leave their selves behind. "The gay bathhouse is especially favorable to ideal cruising because, in addition to the opportunity anonymous sex offers its practitioners of shedding much of the personality that individuates them psychologically, the common bathhouse uniform—a towel—communicates very little . . . about our social personality" (21). Though *Journey* does not introduce explicitly sexual forms of intimacy, the structure of a journey in which one finds anonymous companions arguably resembles cruising.

97. Warner, *Publics and Counterpublics*, 121.

Chapter 5

1. "Tomorrow Calling—A Game for the Future 'Elevator Pitch,'" http://online .education.ed.ac.uk/gallery/sides_wolff_tomorrow_calling.pdf.

2. That game site was located at http://www.temporalkinephonics.com/.

3. For more on network failures, see Susanna Paasonen, "As Networks Fail: Affect, Technology, and the Notion of the User," *Television & New Media*, October 8, 2014.

4. For the term "pervasive games," see Markus Montola, Jaakko Stenros, and Annika Waern, *Pervasive Games: Theory and Design* (Burlington, MA: Morgan Kaufmann, 2009). For "immersive games," see Jane McGonigal, "This Is Not a Game: Immersive Aesthetics and Collective Play," presentation, Digital Arts and Culture Conference, RMIT Univeristy, Melbourne, 2003, http:// hypertext.rmit.edu.au/dac/papers/McGonigal.pdf, accessed March 9, 2015. The term "transmedia games" comes up in many contexts. For an early discussion of "transmedia storytelling," see Marsha Kinder, *Playing with Power in Movies, Television, and Video Games: From Muppet Babies to Teenage Mutant Ninja Turtles* (Berkeley and Los Angeles: University of California Press, 1991). For an elaboration on "transmedia storytelling" that includes games such as *The Beast*, see Henry Jenkins, *Convergence Culture: Where Old and New Media Collide* (New York: New York University Press, 2006). For "search operas," see Sean Stewart, "Alternate Reality Games," http://www.seanstewart .org/interactive/args/. For the terms "unfiction" and "chaotic fiction," see Sean Stacy, "Undefining ARG," http://www.unfiction.com/compendium /2006/11/10/undefining-arg/, accessed March 9, 2015. For consistency, I use the term "alternate reality games," or "ARGs," throughout this chapter.

5. Roger Caillois, *Man, Play, and Games* (New York: Free Press of Glencoe, 1961), 82.

6. José van Dijck, *The Culture of Connectivity: A Critical History of Social Media* (Oxford: Oxford University Press, 2013), 4.

7. Ibid., 8.

8. Marshall McLuhan, *Understanding Media: The Extensions of Man* (Berkeley, CA: Gingko Press, 2003), 327.

9. Jodi Dean, "Why Is the Net Not a Public Sphere?" *Constellations* 10, no. 1 (2003): 102.

10. Lauren Berlant, *Cruel Optimism* (Durham: Duke University Press, 2011), 15.

11. A number of ARGs have educational components, including *World without Oil* (2007), *Black Cloud* (2008), *Evoke* (2010), *Project Velius* (2011), *Arcane Gallery of Gadgetry* (2011), and *Speculation* (2012). For more on educational ARGs, see Greg Niemeyer, Antero Garcia, and Reza Naima, "Black Cloud: Patterns towards da Future," in *MM '09: Proceedings of the 17th ACM International Conference on Multimedia* (New York: Association for Computing Machinery, 2009); J. Battles, V. Glenn, and L. Shedd, "Rethinking the Library Game: Creating an Alternate Reality with Social Media," in *Journal of Web Librarianship* 5, no. 2 (2011): 114–31; Elizabeth Bonsignore et al., "Alternate Reality Games: Platforms for Collaborative Learning," in *Proceedings of the Tenth International Conference of the Learning Sciences* (online, Lulu Press, 2012); Shira Chess and Paul Booth, "Lessons down a Rabbit Hole: Alternate Reality Gaming in the Classroom," *New Media & Society* 16, no. 6 (2013): 1002–17; Benjamin Stokes et al., "A Reality Game to Cross Disciplines: Fostering Networks and Collaboration," in *Proceedings of DiGRA 2013: DeFragging Game Studies* (Atlanta, GA, August 2013), http://benjaminstokes.net/doc/Stokes,Watson,Fullerton,Wiscombe%282013%29Reality-Game-To-Foster-Networks_%28conf-final2%29.pdf, accessed May 23, 2015; and N. Katherine Hayles, Patrick Jagoda, and Patrick LeMieux, "Speculation: Financial Games and Derivative Worlding in a Transmedia Era," *Critical Inquiry* 40, no. 3 (Spring 2014): 220–36.

12. My ARG designs, which encompass both art and educational games, have included *Oscillation* (2011, http://vimeo.com/26438531), *Speculation* (2012, http://vimeo.com/39947942), *Stork* (2012, http://vimeo.com/60689753), *The Project* (2013, http://vimeo.com/72283300), *The Source* (2013, http://lucian.uchicago.edu/blogs/gamechanger/portfolios/the-source/), *Play as Inquiry* (2013, https://lucian.uchicago.edu/blogs/gamechanger/portfolios/play-as-inquiry/) and *S.E.E.D.* (2014, http://lucian.uchicago.edu/blogs/gamechanger/portfolios/seed/).

13. Tim Ingold, *Making: Anthropology, Archaeology, Art and Architecture* (Milton Park, Abingdon, Oxon: Routledge, 2013), 3.

14. Lucy Kimbell, "If Networked Art Is the Answer What Is the Question?" in *Network Art: Practices and Positions*, ed. Tom Corby (London: Routledge, 2006).

15. Matt Ratto, "Critical Making: Conceptual and Material Studies in Technology and Social Life," *Information Society* 27, no. 4 (2011): 252, 253, 254.

16. Montola, Stenros, and Wærn, *Pervasive Games*, 32–38.

17. Jane E. McGonigal, "This Might Be a Game: Ubiquitous Play and Performance at the Turn of the Twenty-First Century" (PhD diss., University of California at Berkeley, 2006).

18. Nicolas Bourriaud, *Relational Aesthetics* (Dijon: Les Presses du Réel, 2002), 8.

19. Ken Friedman, "The Wealth and Poverty of Networks," in *At a Distance: Precursors to Art and Activism on the Internet*, ed. Annmarie Chandler and Norie Neumark (Cambridge: MIT Press, 2006), 411.

20. Johanna Drucker, "Interactive, Algorithmic, Networked: Aesthetics of New Media Art," in Chandler and Neumark, *At a Distance*, 40–41.

21. For more on network art, see especially Corby, *Network Art*, and Rachel Greene, *Internet Art* (New York: Thames & Hudson, 2004).

22. N. Katherine Hayles, *Electronic Literature: New Horizons for the Literary* (Notre Dame: University of Notre Dame, 2008), 6–7.

23. Dick Higgins, "Statement of Intermedia," http://www.artpool.hu/Fluxus /Higgins/intermedia2.html, accessed March 9, 2015. As the art historian Owen Smith observes, following Higgins, Fluxus did not approach "the creative arena as clearly or rigidly segmented into various arts" ("Fluxus Praxis: An Exploration of Connections, Creativity, and Community," in Chandler and Neumark, *At a Distance*, 126).

24. Friedman, "The Wealth and Poverty of Networks," 413.

25. *An Aesthesia of Networks: Conjunctive Experience in Art and Technology* (Cambridge: MIT Press, 2013), 160.

26. Ryan, introduction to *Narrative across Media*, 18.

27. I lay out some of the transmedia dimensions of ARGs with N. Katherine Hayles and Patrick LeMieux in "Speculation: Financial Games and Derivative Worlding in a Transmedia Era."

28. Caillois, *Man, Play, and Games*, 7.

29. J. Huizinga, *Homo Ludens: A Study of the Play-Element in Culture* (New York: Roy Publishers, 1950).

30. Guy Debord, "Contribution to a Situationist Definition of Play," trans. Reuben Keehan, *Internationale Situationniste* 1 (June 1958), http://www.cddc.vt .cdu/sionline/si/play.html, accessed October 20, 2015.

31. McGonigal, "This Is Not a Game."

32. Montola, Stenros, and Waern, *Pervasive Games*, 111–16.

33. Richard Schechner, *Performance Studies: An Introduction* (London: Routledge, 2002), 92, 119.

34. McGonigal, "This Is Not a Game." While McGonigal observes that "immersive" games such as *The Beast* frequently incorporate "pervasive" features, I would argue that in ARGs, the so-called immersive effects *depend on* the "pervasive" features.

35. As Alexander Galloway and Eugene Thacker observe, "Digital media seem to be everywhere . . . in the *everydayness* of the digital (e-mail, mobile phones, the Internet). Within First World nations, this everydayness—this banality of the digital—is precisely what produces the effect of ubiquity, and of universality" (*The Exploit: A Theory of Networks* [Minneapolis: University of Minnesota Press, 2010], 10).

36. For an exploration of participatory culture, see especially Henry Jenkins, *Fans, Bloggers, and Gamers: Exploring Participatory Culture* (New York: New York University Press, 2006). For a discussion of transmedia story worlds, see Henry Jenkins, Sam Ford, and Joshua Green, *Spreadable Media: Creating Value and Meaning in a Networked Culture* (New York: New York University Press, 2013), 132.

37. I am indebted to a conversation with Adrian Danzig for this insight.

38. Stewart, "Alternate Reality Games."

39. *The Project* was supported by a grant from the Gray Center for Arts and Inquiry. For more information about the game, as well as related events, see http://graycenter.uchicago.edu/experiments/alternate-reality-a-pervasive-play-project. For *The Project* forum, see http://theproject.boards.net/.

40. This argument in favor of tracking networking processes over networked objects shares parallels with a certain line of thinking in media studies. Alexander Galloway, in particular, departs from the object-centered approach taken by critics such as Marshall McLuhan for whom media objects are technological extensions of the human body. For Galloway, media are not "objects or substrates" but rather "practices of mediation" (*The Interface Effect*, 16).

41. Munster, *An Aesthesia of Networks*, 28.

42. Christy Dena, "Emerging Participatory Culture Practices: Player-Created Tiers in Alternate Reality Games," *Convergence: The International Journal of Research into New Media Technologies* 14, no. 1 (February 2008): 41–57.

43. Munster, *An Aesthesia of Networks*, 183.

44. The ARG designer, like Gilles Deleuze and Felix Guattari's poet, hopes to "sow the seeds of, or even engender, the people to come." (*A Thousand Plateaus: Capitalism and Schizophrenia* [Minneapolis: University of Minnesota Press, 1987], 345).

45. N. Katherine Hayles, *How We Think: Digital Media and Contemporary Technogenesis* (Chicago: University of Chicago Press, 2012), 19.

46. See Schechner, *Performance Studies*, 91. As Schechner suggests, "Play is characterized both by flow—losing oneself in play—and reflexivity."

47. Galloway and Thacker, *The Exploit*, 100.

48. Manuel Castells, "An Introduction to the Information Age," *City* 2, no. 7 (1997): 8.

49. Craig Saper, "Fluxus as a Laboratory," in *The Fluxus Reader*, ed. Ken Friedman (Chichester, West Sussex: Academy Editions), 136.

50. I explore the concept of "gamification" at greater length in Jagoda, "Gamification and Other Forms of Play," *boundary 2* 40, no. 2 (Summer 2013): 113–44. For additional examples of gamified applications, websites, and curricula, see Rajat Paharia, *Loyalty 3.0: How to Revolutionize Customer and Employee Engagement with Big Data and Gamification* (New York: McGraw-Hill, 2013).

51. Jason Mander, "Daily Time Spent on Social Networks Rises to 1.72 Hours," *Global Web Index*, January 26, 2015, https://www.globalwebindex.net/blog /daily-time-spent-on-social-networks-rises-to-1-72-hours, accessed June 8, 2015. These numbers come from a survey that covered 170,000 respondents, ages sixteen to sixty-four.

52. Jacques Derrida, *Of Spirit: Heidegger and the Question*, trans. Geoffrey Bennington and Rachel Bowlby (Chicago: University of Chicago Press, 1989), 40.

53. For more on "counterplay," see Nick Dyer-Witheford and Greig de Peuter, *Games of Empire: Global Capitalism and Video Games* (Minneapolis: University of Minnesota Press, 2009), 191–94. For more on "countergaming," see Alexander Galloway, *Gaming: Essays on Algorithmic Culture* (Minneapolis: University of Minnesota Press, 2006), 107–26.

54. Rita Raley, *Tactical Media* (Minneapolis: University of Minnesota Press, 2009), 12.

55. Jenkins, Ford, and Green, *Spreadable Media*, 163.

56. Jesper Juul, *The Art of Failure: An Essay on the Pain of Playing Video Games* (Cambridge: MIT Press, 2013), 109.

57. As McKenzie Wark explains, in greater detail, "The twenty-first century is the culmination of two forms of individualism. In the first, individuals are all the same; in the second, they are all different. The first is classically bourgeois, the second distinctively bohemian." In our time, however, "bourgeois individualism is now infused with bohemian flourishes." In fact, even social media, despite being networked and multiuser spaces, reinscribe individualism in a variety of ways—through personal profiles, status updates, and various opportunities for self-promotional networking. Wark, *The Beach beneath the Street: The Everyday Life and Glorious Times of the Situationist International* (London: Verso, 2011), 11–12.

58. The collectivity of any ARG is not necessarily the chaotic "crowd" feared by crowd psychologists such as Gustave Le Bon and Gabriel Tarde or the postliberal "multitude" with its focused political energies in the work of Michael Hardt and Antonio Negri (though it could be either). Different ARGs are designed for different potential player collectives (or, in some case, audiences or customers). The point is that *The Project* opened up a space for different kinds of collectives to emerge. For more on the "crowd" versus "multitude" distinction, see William Mazzarella, "The Myth of the Multitude; or, Who's

Afraid of the Crowd?" *Critical Inquiry* 36, no. 4 (2010): 697–727. Manuel Castells offers another relevant distinction, observing that computer networks may generate "togetherness" but not necessarily a "community" with shared values. In political situations, he notes, "community is a goal to achieve, but togetherness is a starting point and the source of empowerment" (*Networks of Outrage and Hope: Social Movements in the Internet Age* [Cambridge, UK: Polity, 2012], 225).

59. Christopher Alexander, *The Process of Creating Life: An Essay on the Art of Building and the Nature of the Universe* (Berkeley, CA: Center for Environmental Structure, 2002), 13.

60. Juul, *The Art of Failure*, 45.

61. Chess and Booth, "Lessons down a Rabbit Hole," 5.

62. J. Halberstam, *The Queer Art of Failure* (Durham: Duke University Press, 2011), 3, 92, 120.

63. Wark, *The Beach beneath the Street*, 28

64. McGonigal, "This Is Not a Game."

65. Jenkins, Ford, and Green, *Spreadable Media*, 17, 19, 7.

66. Ibid., 1.

67. In this regard, we might think again of the Situationist International—one of the collectives whose approach to social play and games serves as a critical precursor of ARGs. As Wark points out, only nine people were present at the founding meeting of the Situationist International, and remarkably, "in its first fifteen years of existence, only seventy-two people were ever members" (*The Beach beneath the Street*, 61). And yet this small group of practitioners and thinkers came, especially many years after their dissolution, to have a profound impact on the work of numerous artists, activists, and political thinkers. My intention here is not to draw some grandiose parallel between the work of the Situationists and the much more modest practice-based research of *The Project*. The correspondence does, however, highlight the limits of the spreadable media paradigm as a way of approaching networks.

68. Jane McGonigal, *Reality Is Broken: Why Games Make Us Better and How They Can Change the World* (New York: Penguin, 2011), 305.

69. There are some exceptions of games in which rules are created, by players, as the game unfolds. One such example would be *1000 Blank White Cards*, in which players take turns making up new rules from turn to turn. Even this game, however, has implicit metarules, for instance about the sequence of turn taking.

70. "Tomorrow Calling—A Game for the Future 'Elevator Pitch.'"

71. Wark, *The Beach beneath the Street*, 51

72. Jodi Dean, "Affective Networks," *MediaTropes* eJournal 2, no. 2 (2010), http://www.mediatropes.com/index.php/Mediatropes/article/viewFile/11932/8818, 42, accessed March 10, 2015.

73. Mazzarella, "The Myth of the Multitude," 726.

74. Debord, "Contribution to a Situationist Definition of Play," 1.

75. As Anna Munster notes, the interplay between "anticipation (imaging a network to come) and tedium (the pragmatics of engaging with online computation) continues to fold into and constitute the duration of network experience" (*An Aesthesia of Networks*, 19).

76. Jenkins, Ford, and Green, *Spreadable Media*, 137.

77. Jonathan Crary, *24/7: Late Capitalism and the Ends of Sleep* (London and New York: Verso, 2013, 19, 8.

78. Huizinga, *Homo Ludens*, 13.

79. Bernard Suits, *The Grasshopper: Games, Life, and Utopia* (Toronto: University of Toronto Press, 1978), 161.

80. Halberstam, *The Queer Art of Failure*, 15.

Coda

1. Albert-László Barabási, *Linked: How Everything Is Connected to Everything Else and What It Means for Business, Science, and Everyday Life* (New York: Penguin, 2003), 5–6.

2. Manuel Lima, *Visual Complexity: Mapping Patterns of Information* (New York: Princeton Architectural Press, 2011), 69, 224–26. In setting up this claim, Lima foregrounds the physicist Richard P. Taylor's work on the fractal patterns that appear in Jackson Pollock's paintings. For more, see, for example, R. P. Taylor, B. Spehar, P. Van Donkelaar, and C. M. Hagerhall, "Perceptual and Physiological Responses to Jackson Pollock's Fractals," *Frontiers in Human Neuroscience* 5, art. 60 (2011), doi.org/10.3389/fnhum.2011.00060. Here, Taylor et al. speculate that fractal patterns may "trigger" a "resonance" in the act of viewing when "the eye sees a fractal pattern that matches its own inherent characteristics" (6). Such discourse, however speculative and even mystical it may be, begins to naturalize fractal aesthetics in a parallel fashion to Lima's discussion of network forms in art.

3. Michel Foucault, *The Order of Things: An Archeology of the Human Sciences* (New York: Vintage Books, 1970).

4. Manuel Lima explores trees in *Visual Complexity*, 21–41. Also see Franco Moretti, *Graphs, Maps, Trees: Abstract Models for a Literary History* (London: Verso, 2005), 67. Moretti takes up Darwin as his opening example of how a tree diagram might be used to map changes in literary form.

5. N. Katherine Hayles, *Electronic Literature: New Horizons for the Literary* (Notre Dame: University of Notre Dame, 2008), 132.

6. Lauren Berlant, "Thinking about Feeling Historical," *Emotion, Space and Society* 1, no. 1 (2008):" 5.

7. Harry Harootunian, "Remembering the Historical Present," *Critical Inquiry* 33, no. 3 (Spring 2007): 490.

8. Alexander Galloway, *The Interface Effect* (Cambridge, UK: Polity, 2012), 138.

9. Ibid.

10. See, for instance, Woodrow Hartzog and Evan Selinger, "Quitters Never Win: The Costs of Leaving Social Media," *Atlantic*, February 15, 2013. Also see José van Dijck, *The Culture of Connectivity: A Critical History of Social Media* (Oxford: Oxford University Press, 2013).

11. See, for instance, Beth Anderson et al., "Facebook Psychology: Popular Questions Answered by Research," *Psychology of Popular Media Culture* 1, no. 1 (January 2012), doi:10.1177/0163443714557983. Also see Hanna Krasnova et al., "Envy on Facebook: A Hidden Threat to Users' Life Satisfaction?" in *Wirtschaftsinformatik Proceedings* (2013), http://aisel.aisnet.org/wi2013/92/, accessed May 23, 2015.

12. For a parallel articulation of Galloway's position, see Zach Blas, "Informatic Opacity," *Journal of Aesthetics and Protest* 9 (Summer 2014), http://www.joaap.org/issue9/zachblas.htm, accessed May 23, 2015. Also see Irving Goh, "Prolegomenon to a Right to Disappear," *Cultural Politics* 2, no. 1 (2006): 97–114.

13. Lauren Berlant and Lee Edelman, *Sex, or the Unbearable* (Durham: Duke University Press, 2014), 61, 12.

14. For an exploration of ways that art can open up an understanding of slowness, see Lutz P. Koepnick, *On Slowness: Toward an Aesthetic of the Contemporary* (New York: Columbia University Press, 2014).

15. For a fuller account of the *Speculation* alternate reality game and its outcomes, see N. Katherine Hayles, Patrick Jagoda, and Patrick LeMieux, "Speculation: Financial Games and Derivative Worlding in a Transmedia Era," *Critical Inquiry* 40, no. 3 (Spring 2014): 220–36.

16. Jodi Dean, *Democracy and Other Neoliberal Fantasies: Communicative Capitalism and Left Politics* (Durham: Duke University Press, 2009), 4.

17. Itai Himelboim, Stephen McCreery, and Marc Smith, "Birds of a Feather Tweet Together: Integrating Network and Content Analyses to Examine Cross-Ideology Exposure on Twitter," *Journal of Computer-Mediated Communication* 18, no. 2 (January 2013): 40–60.

18. Jonathan Zittrain, *The Future of the Internet and How to Stop It* (New Haven: Yale University Press, 2008), 3.

19. Henry Jenkins, "Collective Intelligence vs. the Wisdom of Crowds," November 27, 2006, http://henryjenkins.org/2006/11/collective_intelligence_vs_the.html, accessed May 24, 2015.

Index

accidents: Aristotle's theory of, 79, 259n21; cinematic reflection on, 258n15; conspiracy films vs. network films and, 100; in network film, 77–80; in *Syriana*, 78–80, 89–90, 92, 262n48, 263n58

action: Arendt's theory of, 160–61, 162–63; *Between* and, 160–63; reflection, active, 165; *Uplink* and, 153

actor-network theory (ANT), 108–10, 128, 243n90, 268n19, 268n22, 275n72

Adorno, Theodor, 26, 230n13

aesthetic politics, 101, 265n75

aesthetics: concept of, 16–19; of dejection, 99–100; intersubjectivity and, 141; post-identity collectivity and, 141; tensions in, 26. *See also* network aesthetics; *and specific works*

affect: human and nonhuman dimensions of networks and, 31–33; intensity in *Syriana*, 90–91; *Journey* and, 171–75, 286n86, 287n68; network films and affective experiences, 85–86, 102; Stewart's "ordinary affects," 287n69; terrorist networks and, 82; *Uplink* and, 154;

The Wire, structures of feeling, and affective complicity, 134–38

affect theory, 33, 243n92, 264n66

Agamben, Giorgio, 223

agency: digital games and, 147, 148; in *The Wire*, 117

agnotology, 58, 251n37

Alexander, Christopher, 208

alone-togetherness, 2, 7

al Qaeda, 260n32

alternate reality games (ARGs), 181–219; alternate reality, production of, 193; collective dimension of, 195–96, 295n58; connectivity and, 183–84; defined, 183; designer-player distinction, breakdown of, 193–95; ephemera and, 218–19; exhaustion and, 216–19; and experience of networks, vs. representation or imagination of networks, 183; human-environment coupling in, 200; integration of play with everyday life, 191–93; names for, 182; as networking, 186; practice-based research and, 185–87; prehistory of, 187–89; process and, 199–200; scale and difficulty, 195; *Speculation*, 194, 226–27; *Tomorrow Calling*, 181–82, 194, 208, 214;

complexity (*cont.*)
 self-organizing system, 86–87;
 sublimity and, 47–49; televisual
 seriality and, 103–4
complexity science, 78, 84–85, 261n37
complicity: collaboration as, in *The
 Project*, 202–8; Derrida on, 205; *The
 Wire* and affective complicity, 137,
 278n95
computer games. *See* digital games and
 videogames
computer networks: breakdown and,
 182; control and history of, 21–22;
 in *Cryptonomicon*, 253n57; digital
 games and, 144; failure and, 210;
 new cultural and art forms from,
 182. *See also* networks
computer network simulations, 148–49
Computer Space (game), 156
Comte, Auguste, 85
connection and connectedness:
 connectivity vs., 183, 203; control
 vs. limitless connection, 21;
 "everything is connected," 7–8;
 excess of, 224; as infrastructural
 basis of everyday life, 1–2; linkage-
 disconnection spectrum and, 7;
 network films and, 102. *See also*
 network imaginary; *and specific
 works*
connectivity: ARGs and, 183–84;
 connectedness vs., 183, 203; as
 weapon, 81
conspiracy: collective nature of,
 258n13; conspiracy films, 76–77,
 100, 262n45; Krapp on conspiracy
 theory, 258n11; network films and,
 77–78
Contagion (film), 258n12
control: Anthropy on digital media
 and, 170; *Between* and, 162;
 Cryptonomicon and the Internet

and, 67; cyberspace and sense
 of, 239n61; Deleuze's "control
 societies," 27, 152–53, 155; digital
 games and, 161–62; network
 aesthetics and, 21–23, 27; "power
 without control" interaction, 194;
 temporality and, 153; *Uplink* and
 computer network simulations and,
 152–53
controversy, 125, 274n66
convergence culture, 30–31
Corner, The (Simon), 268n19
Cosgrove, Dennis, 43, 245n1
counterplay, 205
counterpublics, 180
Crary, Jonathan, 181, 208, 217
Crawford, Chris, 281n14
criss-crosser films, 74, 256n2
critical theory, 15–16
Cronenberg, David, 89
cruising, 180, 291n96
Cryptonomicon (Stephenson), 62–71;
 analogous relationship between
 novel and network in, 62–64;
 departure from earlier technological
 fiction, 64–65; epistemological
 limits, sense of, 70; historical
 parameters and maximalist form of,
 63, 65; Lawrence in underground
 railway, 68–69; libertarianism
 and, 255n74; materiality and, 64;
 maximalism and, 63, 65, 253n61;
 as network novel, 44–47; prologue
 and Shaftoe's haiku, 62–63; Randy
 and computer networks in, 253n57;
 spatial, temporal, and geopolitical
 dimensions of networks in, 66–69;
 title of, 69–70, 255n72; undersea
 cables venture, 65–66; *Underworld*
 compared to, 64, 72
Csikszentmihalyi, Mihaly, 161
Cunningham, David, 71